SACRED MOUNTAINS
IN CHINESE ART

Kiyohiko Munakata

An exhibition organized by the Krannert Art Museum
and curated by Kiyohiko Munakata

Krannert Art Museum
November 9 – December 16, 1990

The Metropolitan Museum of Art
January 25 – March 31, 1991

Krannert Art Museum
University of Illinois at Urbana-Champaign

University of Illinois Press
Urbana and Chicago

This publication was made possible in part by grants
from the National Endowment for the Humanities, a
Federal agency, and from the Research Board of the
University of Illinois at Urbana-Champaign, and by
contributions from Rosann and Richard Noel, Sophie
and Brian Leung, Juliana and Ronald Chao, and the
Marine Corporation, Springfield, Illinois.

Manufactured in the United States of America

P 5 4 3 2 1

Library of Congress Cataloging-in-Publication Data

Munakata, Kiyohiko, 1928-
 Sacred mountains in Chinese art : an exhibition organized
 by the Krannert Art Museum at the University of Illinois,
 Urbana-Champaign, curated by Kiyohiko Munakata :
 Krannert Art Museum, November 9 – December 16, 1990,
 The Metropolitan Museum of Art, January 25 – March 31,
 1991 / Kiyohiko Munakata.
 p. cm.
 Includes bibliographical references and index.
 ISBN 0-252-06188-8 (alk. paper)
 1. Mountains in art – Exhibitions. 2. Art, Chinese –
 Exhibitions. 3. Mountains – China – Religious aspects –
 Exhibitions. I. Krannert Art Museum. II. Metropolitam
 Museum of Art (New York, NY). III. Title.
 N8214.5.C6M86 1991
 704.9'436'095107477366 – dc20 90-48468
 CIP

CONTENTS

Lenders to the Exhibition

The Art Institute of Chicago

The Art Museum, Princeton University

Asian Art Museum of San Francisco

Ching Yuan Chai Collection, Berkeley, California

The Cleveland Museum of Art

The Far Eastern Art Seminar, Department of Art and Archæology, Princeton University

Field Museum of Natural History, Chicago

Honolulu Academy of Arts

Indianapolis Museum of Art

Krannert Art Museum, Champaign, Illinois

The Metropolitan Museum of Art, New York

Minneapolis Institute of Arts

The Museum of Fine Arts, Boston

Nelson-Atkins Museum of Art, Kansas City

Nicholas Cahill Collection, Berkeley, California

Portland Art Museum, Portland, Oregon

Private Collection, Urbana, Illinois

Robert Poor Collection, Minneapolis

Sarah Cahill Collection, Berkeley, California

Seattle Art Museum

University Art Museum, University of California at Berkeley

The University of Michigan Museum of Art, Ann Arbor

FOREWORD

It is with great pleasure that we present this beautiful exhibition to our public, a presentation of particular significance because it documents important strains of Chinese thought and their transformations over a long expanse of time. The rich connections between the life of the spirit and the objects that express it are revealed here; the myths, poetic fantasies, and visions of two thousand years appear before us.

I would like to express gratitude to the many people whose efforts made this presentation possible. Foremost among them is Kiyohiko Munakata, whose knowledge and insight animate both this catalogue and the exhibition. Professor Munakata was ably assisted in the practical realization of this project by Linda Duke. Alfreda Murck, Associate Curator of Asian Art at The Metropolitan Museum of Art, provided invaluable support and encouragement. Ann Tyler, designer, and Carol Bolton Betts, editor, are responsible for the production of this very handsome catalogue. Four outstanding graduate students from the Art History program at the University of Illinois also made significant contributions to this publication: Li-jiuan Lin; Xian-min Zhu; Kathryn Bonansinga; Yuming Sun; Ching-fei Wang. The entire staff of the Krannert Art Museum was unstinting in its devotion to this project; special thanks go to Jim Peele, assistant director; Kathleen Jones, registrar; Jeff Everett, exhibition designer; Eric Lemme, and Viktoria Ford, preparators; Joyce MacFarlane and Pamela Cooper, secretaries. Clifford Abrams served ably as design consultant for installation. Photographer Cornelia (Poppy) Perrone of the University of Illinois Slide Library deserves special thanks.

Several people assisted during the early, grantwriting phase of the project and should be remembered, especially George Dimock and Margaret Sullivan. Sarah Handler guided the project through its initial planning. Thanks to Beverly Friese and Dean Jack H. McKenzie for their help.

Financial support for the exhibition came from several loyal friends of the museum and the University of Illinois. We are most grateful to Rosann and Richard Noel, Sophie and Brian Leung, and Juliana and Ronald Chao.

We are grateful to the National Endowment for the Humanities, a Federal agency, for planning and implementation grants which in part supported this endeavor. A generous gift from the Marine Corporation, Springfield, Illinois, has been most helpful. Thanks go to Professor Shujiro Shimada and the Metropolitan Center for Far Eastern Art Studies, of Japan, for a Field Studies Grant which made possible Professor Munakata's travels in China during 1984-85. Thanks, also, to the Research Board of the University of Illinois for additional assistance in the preparation of this exhibition, as well as to the University of Illinois Press, co-publisher with the Krannert Art Museum of this catalogue.

Finally, I would like to express my appreciation to the many lenders to this exhibition without whose generosity and cooperation it would not have been possible.

Stephen S. Prokopoff
Director, Krannert Art Museum

PREFACE

The present exhibition and catalogue are the results of a long period of research and preparation. I am deeply indebted to many people who encouraged me and supported me in various ways during this period. My gratitude goes to the persons and institutions mentioned in Professor Prokopoff's foreword, whose direct contributions to this project were invaluable. In addition, I would like to express my special thanks to the following: Professor Stephen Prokopoff, the director of the Krannert Art Museum, who initially suggested I turn my research toward this exhibition, and who has provided continuing support for this project; Professor Wen Fong of Princeton University, who supported me and helped me in the various stages of exhibition preparation; Professor James Cahill of the University of California, Berkeley, who gave me his unfailing support, in addition to allowing us to exhibit many of the works of art in his private collection; Professor Shujiro Shimada, who has been a source of inspiration and encouragement throughout my research; Professor Marcel Franciscono of the University of Illinois, who has been a trusted friend and has extended to me his kind assistance, including reading and editing some of my early manuscripts which became part of the present work; the Ministry of Culture of the People's Republic of China, which kindly made arrangements for my research trip to the sacred mountains in China during 1984, and Mr. Anan Qiang, an official of the ministry at that time, who accompanied me on the trip and made extraordinary efforts to realize my demanding requests.

My thanks go also to many of the present and past graduate students at the University of Illinois who contributed to this project through their participation in my seminars on Chinese art, or in other ways. In particular, Charng-jiunn Lee helped me in deciphering Chinese characters in the inscriptions on works of art and provided preliminary translations of many passages which are fully incorporated into my translations in the catalogue entries. Kathryn Bonansinga's research on Gong Xian's paintings formed the basis of the entries for catalogue numbers 74, 75, and 76. Li-juan Lin's paper on Lu Guang's painting gave suggestions for a new interpretation of the painting that is catalogue number 52. Sharon Anderson assisted me in various ways during the preliminary phase of my research, including providing me an extensive bibliographical study on Han art.

My special thanks go to Carol Betts, who edited my manuscript with extreme expertise and care, and made my English readable, and to Ann Tyler, who patiently managed a difficult schedule and demanding requests, and created a beautiful design. Finally, my deepest gratitude goes to Linda Duke, whose dedication, far beyond the ordinary duty as a coordinator, brought this project to its fruition.

For the format of this catalogue, the following should be noted:

Brief captions are given for figures that appear in the main catalogue essay. More information is given in the list of figures at the back of this catalogue.

References given at the end of a catalogue entry list selected works in which additional pertinent data and bibliography can be found.

Kiyohiko Munakata
University of Illinois

SACRED MOUNTAINS IN EARLY CHINESE ART

Majestic mountains with soaring peaks appeal to our hearts and purify and heighten our spirits. Whether we view the expansion of the world atop the Rocky Mountains, the Alps, or the great mountains in China, we feel we are part of a cosmic entity. The clouds hovering around the high peaks appear mysterious, suggesting unfathomable energy concealed in the earth to be released in an orderly fashion or in unpredictable turbulence. This pantheistic effect of the great mountains, which is experienced by many people in different cultures, was undoubtedly one of the basic elements of the Chinese mountain cult. A prayer of Emperor Taizong of the Tang dynasty to Mt. Heng, the Sacred North Mountain, dated 645 AD, summarizes this perception. It reads in part as follows:

The sacred mountains contain fine soaring peaks and fields of wilderness with special markers where strange animals roar and dragons rise to heaven, and the spots where wind and rain are generated, rainbows stored and cranes beautifully dressed. These are the places where divine immortals keep moving in and out. The countless peaks overlap each other, thick vapor wraps green vegetation, layers of ranges move into each other, and thus the sunlight is divided into numerous shining rays. The steep cliffs fall one thousand leagues into the bottom and the lone peaks soar to ten thousand leagues high. The moon with laurel flowers blooming in it sheds veiled light. The clouds hang over the pine trees with clinging vines. The deep gorges sound loud in winter and the flying springs are cool in summer. . . . Its rugged mass is forever solid, together with the Heaven and Earth. Its great energy is eternally potent, in the span from the ancient to the future. . . .[1]

The worship of the great mountains as embodiments of mysterious power was one of the major elements of the Chinese state religion. Emperors of the successive dynasties—possibly from as early as the early period of the Zhou dynasty (1027 [date traditional]–256 BC) through the end of the Qing dynasty in 1912—prayed to the sacred mountains at imperial altars to ensure the prosperity of the state. This was a part of the sacrifice to Earth, one of the three components of cosmic power in Chinese religious belief, i.e., heaven, earth, and man (ancestral souls, in the religious sense of this term). These court rituals are manifestations of religious beliefs which were fundamental to Chinese culture. The complex aspects of the man-mountain relationship in the history of Chinese culture, which we deal with in this study, all reflect these beliefs.

In early periods the mountains were not only revered but were considered as forbidden spaces where gods and mysterious creatures resided. The mountains gradually became familiar and provided havens for those who sought to attain supernatural powers or spiritual enlightenment. People who practiced religious Daoism, which developed from the second century AD onward, associated the great mountains with the theological concept of the realms of the immortals. This association became a profound source of inspiration for poets and artists. More secular, Confucian scholars, in contrast, regarded the mountains as paradigms of world order. Eremitism in China, in both the Daoistic (i.e., seeking spiritual enlightenment or freedom of mind) and the Confucian (taking refuge from unacceptable social circumstance) senses, has been inextricably associated with both the awesome and the benign forces of the mountains.

The development of this man-nature relationship is reflected in Chinese art. From the early bronze and pottery designs to the later paintings, Chinese designers and artists expressed in visual forms their sense of piety, prayers, fear or joy, serious thought or fantasy, or anything that they felt or conceived in their associations with the mountains. Some of those expressions are direct and quite obvious, some subtle and merely suggested. Some of the images are large and overwhelming, others small, almost microscopic in scale. Many images are fantastic, revealing the rich inner world of the Chinese mind.

Modern scholarship in Chinese art has been concerned predominantly with its rational aspects, and has ranged from stylistic studies of the works of art to studies of historical, political, social, or humanistic contexts of the art. Only a few scholars have pursued the study of the religious aspects of Chinese art, other than those of Buddhist art. This trend is a reflection of a general notion of the historian of China that Chinese culture is essentially rational and that those irrational or fantastic aspects are either elements belonging to a "low culture" or aberrations not really worthy of discussion. The truth is that there are many nonrational aspects in Chinese art which are neither idiosyncratic nor the products of a "low culture."

1

Quan Tang wen (Complete Tang Writing) (reprint, Wenyou shudian, 1972), 10/31a-b. Translation is mine.

In recent years, studies of Chinese religious life, including early Chinese religion, religious Daoism, folk cults, and their various forms of expression, have gained momentum in the fields of literature, social history, anthropology, and religious studies. Drawing from these recent studies, we shall reexamine works of art from a viewpoint other than that of "secular orthodoxy." A culture is a complex totality. Unavoidably, we have to deal here with many controversial issues, and we shall propose new interpretations of works of art. We do not pretend to offer any definitive solutions to the complex issues involved. Instead, we intend to place those issues properly in a broad historical and cultural context and to establish a basis for future studies.

Mountain Worship in Early China

The revered mountains in China are numerous, some designated as nationally important sacred mountains, and many worshipped locally. It is difficult to generalize topographical features common among the numerous sacred mountains in China. They are by definition the most prominent mountains in their own areas. The nationally revered mountains were particularly chosen for their geographical positions and historical prominence, rather than their formal superiority *per se*. Thus, as the Chinese say, "a mountain is not necessarily noble, even if it is high." Generally speaking, a mountain in China is defined as a large landmass which includes many peaks. Although some, such as Mt. Tai (the Sacred East Mountain), are relatively simple in form, with a main peak accompanied by a limited number of subordinates, others are more akin to an American national park, as in the case of Mt. Huang (the Yellow Mountains), which encompasses an area of 154 square kilometers and includes 72 peaks. A "mountain" merits veneration not merely because of the shape and height of its major peak(s), but also because of the topographical character of the whole area.

It is difficult to determine when and how the worship of mountains started in China. We can trace the development of Chinese religion from a totemism combined with ancestor worship in the Neolithic period, around 5000 BC in the case of the typical Yangshao culture, through magico-religious phases which included strong elements of animism and shamanism, and finally into a cosmic religion, "Universism" as some scholars call it, which was established by the end of the Zhou dynasty (1027?–256 BC). The people of the Zhou—probably during the late Zhou (770–256 BC)—organized and systematized, according to their cosmology of heaven, earth, and man, the beliefs and sacrificial rituals which they inherited from the earlier periods. This religion, or religious system, prevailed during the late Zhou, the Qin (221–207 BC), and the Han (206 BC–220 AD) periods, and was maintained more or less throughout later eras. Mountain worship occupied an important position in this system.

The royal court rituals supposedly performed during the Zhou dynasty are recorded in the *Zhou li* (Institute of Zhou), compiled probably in the late Zhou or early Han period. It lists, as the major rituals conducted by the Grand Master of Ceremony (*da zongbo*) in the Zhou royal court, the sacrifices offered to the following:[2] 1) the ancestral spirits of the nation; 2) the heavenly deities, starting with the Supreme Heavenly Sovereign, and followed by the Sun, the Moon, and the important stars and constellations, including the Wind-master Star and the Rain-master Star, which apparently had a correlative function with wind and rain on earth; and 3) the earthly deities, which include the God of Earth, Five Divine Sovereigns (of five elements, i.e., wood, metal, water, earth, fire), the Five Sacred

2

Zhou li (Institute of Zhou), *Si bu cong kan* edition (hereafter, SBCK ed.), 5/10a-12a.

Mountains (*wuyue*), Mountains and Forests, Rivers and Marshes (*ze*), and One Hundred Things in the Four Directions.[3] The objects for the royal sacrifices in this list include almost every natural being that existed in the sky and on earth, indicating that one of the main bases of early Chinese belief, besides ancestor worship, was animism. However, the Supreme Heavenly Sovereign, often simply called "Heaven," was a transcendental power controlling the whole of cosmic affairs. This represents religious beliefs that were beyond the limitation of simple ancestor worship and animism.

The Five Sacred Mountains in the list are set apart from all other mountains included in the category of "Mountains and Forests," and are particularly designated to receive a separate sacrifice. In the most standard set (sometimes a slight alteration was made), the five are Mt. Tai (The Sacred East) of Shandong province, Mt. Hua (West) of Shaanxi, Mt. Heng (North) of Shanxi, Mt. Heng (South) of Hunan, and Mt. Song (Center) of Henan.[4] In addition to the Sacred Five, the Four Garrison Mountains (*sizhen*)—Mt. Huiji of Zhejiang, Mt. Yi of Southern Shandong, Mt. Yiwulü of Liaoning, and Mt. Huo of Shanxi (or Mt. Wu of Sichuan)— were sometimes included among the categories for imperial sacrifices.[5] Although not clearly identified in the above list of the Grand Master's sacrifices, one important category of the imperial sacrifices from the Han dynasty onward is that of the Four Sacred Rivers (*sidu*): the Yellow River, the Yangzi River, the Huai River, and the Ji River. The Four Seas, i.e., the seas existing in the four cardinal directions (of which only the Eastern Sea—the Pacific Ocean—was known, and the other three seas were imaginary), were a part of the Han concept of cosmic structure, but became fixtures of the imperial court rituals only from the Tang dynasty (618–907) onward.[6] (See map, cat. no. 1.)

One clear role of the Five Sacred Mountains was to represent all the existing mountains and their earthly powers. As such, together with the Four Sacred Rivers, they symbolically represented the power of earth as a whole. Among many powers ascribed to mountains, the most important for an agricultural society like China was their ability to provide water; not only were they sources for the water of rivers, but more important, they were sources of clouds which brought down the rain. Every time a drought took place, the emperor, in addition to praying at the Imperial Altar of Earth, dispatched special imperial messengers to the individual mountains to ask their favor. In another role, the Five Sacred Mountains were supposed to act collectively or individually as intermediaries between earth and heaven, where the Supreme Heavenly Sovereign resided. When the foundation of a dynasty was

3

The term *ze* is generally interpreted as "marsh," but means in fact all the uncultivated lands, which have water sources such as lakes, springs, ponds, and streams, and which are rich with trees and other vegetation, animals, and birds. The land itself is not necessarily swampy, as the English term "marsh" suggests. See Derk Bodde, "Marshes in *Mencius* and Elsewhere: A Lexicographical Note," in David Roy and Tsuen-hsuin Tsien, eds., *Ancient China: Studies in Early Civilization* (Hong Kong, 1978), 157-66. "One Hundred Things" means numerous minor deities supposedly residing on earth. It is possible to read this part as "Four Directions and One Hundred Things." See Ikeda Suetoshi, "Shihō hyakubutsu kō," in his *Chūgoku kodai shūkyōshi kenkyū* (Tokyo, 1981), 122-37. I here follow Ikeda.

4

As an exceptional case, Emperor Wu (reigned 140–87 BC) of the Han designated Mt. Tianzhu (sometimes called Mt. Huo, or Mt. Qian) of Anhui as the Sacred South, and some of the Han emperors followed this selection.

5

It was mentioned in passing in *Zhou li*, 6/6b. The Han commentator of the book, Zheng Xuan (132–200), says that the "Four *Wang* Sacrifices" performed by the Assistant Grand Master of Ceremony includes categorically the Four Garrison Mountains as well as the Sacred Five and the Four Great Rivers (ibid., 5/19b). The Tang court officially added this category to the list of the objects of royal sacrificial rituals at the Altar of Earth. See *Jiu Tang shu*, SBCK ed., "Zhi" section, 1/4a.

6

As I see it, the Tang people were more concerned with cosmic symmetry in structuring their court rituals than were the Han people, who were more concerned with the immediate efficacy of the rituals.

secured, the emperor was supposed to visit these mountains, or at least Mt. Tai. He was to report to heaven through them and to receive the heavenly mandate for ruling the whole world.

The imperial rituals are in many ways magnified and cosmically elevated manifestations of the beliefs of the Chinese people in general. Many mountains other than those imperially selected ones had local importance. During the Zhou dynasty the lord of each feudal state sacrificed to the prominent mountains and rivers in his own domain.[7] In the later periods each provincial government had its own "altar of earth" and sacrificed to the prominent mountains in its jurisdiction. Many mountains not officially recognized have their own shrines from which to receive sacrifices by the local people.[8]

Mountain worship in China grew from several roots. In the very beginning, people in the primitive society naturally feared the unfamiliar areas surrounding them; they expected all sorts of dangers to life, including those posed by snakes and roaming animals. The high, large mountains and deep forests had a forbidding presence, and people imagined that peculiar and fearful creatures resided in them. This fear was easily elevated to animistic worship of the mountains. This fear-reverence complex is still quite evident in the writings of the late Zhou period, such as *Shan hai jing* (Classic of Mountains and Seas), which we shall discuss later.

Totemism was the earliest religious concept found in the history of Chinese culture. It is generally thought that birds, lizards, snakes, tortoises, fish, and other zoomorphic images painted on pottery from the early Neolithic cultures of China were totemistic symbols.[9] The predominant image associated with a community was presumably the symbol of the protective power of the tribe. Ancestor worship was closely related to this totemism. Although the magico-religion of the Shang dynasty (c.1800–1025 BC) may not be characterized as totemism, it retained at least some elements of earlier totemism. Many of the decorative motifs as well as pictographical emblems appearing on the bronze ritual vessels from this period—animals, birds, lizards, and monstrous composite animals—can be traced back to prehistoric origins.[10] Studies of mythology also indicate that the myth of the origin of a clan, as well as its ancestral deity, had a close relationship with its totemistic symbol.[11] The evidence relating this totemism with mountain worship is mostly indirect. Nevertheless, those creatures that had totemistic origins were later associated with animism and shamanism and were imagined to be living in the mountains, as we shall see in the writings and pictorial representations of late Zhou and Han dates.

7

Han shu, SBCK ed., "Jiao si zhi," 25/3b.

8

The local gazetteers list the altars of earth for the provincial governments as well as the local shrines for specific mountains in their sections on "altars and shrines."

9

Generally speaking, pieces of painted pottery from one particular site have one or two predominant zoomorphic motif(s), or their geometricized derivatives. Some effort has been made to trace the geographical and stratigraphical distribution of a single motif, which would indicate the movement and spread of a particular tribal unit.

10

Hayashi Minao's extensive study of pictographic emblems which appear on the Shang and Zhou bronze vessels made clear that those emblems are names of states, clans, tribes, individuals, and places, as well as official titles. Among the numerous emblems that Hayashi illustrates we find many zoomorphic motifs that can be traced back to the totemic symbols known from the Yangshao culture, i.e., fish, bird, lizard-dragon, snake, tortoise, frog, and so forth. See Hayashi Minao, "Inshū jidai no zushō kigō," Kyoto *Tōhōgakuhō* 39 (1968): 1-117.

11

The study of ancient Chinese mythology is concerned with the reconstruction of certain groups of myths which were believed and transmitted within the separate tribes or clans that coexisted in the prehistoric and early historic periods of China; the reconstruction is made from fragmental and often greatly altered or distorted remnants of "mythological material." For the problems and comprehensive bibliography, see, for example, Derk Bodde, "Myths of Ancient China," in Samuel N. Kramer, ed., *Mythologies of the Ancient World* (Chicago, 1961), 367-408. The most recent and comprehensive study of this subject is Mitarai Masaru, *Kodai chūgoku no kamigami* (Tokyo, 1984). Mitarai established that as their ancestral deity, the Xia people (the ruling people of the semi-legendary Xia dynasty, later known as Su clan) had the snake-dragon, and the Shang people (Zi clan) had the bird.

The sacrifices offered to Yue (the mountain, probably Mt. Song, the Sacred Center), to He (most likely the Yellow River), and to some other rivers by the late Shang kings are recorded in the oracle-bones (animal bones and tortoise shells used in divination).[12] It has been noted that these nature deities have some aspects of ancestral deities; the Shang people sometimes offered sacrifices to those nature deities grouped with ancestral deities.[13] The mountain Yue itself is known to be the ancestral deity of the Jiang clan. *Zuo zhuan* (Zuo's Commentaries on the Spring and Autumn Annals) says that "Jiangs are the descendants of the Great Mountain (Da Yue)."[14] The first four lines of the poem "Song gao" (Grand and Lofty) in the *Shi jing* (Book of Songs) reads:

Grand and lofty is the Mountain,
With its might reaching to Heaven.
The Mountain sent down a Spirit,
Who gave birth to [the ancestor of] Fu and Shen.[15]

Here the Fu and Shen families are branches of the Jiang clan. The Shang people probably took over the right to perform sacrificial rituals for those nature-ancestral deities from the clans whom they subjugated. We may safely say that the nature worship of the Shang people had two aspects: animistic (belief in the mystical powers of natural objects) and totemistic (in the sense of belief in the power of a clan associated with a specific natural object).

The *Shan hai jing* (Classic of Mountains and Seas) is an important source for learning about the practices and imagery associated with mountain worship during the Zhou dynasty. This book was compiled in several stages, with later sections undoubtedly added during the Han dynasty. Its first five chapters, distinguished from the rest of the book and called "The Chapters of the Mountains in Five Areas" (*Wu zang shan jing*) or simply "The Chapters of Mountains" (*Shan jing*), were possibly written during the relatively early years of the Warring States period (480–222 BC) in Luoyang, the capital of royal Zhou at that time.[16] Those chapters—each covering one of the five areas, i.e., south, west, north, east, and center—describe the mountains existing in the whole territory of China at the time. In each area, the mountains are grouped into three or four ranges, with the exception of the central area, which lists twelve ranges. For each range the major mountains and streams are listed in the order of their location from the beginning of the range to the end, and descriptions are given of their specific features, such as unique animals, birds, and fish (some are ordinary kinds, but many are fantastic creatures),

plants (often with their medicinal properties), metals, jade, and so on. At the end of the description of each mountain range the presiding deities (often just one, but sometimes several) of the range are identified with their names and appearance, such as "with the face of man and body of bird." In addition, the sacrifices to them—particular kinds of animals, birds, and jade to be offered, and sometimes drinks and food to be

12
Chen Mengjia, "Gu wen zu zhong zhi Shang Chou ji su," *Yan jing xue bao* (1936):123-31.

13
Ikeda, 554-62.

14
Zuo zhuan (Zuo's Commentaries on the Spring and Autumn Annals), SBCK ed., "Zhuanggong," 22nd year, 3/14b.

15
Shi jing, SBCK ed., 18/14b-15a. Translation is from James Legge, *The She King*, The Chinese Classics (reprint, Hong Kong, 1960), 4:535-56, with some modification. One of the major changes I made here is taking Yue as a single mountain, rather than Legge's Four Great Mountains. Legge's translation follows the commentary by Zhang Xuan of the Han dynasty. However, the idea of the Four (or five) Great Mountains of China cannot be traced back earlier than the Zhou dynasty, and is not really applicable to the origin of the Jiang clan, which was prominent already before the Zhou dynasty. I owe my interpretation to Mitarai, 368-73, 650-51.

16
A thorough study of the *Shan hai jing* which includes textual criticism is in Ogawa Takuji, *Shina rekishi chiri kenkyū* (Tokyo, 1928). Ogawa's dating and location of the authorship of "The Chapters of Mountains," which I follow here, is mainly based on the geographical knowledge of the author(s) of the chapters revealed in the text.

served—are mentioned.[17] Generally speaking, the geographical descriptions are relatively accurate when they present areas familiar to the authors, that is, the known territories of China at the time; for instance, the Luoyang area is particularly detailed. The accounts become increasingly imaginary when they touch on peripheral areas. The descriptions of the far western region, which features the imaginary cosmic mountain, Mt. Kunlun, and the mystical hills in its vicinity, are apparently fictional.

Several elements of early Chinese mountain worship can be drawn from "The Chapters of Mountains" of the *Shan hai jing*. Many of the animals believed to be living in the mountains, even in the known areas, are fantastic in appearance. There is one that looks like a bull, but with four horns, human eyes, and the ears of a hog, who eats human beings (*zhuhuai*, living in the area of Mt. Heng, the Sacred North).[18] Another is a bird that looks like an owl with ears, but it has three eyes and cries like a deer (*da* bird in the area of Mt. Song, the Sacred Center).[19] Some beasts are harmful, but others are benign and even beneficial to man as medicinal material. As a whole, the book conveys the image of mountains where all sorts of peculiar animals roam, fantastic birds fly, and unusual fish swim or even fly with wings. The mountains were dangerous and forbidding, and were extremely potent with their mystical powers. The numerous pictorial representations seen in the decorations of many objects from the late Zhou and the Han dynasty, which will be discussed later, vividly show the lively animals, birds, and peculiar creatures active in the mountain settings, as seen in figure 1 (to be discussed below), where the power of a hidden area in the mountains radiates from the scene.

Another point conveyed in "The Chapters of Mountains" is that the sacrifices are offered to the mountain range as a whole, not to individual mountains. The deities presiding over the mountain ranges are, in many instances, described as composites of two of three beings: a human, a dragon, and a bird. There can be a human head with a bird body, a bird head with a dragon body, a dragon head with a human body, and so forth. Other variations feature a human head with the body of an animal, for example, a horse, sheep, or snake. Some of them have antlers over their human heads. The dragon, the bird, and, to a lesser degree, the snake are predominant motifs in the ritual bronzes of the Zhou dynasty. It is quite clear that the deities supposedly presiding over the mountains are actually those in the mainstream of the Zhou religious system.

Shamanism was a dominant element of the religions of the nomadic people in central and northern Asia, and it also played some important roles in religious life in many societies all over the world, including China proper.[20] It is characterized by the very special abilities of shamans, who separate their spirits from their physical bodies, in a state of ecstasy or in a seance. They make trips, in such a state, to other cosmic spheres, ascending to heaven or descending to the underworld, and communicate with other spirits, including the souls of the deceased. Shamans assume that the supreme heavenly god and the supreme earthly god exist. In their cosmic trips shamans often pass through a cosmic pillar that connects heaven, earth, and the underground world. The most prominent image of a cosmic pillar is a cosmic mountain. A tree or a pole could, on many occasions, also function as a cosmic pillar.[21] It should also be noted that according to the studies of shamanism in central and north Asia, shamans never functioned as sacrificial priests.[22]

[17] A group of mountains in a linear succession described in these chapters, which I call "range" here, does not necessarily coincide with the modern definition of mountain range, since the mountains are conceived as a religious unit as well as a topographical unit.

[18] *Shan hai jing*, SBCK ed., 3/(*shang*) 36a.

[19] Ibid., 5/(*xia*) 8a.

[20] Shamanism has been defined variously, and its historical and religious meanings have been clouded with confusion and controversy. I take Mircea Eliade's definition of shamanism as basically psychic phenomena. The following summary of the definition and characterization of shamanism is based upon Mircea Eliade, *Shamanism* (Princeton, 1964).

[21] Ibid., 259-74.

[22] Ibid., 181-82.

Scholars disagree about precisely when sha-manism started in China proper. It depends upon how we define shamanism.[23] The people traditionally called *wu*, who appear in many historical records as those having performed religious roles in an official capacity or more often in folk religion, are generally interpreted as shamans. The *Zhou li* (Institute of Zhou) lists among the people who served religious functions in the royal Zhou court "countless numbers" of male and female *wu*s as low-ranking members, ranking below diviners (*zhanren*), dream-diviners (*zhanmeng*), and prayer-orators (*zhu*).[24] Their assigned jobs listed include: dancing in the rain-making rituals, bringing down their own ancestral spirits to assist at the time of a great calamity, burying jade as an earth-pacifying sacrifice, bringing down (back?) the soul of the deceased at a funeral, inviting the spirits from far-off locations at the *wang* rituals (sacrifices offered to distant spirits), and singing and wailing at the time of a great calamity (a task assigned especially to female *wu*s) to invoke divine response.[25]

The term *wu* appears in oracle-bone inscrip-tions of the late Shang dynasty, and it was used in three different ways. There was the *wu* who performed certain rituals, such as the one for rain making, the *wu* as a spirit for which sacrifices were offered, and the *wu* who was put to death by being exposed to the sun for many days, or even by being thrown into a fire, in connection with rain-making rituals.[26] The Shang people recognized the special powers of the spirits of the *wu*s, whether alive or dead, and used them as elements of magical rituals. There is still uncer-tainty about the identities and social status of *wu*s in Shang society, but they were people who were addressed specifically, apart from the sacrificial priests—kings and heads of clans in most cases—and the diviners (*zhenren*).[27] They were regarded as ancestors by the later *wu*-shamans, related if not by blood, at least by the heritage of their functions in society.[28] The general separation of priests and shamans seen in many Asian societies seems applicable to the late Shang and Zhou societies. Shamanism functions as only a part of a religious system in China and other parts of Asia. This does not preclude, however, the possibility that shamanis-tic concepts and cosmology influenced the shaping of the state religion of the Zhou.

One important point in considering shaman-ism is that the shamans' function is related to the establishment of the concept of heaven as a transcendental sphere separated from the earth.

23

Chen Mengjia argues that kings of the Shang were the heads of the group of *wu*s. See Chen Mengjia, "Shang dai de shen hua yu wu shu," *Yan jing xue bao* 20 (1936): 535-36. K. C. Chang following Chen says that "the king [of the Shang] himself was actually head shaman." See K. C. Chang, *Art, Myth, and Ritual* (Cambridge, Mass., 1983), 45. However, I believe that it is more beneficial for our study to take the narrower definition formulated by Eliade and to distinguish shamans (especially for their ability to make cosmic trips) from priests (even if priests had certain magico-religious psychic roles in the rituals).

24

Zhou li, "Chun guan zong bo," 5/8a.

25

Ibid., 6/36b-41b.

26

Chen Mengjia, "Shang dai de shen hua yu wu shu," 533-76. An expansion of Chen's study of "exposing the shaman" and "burning the shaman" in the above article is Edward H. Schafer, "Ritual Exposure in Ancient China," *Harvard Journal of Asiatic Studies* 14 (1951): 130-84. Hayashi Minao, "Chūgoku kodai no shinfu," Kyoto *Tōhōgakuhō* 38 (1967): 199-224, finds a relation-ship between *wu* and *shen wu* (deified *wu*) through a careful study of the early history of *wu* from the Shang dynasty to late Zhou; he includes an extensive discussion of *wu* during the Shang dynasty.

27

Among the oracle-bone inscrip-tions there are some that can be interpreted as divinations con-cerning whether other states, including that of Zhou, would send *wu* to the Shang court; see Hayashi (1967), 211-12. It is very possible that during the Shang dynasty, *wu* were very special people who did not belong to the ordinary social fabric of the Shang, and the Zhou and other non-Shang states were the places where shamans' activities were more prominent.

28

Hayashi (ibid.) is most concerned with this aspect of *wu*.

There is uncertainty about when the concept of heaven was clearly established in China. It was implied that the Shang supreme god, Di, or Shang Di (Supreme, or Upper, Di), who had the power of controlling natural phenomena as well as human fates, was located somewhere above. According to the oracle-bone records, Di was very rarely offered sacrifices, unlike the other Shang ancestral and nature deities to whom sacrifices were frequently offered for the purpose of asking favors. In other words, Di of the Shang was considered beyond the influence of sacrificial rituals.[29] In contrast, Tian (Heaven), the supreme god of the Zhou people, was the most important god in the Zhou sacrificial system, although Tian was an immediate successor of Di of the Shang.[30] The concept of heaven, which was transcendental and responsive to human prayers, or reachable through mystical means, was apparently developed into its full stage by the Zhou people. If we take shamanism in its narrow definition, which includes the concept of heaven as a transcendental space to which shamans make their ecstatic trips, we can clearly see that it was the cosmology of the Zhou which provided a basis for the shamans to function fully. The term "Di" continued to be used through the Zhou and later periods, but in the sense of a transcendental sovereign; for instance, there is Tian Di (Heavenly Sovereign, i.e., the personified Heaven), Huang Di (Yellow Sovereign), and another Huang Di (Heaven-endowed Sovereign, i.e., the emperor of the earthly empire).

The concept of the cosmic pillar, often in the form of a cosmic mountain, as a mystical passage to heaven—one of the basic elements of shamanistic cosmology—was widely shared by many cultures in the ancient world. We find two types of cosmic mountains in the Zhou religious concept: the actual sacred mountain, and the conceptual mountain called Mt. Kunlun which was imagined to exist to the northwest of the central region of China. As stated earlier, some of the prominent existing mountains, such as the Five Sacred Mountains, acquired, before the Han dynasty, the function of intermediaries between heaven and earth, besides being sources of animistic power. Of course the imperial sacrifices to and communications with heaven through the existing great mountains were not necessarily shamanistic events, but the underlying idea of this practice was very likely influenced by shamanistic cosmology.

The involvement of the *wus* in local mountain worship during the Zhou period can be seen in the *Shan hai jing*. In the tenth section of the "Chapter of the Central Mountains," it says: "Mt. Gui is Di [probably meaning in this case the mountain which is connected directly with the Heavenly Sovereign]. For the shrine-sacrifice [*ci*, sacrifices offered at the god's shrine], wine and the grand sacrifice [*tailao*, the largest sacrifice to be offered, using cows, sheep, and pigs] are

29

The exact identification of Di, beyond a general understanding of it as the supreme god for the Shang, has been controversial. The most up-to-date and convincing interpretation of Di is found in David N. Keightley, "The Religious Commitment: Shang Theology and the Genesis of Chinese Political Culture," *History of Religions* 17 (1978): 211-25. A more detailed study of the problem, including critical evaluations of various theories offered by many scholars, is Ikeda, *Chūgoku kodai shūkyōshi kenkyū*, 25-63. Both agree on the point that Di was beyond the category of an ancestral deity, although it retained vaguely some aspects of an ancestral deity. Hayashi Minao's study of the *taotie* motif in Shang bronze designs, which he identifies as the image of Di, found the origin of the motif in the design of the "Sun-god with wings, or sun-bird" from the prehistoric Homudu culture in southern China (Zhejiang province, c.5000 BC); he traced its lineage through the typical Longshan culture in the Shandong region up to the Shang. See Hayashi Minao, "Iwayuru tōtetsumon wa nanio arawashita mono ka?" Kyoto *Tōhōgakuhō* 56 (1984): 1-97. We can conjecture from Hayashi's study and the generally understood nature of Di, that Di, with the image of *taotie* (a combination of dragon-snake motif and the "sun-bird" motif), was formulated before the Shang (possibly during the Xia dynasty?), combining several totemistic symbols of intermarried clans as the image of a general, yet somehow ancestral, supreme deity, which the Shangs inherited with a further weakened notion of "ancestral" nature.

30

For the meaning of Tian in early Zhou thought, see Benjamin I. Schwartz, *The World of Thought in Ancient China* (London, 1985), 40-55.

offered. *Wu* and *zhu* dance together.[31] For burial sacrifice one piece of jade is used."[32] There are two other cases in the same chapter that describe dances offered to the gods of mountains without specifying who performed. It is most likely that the performer was a *wu*, one of whose major functions was dancing.[33] Nevertheless, it is certain that shamans had roles in mountain worship during the Zhou period.

Mt. Kunlun is important in the history of Chinese religion and cosmology as the cosmic mountain of China, and has sometimes been compared with Mt. Sumeru of India and the ziqqurats of Mesopotamia, which some scholars even considered as the origins of the concept of Mt. Kunlun in China.[34] The earliest written record of Mt. Kunlun is found in the "Chapter of Western Mountains" from the *Shan hai jing*. The descriptions in this chapter start with a known region of the northwestern corner of Henan, around Mt. Hua (the Sacred West), and move further northwest. Its section three is concerned with a range of mystical mountains supposedly existing to the northwest of the then known regions of China. Here, unlike in later descriptions, Mt. Kunlun is shown not as an independent soaring peak, but as one of the mystical topographical features. It says:

It is called the Hill of Kunlun. This is really the "Lower Capital" of Di [here meaning Tian Di, the Heavenly Sovereign]. It is administered by the god Luwu whose appearance is a tiger with nine tails and whose job is to administer the nine lands of heaven and Di's mystical parks. There is an animal who appears like a sheep with four antlers, is called Tulou, and eats human beings. There is a bird who appears like a bee but with the size of a duck, and is called Qinyuan. When he stings birds or animals, they die, and when he stings trees, they wither. There is another bird called Duan Bird, whose job is to administer Di's utensils and clothing. . . .[35]

It is also said that from this mountain the Yellow River, the Red River, the Yang River, and the Black River flow. When we move 970 *li* to the west of this mountain via three other mountains, we come to a mountain called Jade Mountain. The description of this mountain reads: "This is the place where the Queen Mother of the West dwells. As for the Queen Mother of the West, her appearance is like that of a human, with a leopard's tail and tiger's teeth. Moreover, she is skilled at whistling. In her disheveled hair she wears a jade *sheng*. She administers the Heaven's [orders of] calamities and five punishments."[36] In the later versions of Kunlun mythology the Queen Mother of the West appears as a beautiful lady and resides right on the mountain.[37]

The early Kunlun mythology quoted above takes the whole mountain range, which stretches 6,744 *li*, as a particularly sacred realm where many high-ranking deities such as the White Sovereign (Bai Di), the Yellow Sovereign (Huang Di), and others who administer various jobs for the Heavenly Sovereign (Tian Di), including the Queen Mother of the West, reside scattered over

[31] A *zhu* is a lower-ranking priest in the royal court of the Zhou, but was probably a major priest in the local rituals. *Zhu*'s major function was said to be reciting prayers at the rituals, but apparently he performed also ritual dances.

[32] *Shan hai jing*, 5/(*xia*) 24b-25a. There is an irregularity here. Mt. Gui is not listed in the descriptive part of this section. Either the name is miscopied, or the ritual was performed at one of the several mountains named Mt. Gui listed in other sections, such as in the third section of the same chapter, 5/(*xia*) 5b.

[33] Ibid., 5/(*xia*) 6b, 23b. For dancing ritual as a function of *wu* see, Chen Mengjia (1936), 538-43.

[34] One of the most comprehensive studies about Mt. Kunlun, including critical reviews of the scholarship in the past, is Mitarai Masaru, *Kadai chūgoku no kamigami*, 653-719.

[35] *Shan hai jing*, 2/(*shang*) 23a-23b; the translation is mine.

[36] Ibid., 2/(*shang*) 24b. Translation here is taken, with a slight modification, from Suzanne E. Cahill, "The Image of the Goddess Hsi Wang Mu in Medieval Chinese Literature" (Ph.D. diss., University of California, Berkeley, 1982), 11.

[37] For a historical survey of the legends of the Queen Mother of the West, see S. E. Cahill, 6-142.

the whole region. Mt. Kunlun, or the Hill of Kunlun as it is called here, is the center of the region and is defined as the "Lower Capital" of the Di. Apparently the whole region has the character of an intermediary space between heaven and earth, with Kunlun as its focal point, although the region is supposed to be on earth.

The character of Kunlun as a passage to heaven from earth becomes clearer in the later writings about this mountain. The poem "Tian-wen" (The Heavenly Questions) by Qu Yuan (late fourth century to early third century BC) includes questions about the mountain: "Where is Kunlun with its Hanging Garden? How many miles high are its ninefold walls? Who goes through the gates in its four sides? When the north-east one opens, what wind is it that passes through?"[38] The early Han writing of *Huai nan zi* (c.130 BC) in its "Chapter of the Topography of Earth" says: "As for the Hill of Kunlun, when you climb up twice its height, you reach the Mountain of Cool Breeze where you do not die, and when you climb up further twice the height, you reach the Hanging Garden where you attain [the status of a] spirit and can control wind and rain, and further when you climb up twice that height, you reach the Upper Heaven where you become a god—in fact this is the dwelling of the Grand [Heavenly] Sovereign (Tai Di)."[39]

Mt. Kunlun is undoubtedly a cosmic mountain, and its basic concept was most likely derived from the shamanistic trip between heaven and earth. Chapters 6 to 18 in the *Shan hai jing* are later additions, probably from the early period of the Han dynasty. They are a compilation of many myths and legends associated with the lands that are supposed to exist outside the known land of China. In those chapters several versions of the Mt. Kunlun myths are recounted. One of them, in chapter 11, names and describes six *wu*s with elixir on their hands who guard the corpse of Zhayu in the vicinity of Mt. Kunlun.[40] Chapter 16 also refers to Mt. Kunlun, and includes a section that is apparently derived from a Kunlun myth, judging from the iconographical elements included, such as the Queen Mother of the West. It describes ten *wu*s who are busy ascending and descending a "sacred mountain," collecting elixirs.[41] The names of the *wu*s given in these two parts are most likely from a legendary lineage of past great *wu*s who were deified and worshipped at the time.[42] In these later accounts we find not only a close relationship

between Mt. Kunlun and *wu*-shamanism, but a new development of the cult of immortals and immortality associated with them.

The cult of immortals became an increasingly important cultural phenomenon from the late Zhou period onward. It is believed to have started in the eastern coastal area of Shandong during the later part of the Warring States period, about the fourth century BC. It propounded not only the existence of immortals, but the possibility of mortals' gaining immortality with the aid of elixir. It is important to note here that this cult started as an intellectual twist on shamanism, an ingenious transfiguration of the idea of the shaman's ecstatic cosmic trip into the image of the free-flying "mountain man" (*xianren*) and further, that of the "achieved man" (*zhenren*) who attained a cosmic vision and life freed from earthly bounds of space and time.[43] On the level

38

Chu ci (The Songs of the South), SBCK ed., 3/8b-9a. Translation by Hawkes; see David Hawkes, *Ch'u Tz'u, The Songs of the South* (Oxford, 1959), 49.

39

Huai nan zi, "Zhui tu xun," SBCK ed., 4/3a. Translation is mine. An extensive study of this particular chapter of *Huai nan zi* is found in John Stephen Major, "Topography and Cosmology in Early Han Thought: Chapter Four of the Huai-nan-tzu" (Ph.D. dissertation, Harvard University, 1973). His translation and annotation of the particular section quoted here is on pp. 44-45.

40

Shan hai jing, 11/(*xia*) 53a-54b.

41

Ibid., 16/(*xia*) 74a-74b.

42

Hayashi is concerned with identifying those specific names of *wu* in *Shan hai jing* and other early literary sources, particularly in their relationship to the names of gods given in the "Silk Manuscript from the Warring States Period."

43

Joseph Needham, *Science and Civilisation in China* (Cambridge, 1956), 2:132-39, deals with the transition of earlier *wu* shamanism into later Daoism.

of popular culture, those propagators of this cult, called *fangshi* (magician-gentlemen), insisted that gaining elixir was the key to attaining immortality, and they knew how to get it. This cult captured the fancy of many people, from the emperors of the Qin and Han down to the commoners.[44] It eventually developed into religious Daoism.

Mountain worship in China developed from a naive fear of the power of nature into a multi-layered religious element of the cosmology-religion complex of Han China. On one level, mountains were revered for their own power to protect the welfare of the communities, or the state as a whole. On another level, mountains as cosmic pillars were regarded as intermediary realms in man's communications with heaven, or with heavenly spirits. Mt. Kunlun as an imaginary cosmic mountain was most likely conceived initially in a shamanistic scheme of a heaven-man relationship, and as such it was never placed in the orthodox state religious system—it was never listed among those mountains that re-

ceived imperial court sacrifice. However, the mountain became an accepted element of the speculative cosmological writings, and also gained considerable importance in the popular religion—not only among commoners, but also among emperors and high court officials in their private beliefs—during the late Zhou and the Han dynasties. Religiously, Mt. Kunlun was to fulfill individuals' personal wishes, that is, to give assurance for the safe ascent of the souls of the deceased to heaven, and to provide prosperity for individual families and their descendants through the power of Queen Mother of the West, who resided on the mountain. The visual representations in the art from the late Zhou and the Han periods provide us with vivid imagery involved in the various religious thoughts discussed in this section.

THE MOUNTAIN WILDERNESS AS RITUALISTIC VISION: THE LATE ZHOU PERIOD

The mysterious world of mountains in the early Chinese people's thinking which we observed in the *Shan hai jing* (The Classic of Mountains and Seas) appears in visual form on the bronze ritual objects from the Warring States period (480–222 BC), during the late Zhou, and in various media from the Han dynasty. In those representations peculiar creatures, animals, birds, and sometimes human beings engage in various lively activities.

There are two groups of pictorial representations depicting mountain scenes, which were excavated archæologically from tombs of the Warring States period. One is from a tomb excavated in 1937 at Liulige near Huixian in northern Henan,[45] and another is from a tomb excavated in 1978 at Gaozhuang near Huaiyin city in northern Jiangsu.[46] Both tombs are dated to the middle of the Warring States period, about the fourth century BC.[47] Mountain scenes depicted with incised lines in low relief are found on bronze objects from both tombs, a cylindrical box called a *lian* from the former tomb and many objects from the latter, and are very close to each other both in style and in iconography.

The representations on the Huaiyin objects are rich in iconographical details. The lively scenes found on the fragments of *yi* vessels are typical examples of this group (fig. 1). Mountains

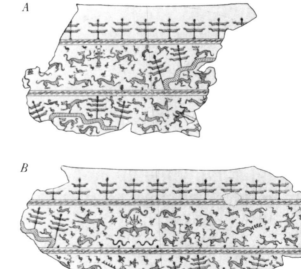

Figure 1 ○ Bronze Yi vessel from a tomb nehr Huaiyin.

are represented in a stepped-mound form defined by winding narrow bands. Tall trees are placed on them, reinforcing their identity as mountains. Animals and birds are shown walking, running, or gesturing on the slope. Enclosed within the contour of each mountain, a prominent figure—probably the main deity of the mountain region—is shown flanked by an animal on each side, an exception being a depiction of two running animals (fig. 1a, lower register). The rest of the space of the horizontally divided surface is filled with peculiar figures, running animals, monkeys, snakes, and several types of birds.

Similar but more intriguing representations are found on the fragments of a thin circular bronze plate called a *suanxingqi* (literally, "calculator-shaped-instrument"), with reconstructed measurements of about 50 cm in diameter by 0.2 cm thick (fig. 2). This plate has 35 circular holes 4 cm in diameter, including one placed at the center. In its central circular band there is a mountain containing in its enclosure a deity-monster flanked by two birds. In the outer band the holes are used to represent mountains; their identity is clearly shown by the trees and/or walking birds or animals placed on the upper parts of the peripheries. Some animals are shown jumping across the gorge, i.e., the space between the two holes, or diving from the "peaks." In figure 3, there is one especially prominent mountain shown with a usual mountain enclosure at the upper periphery of a hole and a very tall tree on top of the mountain. This mountain of double peaks with a tree-pillar is probably meant to represent a cosmic pillar connecting the underground world with heaven. The figure standing next to this mountain-pillar must be a shaman.

It should be noted here that some of the deity-monsters in our group of representations are shown with a single head, often human, and with the body of an animal which appears split into two symmetrical profile views. This split-body representation is in the tradition of Shang dynasty bronze decoration. In our group of representations this convention is only applied to depict particularly important creatures. They are either enclosed in the mountain forms or shown in a relatively large size, and appear godlike—imposing, frontal, and static—in contrast to other creatures which are shown in profile and engaging in certain activities.

The mountain scenes in the Huaiyin reliefs are essentially animistic images of the sacred realm in an area of mountains enlivened with the activities of many animals and monstrous creatures. However, the shamanistic concept is superimposed upon them. Snakes, birds, and some other animals such as tigers and deer were totemistic as well as animistic symbols that can be traced back to the Shang; some can be traced

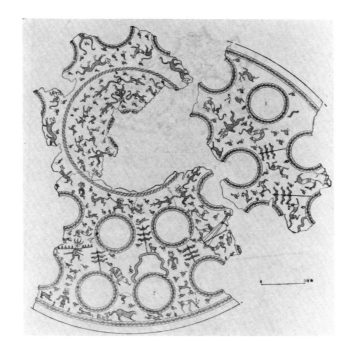

Figure 2 ○ *Bronze* SUANXINGQI *from a tomb near Huaiyin.*

44

For a good summary of the historical accounts of *fangshi*, see Kenneth J. DeWoskin, *Doctors, Diviners, and Magicians of Ancient China: Biographies of Fang-shih* (New York, 1983), 1-42.

45

Liulige Tomb No. 1, in Guo Baojun, *Shanbiaozhen yu Liulige* (Beijing, 1959), 62-66, pls. 29, 30, 31.

46

Huaiyinshi Bowuguan, "Huaiyin Gaozhuan Zhanguo mu" (hereafter, "Huaiyin Report"), *Kao gu xue bao* 88, no. 2 (1988): 189-232.

47

Guo Baojun identified the Warring States tombs excavated in the Huixian area, altogether eighty in number, as those belonging to the aristocrats of the state of Wei (445–225 BC) and classified them chronologically into five periods. In his chronology, Liulige Tomb No. 1 belongs to the fourth period (late fourth to early third century BC). See, Guo, 72-73. Disagreeing with Guo, Charles D. Weber, in his "Chinese Pictorial Bronze Vessels of the Late Chou Period—Part II," *Artibus Asiae* 28, no. 4 (1966): 296, gives the date of this tomb as the first half of the fifth century BC. Thomas Lawton agrees with Weber, in Lawton, *Chinese Art of the Warring States Period: Change and Continuity, 480–222 BC* (Washington, DC, 1982), 34. The Huaiyin tomb is roughly dated about the middle of the Warring States period by the author of the excavation report; see "Huaiyin Report," 230.

further back to the prehistoric Yangshao culture. But they are also important in shamanism. Those animals are reported to be important "helping spirits" for shamans in their initiations and in their ecstatic trips—horses, deer, and bears mostly in northeast Asia, tigers, panthers, and the like in southeast Asia, and snakes and birds in all parts of Asia.[48] Among these, birds and snakes are particularly important in interpreting iconographical elements of the Warring States representations—birds for their strong connection with heaven, and snakes for their link with the underworld. Dragons, although they are imaginary creatures and thus not helpful to shamans in practical ways, fit easily into the structure of shamanistic cosmological fantasy because of their dual nature: they combine an aspect of the earth-water spirit (their reptilian quality) and that of the heavenly spirit (their ability to fly).

Some figures appearing in the Huaiyin representations are clearly shamanistic. The figure in the lower register on the fragment in figure 3b is a human being in general appearance, but he has wings on both sides of his waist and a bird's tail. He wears two snakes on his ears and has two thin winding horns (probably meant to be in the form of a snake) which are pulled upward by two flying birds. He extends his arms to the sides and holds in each hand the tail of a flying animal that appears be a tiger but has a dragon's head and hoofs and a projection (most likely a wing) on its back. There are snakes also around his feet— only one foot is actually visible due to the damage of the fragment. The whole image appears to represent a shamanistic flight, aided by the spirits of birds, snakes, and dragon-like animals. The presence of this image, together with the roaming creatures, indicates that the mountain scenes represent the realms of wilderness that are intermediary spaces between this world and heaven. A similar "ascending" figure holding the snake-like horn of a winged animal in each hand can be seen in the upper register on the same fragment.

One noticeable characteristic of the Huaiyin iconography is that snakes and birds have considerable importance. Scenes on the fragments of bronze objects in figure 3a and b are especially noteworthy. The mountain in the middle register of figure 3b contains four interlocked snakes which, as a group, appear to be one of the major ruling powers of the area. According to one Siberian myth concerning the origin of shamans, the body of the "first shaman" was made of a mass of snakes.[49] The four interlocked snakes could well represent a deified image of this most powerful legendary figure. The contour of the mountain on the upper register of figure 3a is delineated by a band which winds like a snake and is patterned with alternating hatched areas and blank areas. The deity-monster enclosed in

this mountain has a bird head and a split animal body. It has two winding horns and tail(s) which look like snakes. A running figure with a bird head, human body, and a tail, at the right end of the top band in figure 1b, holds a snake in one hand and a hammer-like weapon in the other. A very similar figure, except for his human head with two horns, is found in the central part of the same band. They both appear to be spirits fighting through the realm of wilderness—the former a heavenly spirit and the latter an earth-bound spirit. The same bird-man figure is shown repeatedly in the posture of shooting arrows in many of the Huaiyin representations.

A

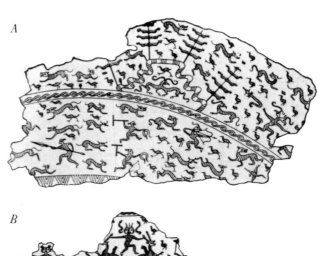

B

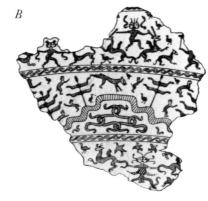

C

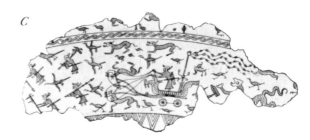

Figure 3 ○ Fragments of bronze vessels from a tomb near Huaiyin.

48

Eliade discusses the roles of animals in shamanism in various parts of the world throughout his *Shamanism*, and devotes pp. 88-95 to specific aspects of animals as "helping spirits."

49

Ibid., 68.

The area of Huaiyin was under the control of the powerful southern state of Chu from the beginning of the Warring States period to the middle of the third century BC, with occasional intrusion by the people of another southern state, Yue.[50] The Chu people are known for their particularly strong shamanistic inclination, although all the states of the Zhou dynasty had shamanistic elements in their religion to varying degrees.[51] It is natural that the iconography of the Huaiyin representations reflects the religious trend of the Chu state, whose political and cultural center was in the middle part of the Yangzi River basin, including the area of Dong-ting Lake. According to the *Shan hai jing*, a god called Yuer supposedly residing on Mt. Fufu near Dongting Lake appears like a human being and handles one snake in each hand. He very often visits the deep place of the nearby Yangzi River.[52] Also in the same area on the Mountain of Dongting there are many strange deities who look like human beings and wear snakes on their heads and handle snakes with both hands.[53] These descriptions certainly correspond to the snake-associated creatures in the Huaiyin representations.

One representation on a small fragment of a bronze vessel from Huaiyin shows a figure riding a chariot in the shape of a dragon and pulled by two horses (fig. 3c). A long streamer flutters at the top of a tall pole rising from the rear of the chariot. In the middle of the pole are two inter-twined snakes. Foot soldiers carrying various weapons—only four can be seen due to damage of the piece—precede the chariot. Two dragon-headed animals and many birds accompany the chariot, as if protecting the procession. One monstrous animal tries in vain to attack the chariot from behind. This scene is superficially similar to the hunting scenes which often appear in bronze representations from this period, but is separated from them by the distinctive dragon shape of the chariot and the lack of an archer on the chariot, a stock figure in hunting scenes. This scene should be interpreted as representing a journey of the soul of a deceased high-ranking person, or possibly the carrying of a royal message to heaven, through the intermediary realm of wilderness.

The soul of a man, deceased or severely ill, was believed to wander in the world of dangerous spirits. Shamans engaged in calling back such wandering souls. "The Summons of the Soul" (*Zhaohun*) in *Chu ci* (The Songs of the South) is a poem composed by Song Yu (active early fourth century BC in the state of Chu) that takes the form of such a shaman's calling.[54] It reads in part:

O soul, come back! Climb not to the heaven above.
For tigers and leopards guard the gates,
 with jaws ever ready to rend up mortal men,
And one man with nine heads, that can pull up
 nine thousand trees,
And the slant-eyed jackal-wolves pad to and fro;
They hang out men for sport and drop them
 in the abyss,
And only at God's command may they ever rest
 or sleep.
O soul, come back! lest you fall into this danger.
O soul, come back! Go not down to the
 Land of Darkness,
Where the Earth God lies, nine-coiled, with
 dreadful horns on his forehead,
And a great humped back and bloody thumbs,
 pursuing men, swift-footed:
Three eyes he has in his tiger's head, and his body is
 like a bull's.
They all enjoy the taste of men.
Come back! lest you bring on yourself disaster.[55]

᠅

50
"Huaiyin Report," 230-31.

51
A good summary of our knowledge about Chu religion and its relationship with other areas of China during the Warring States period is John S. Major, "Research Priorities in the Study of Ch'u Religion," *History of Religions* 17, nos. 3-4 (1978): 226-43.

52
Shan hai jing, 5/(*xia*) 31b.

53
Ibid., 5/(*xia*) 32b.

54
A discussion and translation of "The Summons of the Soul" is in Hawkes, *Ch'u Tz'u*, 101-9. For a brief summary of the poet Song Yu, see 92.

55
Chu ci, 9/5a-6a. The translation is by Hawkes, with my addition of the second line from the bottom, which Hawkes omitted in his translation; see Hawkes, 105.

The area of wilderness which the caller of the soul covered extended to above (heaven) and below (the land of darkness), and to the four corners of earth. The sacred realm hidden in the mountains which we see in the Huaiyin representations is nothing but a part of this vast area of wilderness existing between heaven and this world. The gods and monsters residing there had certain effects upon the welfare of the state as well as that of individuals, particularly at the time of their sickness and death. The offering of sacrifices to the deities, the conducting of funeral rites, and the use of special powers of shamans were the people's ways of coping with critical situations in their lives. It is safe to assume that the activities of heavenly and earthly spirits in the Huaiyin representations occurred in the intermediary realm where human efforts interact with the resident spirits in the realm.

The mountain scene in the decoration on a *lian* box from Liulige near Huixian, north of the Yellow River in the northern Henan province, which belonged to the state of Wei during the Warring States period, proves that mountain scenes are not limited to the art of the Chu state. The representation on the lower band of the *lian* (fig. 4) includes a familiar stepped-mountain form outlined by a narrow winding band. A deity enclosed within the outline has a human head and a split animal body.[56] A bird-man archer is about to shoot a peculiar animal from whose body three bushy tree-like objects project, one on its head and two on its back. The human figure, standing to the left of the mountain, holds a rope-like object which may represent two intertwined snakes. He may be a shaman-deity. The mountain scene in the Liulige representation is apparently meant to show the sacred realm of wilderness which we observed in the Huaiyin representations.

One interesting aspect of the Liulige decoration is that the mountain scene is placed side by side with a banquet scene, separated from it by a city gate. The scene to the right of the city gate includes dancing figures, a drum player, part of a set of bells hung on a horizontal bar, and people engaged in cooking using a large *ding* tripod cauldron. This scene, although a section of it is missing due to damage to the vessel, apparently is the same type of palace banquet scene commonly found among many pictorial bronze decorations from the Warring States period. The banquet scenes in the representations of this period were usually meant to show the ritual banquet given by the king of the Zhou or by the head of a feudal state, following hunting, shooting birds, and fishing, and the offering of the game on the ancestral altars.[57] The major aim of hunting-banquet rituals was to secure prosperity of the state. If we take the banquet scene in

the Liulige *lian* in this context, the entire decoration can be interpreted as a symbolic representation of the annual prayer of the state and its effect on the intermediary realm between heaven and this world.

There is another possible interpretation of the *lian* decoration: We can consider the whole scene in the context of "The Summons of the Soul." After describing all the dangers of staying in the realm of wilderness, the poem quoted above continues:

O soul, come back! lest you bring on yourself disaster.
O soul, come back! and enter the gate of the city.
The priests are there who call you, walking backwards to lead you in.

○ ○ ○

O soul, come back! Why should you go far away?
All your household have come to do you honour; all kinds of good food are ready:
Rice, broom-corn, early wheat, mixed all with yellow millet;

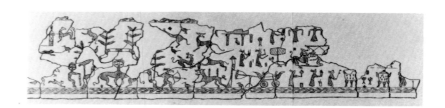

Figure 4 ○ Bronze LIAN box from a tomb at Liulige.

56

The third section of the "Chapter of Northern Mountains" of the *Shan hai jing* covers the vast area east of Mt. Taiheng, which includes the area of Liulige. It counts forty-four mountain deities and says that twenty of them appear with the body of a horse and a human head. The mountain deity in the Liulige scene fits this description.

57

Hayashi, "Sengoku jidai no gashōmon," *Kōkogaku Zasshi* 48, no. 1 (1962): 3-7.

Ribs of the fatted ox cooked tender and succulent;
Sour and bitter blended in the soup of Wu;
Stewed turtle and roast kid . . .
Geese cooked in sour sauce, casseroled duck . . .
Braised chicken . . .
Fried honey-cakes of rice flour . . .
Jade-like wine, honey-flavoured, fills the winged
* cups;*
Ice-cooled liquor, strained of impurities, clear wine,
* cool and refreshing;*

 ◦ ◦ ◦

They set up the bells and fasten the drums and sing
* the latest song:*

 ◦ ◦ ◦

Bells clash in their swinging frames; the catalpa
* zither's strings are swept.*
Their [the dancers'] sleeves rise like crossed bamboo
* stems, then they bring them shimmering down-*
* ward.*[58]

The elements included in the poem—foods, musical instruments, dancers, and so forth—all appear in the picture. And particularly noticeable is that in the picture the whole city scene is separated from the scene of wilderness by the city gate, through which the soul was urged to come back in the poem. We may wonder, then, if the decoration of this *lian* might have been designed particularly to represent the theme of a "summons of the soul," as part of a funeral ritual. The man standing alone in the realm of wilderness could be the wandering soul.

A *hu* vessel found in a tomb at Liulige (fig. 5) belongs to a group of *hu* vessels commonly called "hunting *hu*," so named because they bear characteristic "hunting" scenes.[59] The decorations of this group of bronze vessels, though "pictorial," are essentially symbolic in nature, and their meanings are inevitably controversial.[60] However, we can interpret them with greater certainty if we compare them with the meanings of the mountain theme and its iconographical components which we have observed in the essentially narrative representations on the objects from Huaiyin and Liulige.

The surface of the Liulige vessel is divided into seven major horizontal layers by paired isosceles triangles. The topmost register is divided into two parts showing the same compositions in mirror image. In each a large bird holds in its beak a snake; with its feet it grasps another snake whose head is raised to meet the beak of a smaller, long-necked bird. This image of a bird holding a snake calls to mind the representation of the bird-headed man holding a snake and

fighting through the sacred realm filled with dangerous creatures, which appears in the Huaiyin representations (fig. 1b, extreme right on the upper register, and fig. 3a, on the lower register). We have previously interpreted this figure as a heavenly spirit (bird) aided by an earthly spirit (snake) in exorcising the field of wilderness. We can conjecture that the image of a bird holding a snake in its beak is a symbolic representation of the same concept. The fifth register from the top of the *hu* vessel is an abstraction of the naturalistic image of the bird holding a snake in its beak. The seventh register includes the repetition of the image of a long-necked bird, a water fowl, who looks down on the snake below while the snake raises its head to meet the beak of the fowl. This image is a variation of the bird-snake combination, and must refer to exorcising the waterfront area within the field of wilderness.[61]

The second register of the *hu* decoration has a figure with two snakes on his head who holds one snake in each of his outstretched hands. There is another snake on his one leg. He has wings on his shoulders, and a body that looks like a profile view of a bird with a tail. On each

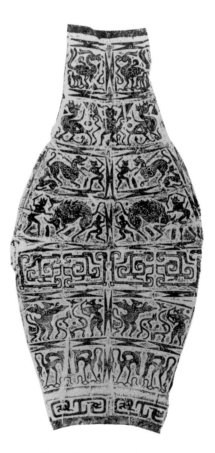

Figure 5 ◦ *Bronze Hu vessel from a tomb at Liulige.*

58

Hawkes, 105-8.

59

This *hu* from Tomb No. 59 at Liulige (Guo, 66, and pl. 93) belongs to a group of *hu* vessels which Weber classified as Group VII; see Weber, Pt. III, 137 ff, and figs. 32, 33, 42, 43, 44.

60

Weber discusses extensively the motifs shown in the decorations of the *hu* vessels belonging to this group, introducing various proposed interpretations of them and his own opinions; see Weber, 161-73.

61

As Weber discusses (ibid.), scholars generally interpret the combination of bird and snake as symbolizing a good or heavenly spirit (bird) overcoming an evil spirit (snake). However, this interpretation is not acceptable, since shamanism in East Asia, as discussed above, takes snakes as helping spirits, and not as evil spirits.

side of him appears a large bird with deer antlers on its head. Each bird holds a snake with both feet, and faces away from the central figure, as if protecting him from surrounding evil spirits. A comparable narrative image in the Huaiyin representations is a figure with wings at his waist who is fully guarded by snakes—two on his head, two on his ears, and two around his feet—and who holds the tail of a dragon-headed winged animal with each hand (fig. 3b, on the lowest register). We assumed that this was a figure, possibly a shaman, in the process of ascending, aided by the two winged animals and two birds pulling up the snakes on his head. Although there are some differences in iconographical details, the winged figure on this *hu* apparently symbolizes the same concept, an ascending spirit. It is hard to decide whether this spirit is the spirit of a shaman on his ecstatic trip, that of a deceased person, or a spiritual messenger who conveys the prayer of the people to heaven. In any case this image must be a symbolic representation of an ascension of a spirit to heaven through the intermediary realm of wilderness.

The third and fourth registers show men attacking monstrous animals—identical scenes are repeated in mirror image, separated by paired isosceles triangles in each register. In the third register a man holds a sword and faces a huge leopard-like animal whose neck has already been pierced by a spear. At the feet of the monstrous animal a deer crouches with his head raised high. In the fourth register a figure wearing headgear that looks like a crown, but is possibly a headdress of feathers, raises a sword or a club against a bull-like animal with a long horn.[62] His assistant also raises his weapon against the rear of the animal. A strange bird is depicted between the head of the main combatant and the body of the animal. The rectangular objects at the feet of the fighting men in both scenes have been generally identified as shields that have been thrown away.[63] These scenes are commonly called "hunting" scenes, but, considering the context of the total design program of the *hu* decoration, they are definitely not ordinary hunting scenes from daily life.

The bull-like animal with a long horn is most likely a unicorn called *si*. The "Chapter of the Southern Mountains" of the *Shan hai jing* says that many *si* and rhinoceroses live in the western portion of its third mountain range, the location of which is considered to be roughly the area around modern Lingling in the southern Hunan.[64] In the "Chapter of Southern Region inside the [Surrounding] Sea" of the *Shan hai jing*, which is one of the chapters added to this book later in the early Han, there is a statement which says: "*Si* lives to the east of Shun's Burial [an area near Mt. Cangwu where the legendary

emperor Shun was believed to be buried] and to the south of the Xiang River. Its shape is like a bull and it is dark-blue in color. It has one horn."[65] Mt. Cangwu (present Mt. Jiuyi) is in southern Hunan and thus this statement agrees with the description in the "Chapter of the Southern Mountains." An important point here is that *si* were thought to live in the southernmost mountain area of the state of Chu during the Warring States period, an area which was not well known and was regarded as mysterious by the people of the Chu. There is little doubt that the combat scene in the decorations of the *hu* originated in

62

Weber (ibid., 167) takes this animal as a bull, and relates it to religious meanings of the bullfight, citing Carl Whiting Bishop, "The Ritual Bullfight," *Annual Report of the Smithsonian Institution for 1926* (Washington, 1927), 447-56. One problem with this identification is that the horn of this animal is longer and straighter than bulls' horns. The animal looks like a bull-shaped unicorn.

The headgear of the major combatant in the identical scene on the *hu* in the Pillsbury collection is identified tentatively by Karlgren as a feather (he adds a question mark to his identification); see Bernhard Karlgren, *A Catalogue of the Chinese Bronzes in the Alfred F. Pillsbury Collection* (Minneapolis, 1932), 142. Some of the headgear appearing in the identical scenes in the decorations of the *hu* vessels belonging to the same group look more clearly like feathers.

63

Karlgren convincingly identified these objects as shields, and other scholars follow him; see Karlgren, 142.

64

Shan hai jing, 1/(*shang*) 9a. The geographical knowledge of the author of this chapter of the *Shan hai jing* was vague, except for the area to the south of the Great Lake, and most of the names of the mountains listed cannot be identified with present geographical features. However, Ogawa convincingly related the third "mountain range" described in this chapter to the general area in the southern Hunan; see Ogawa Takuji, *Shina rekishi chiri kenkyū*, 213-22.

the southern state of Chu and was adopted by the people of the northern states, such as the Wei, as a particularly potent image.

The meaning of the two combat scenes, one with leopards and another with *si*, becomes clearer when we refer to a more dramatic representation in another *hu* in Taibei (fig. 6). In the Taibei *hu*, the two scenes are placed in one composition; the spaces above and between the two scenes are filled with monstrous birds, and two animals are running at the bottom. All together, this composition conveys a tense feeling of the combat which is taking place in the mysterious and dangerous realm. Among the Huaiyin representations a "hunting" scene appears in the lower band of figure 3a, where we see four bird-men, one with bow and arrow, two who hold snakes in one hand and hammer-like weapons in the other, and one who holds a spear and rushes toward the left. They are heavenly spirits who are pacifying, or exorcising, the mysterious realm. In the cases of the Liulige and Taibei *hus* the combatants appear to be human figures, but they must be special people. Their special status is indicated by their crown-feather headgear, worn in spite of being naked otherwise, and by the dots marking their nipple areas—are they women, or men with special emphasis on breasts? Considering the southern origin of the iconography, their images could well be derived from those of the tribal people who were imagined by the people of Chu to have special mystical power and to live together with monstrous animals in the mysterious southern mountains. We can assume that the *hu* combat scenes represent the earthly powers, a counterpart to the heavenly spirits, in their act of pacifying the mystical realm of wilderness.

In the sixth register of the Liulige *hu*, separated from the decorations of the upper registers by the abstract design of the fifth register, a bird-man is going to shoot a bird-monster who extends his wings and raises his claws in a threatening manner.[66] Two dragons and a flying bird are shown between the two combatting figures. The scene must be a symbolic representation of exorcising the higher space (sky) of the realm of wilderness. The seventh register includes, as discussed above, symbolic representations of waterfront pacification. Thus, the representations in the two lower registers, below the band of the abstract design, together assure that the intermediary realm from the top (sky) to the lowest part, that is, the water, is pacified and made safe.

The decorative program of the Liulige *hu* is now clear. The whole surface represents the realm of wilderness, through which the ascending spirit in the form of a winged man protected by many snakes, the earthly helping spirits, moves to heaven. Although no image of mountains appears here, we can now safely assume that the whole mystical realm shown was supposed to exist in the sacred mountains.

A *hu* vessel in the Pillsbury collection of the Minneapolis Institute of Arts (cat. no. 13) shows a variation of the same type of decoration. An important difference is that the Pillsbury *hu* decoration has two actual hunting scenes. In the second register a chariot is drawn by four horses, with a driver and an archer riding on it, and two foot soldiers move after fleeing animals; in the third register four kneeling archers shoot with corded-arrows birds flying above. These are symbolic portrayals of the ritual hunting practiced in the royal Zhou court and in the feudal states at the time.

In the early Zhou period, at the time of the annual ancestral sacrifice, the king of the Zhou

Figure 6 ○ Bronze Hu vessel, National Palace Museum, Taibei.

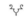

65

Ibid., 10/(*xia*) 49b. *Si* is also mentioned in a poem, "Xi du fu" (Western Capital Rhapsody) by Ban Gu (32-92); see, "Xi du fu," *Liu chen zhu wen xuan* (hereafter, *Wen xuan*), SBCK ed., 1/21a, and its translation in David R. Knechtges, *Wen xuan, or Selections of Refined Literature* (Princeton, 1982), 1:139. Knechtges identifies *si* as "gaur," citing Carl Whiting Bishop, "Rhinoceros and Wild Ox in Ancient China," *China Journal* 18 (1933): 322-30; see Knechtges, 138. Gaur, however, does not have horns. It is possible that this animal of southern origin metamorphosed into a unicorn in the Chinese mystical imagination.

66

In "The Chapter of Western Mountains" of the *Shan hai jing* it says that the deity Qinpei, after murdering another deity, and himself being killed by the Heavenly Sovereign as punishment, metamorphosed into a huge monster, whose appearance is like an eagle, but with black body patterns, a white head, a red beak, and the claws of a tiger. It is said that when it is sighted, there will be a big war. Another deity, Gu, punished together with Qinpei, is said to have been changed into a hawk-like bird with a straight beak, whose appearance to a community causes great drought. See *Shan hai jing*, 2/(*shang*) 21b-22a. The ferocious bird-monster in the Liulige *hu* fits this description of Qinpei particularly well.

led feudal vassals to the imperial park outside the capital for hunting. The huge park, or reserve, included mountains and gorges, lowlands and lakes, and teemed with various animals and birds.[67] It was, in fact, a sacred realm, an inner sanctuary for the Zhou royal court. Hunting in this sacred realm was a religious act of the king of Zhou, the head priest of the state, as he physically interacted with the forces of nature. The hunting of animals from chariots in the wild field, the shooting of birds at the waterfront, and the catching of fish from the lake were the components of the "hunting" ritual. The catch from the hunting and fishing was offered at the ancestral shrine and later served at the ritual banquet. In the later Zhou period a similar practice was carried on by the heads of the powerful feudal states. We can reasonably suppose that the hunting rituals of the early Zhou had a strong animistic connotation, i.e., their religious significance lay in the physical interaction of men with the world of animistic spirits, and that, by the late Zhou, it gained shamanistic overtones with the added significance of pacifying or exorcising the intermediary realm of wilderness. The Qin and Han emperors revitalized this tradition on an imperial scale, mobilizing large military units, but with the effect of increasing its significance as a military exercise and as sport.[68]

The decoration of the Pillsbury *hu* represents two aspects of ritual hunting. The hunting scene with a chariot and the shooting of birds, as depicted in the second and third registers, represents actual deeds of ritual hunting. The combat of two men with a unicorn in the fifth register, and the same scene shown in a mysterious realm over the flying birds in the fourth register, visually represent the religious meaning of the ritual hunting, which is the pacification of the intermediary realm. The decoration of the Pillsbury *hu* as a whole has a strong emphasis on ritual hunting. This vessel was most likely designed to be used during hunting-banquet rituals. The Liulige *hu* design, in contrast, has less emphasis on hunting and more emphasis on communication with heaven, with the addition of the image of an ascending spirit. It could have been intended for funerary use, since the ascending spirit can be interpreted as an ascending soul of the deceased.

Representations of mountain scenes increase dramatically when we come to the Han dynasty. They were shown in various forms and media, and with varieties of context. However, they were all extensions of the basic themes developed during the late Zhou period. The concept of mountain wilderness as a sacred realm filled with deities and monstrous creatures, as well as with ordinary animals, birds, and fish in an animistic sense, remained the basic idea. The concept of this sacred realm as an intermediary realm between heaven and the human world, with or without a shamanistic overtone, was further developed and enriched with many types of new imagery.

MOUNTAINS OF THE COSMIC ORDER: THE HAN DYNASTY

The Han dynasty was divided into three periods, the Western Han (206 BC–8 AD); the Xin (9–25 AD), a period of usurpation by Wang Mang; and the Eastern Han (25–220 AD). Representations of mountain scenes in Han art, which reveal a fascinating imaginary world of the unknown, were increasingly rationalized and humanized as the three periods evolved. It should be noted that here the terms "rationalized" and "humanized" must be understood in the context of Han culture, not in the context of twentieth-century Western culture. Mysticism and its visual assertion had an immediate impact on the daily lives of the Han people. What we deal with here are new configurations of the imaginary world of the unknown, reflecting the Han people's quest for a better understanding of the cosmic structure which would bring them a better life, both in this world and after death.

One of the new iconographical elements in Han mountain scenes is the *yunqi* (literally, "cloud-spirit" or "cloud-force") motif, sometimes called "cloud scroll" in English. Its most basic form is a rhythmic curvilinear pattern accentuated with cloud-like scroll forms that often suggest birds' heads, beaks, and dragons' claws. The motif looks like a group of clouds charged with animistic energy (see below, figs. 8-10). Its immediate predecessors were abstract patterns

derived from the forms of birds or dragons, or the combination of the two, which were commonly found in the decoration of bronze vessels and some sculptural images of animals and monsters in the Warring States period. A good example of the latter is the bronze monster figure in the collection of the Nelson-Atkins Museum in Kansas City, the surface of which is decorated with inlaid abstract patterns that give the piece an animistic, mystical power (fig. 7). This motif, which we might call the *qi* (mystical vital force) motif, was modified by Han designers with added scroll forms to become the *yunqi*, making it appear more flamboyant and cloud-like. Behind this modification was the concept of *yunqi*, a mystical force gathered in a cloud-like form which could be a vehicle of the immortals, and, if sighted by people, would signify a good omen for the emperor or for society as a whole.[69]

A mountain scene depicted in a pattern of inlaid gold and silver on a bronze tube in the Eiseibunko collection in Japan, an example of the superb artistic achievement of Han designers, provides us with a very basic formula for the way a mountain scene was combined with the *yunqi* motif (fig. 8). The elements of *yunqi*, such as sharp, barbed projections in the form of bird beaks, or scrolls in the form of birds' heads or dragons' claws, serve as mountain peaks, cliffs, valleys, and bumps on a slope. This dynamic representation of topographical features contrasts remarkably with the static stepped peaks in Warring States mountain scenes which we have observed above. Animals are shown in full motion in this new setting: An animal resembling a rabbit is about to jump from a peak, while two birds perch just underneath the cliff (fig. 8a). Antelopes and boars run and jump over the slopes, sometimes chased by other animals (figs. 8c and d). A tiger is ready to attack an oncoming antelope, while a monkey tries to reach a higher cliff (fig. 8b). The rhythmic movement of the *yunqi* motif interacts with the activities of the animals, creating a powerful total image that emits mysterious energy. One noticeable aspect of this design is the absence of the mountain deities, heavenly spirits, and shaman-like figures that we observed in the mountain scenes of the Warring States period. Probably the mysterious mountain-cloud motif was considered sufficient to suggest the presence of mystical divine powers in the scene.

We have already noted that one of the most important powers attributed to the great mountains in China was their ability to produce clouds, which, in turn, bring rain, the life source for agricultural communities. Thus the *yunqi* on the Eiseibunko bronze tube, a combination of the image of mountains imbued with animistic powers and that of auspicious clouds, is an ultimate expression of the sacred mountains in early Chinese thought.

Figure 7 ○ *Bronze supporting leg, Nelson-Atkins Museum of Art.*

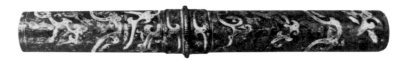

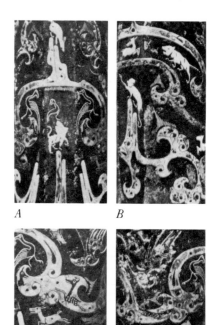

A B

C D

Figure 8 ○ *Bronze tube, Eiseibunko Collection, Tokyo.*

67

The exact scale and topographical features of the ancient sacred hunting ground of Fengjing are not recorded. However, we get a general picture of it from the description of the Shanglin Park of the Western Han, which was supposedly a revival of the once abandoned Fengjing Park; it was reclaimed by the first Emperor of the Qin upon his unification of the country and inherited by the Han emperors. A detailed description of the Shanglin Park is found in the "Shanglin fu" (Rhapsody of the Shanglin Park) by Sima Xiangru (179–117 BC); see "Shanglin fu," *Wen xuan*, 8/1a-20a, and its English translation by Knechtges, "Rhapsody on the Imperial Park," in Knechtges, 2: 72-114.

68

Hayashi Minao, "Sengoku jidai no gashōmon—3," *Kōkogaku zasshi* 48, no. 1 (1962): 3-14, and Edward H. Schafer, "Hunting Parks and Animal Enclosures in Ancient China," *Journal of the Economic and Social History of the Orient* 11 (1968): 318-43. For the military exercises and hunting as parts of the annual rituals during the Han dynasty, see Derk Bodde, *Festivals in Classical China* (Princeton, 1975), 349-57, 381-86.

69

Wu Hung, "A Sanpan Shan Chariot Ornament and the Xiangrui Design in Western Han Art," *Archives of Asian Art* 37 (1984): 46-48.

There are only three bronze tubes of this kind known to us. One that was excavated from a Western Han tomb at Sanpanshan in Hebei province is important in providing clues to their dates as well as their use (fig. 9). The tomb has been identified as that of Prince Kang of the Zhongshan feudatory state, a member of the Han royal family, who was buried in 90 BC. The bronze tube with *yunqi*-mountain ornamentation was found as part of a particularly elaborate chariot buried in the tomb.[70]

The decoration of the Sanpanshan bronze tube is more complex than that of the Eiseibunko tube. There are many more diverse kinds of animals and birds, including an elephant, a camel, a winged horse, a dragon, and a peacock. Also included are some human figures—not shamans or deities in human form, but riders on the elephant and the camel, and an archer on horseback. The *yunqi* motif, with its characteristic rhythmic curvilinear pattern, serves as a mountain setting, as in the Eiseibunko design. Here, the scroll patterns no longer reveal animistic images, such as birds' beaks and heads; instead, they represent vegetation, such as trees and vines. It has been argued that many motifs used in this decoration are essentially what should be called *xiangrui* (good omen) designs, and consequently the whole design had that meaning. This theory explains why exotic animals such as the elephant and camel with their riders were included in the design. When those animals were brought from foreign countries as tributes to the court of Emperor Wu (reigned 140–87 BC), the events were considered as *xiangrui*, that is, good omens signaling heaven's blessing on the emperor's reign.[71]

The dangerous realm of the mountain wilderness depicted in Warring States designs, the quality of which was retained to some degree in the Eiseibunko tube, was changed in the Sanpanshan tube into a world filled with auspicious omens. Although the inclusion of archers and some fighting animals in its design indicates that this mysterious realm still has some elements that need to be exorcised, the prevailing mood in the whole decoration is peaceful, even festive. The artist exhibits almost a fairy-tale illustrator's skill in drawing bears, either in contented lazy postures or in child-like motions (fig. 9a, center top; 9b, right middle; 9c, right middle; 9d, left top, and bottom center). There is a pastoral atmosphere in a small scene where a stag and a yearling who follows him look back at something happening behind them (fig. 9b, bottom left).

The third bronze tube of this type is in the collection of the Tokyo Art Institute, and its decoration is very close to that of the Sanpanshan tube in general outlook (fig. 10). However, its design does not include the exotic elephant and camel. Also excluded are human images, except for the archer on horseback (fig. 10b). *Yunqi* motifs represent a mountain setting, as in the Sanpanshan design, but they define the topographical features of the mountain more clearly, and retain some animistic characteristics, particularly where the band of mountains turns into

70

Ibid., 38-39.

71

Ibid., 39-46.

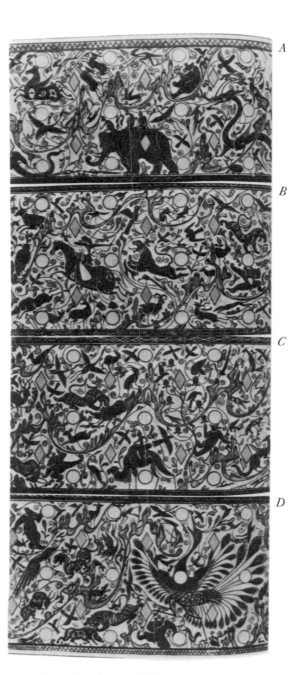

Figure 9 ○ Bronze tube from a tomb at Sanpanshan.

abstract scrolls (fig. 10b, top). In one place, such a band turns into a dragon, claws appearing first and then the head at the very end (fig. 10c, bottom center). The general mood of the design is more tense than that of the auspicious Sanpanshan design. We can place the design of the Tokyo Art Institute tube stylistically between the Eiseibunko design and the Sanpanshan design. The Eiseibunko design is most likely the earliest of the three, because it retains more of the basic concept of the mountains as a dangerous realm of wilderness and includes none of the additional *xiangrui* motifs.

It is possible that the special chariots equipped with the bronze tubes bearing *yunqi*-mountain designs were a kind of chariot called *yunqiche* (*yunqi* chariot). According to *Shi ji* (The Record of History), a *fangshi* (magician-gentleman) called Wencheng, around 110 BC, told the Emperor Wu, "If you want to communicate with spirits, the palace and palace clothes must be decorated with images of the spirits—otherwise the spirits will not come to you." Then, "he designed [five] *yunqi*-chariots [each colored with one of the five basic colors], suitable to be used on *shengri* [literally, "overcoming days," the special days designated in accordance with the Five Elements theory], for riding and exorcising evil spirits."[72] This anecdote implies that the decorations of palace walls, clothes, or chariots should provide images of the ideal mystical environment for the efficacy of magical rituals.[73] The *yunqi*-mountain design employed for the chariots was to enhance the effect of exorcism.

There is no record of what actual act was involved in "exorcising evil spirits" on these occasions recommended to Emperor Wu. We can assume, however, that it was similar to the ritual of *quliu*, an autumn festival observed during the Han. It is said: "In this ceremony the emperor rides in a war chariot of white horses with deep red manes. He himself holds a crossbow in his hands, with which he shoots the sacrificial victims. These victims consist of young deer. The Prefect Grand Butcher and the Internuncios load the game in chariots and drive them to the imperial tombs, one man for each [tomb]. Then the Emperor returns to the palace."[74] This ritual is apparently a symbolic, formalized version of the hunting rituals of the Zhou period. As we have discussed earlier, one of the major purposes of the hunting rituals was to exorcise the intermediary realm of wilderness between heaven and this world in order to secure communication with heaven, or with a heavenly spirit or ancestral

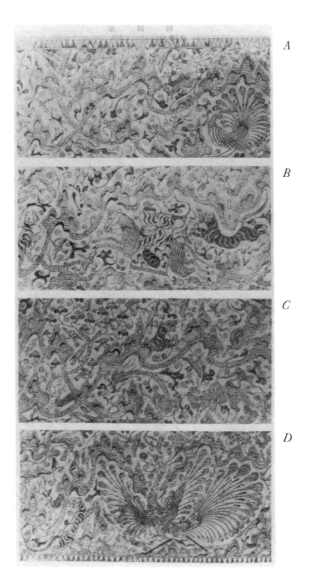

A

B

C

D

Figure 10 ○ Bronze tube, Tokyo Institute of Art.

72

Shi ji, SBCK ed., 28/25a. The Five Elements (*wuxing*) theory, which became popular from the early Han dynasty on, was based upon the premise that all existing beings and phenomena were results of the evolution of the Five Elements or Agents (earth, wood, metal, fire, and water). Five Colors and Five Directions are among many categories of groups of five which were equated with the Five Elements.

73

A basic principle underlying this mystical design concept is *ganlei* (sympathetic response of the similar kinds). About this principle and its meaning in early Chinese art, see Kiyohiko Munakata, "Concepts of *Lei* and *Kan-lei* in Early Chinese Art Theory," in S. Bush and C. Murck, eds., *Theories of the Arts in China* (Princeton, 1983), 105-31

74

Bodde, *Festivals in Classical China*, 327-28.

soul. The *yunqi*-mountain design is, then, most appropriate to decorate the chariots to be used in such rituals.

A chariot with elaborate decorations in gold and silver inlay has been excavated from the tomb of Liu Sheng (died 113 BC), Prince Jing of the Zhongshan feudatory state. Liu Sheng was the father of Prince Kang, who was buried in the Sanpanshan tomb. The bronze tubes from Liu Sheng's chariot are decorated with an abstract design that combines the *yunqi* motif and a sharp zigzag motif that most likely symbolizes mountains.[75] This design must be a prototype of the *yunqi*-mountain design used to decorate the three bronze tubes discussed above. The chariot of Liu Sheng, a war chariot equipped with bow fittings, was decorated with the *yunqi*-mountain motif, making it well suited for use in ritual hunting and *quliu*-type rituals. The existence of such a chariot in the household of Prince Jing seems to indicate that each feudatory state practiced the same types of rituals as those observed in the imperial court.

We may note that Prince Jing's *yunqi*-chariot predates the anecdote of Wenchang's recommendation to Emperor Wu around 110 BC, which suggested the use of a new design of *yunqi*-chariot. Apparently the *fangshi* did not invent a new chariot type, but devised a new design for the decoration of the chariots to be used for a particular ritual purpose, a design which was to have had better efficacy. The change in design of the *yunqi*-mountain for chariot decorations, from an abstract design to more narrative mountain scenes showing lively activities of creatures, took place within the court of the Zhongshan feudatory state between the time of the tomb of Prince Jing (113 BC) and that of Prince Kang (90 BC). It is very likely that the court of the princes of the state of Zhongshan followed closely the fashion of the imperial court in the capital, and that the new design of *yunqi*-mountains on Prince Kang's chariot was a reflection of the new mode in Emperor Wu's court which resulted from the *fangshi*'s recommendation. If this is the case, the dates of the three bronze tubes—the Eiseibunko, Tokyo Art Institute, and Sanpanshan tubes—fall within the brief period between 110 BC and 90 BC.

Among the most remarkable representations of mountain scenes from the Han dynasty are the paintings decorating the coffins excavated from Tomb 1 at Mawangdui in Hunan province, datable to c.168 BC.[76] As funerary art, those mountain scenes are related to the concept of death current at the time; thus they reveal the development of the idea of the mountain as the place of passage of the soul of the deceased during the Western Han. While these coffins are not part of this exhibition, a detailed examination of them provides us with background that helps

us to understand other objects from the Han and the ideas behind them.

There were four coffins, one inserted into another, with the body of the deceased placed in the innermost coffin. The innermost coffin was decorated with brocade bearing a geometricized *yunqi* pattern. The fabric was pasted over the black lacquered surface of the wooden panels. Placed over the lid of this coffin was a piece of painted silk in the form of a garment called a "flying garment." The second (red lacquered) and the third (black lacquered) coffins, counting from the inside, are profusely decorated with paintings and abstract patterns. The outermost coffin is also black lacquered, but without any decoration. The paintings on the "flying garment" have been studied and discussed by many scholars. Although there still exist many controversial problems to be solved, the consensus of

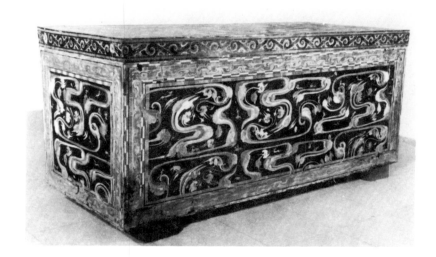

Figure 11 ○ Black lacquered coffin from a tomb at Mawangdui.

75

See Zhongguo shehui kexueyuan kaogu yanjiusuo, *Mancheng Hanmu fajue baogao* (Beijing, 1980), p. 186, and fig. 130 on p. 189 (hereafter, *Mancheng Report*). For a detailed report of the remains of horse chariots, see 179-206.

76

A comprehensive excavation report on this tomb is Hunan-sheng Bowuguan and Zhongguo Kexueyuan Kaogu Yanjiusuo, *Changsha Mawangdui yihao Han mu* (Beijing, 1973), (hereafter, *Mawangdui Report*). For the identification of the buried person, and the date of the tomb, see 156-58, and Michael Loewe, *Ways to Paradise* (Boston and Sydney, 1979), 27-30.

scholars is that they depict scenes of the soul of the deceased, situated between the underground world below and heaven above, ready to ascend to heaven.[77] The meaning of the decorations of the other two coffins, particularly the unifying programmatic concept underlying the coffin decorations as a whole, has not yet been properly addressed.

The scenes painted on the lid and four sides of the black lacquered coffin from the Mawang-dui tomb are a source of endless fascination for the viewer (fig. 11). Each scene on those panels, framed by highly abstracted *yunqi* motifs, is basically the same in style and content as the others, with only slight variations. The boldly brushed *yunqi* motifs at times look like a mountain topography with peaks, cliffs, and plateaus, and at other times appear like swirling clouds. The motifs are shown in continuous rhythmic movement, like the brushwork of Chinese calligraphy, turning and sweeping, speeding and slowing down, expanding and diminishing. The powerful movement of the decoration, incorporated within its characteristic scroll forms and projections suggesting birds' heads and beaks, imparts a mysterious animistic energy (figs. 12-13). There are many independent small units of the *yunqi* motif: some are shown emerging from the main body of the *yunqi* and others are placed independently along the curves of the main body. Each smaller motif consists essentially of a curved or straight wire-thin line with a feather or claw element attached to one end, and in some cases with additional elements—possibly abstractions of birds' heads or claws—attached in the middle. Those small, independent *yunqi* units often look like arrows or speeding comets. The active human figures, half-human figures, animals, and birds in these scenes appear on or around the topographic features of the *yunqi*-mountains (fig. 14).

In the Mawangdui design, the major *yunqi* motif in each panel, which forms the topographical setting, is not contained by the peripheral band. It begins at the bottom, rising out of the abstract *yunqi* pattern in the "frame," and crosses over the lower border line at one or several points (see fig. 15, bottom). This feature enhances the feeling that the *yunqi*-mountains are floating, surrounded by the auspicious clouds. Negative space in the composition is subtly handled to enhance this effect. The figures not securely fixed on the topographical features are often supported by the independent *yunqi* units—sometimes they glide through space on

arrow-like flying *yunqi*. A wolf-man clad in a short garment (fig. 13) stands on the hair-thin body of an independent *yunqi* and keeps his balance by holding the edge of a stationary main *yunqi*. He is fed a snake by a bird perched on a nearby cliff. There is a certain topographical reference, but the presence of a void dominates the scene. The wolf-man reminds the viewer of an astronaut working outside his spaceship.

The presence of immortals (*xianren*) distinguishes the Han mountain scenes from earlier scenes. These immortals play music and dance (fig. 16, nos. 13 and 14), or stand triumphantly, commanding respect from monster-animals (fig. 12). They are permitted to stay permanently in the transcendental space between heaven and earth, and therefore are greatly different from the shamans in the Warring States scenes. The shamans, as we have seen in the previous section, have to fight and wade through the dangerous realm of wilderness with the aid of heavenly and

Figure 12 ∘ Detail of figure 11.

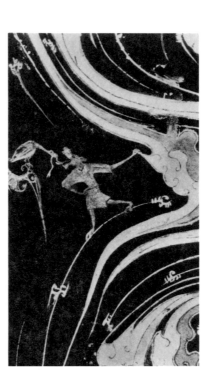

Figure 13 ∘ Detail of figure 11.

77

There are two major studies on the meaning of this painting. See Loewe, 17-59, and Sofukawa Hiroshi, *Konronzan eno Shōsen* (Tokyo, 1981), 69-165. Both discuss the iconographical elements involved in this painting in great detail and conclude that the painting represented the theme of the ascent of the soul of the deceased. However, they differ in identifying the lower portion of the painting. While Loewe suggests that it is a scene of the Penglai Island of the Eastern Sea, Sofukawa takes it as a scene of the underground world.

earthly spirits. However, we must note that in Han decorations, the immortals' actions, whether playing music or dancing, may represent an attempt to please or pacify the mountain gods, most likely reflecting the ritual dancing performed by the priests and shamans at the mountain shrines, as described in the *Shan hai jing*. We also note, in light of the description of the *Shan hai jing*, that the half-human animals are mountain deities of various ranks.

The paintings on the five panels of the black Mawangdui coffin are very similar to each other, yet are subtly differentiated, showing a structural order of the mysterious terrain. The emphasis of the design changes from panel to panel, beginning with the panel to the right side of the body of the deceased. From this starting point, the design flows in an orderly fashion to the panel on the left, then to the panel at the foot of the coffin, then to the panel at the head, and finally to the lid. The scenes on the right panel are the most violent; many peculiar animals are combatting or chasing each other, including one horned animal aiming his spear at a bull (fig. 15). This panel retains some of the earlier character of the mountain scene as a dangerous realm of wilderness. As we follow the sequence of the panels, the scenes become more peaceful. For example, the scenes on the panel at the head show the immortals playing music and dancing. We finally reach the panel on the lid, where a calm mood predominates. Here only a few quiet, living creatures are to be seen, such as birds, snakes, tamed leopards, and wolf-men (fig. 14). The wolf-men—one receiving a snake from a bird, another holding a snake in his hand, a third walking alone with his mouth open—correspond to the exorcising figures, such as bird-men, in Warring States representations (fig. 15, nos. 1, 4, 5). However, they are not engaged in the act of exorcism, but are there to maintain the peaceful realm.

The paintings on the red lacquered coffin are more abstract and symbolic, using an abstract *yunqi* pattern and dragons as major components. A recent study interpreted the painting on the left panel of this coffin as depicting Mt. Kunlun, the cosmic mountain, which is supposed to be a gateway to heaven.[78] The decoration of this panel has a pointed mountain at the center flanked by two writhing dragons (fig. 17). On the left side a tiger and a horse are shown tumbling over parts of a winding dragon body, as if they have slipped down to the bottom of an abyss. On the right side a large bird stands sure-footed on a flat section of the dragon body, and a man sprouting bird feathers holds onto a vertical part of the dragon, as if he is climbing a steep cliff. It is possible to interpret the two scenes as symbolically showing the difficulty—or rather impossibility, without a transcendental power—of

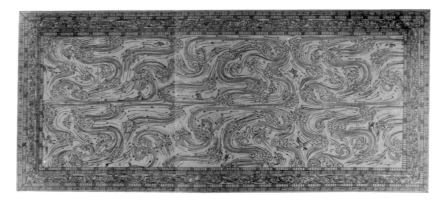

Figure 14 ○ *Lid of coffin in figure 11.*

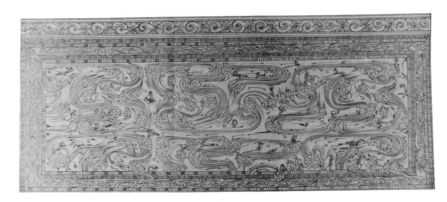

Figure 15 ○ *Panel on right side of coffin in figure 11.*

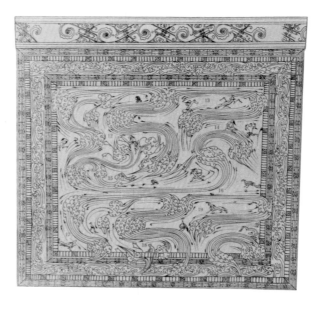

Figure 16 ○ *Panel at head of coffin in figure 11.*

78

Sofukawa, 30-61.

26

crossing deep ravines and climbing high cliffs on the way to reach the top of Mt. Kunlun.[79]

The structure of the mountain on the panel on the left side of the coffin is difficult to see in the available reproductions. However, it looks essentially the same as the one at the head of the coffin, which is well preserved (fig. 18). Referring to the latter, we can learn the way Mt. Kunlun is represented in this coffin design. The mountain has a triangular shape with a sharply angled step on each side. We may take this as an intermediate shape between that of the stepped mountains of the Warring States period and the pattern of the three-peaked mountain. Inside the triangular mountain there are two units of three-peaked mountains, one placed over the other, and they merge into cloud forms. The higher mountain unit looks like a lotus flower supported by two cloud-shaped stems. The lower mountain unit is basically of the same structure, but its two stems and two side peaks are well integrated with two *yunqi* patterns, one on each side, which cross the boundary of the outer mountain and rise high. The upper parts of these two *yunqi* motifs support two auspicious animals, white deer, on each side of the triangular outer mountain. Close observation reveals that the right side of the base of the outer mountain also merges into *yunqi* motifs. In short, all three mountain units on this panel are *yunqi*-mountains, as are those in the designs on the black lacquered coffin.

As we have already noted, *Huai nan zi*, a writing that was contemporary with the Mawangdui designs, describes Mt. Kunlun as having three layers: the lowest, Cool Breeze (Liangfeng); the middle one, Hanging Garden (Xuanpu); and the top peak, which reaches Upper Heaven.[80] We can safely assume that the three units of mountains on the panel at the head of the red lacquered coffin are meant to represent the three layers of mountains of the Mt. Kunlun complex. The tip of the outer mountain on this panel touches the upper edge of the frame and is connected with one of the cloud forms of the *yunqi* pattern in the peripheral design. The design on the coffin lid is essentially a swirling pattern of two dragons in *yunqi* form intertwined with two tigers. At the bottom center of this design there is a *yunqi* unit with a mountain-shaped projection, assuring that this whole design is meant to represent the Upper Heaven reached by the tip of Mt. Kunlun.

Assuming that the designs of the two coffins are part of a unified program, we can interpret the lively mountain scenes in the decoration of the black lacquered coffin as representing the realm of wilderness existing at the lowest level of

Mt. Kunlun. We might add here that the design of the embroidery pasted over the innermost coffin, which shows a geometricized *yunqi* motif with a floral motif at the center of each framed unit, can be interpreted as symbolizing the heavenly realms.[81] Thus, in the sequence of designs of the three decorated Mawangdui coffins, from the outer coffin to the inner one, we observe a well-structured mystical vision of the Han people concerning the passage of the ascending soul through Mt. Kunlun, the cosmic mountain, to heaven.

Our identification of the *yunqi*-mountain scenes on the coffins from the Mawangdui tomb as representing Mt. Kunlun needs to be carefully

79

Ibid., 33-44.

80

See above, 11.

81

The floral motif as a symbol of heaven in Han art is discussed in detail in Minao Hayashi, "Chūgoku kodai ni okeru hasu no hana no shōchō," first published in Kyoto *Tōhōgakuhō* (1987); reprinted in Hayashi, *Kandai no kamigami* (Kyoto, 1989), 219-80.

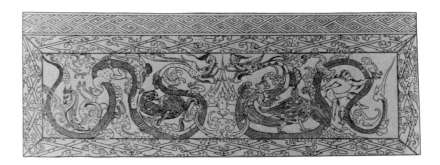

Figure 17 ○ *Panel on left side of red lacquered coffin from tomb at Mawangdui.*

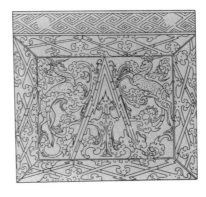

Figure 18 ○ *Panel at head of coffin in figure 17.*

evaluated. Mt. Kunlun became important as the central axis of the universe in early Han cosmology. Yet, it is uncertain how commonly the concept of Mt. Kunlun was involved in religious practice in the early Han. There are strong indications that actual mountains, including the Five Sacred Mountains and other locally revered mountains, rather than the imaginary Kunlun, were more commonly involved in Han religious practices, such as annual sacrifices, exorcising rituals, and possibly funerals. The region of Mawangdui, the middle Yangzi River region which had been the cultural center of the state of Chu during the preceding Warring States period, might have had a strong local religious tradition in the early Han period. The association of the Mt. Kunlun cult with funerals, that is, its association with the idea of the ascent of the soul of the deceased, might have had its root in the shamanism of this region in the Warring States period. As we shall discuss later, when the cult of the Queen Mother of the West became popular among people in the larger area of China from the late first century BC on, Mt. Kunlun was identified as her seat, or as a path to reach her, and became an important factor in funerals. The religious significance of Mt. Kunlun during the Han period is a complex problem of interregional and historical religious development and must be left for future study.

Incense burners commonly called *boshanlu* (literally, "Bo Mountain censer"), or *boshan* censers, are three-dimensional representations of spirit mountains. The basic *boshan* censer consists of a mountain-shaped lid, sometimes structured with overlapping vertical peaks, and a bowl-shaped body supported by a stem which stands on a circular foot. The censer is often placed in the center of a shallow water basin. It looks like a lotus flower growing from a pond. However, the peaks on the lid bear the images of animals and humans in various activities, in the tradition of sacred-mountain iconography. The lid is perforated—holes often hidden between the peaks allow smoke from burning incense to escape, creating an image of mysterious clouds rising from a sacred mountain.

There are many *boshan*-type mountain censers in Western collections and they are also found among the objects recently excavated by archæologists. They can be made of bronze or pottery and exhibit varying degrees of sophistication. Two of them are particularly beautiful, with elaborate inlaid work. One is the bronze censer excavated from Tomb No. 1 at Mancheng, Hebei, the tomb of Liu Sheng, Prince Jing of the

Zhongshan feudatory state, who, as stated above, died in 113 BC (figs. 19-20).[82] Its lid is structured with many soaring peaks which, as a whole, form the contour of a conically shaped mountain. This mountain complex is continued on the upper part of the body of the censer, thus visually unifying the lid and the body. The bowl-shaped lower part of the body has a smooth surface which is decorated with *yunqi* motifs in gold inlay. Inlaid *yunqi* motifs are also applied on the narrow surfaces of the peaks. The stem of the censer is of open metalwork with gold inlay in the form of an abstracted dragon. There are many small figures of humans and animals in sculptural form attached to the edges and flat parts of the peaks. They are difficult to identify in the available reproductions, but, according to the archæological report, they include divine animals, a running tiger and leopard, monkeys

82

Mancheng Report; for the dates of Liu Sheng's tomb (Tomb No. 1) and that of his wife (Tomb No. 2), and a general summary of the excavation of the tombs, see pp. 336-39, and its English abstract, pp. 449-51; for the *boshan* censer, see pp. 63-66 in the same volume.

Figure 19 ○ BOSHAN censer excavated from tomb of Liu Sheng at Mancheng.

Figure 20 ○ Drawing, decoration of censer in figure 19.

seated on the higher part of the peaks or riding on animals, and archers walking or chasing wild boar.

The design of this *boshan* censer is quite obviously an ingenious application of the two-dimensional *yunqi*-mountain design to a three-dimensional censer form; the artist literally adopted the idea of the *yunqi*-mountains floating above the auspicious clouds, as well as the iconographical details of the actions of the creatures. This *boshan* censer was apparently a very special object among the possessions of Liu Sheng, since the other four incense burners found in the same tomb were strictly functional in design. According to *Xi jing za ji* (Miscellaneous Notes of the Western Capital), claimed to be written by Liu Yin (died 23 AD) of the Han dynasty but possibly a sixth-century compilation, "the clever craftsman Ding Huan of Changan . . . made a nine-layered *boshan* censer on which he engraved strange birds, monstrous animals, and evil and benevolent spiritual beings that appear very natural in their activities."[83] It also lists a five-layer metal (bronze) *boshan* censer as one of the gifts to Empress Zhao from her sister when Zhao became the empress in 16 BC.[84] The design of Liu Sheng's *boshan* censer—even the nine layers of mountain peaks—fits very well with the description of Ding Huan's design. It was undoubtedly one of the highest-quality censers available in the capital and was possibly given by the emperor to the prince.

Equally high in quality and the only other extant *boshan* censer with elaborate inlaid decoration is the one in the Freer Gallery of Art in Washington, DC (fig. 21). The handling of the overlapping peaks in this censer is less flamboyant and more static and two-dimensional than that of Liu Sheng's censer. The side of each peak is larger, allowing for more complex decorations. The inlaid patterns are also more restrained and static—in fact, they are not really swirling *yunqi* patterns, but are closer to the *qi* patterns commonly used in the decorations of bronze pieces from the Warring States period. They are, however, well incorporated with inlaid precious stones in turquoise and amber, and create an exquisite, mysteriously glowing surface effect.

On the surface of each peak, many activities of humans, animals, and birds are represented in relief. These activities are almost identical to those depicted on the censer from the Nelson-Atkins Museum and on the lid of a censer from the Field Museum of Natural History in Chicago (cat. nos. 17-18). These three designs strongly emphasize the "wilderness" of the spirit mountain, as clearly seen in the details of the Field Museum lid (fig. 22). A puzzling iconographical feature is the scene of a man leading a horse cart (fig. 22b, top center). The most likely interpretation of this scene is that the man is bringing animal sacrifices to the ancestral souls through the intermediary realm of wilderness. As quoted above, during the Han *quliu* ritual, which symbolized the hunting rituals, the imperial caretakers loaded the sacrificial animals shot by the

83

Xi jing za ji, SBCK ed., 1/6b; Berthold Laufer, *Chinese Pottery of the Han Dynasty* (Leiden, 1909), 180 n. 3.

84

Ibid., 1/6b-7a. A biography of Zhao Feiyan is in *Han shu*, 97/11a-12b. The year when Zhao became empress is given on 10/10b.

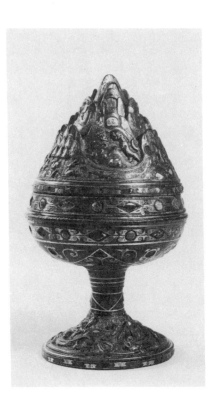

Figure 21 ○ *BOSHAN censer, Freer Gallery of Art.*

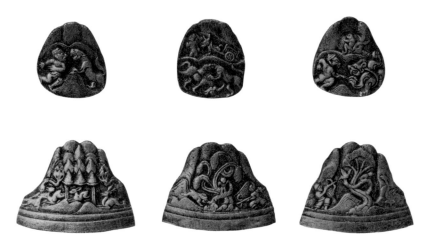

Figure 22 ○ *Cast models, details of BOSHAN censer, Field Museum of Natural History.*

emperor into chariots (the word used is actually *che*, "carts") and transported them to the imperial tombs. The real meaning of this ritual as a whole is to pacify or exorcise the intermediary realm of wilderness and to send the tributes to the ancestral souls. The image of a man bringing sacrificial animals by horse cart to the ancestral souls through the spirit mountain is, in a sense, a replacement for the scene of the sacrificial slaughter of animals in the "hunting scenes" on bronzes from the Warring States period.

It is very clear that *boshan* censers represent cosmic mountains that function as intermediary realms between heaven and this world. However, the origin of the term *boshan* (Bo Mountain) is a puzzle. No prominent mountain called Mt. Bo (Boshan) exists in China.[85] The word *bo*, meaning "broad," or "wide," does not suggest any solution. There have been many studies and much speculation about the origin of this type of censer and its name.[86] Zhu Yidong of the Qing dynasty (1644–1911) offered a very illuminating idea on this matter.[87] According to his theory, Mt. Bo refers to Mt. Hua, the Sacred West Mountain. *Hanfeizi* recounts the story of King Zhao (reigned 306–251 BC) of the Qin state, who climbed to the top of Mt. Hua and left there a plaque with an inscription saying that "King Zhao once played a *bo* game with a heavenly deity in this place." The name Mt. Bo used for Mt. Hua may have come from this anecdote. This theory is supported by several pieces of circumstantial evidence: First, Mt. Hua is located close to the Western Han capital, Changan, where this type of censer was most likely created. Second, the shape of the censer, which looks like a lotus bud growing from water, has a formal and symbolic resemblance to Mt. Hua (meaning "flower" in general, but in a specific sense, "lotus flower," which symbolizes heaven in Han iconography). Third, a poem ascribed to Liu Xiang (77–6 BC) refers to Mt. Hua in describing a mountain censer.[88] Finally, the game of *bo* is a game like backgammon that uses a diagram of the cosmic structure and is played to reach "heaven" through an intermediary realm of wilderness, an aim that coincides with the symbolic meaning of *boshan* censers.[89]

Although the term "*boshan* censer" was commonly used in the following period, inscriptions appearing on the two archæologically excavated mountain censers from the Western Han tombs simply identify them as metal censers, *xunlu* (literally, "fragrance brazier").[90] Two recorded poems of possibly late Western Han dates also call the mountain censers *xunlu*.[91] However, since many types of incense burners were used during the Western Han period, the mountain censers, a unique type among them, must have acquired an identifying name relatively soon after their invention during the reign of Emperor Wu. It is possible that the term *boshan*, the *bo*-game mountain, became popular by the early first century AD, when the cult of immortals was strongly associated with the mountain cult, as attested by a dramatic increase in the number of

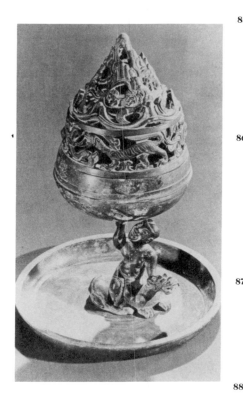

Figure 23 ○ BOSHAN censer excavated from Dou Wan tomb at Mancheng.

85

Only one minor mountain called Mt. Bo is listed in *Zhongguo gujin diming dacidian* (The Large Dictionary of Chinese Place Names of the Past and Present) (Shangwu Yinshuguan, 1931), 878.

86

For a good summary and extensive bibliography on the subject see Susan Nell Erickson, "*Boshanlu* Mountain Censers: Mountains and Immortality in the Western Han Period" (Ph.D. diss., University of Minnesota, 1989), 77-83.

87

Zhu Yidong, *Qun shu zha ji*, quoted in Zhuan Bohe, "Boshanlu suofanying de shenxian shijie," *Zhongguo yishu zhaji* (Taibei, 1976), 74.

88

Yi wen lei ju (reprint, Taibei: Xinxing shuju, 1969), 70/5a.

89

See cat. no. 37.

90

Erickson, 77-80.

91

One poem is identified simply as an "ancient poem," and another, which is a simplified version that repeats verbatim essential phrases of the former, is attributed to Liu Xiang (77–6 BC). Both are included in *Yi wen lei ju*, 70/4a-5a. An English translation of the "ancient poem" is in Needham, vol. 5, pt. 2, 133. See also Erickson, 82-83, 82 n. 2.

images of sacred mountains populated by immortals.[92] It is clear that even if the term *boshan* was originally associated with Mt. Hua, it soon became a general term to mean simply a "sacred mountain," judging from the later usages of it.[93]

An interesting bronze mountain censer was found in Tomb No. 2 at Mancheng, identified as the tomb of Liu Sheng's wife, Dou Wan (figs. 23-24). The date of the tomb is ascribed to between 118 BC and 104 BC from the archæological evidence. The censer has no inlaid decoration, and no overlapping independently rising peaks. However, its lid is in the form of a cone-shaped mountain, and the peaks and the creatures active in the mountain are finely cast in openwork. Interestingly, the scenes on the sides of the peaks on the censer, including the one showing a man leading a horse cart, are exactly the same as those on the Freer Gallery censer. This suggests that both censers were made in the same workshop, possibly that of the imperial court in the capital. There is an additional band at the lower part of the Dou Wan lid which contains depictions of four creatures—a bird, a tiger, a camel, and a dragon—as well as a tree and some *yunqi*-like motifs in openwork. The inclusion of the camel reminds us of the decoration of the bronze tube from Sanpanshan tomb, the tomb of Dou Wan's son, which includes a camel and an elephant in its main motifs, reflecting the fashion of the later period of Emperor Wu's reign, around 100 BC.

An unusual feature of the Dou Wan censer is the fact that the entire mountain is supported by a nude man who sits on a peculiar animal placed at the center of a water basin. The association of water with the image of the spirit mountain, which is common among many *boshan* censers, is important.[94] One of the major virtues of mountains is their being sources of the rivers. In a sense, the image of a sacred mountain is only complete when the mountain is associated with the water which it produces. The main body of water related to the great mountains in north China, such as Mt. Hua or Mt. Taibai, or, for that matter the imaginary Mt. Kunlun, is the Yellow River, into which the waters from those mountains flow. The deity who resides in the Yellow River and who governs passage to the mountains is Fengyi, the Earl of the (Yellow) River (Hebo).[95] In the famous legend of the travels of King Mu of the royal Zhou (reigned 947–928 BC), the Earl of the River was the one whose

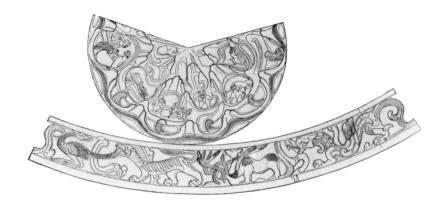

Figure 24 ○ Drawing, decoration of censer in figure 23.

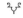

92

See below, 33, for a discussion of this trend. The records ascribed to Liu Yin (died in 23 AD) in *Xi jing za ji*, quoted above, use the term *boshan* censer. Although Han origin of this book has been questioned from time to time, at least those records on *boshan* censers cannot be easily dismissed as later inventions.

93

One poem of a possible late Western Han date, simply called "Ancient Poem," refers to the mountain on the censer as Nanshan (the South Mountain), which usually means Mt. Zhongnan or Mt. Taibai, located to the direct south of the capital, Changan; see *Yi wen lei ju*, 70/4b. The mountain images placed on the crowns used in the official ceremonies were called *boshan* during the Six Dynasties period; see, for example, *Liang shu*, SBCK ed., 25/10a. Apparently the term in these usages simply means "sacred mountains."

94

The presence of water at the bottom of the spirit mountain prompted some people to speculate that the mountain depicted on those censers was meant to represent a mountain-island in the Eastern Sea. However, this idea does not suit most of the *boshan* censers. The mountains in the Eastern Sea, in the context of Han thinking, were regarded as the immortals' dwelling place, not as the realm of wilderness, which was a concept characteristic of *boshan* censer iconography. Also, there is no literary evidence that the mountain-islands were regarded as cosmic pillars during the Han.

95

According to *Shan hai jing*, the Yellow River, the Red River, the Yang River, and the Black River flow out from Mt. Kunlun; see *Shan hai jing*, 2/(*shang*) 23b-24a.

mystical power helped the king to reach Mt. Kunlun.[96] It is likely that it is the Earl of the River who is depicted in the Dou Wan censer.

The strange animal on which the Earl of the River sits has the head of a tiger and the body of a bull. "Zhaohun" (The Summons of the Soul), compiled in *Chu ci* (The Songs of the South), describes such a mythical animal that resides in the Capital of the Nether Region (*youdu*): "three eyes he has in his tiger's head, and his body is like a bull's."[97] The Capital of the Nether Region is described by Wang Yi (died 158 AD), the Han commentator of *Chu ci*, as follows: "*Youdu* is an underground region which is governed by Houtu [the God of Earth]. The underground region is mysterious and dark (*youming*), thus it is called *youdu* [literally, 'capital of darkness']."[98] The chapter of the *Shan hai jing* called "The Regions inside the Sea" lists the Mountain of the Capital of the Nether Region as the area "within the North Sea."[99] Since the mountain of the Dou Wan censer is undoubtedly a cosmic mountain, it is quite logical to see its base as connected with a sacred water and eventually with the nether-world, represented symbolically by the Earl of the River and the mythical animal of the Capital of the Nether Region, respectively. It is impor-tant to recognize that the Dou Wan censer repre-sents a complete image of a sacred mountain as a cosmic pillar connected with heaven above and, through water, with the netherworld below.

The development of the images of sacred mountains during the middle to late periods of the Han dynasty (from around the first century BC to the early third century AD) can be observed in the designs on *boshan* censers, pottery hill jars, *hu* jars, mirrors, and wall decorations of the tombs from this period. Since the issues involved are discussed in detail in the individual catalogue entries of the works in this exhibition, it will suffice here to summarize a general observation of the trend.

The idea of a sacred mountain as an inter-mediary realm between heaven and earth con-tinued through the Han dynasty. Yet, the diverse functions of such a realm were enhanced by new concepts and represented by new iconographical elements. Many *boshan* censers and hill jars of the later Han continued to represent the theme of mountains with active, confrontational animals and monsters that convey the traditional concept of the sacred mountains as the realm of wilder-ness. Many of those animals and monsters were deities or spirits that had either beneficial or destructive powers affecting the affairs of human beings while they lived, or after death. Various rituals were performed to exorcise evil spirits residing in this realm. A new religious dimension developed during the Han dynasty. It assigned certain cosmic functions to some of the deities, who would harmonize cosmic operations and

bring benefits to the people. Beginning in the late first century BC, the designs on TLV mirrors started to include images of the Four Guardian Deities—the Blue Dragon of the east, the Red Bird of the south, the White Tiger of the west, and the Black Warrior of the north—together with other animal-deities in the intermediary space between heaven (the outer circle) and earth (the central square) (see cat. nos. 37-39). The prayer placed as an inscription on a TLV mirror often asks that the Blue Dragon and the White Tiger properly control the seasonal changes, and that the Red Bird and the Black Warrior harmonize the forces of *yin* and *yang*, thus bringing happiness and prosperity to the owner of the mirror and his descendants. The design on the TLV mirror in the Nelson-Atkins Museum (cat. no. 38) depicts lively scenes of the guardian deities and many other heavenly and earthly spirits residing in the intermediary realm.

96

Mutianzi zhuan (A Story of King Mu), SBCK ed., a fictional account of the romantic travels of King Mu, is ascribed traditionally to the third century BC, but its actual date is controversial—some scholars date it as late as the third century AD; see S. E. Cahill, 33-34. In this story King Mu offered repeated sacrifices to the Earl of the River before he reached Mt. Kunlun; see *Mutianzi zhuan, quan*, 1.

97

Chu ci, 9/6a. Its translation is in Hawkes (1959), 105. Hawkes, following the commentary by Wang Yi, takes this phrase as an additional description of the Earl of the Earth, which is described as "nine-coiled, with dreadful horns on his forehead." However, this dragon-like animal with sharp horn(s) is apparently different from the one with a tiger's head and a bull's body. We should here take the latter as another animal-deity which also resides in the Nether Region.

98

Ibid., 9/6a.

99

Shan hai jing, 18/(*xia*) 87a.

Those scenes are outwardly similar to the more traditional representations of the sacred mountains from the pre-Han through the Han dynasty. But they had a more positive meaning as images that directly affected earthly events, and thus were the objects of prayers.

Sacred mountains as cosmic pillars functioned as passages through which the souls of the deceased ascended. The development of the cult of the immortals had a profound influence on this concept. Some late Han designs, such as the one on a hill jar in the Nelson-Atkins Museum (cat. no. 33), show scenes that include winged immortals who receive the ascending souls. These new images indicate that the cult of the immortals expanded from a belief that immortality could be attained during life—although this idea persisted through later religious Daoism—to include a concept that it could be achieved after death; that is, the soul of a deceased person could attain the status of an immortal and live happily forever in the transcendental realm.

Toward the end of the Han dynasty, the cult of immortals created a new image of the sacred mountain as a space inhabited by the immortals. Unlike the earlier images of immortals as winged men or roughly dressed shaman-type figures, the new figures are well dressed and appear like men of the educated class. A mirror in the Freer Gallery ascribed to the second or the third century AD shows many such immortals playing music, taming wild animals, riding on the backs of animals, or just conversing with one another in a mountainous area (fig. 25). A *boshan* censer in the Yale University Art Gallery also shows well-dressed immortals on the sides of the peaks, instead of the usual animals and hunters (fig. 26). These immortals are not ordinary human beings, but "realized" human beings granted their status through their virtues or religious effort. Still, they have the familiar earthly appearance of human beings. This new humanized image of the sacred mountains foreshadowed the coming of the Daoistic concept of the immortals' realm developed in the periods following the Han dynasty.

The recognition of the Queen Mother of the West as a residing deity of Mt. Kunlun and as a main deity of the cult of immortals was a phenomenon that began around the first century BC. A sudden outburst of activity in the cult of the Queen Mother among large numbers of peasants and commoners took place between February and May of 3 BC, and was a culmination of this phenomenon.[100] The image of the Queen Mother in the form of a properly dressed, beautiful lady—her earlier image was as a monstrous figure with a leopard's tail and tiger's teeth—became common from the late first century AD onward, which can be attested by the decorations on certain mirrors as well as among the scenes

represented on the walls of tombs.[101] In the tomb decorations the image of the Queen Mother of the West had obvious implications regarding the ascent of the soul of the deceased through Mt. Kunlun as a cosmic pillar, not through any other existing sacred mountain. In the mirror decorations her image was an object of the prayer requesting the longevity of the owner of the mirror (see cat. nos. 40-42).

Figure 25 ○ *Mirror with immortals, Freer Gallery of Art.*

Figure 26 ○ Boshan *censer with immortals, Yale University Art Gallery.*

100

Suzanne Cahill examined carefully all the literary evidence from the pre-Han through the Han dynasty concerning the development of the concept of the Queen Mother of the West in her "The Image of the Goddess," 6-25. A detailed description of the outburst of the cult of the Queen Mother is on 15-17.

101

Loewe, chap. 4.

The worship of the sacred mountain as an earthly power was essentially an animistic belief and the basis for the imperial sacrifice at the altar of earth that persisted throughout the history of imperial China. It must have continued also on the local level through the Han. The scenes of planting rice, shooting birds, and the salt industry found on the wall decorations in late Han tombs excavated in Sichuan attest to such a practice (see cat. no. 47). The iconography of the pre-Han representations of imperial and state rituals continued, with some modifications, in the decorations of the late Han tombs in remote regions away from the cultural center. These depictions are quite revealing.

The scene of the salt industry in a mountainous area is essentially a variation of the theme of the sacred mountains represented in the *boshan* censers and the hill jars. It shares the same scenes of roaming animals, birds, and hunters represented on the side of the peaks in triangular shapes, in addition to its unique major scene of the production of salt. It appears that this representation was made as a laud and prayer to the benevolent power of the great mountains in the region; these mountains grant the production of salt, an essential material for human life, besides many other benefits. The sure naturalism that made those religious representations so close to descriptions of daily life must be noted as one of the characteristics of the late Han rational attitude toward religion as well as toward art.

The Han dynasty was a period of lively and complex cultural development, with people of diverse social and regional backgrounds living within a unified empire. We have observed numerous images of the sacred mountains as revelations of the various religious concepts developed during the Han dynasty. Some of those concepts were interrelated; others were the results of independent thoughts or cults and included some elements that contradict each other. Nonetheless, there is one clear recognizable trend, that is, the tendency toward rationalism. The Han people inherited the pre-Han religion—essentially a system of magical rituals to cope with the world of the unknown—and, toward the end of the Han period, gradually changed it into a religion of faith. There were still numerous monstrous spirits that roamed the transcendental realm of the Han cosmology, but the deities presiding over the realm metamorphosed from monsters into anthropomorphic beings who would answer human prayers. The image of sacred mountains as the intermediary realm between heaven and earth was also gradually changed from the earlier image of the realm of wilderness to a benign space in which resided the protective deities, such as the Queen Mother of the West or the Four Guardian Deities, or even the immortals, who were nothing more than "realized" human beings.

The Human Dimension in the Mystical Realm: From the Six Dynasties Period to the Tang Dynasty

A new attitude of the Chinese people toward mountain worship evolved gradually as the late Han gave way to the early Six Dynasties period (221–581). The great mountains became places to visit where people could experience their mystical powers firsthand instead of just viewing them as objects of worship. In the late Han period, individual seekers of immortality started to visit mountains in order to discipline themselves; to receive divine revelations and attain immortality, or at least certain magical powers; and, in some cases, to prepare elixir by their own hands.[102] To gain immortality meant to gain free access to the transcendental world. Since in the Han cosmology and religion a sacred mountain was, as we have discussed above, an intermediary realm through which man would reach heaven and where many divine creatures and immortals resided, it was certainly a logical place where an individual should seek immortality. We may view this new phenomenon, from a larger cultural-historical point of view, as an indication of the expansion of the Chinese civilized world into the mountain wilderness.

102

For the best summary of the activities of early (or proto) Daoists during the Han dynasty, see Miyagawa Hisayuki, *Rikuchōshi kenkyū—Shūkyōhen* (Kyoto, 1964), 80-99.

Ge Hong (active early fourth century AD), an important early Daoist thinker, discussed extensively in his *Baopuzi* the art of making elixir and emphasized the importance of the great mountains in the alchemical endeavor or in receiving divine instructions. He recommended for this purpose about thirty renowned mountains, including the Hua, Tai, Heng, Emei, Tiantai, and Yuntai mountains; these were the most suitable places where proper spirits resided and would help the seekers of immortality.[103] Apparently it was very dangerous to visit the big mountains at the time. Ge quotes a popular saying: "At the foot of the Taihua [Great Hua Mountain, possibly meaning both Mt. Tai and Mt. Hua] there are [numerous] skeletons scattered around." Visitors to the mountains expected calamities such as falling trees and rocks, and attacks of tigers, wolves, snakes, and poisonous insects. Ge Hong describes numerous magical as well as practical ways to escape those dangers, such as carrying mirrors and using magical talismans of various kinds.[104]

The emergence of religious Daoism during the late Han period had several causes.[105] One of them, as discussed above, was the new trend of individual efforts to seek immortality in the mountains. Another important factor was the religious interpretation of the Daoist philosophy of Laozi. The book of *Laozi*, which propounded individual freedom from social and physical restrictions through unifying oneself with the Dao, the totality of the universe, was taken as one of the fundamental theoretical texts in the immortal cult. Further, Laozi was deified and worshipped as one of the major divine-immortals, or deities, in this new school of religious thought. The third factor was the socialization of this new religious trend which was practiced by a relatively small number of intellectuals. There was a great demand for a miraculous savior among the peasants, who desperately needed some sort of relief from the extreme misery of life under the collapsing Han regime. Intellectuals who attained certain religious convictions and magical powers, particularly the power to heal, started to attract large numbers of peasant followers, and some even ventured to organize rebellions against the Han regime from as early as the first century AD.[106]

Among the new peasant-oriented religious movements, two were particularly successful in evolving into large-scale religious organizations.[107] They developed side by side during the second century AD, and fostered rebellion against the Han regime. One was Taipingdao (The Way of Grand Peace), which was organized by a religious leader, Zhang Jue (died 186 AD), around 170 AD. It developed into a huge religious organization of several hundred thousand peasants in almost all regions of northern China by 184 AD,

when its followers rebelled against the Han regime. This organization was destroyed by the Han army within two years after the uprising.[108] Another new religion was called Wudoumidao (The Way of Five Bushels of Rice), a movement originated by Zhang Ling (or Zhang Daoling, died 177 AD) and developed by his son and grandson into a large organization based mainly in western China, extending from Shaanxi to Sichuan provinces in the early third century AD.

103

Baopuzi, SBCK ed., 4/19a-b.

104

Ibid., *juan* 17 (Chapter of Climbing Mountains and Crossing Rivers). An English translation of this chapter is in James R. Ware, *Alchemy, Medicine, Religion in the China of* AD *320: The Nei p'ien of Ko Hung (Pao-p'u tzu)* (Massachusetts and London, 1966), 279-300.

105

For a discussion of the complex problem of defining Daoism, and questions of the distinction between "philosophical Daoism" and "religious Daoism," see Nathan Sivin, "On the Word 'Daoist' as a Source of Perplexity, with Special Reference to the Relations of Science and Religion in Traditional China," *History of Religions* 17, nos. 3-4 (1978): 303-30.

106

Miyagawa lists more than five small-scale religious organizations which were suppressed by the government; see Miyagawa, 88-93.

107

The ideological basis of the newly developing religious Daoism, which was associated with the peasants' rebellious movements, is discussed in Anna K. Seidel, "The Image of the Perfect Ruler in Early Taoist Messianism: Lao-tzu and Li Hung," *History of Religions* 9, nos. 2-3 (1969-70): 216-47.

108

Fukui Kōjun, *Dōkyō no kiso teki kenkyū* (Tokyo, 1962), 62-85; Miyagawa, 100-112.

It lost its political power about the time of the end of the Han, c. 220 AD, but survived as a religious organization.[109] It absorbed some aspects of Taipingdao and other smaller organizations and became the earliest Daoist religious establishment, called Tianshidao (The Way of the Heavenly Master).

During the third and fourth centuries AD, Tianshidao gained new support from the aristocrat-administrative class, yet maintained continuing peasant bases, and spread its organization all over China. The sect was propagated from north China to the Yangzi River region, following the large-scale southward move of the aristocrats and intellectuals at the time of the destruction of the Western Jin (265–317) in Luoyang and the establishment of the Eastern Jin (317–420) in Nanjing. There were many aristocratic families whose members were known to be followers of Tianshidao.[110] Besides Tianshidao, smaller schools of religious Daoism were active at the time, such as Ge Hong's followers, and the newly developing Maoshan school of Yang Xi (330–?) and Xu Mi (303–73), which eventually was brought into full bloom by Tao Hongjing (456–536).[111]

An example of the new images of sacred mountains that contained elements of religious Daoism is Gu Kaizhi's (344–405) description of the Yuntai Mountains.[112] Gu Kaizhi was a scholar-official, but has been better known as a genius in painting. He wrote an essay entitled "A Note on How to Paint Mt. Yuntai."[113] Mt. Yuntai is a mountain in Sichuan that was considered to be the site of an event in the life of Zhang Ling, the founder of Tianshidao. Gu's essay is concerned with how to design a whole composition of the mountain, which included scenes of the Heavenly Master Zhang Ling and his pupils. Since Gu Kaizhi is said to have also painted Buddhist subjects, his interest in Daoism was not that of a person exclusively committed to the religion. As in the case of many Chinese intellectuals, Gu was eclectic in his attitude toward religion. Nevertheless, his effort in designing a new type of painting which combined traditional images of sacred mountains and a depiction of Daoists' activities in the mountains is of great historical importance.

There has been some controversy about how to read Gu Kaizhi's crisply condensed writing and how to reconstruct his intended composition.[114] It is important to understand that Gu's basic concept of design was a progression from right to left in the format of a horizontal scroll, with the right side designated as the east and the left as the west. Only with this understanding can we clearly read Gu's amazingly detailed description of his design.[115] Gu divided his composition into three sections and depicted Zhang Ling and his pupils on a terrace over a steep cliff on the left (west) side of the mountain

group in the first section. The middle section is a transitional area leading the viewer to the final section, where the main peak of Yuntai appears.

Fortunately, there is one painting to which we can refer in considering Gu Kaizhi's design of Mt. Yuntai. It is a mountain scene in the scroll of *The Admonitions of the Instructress of the Ladies in the Palace* ascribed to Gu Kaizhi, in the British Museum (fig. 27). It has been disputed whether

109
Fukui, 2-61.

110
Miyagawa, 109.

111
Ibid., 127-39. See also Michel Strickmann, "On the Alchemy of T'ao Hung-ching," in Holmes Welch and Anna Seidel, eds., *Facets of Taoism* (New Haven and London, 1979), 125-30.

112
There are slight differences of opinion among scholars about the dates of birth and death of Gu Kaizhi. Here we follow Wen Zhaotong's chronological table of Gu's life in Yu Jianhua et al., eds., *Gu Kaizhi yanjiu ziliao* (Beijing, 1962), 125-30. For biographical information and a discussion about his life, including the controversy of Gu's chronology, see 113-32.

113
This essay is included in the section of Gu Kaizhi's biography in Zhang Yanyuan, *Li dai ming hua ji*. The text used here is a collated edition by Ono, in Ono Katsutoshi, *Rekidai meiga ki* (Tokyo, 1938), 340-41; his Japanese translation and annotation is in this book, 153-55. English translations and annotations are in Michael Sullivan, *The Birth of Landscape Painting in China* (Berkeley and Los Angeles, 1962), 93-101, and in William R. B. Acker, *Some T'ang and Pre-T'ang Texts on Chinese Painting* (Leiden, 1973), 2: 73-81. Yu Jianhua et al., *Gu Kaizhi yanjiu*, includes Yu's annotations on pp. 71-81. Many other studies are listed in Suzuki Kei, *Chūgoku kaiga shi* (Tokyo, 1981), I, vol. 2, 8-10, nn. 19-21. One of the most extensive studies on this essay is Yonezawa Yoshiho, "Ko Gaishi no ga undasan ki," in his *Chūgoku kaigashi kenkyū* (Tokyo, 1962), 39-84.

this scroll was painted by Gu himself, or even whether it is an original from Gu's time or a later copy, perhaps from the Tang dynasty. However, scholars generally agree that it reflects fairly well the style of Chinese painting around the time of Gu Kaizhi, roughly the fourth and fifth centuries AD. The scroll has received many substantial repairs in the course of its long history. In examining this monument we have to be extremely careful in "reading" the details. Still, this scroll is truly precious because it reveals some of the basic stylistic principles of mountain representations during Gu Kaizhi's time.[116]

The mountains of the *Admonitions* scroll appear to be much more complex than any mountain representations from previous periods. However, the techniques applied in this painting are extensions of earlier conventions. The basic formula for creating a mountain mass is to overlap triangular forms, either diagonally, as in the mass to the right, or vertically, one over the other, as in the mass at the bottom. This convention is in the tradition of *boshan* censers (see cat. nos. 17-26), hill jars (compare cat. no. 29), and the wall decorations of the Sichuan tombs from the Han dynasty (cat. no. 47). The hill jar in the Art Institute, Chicago (cat. no. 27), and the one similar to it in the Cleveland Museum (fig. 28), from the Han, provide prototypes of sharp vertical cliffs and a terrace on the top of a cliff, in addition to overlapping peaks. What is new in the *Admonitions* scroll is that the artist cleverly combined all of these elements and built up a unified mountain mass of complex structure. In this painting, as in Gu's essay, the right side is oriented to the east and the left side to the west; a morning sun appears to the right of the mountain peak, with the moon to the left, and both progress to the left.

Gu Kaizhi's essay begins with a remark stating his general idea of the design, which is to be followed by a discussion of the details.[117] The opening paragraph reads:

The mountain has its face, then the back is its shadow [reflection]. Let auspicious clouds [coming out] from the west be disgorged into the eastern blue sky. For the color of both sky and water use "sky-blue" entirely, so that they reflect each other at the top and bottom of the silk. The sun should be on the west, leaving the mountain. I shall explain one by one the details of [the features] of far and near [of the mountain].

The first sentence is often taken as stating a principle of naturalistic representation of the mountain, taking literally the terms "face" and "back" as the front and back in a three-dimensional composition.[118] However, such an interpretation is

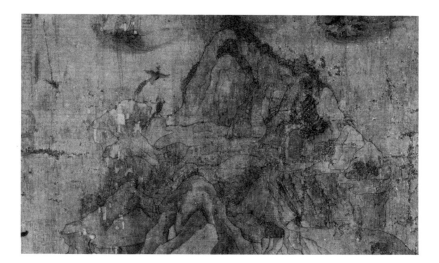

Figure 27 ∘ Mountain scene, ADMONITIONS OF THE INSTRUCTRESS, *British Museum.*

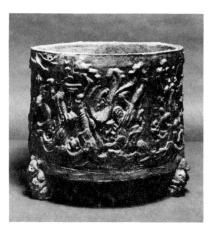

Figure 28 ∘ Pottery cylindrical box (hill jar), Cleveland Museum of Art.

114

There are two ways to read Gu's essay; either as a description of a vertical composition, that is, a layout of the scenes moving near to far in a three-dimensional way, or as a horizontal composition. While most scholars who have studied this essay only describe their concepts of the composition, two scholar-artists have published drawings in which they reconstructed the composition according to their reading of the essay. One is by Fu Baoshi, in his *Jin Gu Kaizhi "Hua Yuntai shan ji" zhi yan jiu* (Zhongqing, 1941). His drawing looks like a modern Chinese landscape. Another is by Shen Yizheng, in Li Lincan, *Zhongguo minghua yanjiu* (Taibei, 1971), pl. 91. Shen's reconstruction is eclectic, taking the first section as a vertical composition, and the middle and last sections as horizontal.

115

If we take Gu's design as a vertical composition and try to read his essay accordingly, as a progression from front to back in a three-dimensional way, his sentences often do not make much sense. Sullivan takes this stand in his translation and complains that "there is much confusion between right and left, east and west"; see Sullivan, 94.

116

For the most comprehensive descriptions concerning this scroll, see Basil Gray, *Admonitions of the Instructress of the Ladies in the Palace* (London, 1966).

117

All translations of Gu's text presented here are mine.

not possible, if we consider the stylistic characteristics of pictorial representations in Gu Kaizhi's time. The concepts of "face" (*mian*) and "back" (*bei*) here were probably based upon the theory of *fengshui* (geomancy). Miao Xiyong, a Ming dynasty scholar of geomancy, explained the front and back of a mountain in *Zang jing yi* as follows: "[The side of] a mountain which gets water [rain] is the face, so that [the side] that does not get water is the back. The fine [side] is the face and the coarse [side] is the back. The moist [side] is the face and the dry [side] is the back. The bright [side] is the face and the dark [side] is the back." The right (east) side of the mountain in the *Admonitions* scroll is relatively smooth, with its contour leading to the summit and appearing relatively well vegetated; in contrast, the left (west) side is rugged, with rocks and cliffs, and relatively dry. This character fits well with Miao's definition of the face and back of a mountain. As we will see below, Gu's Mt. Yuntai design appears to be quite similar in its general topographic characteristics to the *Admonitions* mountain, suggesting that Gu followed the same principles.

There is another aspect of the face-back idea in the composition of a mountain that should be noted. The face is the facade of a mountain. In considering the total content of Gu's essay, we may interpret his opening statement as a general compositional principle which places the front, the facade of the mountain, at the beginning (on the east side) and develops its back, the inner sanctuary of the mountain, to the west. This idea is in line with the traditional thinking that a great mountain contains a sacred realm. When Gu says that auspicious clouds, that is, a naturalistic version of the earlier *yunqi*, must emerge on the west side, move eastward, and be disgorged into the eastern sky, he is stating a symbolic way of revealing the relationship between the mystical inner sanctuary and the front of the mountain. In the Mt. Yuntai design, the sun is placed in the western sky (on the left), probably to make it appear to illuminate the scene of Zhang Ling and his pupils, who are located on a terrace on the left (in the shadow) of the high peaks of the "front" group.

Gu Kaizhi's next paragraph is concerned with the first part of the first section of his three-section composition. This part is, in our understanding, the "front" of the mountain. It reads:

Start with the eastern base, not quite halfway in moving upward; place five or six pieces of purple rock, which look like hard clouds, around a small knoll. Move further upward through these [rocks], while making the force [of the winding movement] like a writhing dragon. [The upward movement] abruptly stops when it reaches and coils

around the pinnacle of a peak. From the top to the bottom, [the mountain mass] is constructed with piling hills. When viewed as a whole, it should appear as if a great vital energy is concentrated into a mass and keeps moving up.*

The idea that topographic features of a mountain should look like a dragon and reveal vital energy in dynamic motion is clearly in the tradition of the *yunqi*-mountain, the dominant concept in representing images of the sacred mountains during the Han. Gu Kaizhi's idea here seems to be, in effect, to put together the rhythmical powers of the linear designs of the *yunqi*-mountain in the decoration of the bronze tubes (figs. 8-10), and the more naturalistic mountain forms of "piled hills" on the hill jars (cat. nos. 29-32) from the Han dynasty. The way of representing the mass on the right side of the mountain of the *Admonitions* scroll is very close to Gu's description of the beginning section of the Mt. Yuntai design. Unfortunately, the aesthetic effect which Gu insists upon in the essay is not strongly evident in the *Admonitions* scroll mountain due to the damage and subsequent repairs; yet, a careful observer of this painting can find a trace of such quality hidden beneath the uncertain forms and tentative lines rendered by repairers.

Gu continues his description of the first section, which ends at the top of a cliff where the anecdote of the Heavenly Master Zhang Ling is to be represented:

There is another peak [next to the first peak]. This one is of rock and faces the vertical cliff of the peak on its east [i.e., the first peak]. The west side of this peak is connected with the cinnabar-red cliff which faces toward the west. [The cliff] leans over a

118

The meaning of Gu's sentences in this section is by no means clear. Consequently each scholar who studied Gu's essay, including Sullivan and Acker in their translations, has taken a very distinctive interpretation. My translation here is based upon my conviction that the basic image behind Gu's writing is not too far from the image of the mountain in the *Admonitions* scroll. It should be assured, however, that taking this stand does not mean making a forced reading of the text. The present translation does not involve any intentionally incorrect reading of the text, either grammatically or in selecting the meaning of each word.

deep gorge below. . . . The Heavenly Master sits on it. The rock and its shelter where he meets [with his pupils later] should be in the gorge, and the peach tree should grow on the side of this rock. . . . Separately draw the scene of Wang and Zhao's leap, in which one figure is hidden behind a tapered rock and only a portion of his robe can be seen, and one figure is completely seen in a room.

The story to be represented tells that Zhang Ling gave a test to one of his pupils, Zhao Sheng, on a terrace over a deep gorge in the Yuntai Mountains. Gu Kaizhi gives here only his instructions for how to paint the scenes of the story, without giving the story itself. The whole story is found in *Shenxian zhuan* (Biographies of Divine Immortals), supposedly compiled by Ge Hong.[119] According to this text, the test had two parts. The first test was for Zhao to jump from the clifftop onto a peach tree growing in the middle of the cliff and bring back its fruits. When Zhao passed this test, the Master himself jumped into the abyss and disappeared. While all other pupils of the Master fell into a panic, Zhao Sheng and another disciple of Zhang called Wang Chang were calm and jumped into the abyss following the Master. Both of them miraculously fell safely onto the place where the Master was comfortably lying on a bed, waiting for them. This was the last test. After passing this test the two disciples received complete instructions on the secret of the Dao from the Master, right in this gorge. Gu Kaizhi's design shows these two tests in one landscape setting, using the so-called simultaneous method of narrative illustration of a story.[120] The last sentence quoted above reads, literally, "one figure is completely seen in a room." There is the possibility that the word "room" (*shi*) may be a mistake in transcribing "air" or "sky" (*kong*). Then, the text can be translated as "one figure is completely seen in the air."[121] Although this possibility is great, we tentatively follow the original text. This is partially because the waiting figure of Zhang Ling in a "room" under the overhanging rock is quite important in the story in *Shenxian zhuan*.

The interpretation of Gu Kaizhi's essay on the middle and last sections of his Yuntai design is a complex problem. Figure 29 is a drawing showing a rough outline of the Mt. Yuntai composition, as reconstructed from our analysis of Gu Kaizhi's essay.[122] Some observations on the basic characteristics of Gu's design may be summarized as follows. His design is symbolic, rather than a realistic rendering of the mountain's topography. It is very doubtful that he ever visited Mt. Yuntai in Sichuan. The conceptual approach to the front (face) and the back of the mountain, as discussed above, is far more essential to his design than

are the actual topographical features. Gu emphasized strongly the importance of specific symbolic aspects as well as expressive natural features in his essay. For example, Gu would like to make the peak facing the cliff on which the Heavenly Master is seated particularly steep and beautiful with a lone pine tree standing on top of

Figure 29 ○ Drawing after Gu Kaizhi's "How to Paint Mt. Yuntai."

119

Zhang Ling (Zhang Daoling)'s biography is in *Shenxian zhuan* (*Shuo ku* edition), 4/3b-5a. The story of the test on Mt. Yuntai is in ibid., 4/b-5a. Sullivan discusses Zhang's story and translates a portion of the text from *Shenxian zhuan*. He did not include in his translation the last part of Zhang's test; see Sullivan, 93-94.

120

The simultaneous method used in paintings during the Six Dynasties period, in relation to Gu Kaizhi's design, is discussed extensively by Yonezawa; see Yonezawa, 48-51.

121

This interpretation is proposed by Kobayashi Taichiro; see Kobayashi, *Chūgoku kaigashi ronkō* (Tokyo, 1947), 54. There is a detailed discussion by Yonezawa on this problem; see Yonezawa, 46-48.

122

This drawing is a reconstruction of Gu Kaizhi's description by Linda Duke in collaboration with Kiyohiko Munakata.

it. He insists that the canyon between the two cliffs must be very narrow. This is because, Ge says, "if you put two cliffs very close to each other, you can make the space between them awesome, yet pure and clear. A dwelling of divine luminaries always has a suitable environment."[123] This canyon is the place where the miraculous leaps of the Master and his two pupils took place, and thus is to be treated as particularly potent with divine power.

Gu Kaizhi uses symbolic motifs effectively in his design. On the major peaks he places either a pine tree, the symbol of immortality, or a vertical slab, which stands for a gate-tower (*que*) symbolizing an entrance to the divine realm. He also says that useful animals and birds must be brought into the painting with their proper appearance and demeanor. He did not specify those living creatures except for one phoenix and one white tiger. However, he certainly envisions the presence of other animals and birds, following the long tradition of the concept of a sacred realm in the mountains where many animals, birds, and monstrous creatures roamed. In the *Admonitions* mountain there are a rabbit and an unidentifiable animal in confrontation on a clifftop terrace at the lower right corner of the composition, and two birds, one of which is a flying phoenix. A large tiger and the head and neck of a horse-like animal are incongruously placed—or rather, superimposed—on the side of the mountain mass. It is difficult to know how they were originally placed, or what was the original state of those parts of the mountain before deterioration and repeated repairs of the painting took place. Nevertheless, this extant painting gives some hints about Gu Kaizhi's idea of "useful" animals and birds in his composition of the Yuntai Mountains.

Gu Kaizhi's symbolic and conceptual approach to the composition of Mt. Yuntai is an important example of how the mountains were painted during the Six Dynasties period. One artist from this period who was said to have visited many renowned mountains and painted the images of them in his studio was Zong Bing (375–443), a younger (by about thirty years) contemporary of Gu Kaizhi. Zong Bing started his association with the great mountains when he joined the group of the followers of Huiyuan (314–417), one of the leading Buddhist monks at the time, who resided at the foot of Mt. Lu and often climbed the mountain with his followers as a religious practice.[124] According to *Song shu* (History of the Song Dynasty, 420–79), the mountains he visited include Mt. Emei and Mt. Wu in Sichuan, as well as Mt. Heng (the Sacred South Mountain), where he built a hut in which he spent his later years.[125] When Zong became too old and ill, he went back to Nanjing and "painted all [the mountains] he visited, on [the walls] of his room, and told others that he wanted to play

the *qin* lute and let it echo on all these mountains."[126] Our question is, in what way did Zong paint those mountains, and how did his paintings differ from Gu Kaizhi's Mt. Yuntai design?

Zong Bing's essay "Hua shanshui xu" (A Preface to the Painting of Mountains and Rivers) is extant. In this work he stressed the importance of achieving *lei* of the great mountains in landscape paintings. The term *lei* used in the context of Zong Bing's essay has been commonly taken by scholars to mean "verisimilitude," and Zong Bing's essay as a whole has been considered the expression of his realistic stand in representing the great mountains that he visited. I have proposed elsewhere that in the case of Zong Bing, *lei* does not mean "verisimilitude," but rather refers to the essential nature shared by objects of the same kind; thus, *lei* of the sacred mountains is their sacred quality.[127] In my interpretation, one of the key paragraphs of Zong Bing reads:

*One who views the painting is only concerned with how the essential nature (*lei*) is skillfully achieved, and not with the matter of smallness of size and impairment in verisimilitude (*si*). This is the natural way [of cause and effect]. And in this way, the majesty of Mt. Song and Hua as well as the*

123

See Ono, 341, for this text.

124

A monumental work on Huiyuan's life and his belief is Kimura Eiichi, ed., *Eon kenkyū*, 2 vols. (Kyoto, 1960-62). Included in this work is a study on Huiyuan's relationship with Zong Bing; see Kimata Tokuo, "Eon to Sō Hei o megutte," ibid., 2: 278-364. A recent study in English, with an extensive bibliography on the problem, is Susan Bush, "Tsung Ping's Essay on Painting Landscape and the 'Landscape Buddhism' of Mount Lu," in Bush and Murck, 132-64.

125

Song shu, SBCK ed., 53/6a.

126

Ibid.

127

Munakata, in Bush and Murck, 105-31.

sacred spirit of the Mysterious Female of the Valley
can all be captured in a single picture. Now, those
who take as their principle "the realization of
[truth] in the heart, through the response of the eye"
*can achieve the essential nature (*lei*) [of the sacred*
mountains] skillfully [in their paintings]. . . .
This is the experience of the mystical communion
and the spiritual [karmic] interaction[of man and
the great mountains], with which the viewer's spirit
achieves transcendence and his mind attains the
truth. Even if we seek [real] solitary cliffs here and
there, what can we gain that adds [to the experience
of the painting]?[128]

What kind of features did Zong Bing consider essential in conveying the nature (*lei*) of a sacred mountain? There is no doubt that he shares those signs of spirit mountains that his contemporary, Gu Kaizhi, employed in the design of the Mt. Yuntai painting, including: a mountain in the form of a writhing dragon, which expresses an ascending motion of a concentrated vital force; a narrow canyon with sheer cliff walls on both sides, which is a suitable location for the dwelling of divine luminaries; and symbolic elements, such as auspicious clouds, lone pine trees, *que*-like stone slabs, and animals and birds. When Zong Bing painted an image of a specific mountain, he must have included some landmarks particular to the mountain. Those landmarks which were known in literature at the time of Zong Bing include the Xianlu Feng (the Incense-Burner Peak) of Mt. Lu, and Mt. Chicheng (Mt. Scarlet-wall) and the stone bridge in the Tiantai Mountains.[129] We can only speculate how Zong Bing actually structured his paintings of specific mountains, combining the symbolic elements with some topographical realities. The lack of sufficient visual material inevitably makes a study of the art of the Six Dynasties period uncertain and controversial. Nevertheless, Zong Bing's achievement in creating images of specific mountains—even though we are not certain how specific they might have been—must be appreciated as a contribution to the development of the images of sacred mountains.

The evolution of representations of sacred mountains from the Six Dynasties to the early Tang dynasty is well reflected by the decorations on artifacts from the Tang dynasty. The images on mirrors are particularly revealing. Two Tang mirrors in the Seattle Art Museum, a marriage mirror (see cat. no. 44) and a cosmic mirror of mountains showing the four directions (see cat. no. 45), indicate the way the design of the Five Sacred Mountains developed into a new iconography. The marriage mirror shows the standard formula of the Five Sacred Mountains, in which four mountains are placed on the four corners of the central square, which is a bit deformed for design purposes, and the central mountain becomes a knob. Water, representing either the Four Sacred Rivers or the Four Seas, is depicted outside the square, between the four mountains. With a slight change of this basic formula, the design of the second mirror, the so-called "cosmic mirror," is derived. In this design the central square is changed into a circular form. The water is now placed inside the square, and the central knob, which is surrounded by water, cannot any longer be interpreted as the Sacred Central Mountain (Mt. Song).

The meaning of this new design is made clear by the inscription placed in the area of the water, which should be read as "[on] the fifth day [in] the River." The character used for "river," *jiang*, is most commonly referred to as the Yangzi River, and the "fifth day" should mean the fifth day of the fifth month, which is the day of the Duanwu festival. According to Wu Jun (469–520) of the Liang dynasty (502–55), this festival day was traditionally associated with the suicide of the famous administrator-poet Qu Yuan (active around 300 BC), who threw himself into the Miluo Abyss in the Dongting Lake region.[130] In choosing death instead of "accepting the foulness of this world" after incurring his lord's disfavor and banishment, Qu Yuan became one

128

Ibid., 124-25. Wade-Giles romanization used in the original translation has been converted here into the pinyin system.

129

The Xianglu Feng is one of the major peaks described substantially by Huiyuan, Zong Bing's teacher in Buddhism, in his *Lu shan lüe ji* (A Brief Note on Mt. Lu); see Obi Kōichi, *Chūgoku bungaku ni arawareta shizen to shizenkan* (Tokyo, 1962), 391-94. Mt. Tiantai and its landmarks appear in *You Tiantai shan fu* (Rhapsody of Visiting Mt. Tiantai), by Sun Chuo (314-71), compiled in *Wen xuan*, 11/4a-13a; for an English translation and extensive annotations of this work, see Richard Mather, "The Mystical Ascent of the T'ien-t'ai Mountains," *Monumenta Serica* 20 (1961): 226-45, and Knechtges, 2: 243-53. Later paintings of this mountain by Wu Bin appear as cat. nos. 56 and 57.

of the most popular historical figures in China.[131] If the water in the mirror decoration is identified as the Yangzi River, the mountains along the river must be identified as those in south China, and not four of the Five Sacred Mountains. The mountain represented by the central knob and a small area surrounding it can now be interpreted as the central area of the sea into which the water of the Yangzi flows. This center of the sea is, according to a traditional theory, Dahe (Great Gap, or Great Ravine), a large hole in the sea which reaches to the bottom of the earth, and in which the fairy mountain-islands float.[132] The knob may represent one of those fairy mountains, or a composite of them.

One question is whether the cosmic mirror in Seattle was designed specifically to commemorate, or to be used in conjunction with, the Duanwu festival in the south. The answer appears to be negative. There is a mirror in Shōsō-in, Japan, which is virtually identical to the Seattle mirror, except that the Shōsō-in mirror has a framing band on the rim, and has no inscription.[133] A careful comparison of the photographs of the two mirrors reveals that all other details, such as small irregularities of raised lines, coincide. There is no doubt that the two mirrors were produced from molds that in turn were cast from a single original mold. It is also almost certain that the one *without* the inscription is the base design, and the one *with* the inscription was created by adding the inscription to it. In other words, it is most likely that the Yangzi River-Sacred Mountains design was first made by modifying the original composition of the Five Sacred Mountains diagram exemplified by the marriage mirror design. The creation of the new design probably took place much earlier than the Tang dynasty, sometime during the Six Dynasties period, possibly around 500 AD. The design of the mirror still retains Han-type iconographical elements, such as the two large anthropomorphic figures, undoubtedly mountain gods, each standing in front of a mountain, and the lively, sometimes ferocious animals on the mountains and in the fields around the mountains.

During the Six Dynasties period the center of Chinese culture was shifted to the south, to the region of the Yangzi River, while northern China was left to the rule of non-Chinese governments. It is quite understandable that during this period the objects of mountain worship were shifted from the Five Sacred Mountains (three of which were in the northern territory) to the mountains along the Yangzi River, and that water worship came to be centered around the Yangzi River itself. In fact, the design of the cosmic mirror in

the Seattle Art Museum and the one in Shōsō-in is a diagram of the cosmos with the Yanzi at its center; while the sacred mountains connect the earth to heaven, the river runs through the land and flows into the sea, finally reaching the Dahe, the Great Gap, which is the bottom of the earth. It should be noted that the two extant mirrors were not actually cast during the Six Dynasties period. Although they are not dated by inscription, they were probably cast during the Tang dynasty, possibly in the eighth century. However, they indicate a long history of the repeated casting of the mirrors in a design that stemmed from the same master mold created in the earlier period. The popularity of this design in the Yangzi River region must have come from its religious potency, which was particularly suitable for the region.

The theme of the Yangzi River in mirror designs can be seen more clearly in another variation of the diagram of five mountains. It is the type called a "seashore" mirror (*haiji jing*, or better known in Japanese as *kaiki kyō*) design. There are three mirrors of this design, all from the Tang dynasty, now in Japanese collections. One is in the Shōsō-in collection and the other two are in the Imperial Collection Presented by the Hōryuji Monastery (*Hōryuji kennō gyobutsu*).[134] The designs of the three are slightly different from one other, but they apparently

130

Wu Jun, *Xu qi xie ji*, quoted in Dun Chong, *Yanjing sui shi ji* (Beijing, 1906), 27a-b (reprint, Kuanwu shuju [Taibei, 1969], 61-62). A discussion of this matter is in Ono Katsutoshi, *Enkyō saiji ki* (Tokyo, 1967), 103-5.

131

For the life of Qu Yuan, see Hawkes, *Ch'u Ts'u*, 11-19.

132

Yi wen lei ju, 9/1a-b, lists passages of early literature concerning Dahe from *Shan hai jing, Zhuangzi, Liezi*, as well as "Dahe fu" (The Rhapsody of the Great Gap) by the Qianwen Emperor (reigned 550–55) of the Liang dynasty.

133

Shōsō-in Office, ed., *Shōsō-in no Kinkō* (Tokyo, 1976), pl. 18.

134

The most detailed study on this type of mirror is Maeda Taiji, "Gyobutsu kaiki-kyō zu kō," *Bijutsu kenkyū* 148 (1948): 104-19.

follow traditions stemming from the same prototype. Among them, the one in the Shōsō-in is most complete (fig. 30).[135]

A unique aspect of the "seashore" mirror design is the placement of the major mountains; they point in toward the center, just the opposite of the arrangement of the mountains in the landscape designs discussed above. These mountains are revealed as immortals' mountains. Their felicitous quality is shown by the distinctive trees with semicircular fruits (or flowers) growing on tall trunks at the tops of the peaks. The trees must be the *qiong shu* (carnelian trees) which are said to provide sacred food for the immortals.[136] Deer, the immortals' favorite animals for riding, are placed on the mountains to strengthen the felicitous mood.

The human figures included in this design are relatively large, and have significant bearing. The scene of a fisherman and a man on shore undoubtedly represents the last event in the life of Qu Yuan (fig. 31a). The event is dramatically narrated in "Yu fu" (The Fisherman) in *Chu ci* (The Songs of the South).[137] Before committing suicide, Qu was wandering along the riverbank and met a fisherman. Against the fisherman's advice to live as a wise man and "to move as the world moves," Qu insisted that he could not submit his "purity to the dirt of others." The fisherman, with a faint smile, struck his paddle in the water and made off, while singing a song. After this incident, Qu jumped into the water and drowned. In the mirror design, the fisherman holds a fishing pole in his right hand and rests the paddle idly in the water to his left, while Qu Yuan raises his right hand in a posture of arguing. As discussed above, this story is important as a water legend in the region of the Yangzi River, besides its popularity as a tale of a man of purity.

The figure standing on a boat and holding a sword high over his head can be identified as Ci Fei of the state of Chu (fig. 31b).[138] He once went to Wu and obtained a treasured sword called Taie. On the way home he crossed the Yangzi River by boat. When he reached the middle of the river, two *jiao* dragons came to attack the boat. According to one source, this was because the god of the river wanted the treasured sword. Ci Fei drew the sword, jumped into the river, and killed the dragons. The god of the river gave up the sword, and the wind which had been blowing around the boat subsided. In the design there is no image of a dragon in the water. Yet, Ci Fei's heroic fight against the mystical power of the water is well represented by his facial expression and his posture, and particularly by his windblown sleeves and trouser

leg, which indicate his movement against a powerful force.

The two scenes thus far identified are of events associated with the Yangzi River. Interestingly, these events are included in the *Jiang fu* (The River Rhapsody) by Guo Pu (276–324), one of the most popular poems concerning the Yangzi River during the Six Dynasties period and the Tang dynasty.[139] "The River Rhapsody" is essentially a mystical account of the Yangzi River, from its origin in the Min mountains in Sichuan through its long course toward the sea, with the sea as its extension. It crisply describes the river's main geographic features, with emphasis on their mystical aspects, and refers to the myths and legends, the vegetation and creatures associated with those places. It says about Ci Fei: "How heroic was Fei of Jing [state of Chu] who overpowered the *jiao* dragon, thus finally succeeding in bringing vital force out of the Taie

135

Shōsō-in no kinkō, pl. 23.

136

A commentary on "Li Sao" in *Chu ci*, 1/44a, says that "the trees of *qiong* grow on Mt. Kunlun . . . the flowers of which, if eaten, give longevity."

137

Chu ci, juan 7; translation in Hawkes, 90-91.

138

Lü shi chun qiu, SBCK ed., 20/6a.

139

Guo Pu, "Jiang fu," in *Wen xuan*, 12/11a-19a; its translation is in Knechtges, 2: 321-51. The inclusion of this poem in *Wen xuan* around 530 AD assured its popularity in the following period. For example, many scholars point out that Du Fu's (712–70) poems concerning rivers have references to the passages of this rhapsody.

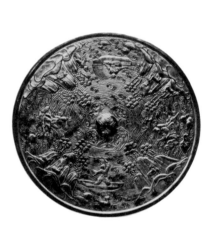

Figure 30 ∘ *Mirror with landscape and figures, Shōsō-in, Japan.*

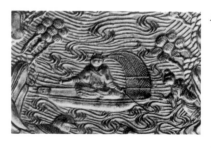
A

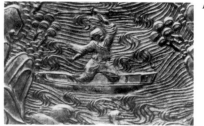
B

Figure 31 ∘ *Details of figure 30.*

sword."[140] And about Qu Yuan: "How sad was Lingyun's [a pseudonym of Qu Yuan] clasping a stone [for jumping into the water], while lamentable was the fisherman's 'song of the oar.'" The two scenes in the mirror represent particular moments from the stories selected to suit precise moods which "The River Rhapsody" expresses.[141] We can expect similar correspondence between the two remaining figures in the mirror design and passages in the "Rhapsody."

If we look for a passage in the "Rhapsody" fitting the two other figures in our mirror design, we find the following couplet in the part describing the large lakes associated with the Yangzi: "This is the place where Haitong (literally, Sea-boy) tours and Qin Gao mysteriously flies [in and out]."[142] Qin Gao is an immortal who was once an official of King Kan (reigned 329–280 BC) of the state of Song, and who, after achieving immortality, flies on the back of a fish in and out of the water. The fish he rides is identified as *li*, which usually means "carp," but it could be the more mysterious *lingli*. The name *lingli* can be found frequently in early literature from the time of *Chu ci* (The Song of the South) on, but its appearance is by no means certain because of conflicting information. About Haitong very little is said, except that he was a god of the sea.

Of the two figures in question in the mirror, the one who sits squarely in three-quarter view on the back of a fish-like creature must be Qin Gao (fig. 31c). The wing-like pattern on his left side seems to suggest his action of "mysteriously flying" in and out of the water. The "fish" has a peculiar oval-shaped mouth, a relatively large eye, a flat body, a strange tail, and four brush-shaped appendages on its belly. The famous Daoist Tao Hongjing (456–536) in his commentary on *Chu ci* made the following observation: "*Lingli* resembles the turtle in shape and is short, and it also resembles the carp and has four legs."[143] This seemingly incoherent statement fits remarkably well the incongruous appearance of our "fish."

The fourth figure in the mirror has a majestic air; his head is erect, his right hand is raised as if giving a blessing, and his leg position is relaxed in a kind of "royal ease" pose common in Buddhist iconography (fig. 31d). The waves around him and the carpet-like shape of the sea monster beneath him indicate that he is gliding on the surface of the water, a suitable representation of Haitong, the sea god, making an "inspection tour" of the lake area in his jurisdiction.

The central part around the knob of this mirror is clearly demarcated, with its auspicious clouds, instead of waves of water, swirling about. The knob itself is decorated as a composite of four mountains. Apparently this part represents the center of the sea, the Great Gap (Dahe), and the fairy mountains of immortals in it. The "Rhapsody" describes this part as follows:

Bounded by winding cliffs,
Hollowed by cavernous ravines,

o o o

It is the place where all rivers and streams gather
* and return,*
Where clouds and fog fume and steam,
Where precious wonders are transformed and
* produced,*
Where great marvels are encaved and lodged.
It receives perfected men hidden and vanished from
* the world,*
Issues extraordinary men from its divine soul,
Spreads numinous moisture over a thousand
* leagues,*
Surpassing the rock-striking clouds emanating from
* Daizong.[144]*

There seems very little doubt that the motifs included in the design of the "seashore" mirror are visual expressions of the corresponding passage in "The River Rhapsody." It is also clear that the structure of the composition as a whole expresses the theme of the "Rhapsody" intelligently and artistically. When we compare this mirror with the cosmic mirror in Seattle, we realize that the "seashore" mirror is nothing but a modification of the former, with the direction

140

Wen xuan, 12/27b; this and the following translations are mine.

C **141**

Ibid., 12/18a.

142

Ibid., 12/24.

143

For the confusing information about the appearance of *lingli*, see the commentaries compiled for "Tian wen" in *Chu ci*, 3/12b. Tao Hongjing's commentary is among them.

144

Wen xuan, 12/16a–b. Translation is from Knechtges, 2:347.

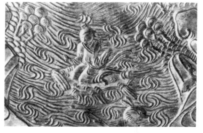

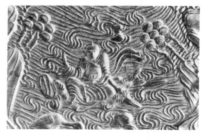

D

Figure 31 ◦ Details of figure 30.

of the mountains changed, and enriched with additional literary content. One difference we may note between the two designs is that the "seashore" design has a Daoistic overtone. In this design the mysterious power emanates from the mystical center, causing all the mysteries of the world, including the growing of the immortals' trees on top of the mountains, and that is exactly what the paragraph of the "Rhapsody" quoted above claims. The Dahe, the Great Gap, at the bottom of the sea is a sacred realm which could be interpreted as the earthly end of the cosmic pillar.

The eight-lobed mirror with mountains, water, and eight-trigram design in the Shōsō-in collection offers a somewhat different image of the sacred mountains (fig. 32).[145] This mirror is one of the most elegant mirrors among those extant from the Tang dynasty. It is made of white bronze (an alloy of copper and tin) and thinly plated with gold and silver. Trimmed by a rim band, the back decoration is divided into three concentric parts. The narrow outer band has eight trigrams (diagrams representing basic combinations of *yin* and *yang* forces) distributed in the eight directions, and a lengthy inscription fills the remaining space; both trigrams and inscriptions are arranged clockwise and are meant to be seen from the center. The next band contains a floral pattern interspersed with a peacock motif. The innermost area is the main motif of the landscape.

The composition of the landscape scene of this mirror is complex. The four prominent mountains are placed in four directions on the land surrounding the water, which occupies the central area. The central knob is decorated with the four towering mountains. There are no mysterious (or powerful) animals roaming in the area of the mountains, only a few peaceful deer. The total effect is calm and felicitous. The inscription placed in the outer band is a poem in five-character form. It reads:

A lone shadow; ah, I have been in exile.

A lone voice of a bird; how many times has spring come back?

Now this "mirror of mind illuminations" is completed.

I recall the lady with beautifully drawn eyebrows far off.

The dancing phoenix will soon go back to the woods;

The coiling dragons have just crossed the sea.

Putting this mirror into a box, I await the day of return.

Taking it out, I see my longing for the beloved in it.[146]

The poem hints at the magical power of the mirror. The "mirror of mind illumination" was originally the name of a large mirror which the first Emperor of Qin (reigned 221–210 BC) was said to have used in his inner palace; it was a magical mirror which revealed the internal organs of the viewer's body and exposed the viewer's inner feelings.[147] The term *zhaodan* ("mind illumination," or literally, "illuminating liver") is often used, together with a similar term, *zhaoxin* ("illuminating heart"), in mirror inscriptions to refer to the mirror's function of revealing the viewer's feelings. The emotional and literary content of this inscription is in diametric contrast to the inscriptions on the Han mirrors, which are prayers for longevity, wealth, and prosperity for the owner of the mirror and his descendants.[148] The intended user of this

Figure 32 ○ Mirror with landscape and musicians, Shōsō-in, Japan.

Figure 33 ○ Detail of figure 32.

145

Shōsō-in no kinkō, pl. 19.

146

The translation is mine.

147

Xi jing za ji, 3/3b.

148

See translations of inscriptions on the Han mirrors; cat. nos. 37-41.

Tang mirror was most likely a court lady whose life was spent, except for a short period of receiving favor from the emperor, in lonely isolation from her family and friends.

The major theme of the landscape scene as well as of the poem is the fairy islands in the Eastern Sea. The design of the area of the central knob has an important meaning in the whole composition (fig. 33). The knob itself, decorated with the four towering mountains, represents the four fairy mountains of the Eastern Sea. On the four sides of the knob, in the small area at the base of the mountains, flanking the holes for attaching strings, are four mystical creatures associated with water. They represent a turtle, a snake-like dragon, a large fish which may be a monstrous fish called *kun*, and a type of dragon with a long tail which has often been used as the animistic image of the rainbow. A further examination of this area reveals that on one side of the knob are four heads of turtles, and on the other side, four tails. This indicates that each of the four turtles carries one of the four island mountains. In the *Hai fu* (Rhapsody on the Sea) by Mu Hua (active in the late third century AD) we find the following passages describing the central part of the sea:

It [the mysterious sea] spouts clouds and rainbows,

Enfolds dragons and fish,

Hides the scaly kun,

Conceals spirit dwellings. . . .

Within their watery repository [water-metropolis],

And the courts of their unplumbed depths,

There are lofty islands borne by giant turtles,

Tall and towering, standing alone,

Cleaving the giant waves,

Pointing to Grand Clarity,

Thrusting mighty boulders,

Roosts for a hundred numina.[149]

The description is quite close to what we observe in the mirror design. This is the same Great Gap in the center of the sea that we discussed above, but with an emphasis on the fairy islands floating in the mystical water.

The two figures placed on the small islets are two immortal musicians. The figure playing the *qin* lute is Boya, and another playing the *sheng* ocarina is Wang Ziqiao. Boya, the legendary master of the *qin*, appears often in mirror designs. In Han mirrors the figure playing the *qin*, generally identified as Boya, is quite often included among the major cosmic deities in so-called "mirrors with deities and animals."[150] In Tang

mirrors Boya often became the center of the decoration. The Tang mirror in the Art Institute of Chicago is one of the examples of this type (cat. no. 46). As recounted in the discussion of that mirror, Boya was left alone on the Penglai Island in the Eastern Sea by his teacher, Cheng Lian, to perfect his skill, and after intense practice in solitude, and presumably with the aid of the mystical power of the mountain-island, Boya brought his playing into a divine level.[151] Wang Ziqiao was one of the earliest immortal-deities. He was skilled in the *sheng* ocarina and was able to make a sound of the singing phoenix.[152] In the mirror design he plays music to a responding phoenix. The power of the music, if played by divine musicians, is considered to harmonize the cosmic order as well as human society.[153]

The poem in the inscription seems to be composed from the point of view of the lonely situation of Boya. At the same time it hints of the power of music to control the movement of the dragon and the phoenix. The mysterious power of music and the magical power of the mirror, which together would bring harmony and happiness to the user of the mirror, may be the intended concept of the maker of this mirror. The great mountains are here part of the harmonious world.

One other observation about this mirror should be added here. The whole composition of the landscape scene is a modified five-mountain scheme. However, unlike most of the mountain scenes in mirror decorations of this type, each of the mountains shown in this Shōsō-in mirror is

149

Mu Hua, "*Hai fu*," in *Wen xuan*, 12/7a-b. Translation is from Knechtges, 2: 313-15; my additions appear within brackets.

150

For a discussion of Boya, and his image in the Han mirrors, see Nishida Morio, "Shinjūkyō no zuzō—Hakuga kyogaku no meibun o chūshin to shite," *Museum* 207 (1968): 12-24, and Hayashi Minao, *Kandai no kamigami*, 44-47.

151

One of the standard references on this story is an old (supposedly Han dynasty) poem, "Shui xian cao," in *Gu shi yuan* (*Si bu bei yao* edition), 1/7a-b. This book quotes a narrative of the story from a Tang source.

152

The legendary account of his life is in *Lie xian zhuan* (*Dao zang* edition, bk. 138), 13b-14a.

represented in its own unique form. For example the mountain on the top, shown in figure 32, has two major pointed peaks with a narrow ravine in between. Another is a group of large massive peaks. Apparently by this time, the mid-eighth century, artists had developed different types of images of sacred mountains. The experience of visiting many of those mountains and observing their unique formal as well as spiritual qualities must have been behind this development. As we discussed earlier, Zong Bing was one of the pioneers of this effort. We can see in the forms of the mountains in this mirror a distant echo of Zong Bing's contribution to the art of representing the mountain images.

Chinese culture of the eighth century is considered the mature phase of the Tang culture, and the period is often called the High Tang. Unfortunately, although the activities of the artists from this period are well recorded, with a few possible exceptions none of the original works by those great artists are extant. However, some paintings used as decorations of the musical instruments and other artifacts preserved in the Shōsō-in in Japan reflect the art of the Chinese cultural center in this period. Most of those objects are from the Japanese imperial collection of the eighth century. *Viewing Clouds*, a painting on a *pipa* lute in this collection, is probably the most appropriate as the final example to be discussed in this essay.

Viewing Clouds is painted on a plectrum guard, a leather sheet placed on the body of the instrument to protect it from being damaged by the plectrum as music is played. The painting received considerable damage by the plectrum—apparently this instrument was used frequently—and the original bright colors of white, red, green, blue, and brown have darkened considerably, some becoming black over the course of eleven hundred years.[154] For our present purpose we use a drawing of this painting made by the Shōsō-in office (fig. 34).[155]

The central peak soars high at the center of the vertical composition of this painting. On both sides the supporting peaks make up a traditional three-peak form, although they are naturally arranged so as to avoid rigid symmetry. Overlapping smaller peaks and clifftops in front of the major peaks—they are not quite clear in the drawing—give a certain sense of depth to the whole mountain group. There is a narrow valley between the central peak and the group of peaks on the left side, from which a stream runs down and flows into a lake at the bottom of the mountain. Clouds rise from this valley. On the

right side there is a smaller stream also running into the lake from the bottom of the mountain. Two figures are seated on a low plateau which projects into the middle of the lake from the right edge of the composition. They are relaxing and looking up at the clouds rising from the narrow valley on the left. Barely visible in the drawing (and even less so in the actual painting, due to the damage) is a shoreline of the lake drawn diagonally at the bottom left of the composition, which suggests that the lake water flows to the lower right and changes into a stream.

The meaning of this painting becomes clear when we refer to a poem composed by Wang Wei (701–61), one of the great poet-painters in the history of China. The poem is entitled "The Villa at Zhongnan."[156] Wang Wei's own villa was in the area called the Wangchuan Valley, which is in the general area of the Zhongnan Mountains, called also Nanshan (the South Mountains).[157]

153

One of the mirrors on the Boya theme has an inscription to this effect; see Umehara Sueji, *Tōkyō taikan* (Tokyo, 1984), pl. 61, and text pp. 71-72. For the early Chinese theory on music, see Kenneth DeWoskin, "Early Chinese Music and the Origins of Aesthetic Terminology," in Bush and Murck, 187-214.

154

Shōsō-in Office, ed., *Shōsō-in no kaiga* (Tokyo, 1968), 42-45. A detailed description of the state of preservation of the painting and of observations of the work through infrared as well as microscopic photographs appears on pp. 36-37 of the same volume.

155

Ibid., pl. 42.

156

Wang Youcheng ji, SBCK ed., 3/11b. Zhongnan, or Zhongnanshan (Zhongnan Mountains), refers, in a general sense, to the Qinling Mountain Range running east-west, parallel to the Wei River on its south side.

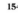

Figure 34 ∘ Drawing of VIEWING CLOUDS, from PIPA lute, Shōsō-in, Japan.

47

The poem reads:

Ever since reaching middle age, I have been greatly
fond of Dao;
In my late years I have lived in the area of the South
Mountains.
Whenever I feel like it, I go alone to [the
mountains],
Learning exceptional things only for myself.
Once, I went up along the stream to its origin;
I sat there and watched the rising of clouds.
I happened to have encountered an old woodcutter.
We talked and laughed together, forgetting
to go home.

The poem is concerned with Wang Wei's experience of an "exceptional thing," which was an essential matter in Daoist philosophy. The valley at the bottom of the mountain is what Laozi calls the "Gate of the Mysterious Female." The famous passage in *Laozi* reads: "The spirit of the valley never dies. This is called the mysterious female. The gateway of the mysterious female is called the root of heaven and earth. It continues on as if ever-present, and in its use, it is inexhaustible."[158] The image of a valley which keeps producing clouds that reach heaven and water that nourishes earth is taken here as a symbol of the source of vital energy, which effortlessly and inexhaustibly causes the evolution of heaven and earth. The poet reached this gate of mysterious power, witnessed the operation of that power, and, unexpectedly, met an old woodcutter who was a free-spirited mountain man. The happening was an ultimate mystical experience for a seeker of Dao. The poem conveys the excitement of the poet after such an experience.

The Shōsō-in painting is almost a direct visualization of Wang Wei's poem, particularly if we replace the two figures in the painting with an aged poet and an old woodcutter. The model which a Japanese court artist copied for the decoration of the musical instrument might even have included a man wearing woodcutter's garb. Nevertheless, the important point here is that a human experience in visiting the mountains became a common subject in painting. We have observed earlier the depiction of a legend or miracle in a landscape setting. What is new here is the rendering of the direct interaction between a mountain and a visitor to the mountain, which, through its naturalistic setting and cleverly positioned figures, invites the viewer to share the experience.

Our review of the development of the image of the sacred mountains in China from the pre-Han period to the Tang dynasty shows a steady process of evolution. The image of an unapproachable mystical realm of wilderness developed into that of a benevolent, accessible entity from whose divine power man may seek benefits. The Tang dynasty marks a new era in this evolution. The Tang culture's basic orientation toward naturalism brought out a new naturalistic image of the great mountains in which an ordinary person enjoys his experience of being in the spiritual environment.

Through the Tang dynasty and the following periods, people became more familiar with the mountains. It became fashionable for the general populace, as well as for religious specialists, namely Daoists and Buddhists, to make pilgrimages to the mountains. The intellectuals, meanwhile, associated with the great mountains in their own individual ways, and represented the mountains from their experiences, or according to their own personal visions. The latter part of this exhibition presents the individual relationships of these people with the great mountains.

In preparation for this project I made pilgrimages to some of the sacred mountains in China. I saw the blue sky over the pointed peaks, heard monkeys crying in the shadows of the massive ranges, and washed my hand and spirit with the pure cold water of mountain springs. Some of the solitary moments of immersion in the spiritual aura of the mountains were counterbalanced by happy encounters with numerous Chinese pilgrims, young and old. I felt a surge of joy in realizing that the ancient tradition of man's spiritual relationship with the great mountains has not died in China, in spite of many social and political changes. I wondered, at the same time, how long it would continue. It is my hope that this long tradition can be reexperienced and revitalized in the hearts of present-day viewers through their involvement in the works of art presented here. The works bear the imprint of people's spiritual lives throughout the various cultural phases of China's history.

157

Generally, Wang Wei calls his villa "Wangchuan Villa," meaning a villa at Wangchuan valley. Thus, some scholars consider that Wang Wei had two villas. This possibility is very slim, judging from the reality of his life. It is more likely that Wang Wei used "Zhongnan" to refer to the mountains around the area of his villa, since the poem was about climbing a mountain. About his Wangchuan Villa and the painting of it, see cat. nos. 91-93.

158

Laozi dao de jing, SBCK ed., 6/I-3b; translation from D. C. Lau, *Lao-tzu; Tao-te ching* (London, 1963), 62.

In China many mountains are associated with mythological and historical legends and are sacred objects of special veneration. Some of them were the objects of imperial worship; these include the Five Sacred Mountains (WUYÜE)—Mt. Tai of the east, Mt. Heng of the north, Mt. Hua of the west, Mt. Heng of the south, and Mt. Song of the center (marked by black triangles on the modern map in the exhibition)—and the Four Garrison Mountains (SIZHEN), Mt. Huiji, Mt. Yi, Mt. Yiwulu, and Mt. Huo (marked by hill-shaped symbols). Many other mountains were the objects of worship by the people in local communities. They were often considered by Daoists as especially important religious sites and were designated as DONGTIAN (cave-heaven) or FUDI (blessed land). Some, such as Mt. Mao, Mt. Longhu, and Mt. Wuyi, have long been the centers of Daoistic religious practice and studies (marked by concentric circles). Some mountains, such as Mt. Lu, Mt. Taibai, and Mt. Huang, are particularly known as inspirational sources for many literary and artistic works (marked by white triangles).

I.

THE GEOGRAPHY AND TOPOGRAPHY OF THE SACRED MOUNTAINS

MAPS OF CHINA

Modern Map of China

Map of China

1

Important mountains marked in color
James Bier, cartographer

▲ Five sacred mountains
◣ Four garrison mountains
◉ Daoistic centers
△ Other prominent mountains
★ Ancient capitals
✹ Archeological site/Buddhist cave

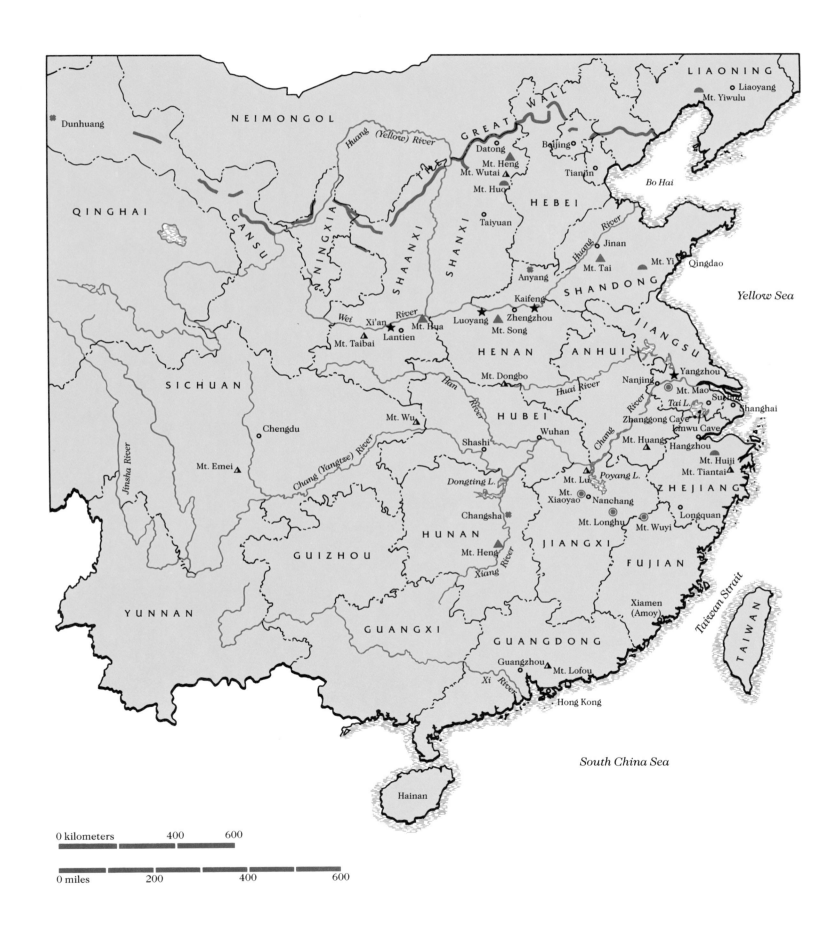

Map making has a long history in China. The ZHOU LI *(Institute of Zhou), a record probably compiled in the late Zhou or early Han, around the third or second century* BC, *lists the office of map making as a part of the royal Zhou (1027–256 BC) institutional structure. Two early geographical writings, the* SHAN HAI JING *(Classic of Mountains and Seas) and the "Tribute of Yu" compiled in the* SHU JING *(Classic of Historical Records)—which both contain main sections written before the Han dynasty—show that the authors had reasonably correct overall knowledge of the country's geography. Those writings have strong religious overtones, suggesting that the religious aspect was an important component of early Chinese geography.*

Yu ji tu

2

Map of the Sites of Sage Yu's Activities

Song dynasty (Qi state), dated 1137

Rubbing, taken from a stele at the Confucian Temple in Xian

79 x 78

Field Museum of Natural History
245523
Inscription:
Seventh year of Fuchang era (1137), the fourth month, the first day, carved on a stone.

Yu ji tu

 3

Hua yi tu

Map of China and non-Chinese
Territories

Song dynasty (Qi state), dated 1137

Rubbing, taken from a stele at the
Confucian Temple in Xian

74 x 76

Field Museum of Natural History
245522
Inscription:
*Seventh year of Fuchang era (1137), the
tenth month, the first day, carved on the
stone (stele) at the School of Qi Prefecture.*

Two maps made during the Song
dynasty illustrate the high technical
level as well as the religious and
cultural implications of map making in
ancient China. According to their
inscriptions, these maps were carved
on stone steles erected at the school of
Qi (or Qishan) prefecture, in Shaanxi
in 1137. This was a time when the area
was nominally under the short-lived
puppet state of Qi, which the non-
Chinese Jin set up after they took over
the northern half of China from the
Song in 1127. It is believed that the
original maps were made during the
Northern Song dynasty (960–1127),
based on maps drawn by Jia Dan
(730–805) of the Tang dynasty, one of
the greatest geographers in the history
of China.

The *Yu ji tu* is a map of China that
brings together the ancient and modern
(as of the Northern Song period) names
of mountains and rivers listed in the
"Tribute of Yu," the other renowned
mountains and rivers, and the major
prefectural centers. Sage Yu was a
mythological figure believed to be the
founder of the semi-legendary first
dynasty of China, the Xia. "Tribute of
Yu" recounts how Sage Yu, with his
supernatural civil-engineering power,
remolded the topography of China,
repairing mountains, lakes, rivers,
canals, and fields that had been dam-
aged by natural calamities. It is, in fact,
a sort of hymn praising Yu. It lists all
the names of major landmarks known
in ancient China which he was believed
to have blessed. The *Yu ji tu* is a "his-
torical map" from which the viewer can
learn the long history of China's sacred
land blessed by divine power.

The *Hua yi tu* is complementary to
the *Yu ji tu*, illustrating the great land of
China in relation to the non-Chinese
peoples living in its periphery. Each of
the inscriptions distributed around the
edges of the map is about the non-
Chinese states and the nomadic
peoples living in those areas, describing
their brief histories in relation to China.

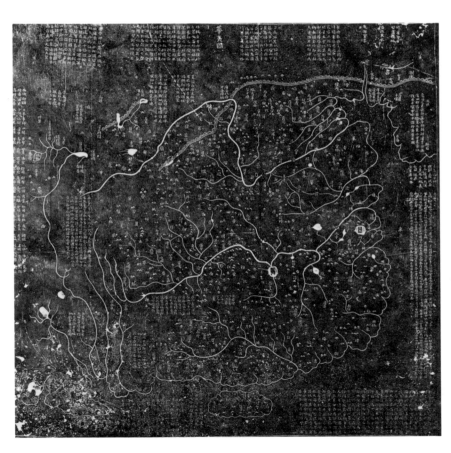

Hua yi tu

The mountains revered as sacred have diverse topographical features. Some cover large areas with many soaring peaks, but others are not more than rolling hills near flat areas where agricultural communities flourish. There is no way to identify a "typical" topography of sacred mountains. Nevertheless, each mountain has its own history, special quality, and landmarks, such as an imposing central peak, mysterious caves, huge rocks on the summits, springs, or waterfalls. The mountains often feature shrines of the mountain deities, as well as Daoist and Buddhist temples that traditionally provided lodging to pilgrims. Many of the nationally renowned sacred mountains have attracted a large number of these pilgrims, and the tradition of visiting these mountains and hiking to the top continues today as one of the most popular vacation pastimes.

Pictorial maps of the topographies of the great mountains were essentially made as guide maps for visitors. Such maps are generally engraved on stone steles erected at the bottom of mountains. They were designed to show the major peaks in their imposing postures, yet they depict fairly accurately the locations of subordinate peaks, valleys, caves and other notable landmarks, bridges, major shrines or temple buildings, and paths that meander through those "tourist attractions" to the summit. Some of the pictorial maps are more personal, however, made to commemorate the visitors' accomplishments in climbing and paying homage to the sacred mountains.

Rubbings from Stone Steles of Pictorial Maps

Tai shan quan tu

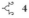 4

Pictorial Map of Mt. Tai

Date unknown, probably Qing dynasty (1644–1911)

Rubbing from a stone stele, Shandong

110 x 62

Field Museum of Natural History 235581

Mt. Tai, the most venerated of the Five Sacred Mountains of China, rises 1,545 meters above sea level in the central Shandong province. When a dynasty was firmly established and was successful in bringing the whole country into good order, the emperor was to go to this mountain to perform a sacrificial ritual called *fengchan*—the *feng* ritual was offered to heaven at the mountaintop and the *chan* ritual was directed to earth at the bottom—for the purpose of securing the mandate of heaven for his house to govern the country. Emperor Wu (reigned 140–87 BC) of the Han dynasty and Emperor Gaozong (reigned 650–83 AD) of the Tang dynasty were among those who performed this ritual.

In popular belief, the god of Mt. Tai was thought to control life and death of all individuals. Pilgrimage to this mountain by the commoners, which is said to have begun as early as the Han dynasty, became extremely popular starting in the late eleventh century, when the goddess called the Primary Lord of Blue Mist, who was believed to control pregnancy, was enshrined on this mountain beside the God of the Mountain. An early-seventeenth-century record says as many as 600,000 people visited this mountain every year during the peak period of the third and fourth months (lunar calendar). This number, about 10,000 a day, is consistent with a record of visitors in the 1940s. The offerings from the pilgrims were also huge. During the sixteenth century the Ming government started to collect an "incense tax" from the visitors and the Daoist management office, an infamous practice discontinued in 1735.

The pictorial map shows the climbing route fairly accurately, starting from the Main Temple to the God of Mt. Tai at the foot of the mountain, ascending more than 6,000 stone steps to reach the South Heavenly Gate, finally leading to the main shrines at the summit. All the major topographical and architectural features are identified with their names. The Main Temple at the foot of the mountain is depicted disproportionately large, so that the location and identity of the various buildings within the temple complex can be clearly seen. This arrangement of enlarging the main temple and its surrounding area gives the viewer a sense of perspective from the bottom of the mountain, where he stands, to the summit. The depiction of the numerous peaks with thickening and thinning lines of calligraphic quality enhances the animistic powers of the mountain.

Reference:
Chinese Rubbings from the Field Museum: no. 32.

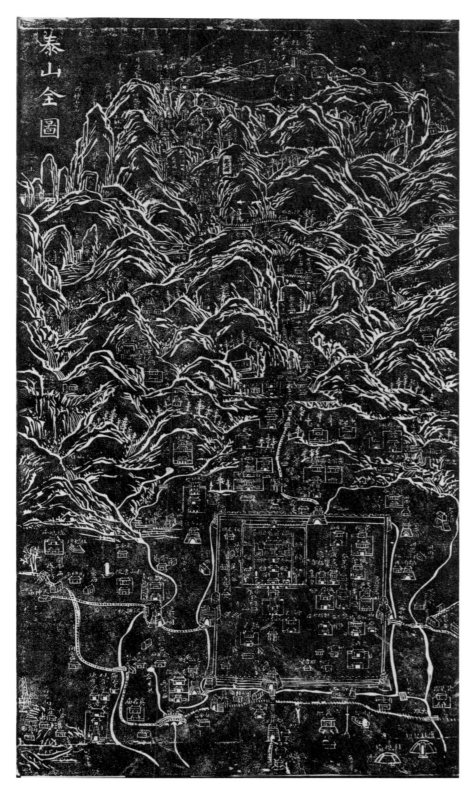

Tai shan quan tu

55

Tai hua shan tu

5

Illustrated Map of Mt. Hua

Ming dynasty, 1585

Rubbing from a stone stele

113 x 60

Field Museum of Natural History
244848

Mt. Hua, the Sacred Mountain of the West, is located in Shaanxi province, southwest of where the Yellow River bends and changes course from south to east. The highest peak stands 2,500 meters above sea level. Its name, Huashan (Flower Mountain), is said to have come from the formation of the three major peaks standing together— the South Peak at the center flanked by the West and East—which looks like a lotus flower from a distance.

Because of the sheer vertical granite cliffs through which one must climb to the top, Mt. Hua had not been climbed much until the Tang dynasty. Even during the Tang many people who visited this mountain reportedly failed to reach the summit. Emperors who visited Huashan stayed at the bottom of the mountain and prayed at the shrine there. On such an occasion the emperor would send a messenger to the top. One of those early imperial messengers reported how dangerous and difficult his climb was. However, Daoist monks started to live on the high cliffs of the mountain where, from the Tang dynasty onward, they built temples and small huts for their religious practices. It is difficult to imagine the patience required and the physical hardship endured by the monks in order to overcome the difficulties and dangers of bringing building materials up among the vertical cliffs.

The illustrated map, dated 1585, shows that by the late sixteenth century the climbing paths were fairly well constructed; there were steps cut in the sides of the rocky cliffs, and bridges built over the gaps. Many temple buildings, including the one at the very top of the South Peak, can be seen on the map. Even so, it was said to be extremely dangerous to pass through some areas. According to a report of two early Western visitors to this mountain in 1933, the steps and chains for handrails that even now aid climbers in traversing the vertical cliffs were made available only as recently as a year before their visit, "replacing an older and cruder chainless system." The great view of the mountain shown in the rubbing—a symmetrical grouping of the three central peaks soaring majestically, adorned with a temple— symbolizes the extreme devotion of the people to the sacred mountain.

This illustrated map was, according to the inscription placed at the bottom left of the composition, made for the first time as an aid to the visitor of the mountain. The inscription placed on the upper part of the map is a prayer to the God of the Western Mountain (Mt. Hua) written by the first emperor of the Ming dynasty, Zhu Yuanzhang (reigned 1368–98); it was composed after he had a dream in which he was mysteriously taken to the summit of this mountain.

Reference:
Chinese Rubbings from the Field Museum: no. 1062.

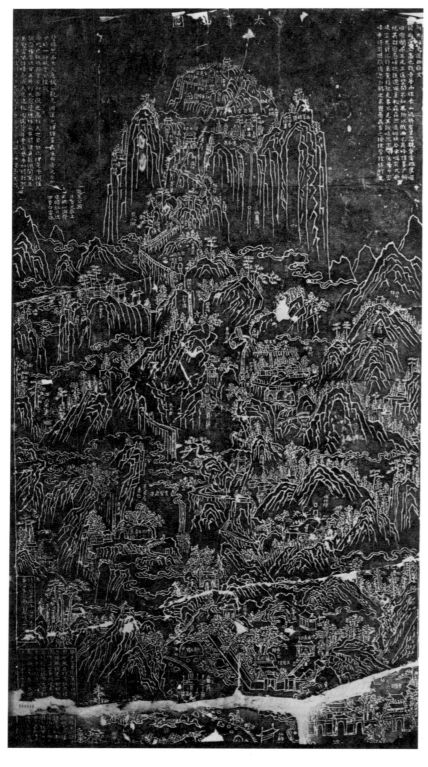

Tai hua shan tu

Tai hua quan tu

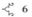 6

Illustrated Map of Mt. Hua

Qing dynasty, 1700

Hanging scroll, rubbing from a stone stele

135 x 69

Field Museum of Natural History
116470

This illustrated map was made in 1700 for a devotional stele commemorating the patron's climb of this mountain. It emphasizes the spiritual power of the mountain. The East Peak has on its face a huge imprint of the palm of a giant, which is one of the mysterious signs of this mountain—this image is also shown in the 1585 map, but in a much more modest size. This giant is often identified as the Earl of the River, the god of the Yellow River. On the face of the West Peak an image of the Giant Immortal (so-called in the inscription, but not particularly identified otherwise) also appears. A sacred waterfall cascading from the gap between the East and West peaks is greatly emphasized, and a mysterious cave behind the waterfall, about in the middle of its fall, is shown very large and is marked clearly. The auspicious clouds surround the upper portion of the mountain. The man-made objects, such as buildings and paths, are drawn into the topography, but they are done in such thin lines that their existence is overwhelmed, almost hidden, by the strong drawings of the natural elements.

Reference:
Chinese Rubbings from the Field Museum:
no. 1499.

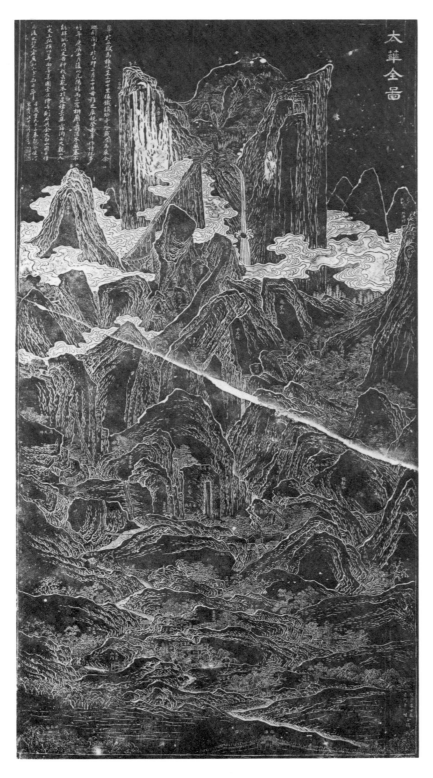

Tai hua quan tu

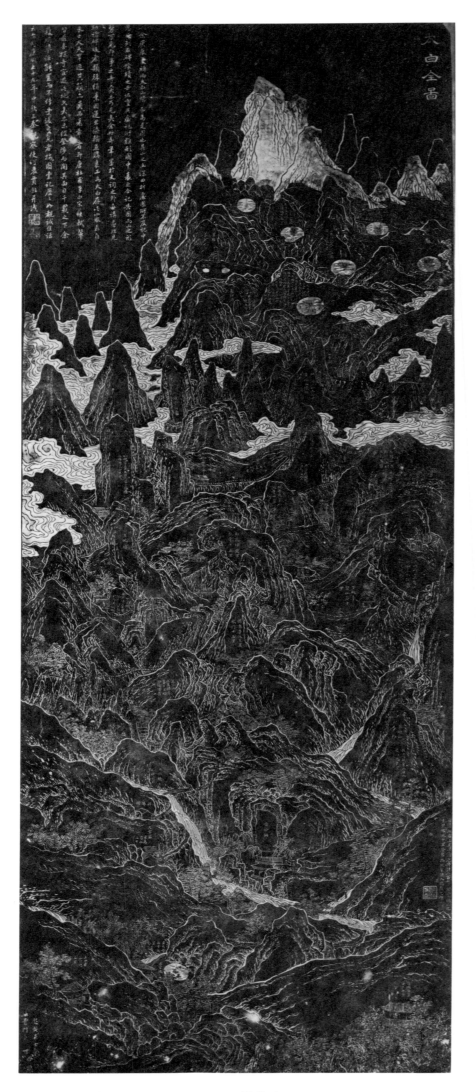

Taibai quan tu

Taibai quan tu

7

Illustrated Map of Mt. Taibai

Hanging scroll, rubbing from a stone stele

Qing dynasty, 1700

190 x 74

Field Museum of Natural History 116471

Mt. Taibai is located to the south of Meixian, Shaanxi, which is not far from Xian, the ancient capital of Changan during the Qin, Western Han, and Tang dynasties. It is one of the major peaks of the Qinling mountain range which runs east-west parallel to the Wei river to the north. Its summit, over 4,000 meters above sea level, is the highest of all the mountains in the Shaanxi region. It was sometimes called Mt. Taiyi, or, further back during the Zhou dynasty, Mt. Zhongnan. In literature those three names are used interchangeably, with Mt. Zhongnan often used to refer more vaguely to the mountains in this range. This mountain was particularly popular among the poets of the Tang dynasty, since it was the most prominent mountain near the capital. This mountain was designated by the Daoists as the eleventh *dongtian* (the sacred place particularly potent and suitable for Daoistic studies).

The illustrated map shows the major topographical features of this imposing mountain; each important site is identified by an inscription giving the name of the cave, rock, building, stele, or other feature, as well as its distance from a neighboring site. The upper part of the mountain is distinguished by the presence of clouds, and the highest peaks are carved in such a way that they appear white in the rubbing. There are six peculiar circular markers in the area right below the highest peaks. They are placed near the shrines built in that area, apparently symbolizing the powers of the gods associated with this mountain.

According to the inscription placed on the upper-left corner, this illustrated map was not made as a guide map to the visitor of the mountain, but was particularly designed to give a simulated experience of being there to the viewer who could not afford to make the trip.

Reference:
Chinese Rubbings from the Field Museum: no. 14982.

Illustrations in Traditional Books

Traditional publications treating great mountains include local gazetteers, books comprehensively dealing with nationally renowned mountains, and monographs on particular mountains. Those publications generally include pictorial maps; descriptions of topographical features, myths, legends, and historical anecdotes concerning those mountains; and sometimes writings and poems about the mountains or their special spots by renowned people of the past who visited those places.

Hua yue zhi

8

Record of Mt. Hua

Qing dynasty, 1831

Li Rong, author, 4 volumes

17.1 wide x 28 long x 1.6 thick

Library, Field Museum of Natural History
#35

Hai nei qi guan

9

Magnificent Scenes in the Country

Ming dynasty, sixteenth century

Yang Erzeng, author, 7 volumes

16.5 wide x 27.3 long x .7 thick

Library, Field Museum of Natural History
#34

Wuyi shan zhi

10

Record of Mt. Wuyi

Qing dynasty, 1644–1911

Dong Tiangong, author

17.1 wide x 26.6 long x 1.3 thick

Library, Field Museum of Natural History
#37-A

Paintings

Paintings representing panoramic views of the actual
topography of specific mountain areas became popular
from the Song dynasty onward, although they remain
in the minority among landscape paintings. Two such
paintings in color are introduced here.

Shen Zhou, 1427–1509

Famous Sights of Wu

 11

Ming dynasty, 1368–1644
Handscroll, ink and color on paper
35.5 x 1798.3
The Nelson-Atkins Museum of Art
70-25

Famous Sights of Wu

60

Wu is the area around the city of Suzhou, on the north side of the Great Lake, in Jiansu province. Rich in water resources, the area has been one of the major agricultural centers in China from as early as the Neolithic period. Its importance as a political as well as cultural center has been recognized since the Spring and Autumn period (770–481 BC). Its cultural significance reached a peak during the Ming dynasty when many numbers of renowned high officials, scholars, poets, and painters were produced. Shen Zhou, the founder of the Wu school, was one of them.

The characteristics of the mountains of this area are best described by Shen Zhou's own inscription written at the end of this scroll. It reads:

Suzhou area has no majestic peaks or high ranges. All are but rolling hills spreading continuously in mutual enhancement on the western periphery of the city. Those such as Tianping, Tianchi, and Tiger Hill are the most scenic places and are within range of a day's outing. As for those that are distant, Mt. Guangfu and Dengyu, overnight will suffice.
(*Eight Dynasties of Chinese Painting*: 181)

The mountains of this area, despite their modest size, are rich in legends and historical anecdotes. There are abundant literary writings about them, both prose and poetry, produced by those who visited them, particularly from the Tang dynasty onward. Shen Zhou, a native of this region and a frequent visitor to those mountains, left many of his writings and poems on them.

The present scroll starts with the approach to the Tiger Hill, one of the most popular tourist attractions of this area, located just on the outskirts of the city of Suzhou. It moves through the renowned mountains, and ends with a mountain on a little island across a bridge. The inscription above this mountain identifies it as Mt. Xuanmu.

The inscriptions inserted into the painting to identify the names of mountains and monuments seem to have been written later by someone, and are not necessarily correct. There are other versions of the same scroll, and some questions have been raised concerning which one of the extant versions is the authentic work of Shen Zhou (ibid.: 181-84). We must leave these questions for future study. Nonetheless, we can see that the present scroll conveys the sense of the artist's love of the topography of the region.

Reference:
Eight Dynasties of Chinese Painting: no. 152.

The Kangxi Emperor's Southern Inspection Tour to Shandong ◦ *Detail*

Wang Hui, 1623–1717

The Kangxi Emperor's Southern Inspection Tour to Shandong

 12

Qing dynasty, 1644–1911

Handscroll, ink and color on silk

58.7 x 1,203.7

The Metropolitan Museum of Art
Purchase, Dillon Fund Gift, 1979
1979.5

The following description from a catalogue of the paintings in the Douglas Dillon Galleries at the Metropolitan Museum of Art succinctly describes this scroll:

The Kangxi Emperor's Southern Inspection Tour was commissioned by the emperor (reigned 1662–1722) in 1691 to commemorate his seventy-one-day journey from Beijing to Suzhou, Hangzhou, Nanjing, and return. Executed under the supervision of Wang Hui (1632–1717), the project took three years to complete. Wang Hui laid out the composition on twelve oversized handscrolls and painted the lanscapes; his disciples painted the animals, figures, and buildings. The Metropolitan's scroll, the third in the set, records the journey through Shandong Province, culminating in the arrival at Mount Tai.

(*Silent Poetry*, 64, with romanization converted into Pinyin system)

This scroll culminates in the scene of majestic Mt. Tai where officials are making preparations for the arrival of the emperor. The sense of this mountain's height is somewhat compromised to fit into a horizontal format. The power of the mountain, however, is well captured by the composition in which all the components of the mountain—such as hills, peaks, boulders, rocks, and trees—are shown in rhythmical upward movement, their momentum converging on the summit with a crescendo. The major buildings are brightly colored and the whole scene seems to be bathed in the warm spring sunlight.

Reference:
Silent Poetry: pls. 48-50.

Detail

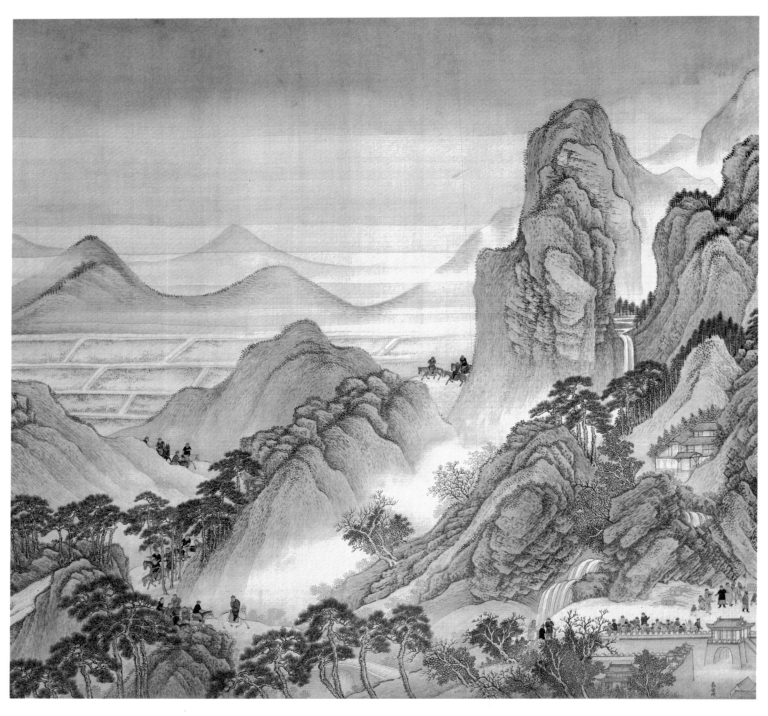

The Kangxi Emperor's Southern Inspection Tour to Shandong ◦ Detail

Three concepts concerning mountain worship developed in the late Warring States period (480–222 BC) and continued through the Han dynasty (206 BC–220 AD). One concept was an animistic belief in the mystical powers inherent in the great mountains within the earthly domain of China. This was the basis of the court rituals for the mountains. The early written sources indicate that this mountain worship was practiced—although probably not as systematically as in later court ritual—by the royal Zhou kings and by the heads of the local states during the Zhou dynasty (1027–222 BC). The second was the concept of the mountains as cosmic pillars, the shafts connecting heaven and earth, and as such was often associated with the shamanistic concept of the ascent of the deceased soul. While the earthly mountains that had been worshipped as sacred in the animistic sense assumed this second role, too, an imaginary cosmic mountain called Mt. Kunlun gained popularity from the late Zhou period onward. The third concept envisioned the immortals' mountains supposedly located in the Eastern Sea, an idea which developed along with the growing popularity of the cult of immortality. It is generally agreed that this concept was developed by practitioners of magic in the coastal area of Shandong around the fourth or third century BC. These three concepts were often combined and developed into a complex cosmology, giving rise to popular cults during the Han dynasty.

The image of a sacred mountain in the Warring States period was that of a dangerous and prohibitive space where heavenly and earthly spirits intermingled with ferocious animals and monsters. Through this realm, which in a cosmological sense functioned as an intermediary domain between heaven and earth, man communicated with heaven, or at the time of death ascended to heaven, often with the aid of shamans. Ritual vessels, important elements in the mystical communications, were decorated with various scenes of this realm or with images symbolically representing such scenes.

The mystical and ordinary animals and birds that were supposed to have been active in the spirit mountains were represented not only as part of the two-dimensional decorations on ritual vessels, but also in independent three-dimensional forms. They could appear as pendants, as vessels, or as parts of vessels, mostly in bronze or in jade.

Eastern Zhou dynasty, 770–256 BC

Bronze

35.2 high x 24.1 diameter

The Minneapolis Institute of Arts
Bequest of Alfred F. Pillsbury
50.46.9

This *hu* vessel from the Warring States period, from around the fourth century BC, belongs to a group of vessels called "hunting *hu*" vessels, which bear characteristic scenes of hunting as a part of their surface decoration. (The meaning of those scenes represented in an archaic pictorial style in low relief on the surface of "hunting *hu*" vessels is discussed in detail in the essay part of this catalogue.) The decoration as a whole represents the ritual of exorcising the intermediary realm between heaven and this world.

The motif of a bird holding a snake in its beak, which appears on the top band on the surface of the vessel, is a symbol of the aid given by heavenly helping spirits and earthly helping spirits, symbolized by the bird and snake respectively, to the performer of the ritual exorcism. The scenes in the second and third bands represent ritual hunting scenes; the second band shows the hunting of animals by archers on chariots and by foot soldiers, and the third band depicts the scene of archers shooting birds with crossbows. Ritual hunting was actually performed annually by the king of the Zhou or by the head of a feudal state during the Zhou dynasty. The fourth and fifth bands show repeatedly a scene of two naked men about to slaughter a ferocious mystical animal which still resists. This scene is interpreted as a representation of the overall meaning of the hunting rituals; that is to say, that the evil spirits in the intermediary realm are going to be exorcised as a response to the hunting rituals performed on earth.

It is important to note that some bronze vessels that were recently excavated by archæologists have decorations representing in a narrative the scenes of the intermediary realm between heaven and the human world, depicting the realm as a place in the mountains where monsters and animals roam and where some figures are in the act of pacifying the area (see fig. 1c). The religious concepts behind those scenes are that a sacred mountain functions as a cosmic pillar connecting heaven and this world, and that an intermediary realm between the two is an area of mysterious wilderness hidden in the depths of the spirit mountain. The scenes depicted in the decoration of the Minneapolis *hu* are those of the mysterious wilderness located in the spirit mountains, even though no image of a mountain is included.

Reference:
Chinese Bronzes in the Pillsbury Collection: no. 53.

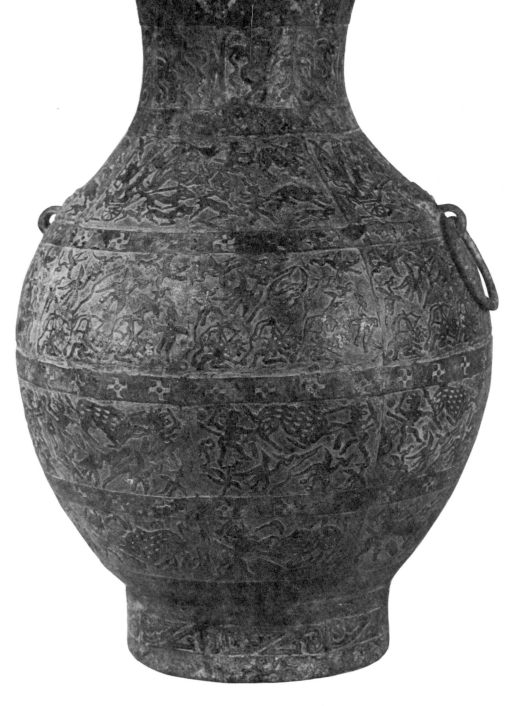

Hu Vessel with Hunting Scenes

Dragon Pendant

14

Warring States period,
fifth to third centuries BC

Jade carving

7.6 high x 13.4 long

Asian Art Museum of San Francisco
Avery Brundage Collection
B60 J675

Dragon Pendant

Dragon Pendant

15

Warring States period,
fifth to third centuries BC

Jade carving

8.5 long x 1.2 wide

Asian Art Museum of San Francisco
Avery Brundage Collection
B60 J665

The dragon is one of the most important and long-lived mythological animals in China. Its history can be traced back to the prehistoric period, when it probably functioned as a totemistic symbol of a powerful clan. It continued to assume various symbolic meanings through the dynastic periods (ended in 1911). It is well known that in the later periods, the image of a dragon was used as a symbol of heaven and as an imperial emblem. During the Warring States period, the dragon was considered to be a mystical animal that moved freely between heaven and earth, and thus, in a shamanistic sense, it was one of the key animals that helped the souls, either those of shamans or of the deceased, in their travel through the intermediary realm between heaven and earth. The images of dragons, in pictorial form or as an element of an abstract pattern, can be found on numerous bronze ritual vessels as decorative motifs that would impart magical powers.

Since the sacred mountains were considered cosmic pillars connecting heaven and earth, dragons were an important element in mountain worship at the time. According to the early chapters of the *Shan hai jing* (Classic of Mountains and Seas), which were written in the Warring States period, many deities supposedly ruling or residing in the great mountains were often imagined to have taken the forms of composites of a human and a dragon, or a bird and a dragon.

Each of the dragon-shaped jade pendants shown here has a hole in the central portion of its body, indicating that it was to be threaded on a cord and worn around a person's neck. It is very likely that a king, a head of a feudal state, or a priest wore such a pendant while performing a ritual. It also could have been used to hang on the neck of the deceased to help his or her soul to ascend to heaven.

Reference:
Chinese Jades in the Brundage Collection:
no. xiii.

Dragon Pendant

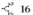

Bear-Shaped Support

Eastern Han/Eastern Jin dynasty,
first to fourth centuries AD

Jade carving

6.9 high x 7.9 wide

Asian Art Museum of San Francisco
Avery Brundage Collection
B65 J2

One of the earliest records referring to a bear in the mythological context was in the *Zuo zhuan* (Zuo's Commentary), written in the fourth or early third century BC. It says that Gun, the father of Yu, the founder of the legendary Xia dynasty, metamorphosed into a yellow bear after his death (*Zuo zhuan*, Zhaogong's 7th Year: 21/18-a). The bear became one of the very common features in Han representations of the spirit mountain as an intermediary realm of wilderness between heaven and earth. It is depicted sometimes as a calm, contented resident of the mystical mountains (fig. 9), and sometimes as a ferocious animal fighting against a monster (cat. no. 31).

This jade piece, originally made as a support of some object, possibly as one of the three feet supporting a vessel, represents a bear as a good-hearted, harmless animal, rather than as a ferocious one.

Reference:
Chinese Jades in the Brundage Collection:
no. xxiv.

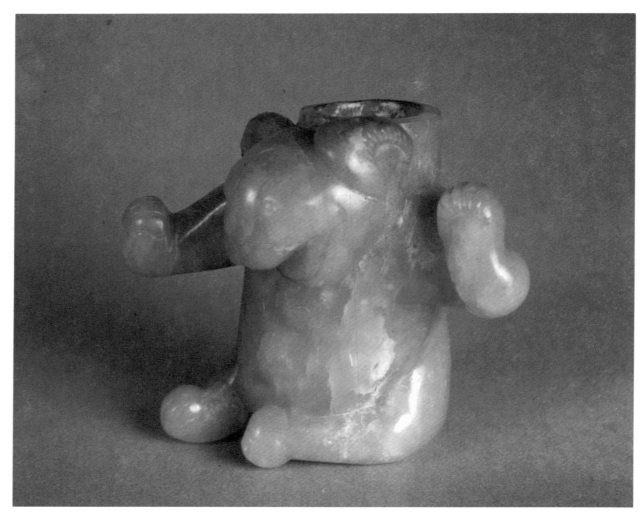

Bear-Shaped Support

*The basic concept of sacred mountains in the Han
dynasty was a continuation and development of that
of the earlier period. However, the images of the
mountains became more descriptive, showing men and
creatures in their actions and interactions among the
peaks and valleys. The sacred mountains, conceived
religiously as intermediary realms between heaven
and earth, became important components of the
schematized world image in Han cosmology. This
system postulated that heaven, in the form of a dome,
is connected by the sacred mountains, as cosmic
pillars, with earth below, which is flat and square in
form. It should be noted here that in the context of Han
thinking, the cosmic images possessed their own iconic
powers. Those images of sacred mountains, whether
represented descriptively, as in the forms of mountain
censers, or symbolically within a schematic image of
the cosmos, as in the decorations of the so-called cosmic
mirrors, were not just representations, but were
conceived as actual sources of power.*

From around the beginning of the first century AD
*onward, the cult of the Queen Mother of the West be-
came popular. The Queen Mother metamorphosed
from an original image of a ferocious deity to that of a
beautiful goddess residing on Mt. Kunlun. The images
of immortals also evolved; early "winged men" who
flew freely over mountains gradually took on the
appearance of ordinary human beings residing in the
spirit mountains, or, along with the development of
Daoism, in the "realms of immortals." In other
words, the images of magic mountains were gradually
humanized. This trend continued through the periods
following the Han.*

Hill Censers (*Boshan* Censers) from the Han Dynasty

A type of incense burner commonly called a BOSHANLU
*(literally, "Bo Mountain censer") presents the Han
image of a spirit mountain in three-dimensional form.
The origin of the term* BOSHAN, *commonly used to
identify hill censers, is a mystery. There is no mountain
called Boshan (Bo Mountain). The word* BO, *meaning
"broad" in common usage, does not give much of a clue
to the origin of the name. The term seems to have been
used much later than the first century* BC *when the hill
censers became popular. The beginning of the use of this
term might have been sometime in the late Han. For
now, we can simply define a* BOSHAN *censer as a censer
symbolizing a spirit mountain.*

A typical BOSHAN *censer has a bowl-shaped body
with a lid in the conical form of a mountain, and a
supporting vertical stem which stands on a circular
foot. It is made of either bronze or pottery. Its lid is
decorated with relief, open metalwork, or even three-
dimensional images. Peaks are often represented by
overlapping triangular forms, among which animals
and human beings are engaged in all sorts of activities.
The perforations of the lid, sometimes hidden between
the overlapping peaks, release the smoke from burning
incense as if mysterious clouds were rising from the
mountain.*

*The censer's circular foot is often decorated with
motifs of rising dragons, symbolizing the active power
of water, and is often placed in a water basin, complet-
ing the ideal image of sacred mountains—they are
supposed to be sources of sacred rivers as well as
mysterious clouds.*

*The activities of the animals and humans depicted
in the mountains vary from one censer to another;
there can be bloody battles between hunters and ani-
mals, peaceful interactions between man and animals,
or the calm presence of immortals. This fact suggests
that the mountain censers were made to suit particular
situations, according to the owner's social class,
regional variations in religious beliefs, and purposes.
Such censers could be used in state rituals, funerals,
the cult of immortals, or just for the enhancement of
daily life.*

Hill Censer

17

Han dynasty, c. 100 BC

Bronze

24.1 high

The Nelson-Atkins Museum of Art
Nelson Fund
43-15

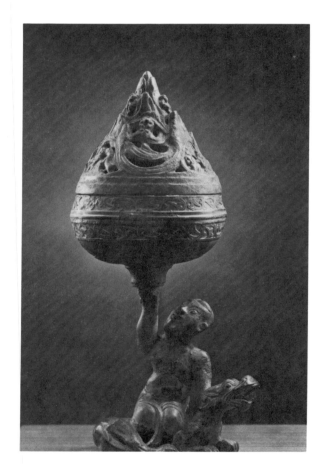

Hill Censer

Lid of a Hill Censer

18

Han dynasty, c. 100 BC

Bronze

7.2 high x 9.2 diameter

Field Museum of Natural History
117384

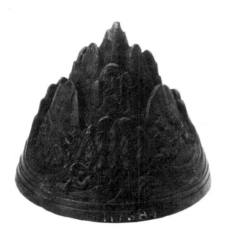

The Nelson Gallery censer has an unusual feature, a giant who supports the mountain while sitting on a peculiar animal. A very similar censer was excavated from a tomb in Mancheng, Hebei, belonging to Dou Wan, the wife of Prince Qing of the Zhongshan feudatory state, and ascribed to 118–104 BC (fig. 22). This Mancheng censer gives a clue to the date and the place where the Nelson censer was made, most likely an imperial workshop in the capital, Changan. Since the Mancheng censer has a circular bronze tray as a water basin from which the giant on the mystical animal arises, a similar water basin originally must have been a part of the Nelson censer.

The lid of the Nelson censer is structured to show overlapping peaks, and on the side of each peak a scene of various activities of man, animals, and birds is represented in open relief: a tiger fighting a unicorn, a man with a rod threatening a squirrel-like creature, a man confronting a tiger, a man shooting an animal on a tree branch while a large bird watches the scene, deer and hounds running, a man with a halberd fighting a bear while a monkey watches from a tree, and so forth (see cat. no. 18). The whole design strongly emphasizes the "wilderness" aspect of the spirit mountain. The scene of a man pulling a cart loaded with a large box is intriguing, but it most likely represents a man bringing animal sacrifices to the souls of the ancestors, with whom the people can communicate through the sacred mountain as a cosmic pillar.

Almost exactly the same iconographical features appear on the lid of the Dou Wan censer, on a censer at the Freer Gallery of Art which is luxuriously decorated with inlaid designs in gold and silver and precious stones (fig. 21), and on a lid of a censer in the collection of the Field Museum in Chicago. These mountain censers are of high quality and share a set of iconographical features, indicating that they were made in the imperial workshop or in the workshops closely related to it.

The mountain represented in the Nelson censer is undoubtedly a cosmic mountain—it could be regarded as Mt. Kunlun, the imaginary cosmic mountain, or more likely as an actual sacred mountain such as Mt. Hua, which was the sacred mountain located closest to the capital. The water in the basin symbolizes the life-supporting water flowing from the sacred mountain. The figure who supports the mountain, rising out of the water, is a water-earth god. In the context of northern China, it can be identified as the god of the Yellow River, commonly called the Earl of the River. He sits on an animal with the head of a tiger and the body of a cow, most likely a monster-deity called the Earl of the Earth who was said to reside in the Capital of Nether Regions. This Capital was sometimes conceived to exist in the bottom of the northeastern sea into which the Yellow River eventually flows. This hill censer provides us with a powerful and complete image of the cosmic mountain standing between heaven and earth.

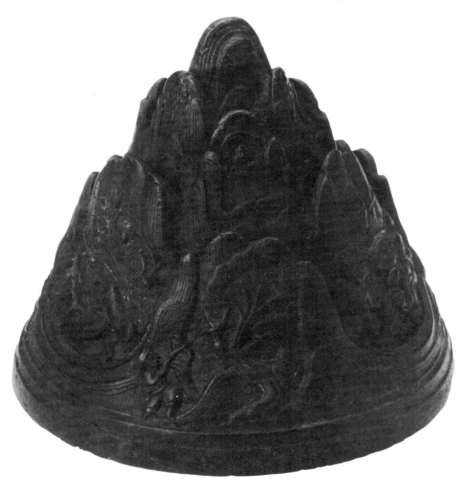

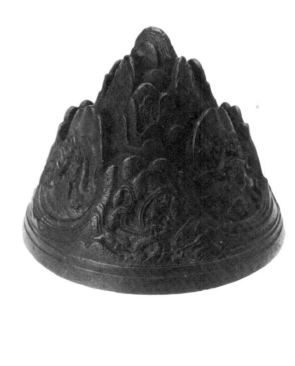

Lid of a Hill Censer: 3 Views

Hill Censer

19

Han dynasty, 206 BC–220 AD

Bronze

29 high x 12 diameter, basin 20 diameter

Field Museum of Natural History
117378

The design of this hill censer may be considered typical. It retains the basic elements of all the *boshan* censers: a lid in a conical mountain shape with overlapping triangular peaks, a vertical stem supported by a skirted foot, and a tray. On the mountains, roaming animals, birds, and trees are represented in low relief, but there is no scene of confrontation between animals, or between a man and an animal. The lack of intensity in the theme of religious significance indicates that this censer was possibly made for use in daily prayers, and not for a special occasion such as a funeral. The general stylistic characteristics of this censer suggest that it was made in northern China around the second or third century AD.

Hill Censer

Hill Censer

20

Han dynasty, 206 BC–220 AD

Bronze

26 high x 22.8 wide

Asian Art Museum of San Francisco
Avery Brundage Collection
B60 B131

This bronze hill censer is unique in several points. There is a bird placed on the top of the conical mountain. A human figure in a stylized form supports the bowl of the censer on his head, and he is seated on a conical mountain-shaped foot that occupies the center of the flat tray. The lid retains a form of overlapping peaks, but in a very simplified manner, providing a larger flat surface on which the images of monsters are incised.

A very similar specimen, datable to the early part of the first century AD, was excavated in Xuyi county, Jiangsu (fig. 35). Compared to the Brundage censer, the Xuyi censer is slightly more naturalistic; the figure is more clearly a human seated on a monster. It is easier to see the iconographical tradition of the Nelson Galley censer inherited in the Xuyi censer, specifically in the sense that the figure, a river god, is seated on a monstrous god of the netherworld. This point becomes obscure in the Brundage censer; while it copies the general features of the Xuyi censer, it is further stylized. A motif placed on the mountains of the Brundage censer, a bear-like monster, is identified as the god Chiyu, the Lord of War, who functions as an exorcist (Berger 1987: 29). The function of the hill censer as an aid for communicating with heaven is clearly kept intact here.

Figure 35

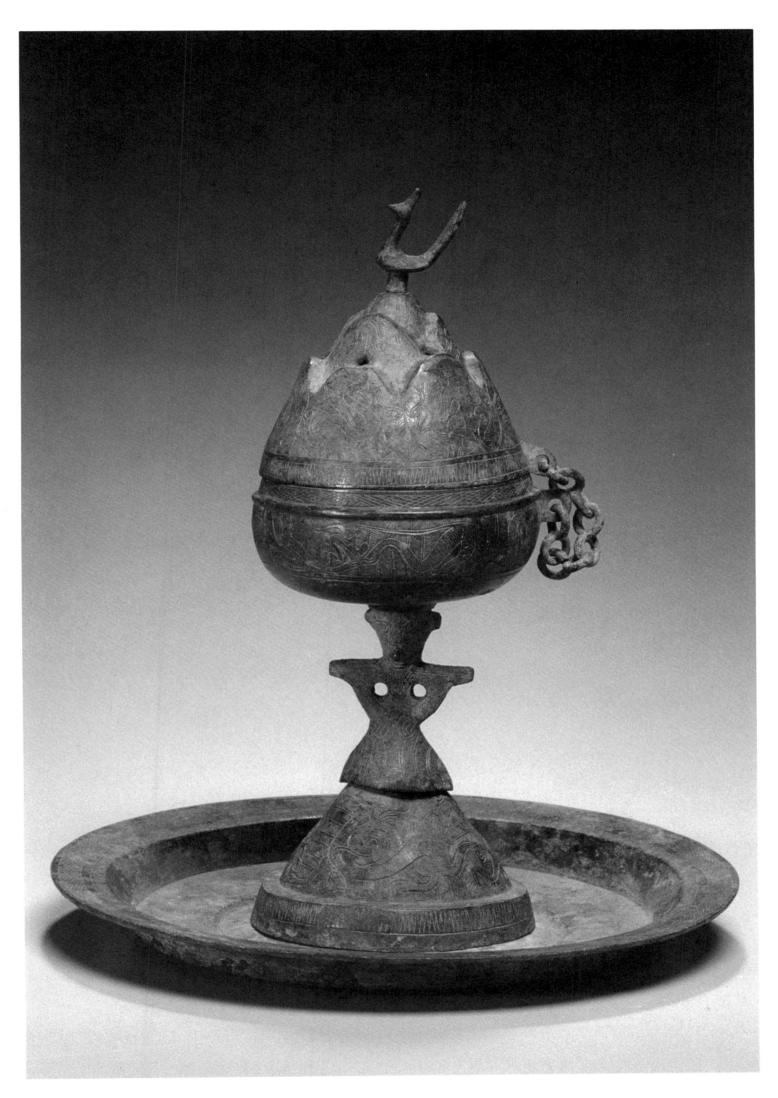

Hill Censer

Hill Censer

21

Han dynasty, 206 BC – 220 AD

Bronze

19.1 high x 11.4 wide

The Minneapolis Institute of Arts
Bequest of Alfred F. Pillsbury
50.46.31ab

As a *boshan*-type hill censer made in bronze, this piece is extremely simple. The conical mountain form of the lid still has overlapping peaks, but in a low relief, similar to those made in pottery, rather than the more three-dimensionally structured independent peaks common among bronze hill censers. There are no animal or human figures represented on the sides of the mountains. Perforations for the rising smoke are not located among the peaks, but on the lower side of the mountain, and because of their large size they look like cave entrances opened on the mountainside.

A very similar specimen was excavated in Hepu county, Guangxi Autonomous Region (*Kaogu* 1972, no. 5: 20). This discovery corroborates the theory that the Minneapolis censer was a product of the southernmost territory of Han China. This area had enjoyed a semi-independent status until 111 BC when it was put under the Han's direct control. Consequently, it had a unique culture which was a mixture of the Han culture of the north and the native culture of tribal people (Berger 1987: 22). The significance of the unique design of the Minneapolis and the Hepu *boshan* censers has to be left for future study.

Hill Censer

Hill Censer

22

Han dynasty, 206 BC – 220 AD

Bronze

9.5 high x 13.9 wide

Asian Art Museum of San Francisco
Avery Brundage Collection
B60 B16

This hill censer is not really a *boshan* censer in its general appearance. It takes the ordinary form of an incense burner, except the form of a mountain with many overlapping peaks is placed on the very top of the lid. This is an interesting example of a hybrid of the common censer and the *boshan* censer.

Hill Censer

Hill Censer

There are a number of pottery hill censers extant. They are, generally speaking, imitations of the bronze censers, and are two dimensional in the contours of their conical mountain-shaped lids.

The Art Institute hill censer has a mountain-shaped lid which has no representation of individual peaks, except for a slight hint of it in a little gap between the lower portion and the upper portion. A striking feature of this censer is the assortment of motifs placed on the side of the mountain. Seminaked human figures are fighting against animals with rods and arrows. In one scene, a man who has fallen on the ground is about to be eaten by a tiger. There are large reptiles and a strange frog-like creature, which were not common residents in the usual mountain scenes from the Han period. There is one huge bear-like animal standing on its hind legs. A human figure stands holding a dog on a leash, and many birds fly about. The spaces between the figures are filled with trees.

There is an almost identical piece in the Asian Art Museum in San Francisco (fig. 36). It has been convincingly attributed to the far-south region of China, based mainly upon the unique wild scenes on the mountainside. There is a literary record stating that the tribal people in the region engaged in a wild, festive (if not ritual) winter hunt in a mountainous area as late as the ninth century AD (Berger 87: 20). The same source mentions "sand mouthers" which are said to be "semi-legendary reptiles which spit sand at men's shadows with fatal results" (Schafer 1967: 51-52). The reptiles in the censer fit the image of "sand mouthers." The concept of ritual hunting as background for the Han mountain scenes would have been the motivation for adopting the tribal hunt as the motif of the mountain scenes of the hill censer.

One question still remains. The quiet design on the Minneapolis bronze censer, discussed above, was definitely from this same far-south region. How do we explain the coexistence of the two so drastically contrasting designs of hill censers in the same region at about the same time?

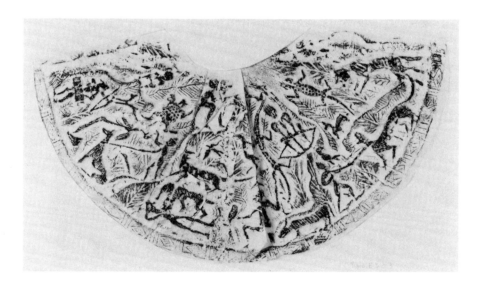

Figure 36

Hill Censer

24

Han dynasty, 206 BC – 220 AD

Earthenware

29.8 high x 17.8 diameter at base

The Minneapolis Institute of Arts
William Hood Dunwoody Fund
32.54.5 a b

Hill Censer

Hill Censer

25

Han dynasty, 206 BC – 220 AD

Painted pottery

22.2 high x 11.2 diameter

The Metropolitan Museum of Art
Gift of Miss Florence Waterbury, 1965
65.74.2

This carefully made, elegant hill censer is unique in many aspects. The body of the burner is shallow and its bottom is relatively flat, not in the usual bowl shape. The stem supporting the body is almost straight, and it stands, without any skirting foot, directly on the tray. In turn, the tray is supported by a mountain-shaped base, with four peaks stretched up and out like flower petals as additional supports. The bird placed on the top of the lid turns its neck and preens its wings with its beak. The peaks on the lid are represented by soft, round, overlapping shapes in two layers. The animals placed on the sides of the peaks are few in number, and quiet.

The bird at the top of the lid, and the lower mountain which supports the upper mountain (the lid and the body of the censer) are two points which this censer shares with a bronze censer in the Brundage collection (cat. no. 20) and one excavated in Xuyi in the northern Jiangsu (fig. 35). The latter further resembles this Minneapolis censer in the shape of the lid and the relative flatness of the body. Mt. Kunlun was said to have layers of peaks piled vertically one over the other; according to *Huai nan zi* those layers are, from the bottom, Kunlun, Cool Breeze, Hanging Garden, and Upper Heaven. In these three censers, the image of two mountains, one at the bottom and another at the top, may represent a cosmic mountain, if not Mt. Kunlun itself. A bird was considered variously as a heavenly messenger, a heavenly helping spirit, or the soul of a deceased person in the tradition of shamanism. In later legend a bluebird is a messenger of the Queen Mother of the West. A bird placed on top of the mountain certainly refers to communication with heaven.

This piece is a rare example of a painted pottery hill censer. It has a bird on the top of the lid. The vertically elongated shape of the lid and the hatches applied on the sides of the hills and peaks indicate that this censer was made in the far southern region, the area of the present-day Guangxi Autonomous Region. Some of the animals and creatures represented on the sides of the peaks, including an immortal crouched on a galloping horse, are shown in lively action, and some, including grazing horses, are calm and peaceful. Either way, the artist's skill in depicting animals is particularly remarkable.

Hill Censer

Hill Censer

26

Han dynasty, 206 BC – 220 AD

Earthenware

15.8 high x 13.3 diameter

The Metropolitan Museum of Art
Gift of the Ernest Erickson Foundation,
Inc., 1985
1985.214.129

This hill censer does not have a stem to support its body; instead, three short legs in the form of roaring bears directly provide support. Unlike most of the pottery censers, the lid of this censer is structured in a three-dimensional way. In particular, the spaces in the lower part that reveal the activities of animals are so deeply cut that they look almost like natural stage settings, and the animals themselves are represented almost like sculpture in the round. Some of the perforations are large and look like caves. In one instance an animal appears to be coming out of its cave. Some of the linear elements depict swirling and waving natural formations, filling the total composition with power.

Hill Censer

Hill Jars and *Hu* Jars

One development in burial customs during the Han dynasty was the use of MINGQI, pottery models of daily utensils, buildings, and other objects, as well as pottery figurines, which were to be buried in tombs to provide comfort to the deceased in the afterlife. Many pottery vessels found in Han tombs are those specifically made as MINGQI.

HU jars had been one of the major types of vessels to be placed in tombs before the Han dynasty, and the decorative designs on the bronze HU jars from the Warring States period are particularly rich with pictorial representations of various scenes. Pottery HU jars of the late Han that were made as MINGQI followed this tradition, but retained only one band of decoration on their shoulders. These bands depicted mountain scenes with wild animals and monsters, and represented the realm of wilderness that was the intermediary area between heaven and this world, as in objects from the earlier Warring States period.

A fascinating Han invention is the hill jar, which was made as a pottery replica of a metal (bronze or iron) ceremonial vessel. A hill jar consists of a cylindrical body with a conical lid molded into mountain peaks. The body, supported by three short legs (often in an animal shape) at the bottom, bears a representation of mountain scenes in low relief. Many extant hill jars have nonfunctional ring handles, often made only in relief, to retain the appearance of the original metal vessels, which were, according to a recent study, "wine-warming vessels" (Sun-Bailey 1988:88-90). The extant metal vessels of this type, however, have ordinary lids—not ones sculpted into mountain shapes. Quite obviously, the unique hill-shaped lids were invented in the process of redesigning the "wine-warming vessel" as a pottery MINGQI, utilizing the plasticity of the clay in order to enhance the symbolic meaning of the vessel.

The conical mountain-shaped lids of hill jars consist of many layers of peaks and mountain ranges where animals and human figures roam. They are very similar in concept and design to the lids of hill censers, except in two respects: they lack perforations, and their larger size provides a greater surface on which the designer could create a more realistic miniature mountain complex.

The scenes of mountains depicted in low relief on the bodies of hill jars are often dynamic, showing many creatures in various activities on mountains or in the air above: dragons, tigers, and other animals and monsters flying in the sky or running, and sometimes immortals soaring on dragons. These iconographical features of mountain scenes assert that the symbolic meaning of hill jars was the same as that of HU jars; both display the images of sacred mountains as an intermediary realm between heaven and this world. There are certain variations in the appearance of this realm, with different aspects emphasized—some are represented as dangerous realms of wilderness, and others are more peaceful realms where immortals reside.

Han dynasty, 206 BC – 220 AD

Earthenware

18.5 high x 22.2 diameter

The Art Institute of Chicago
Gift of Mrs. Bertha Palmer Thorne
1972.1261

Among the many extant hill jars, this jar in the Art Institute of Chicago, together with one in the Cleveland Museum, is unique in the sense that the whole side of its body is covered with decorations in low relief. This is in contrast to the common hill jar decorations which are limited to the space within a horizontal band placed on the side of the body. The Chicago and Cleveland jars also lack the characteristic lids taking the form of mountain ranges. It is difficult to determine whether they were made without lids or the original lids were lost. Nevertheless, the decorations of both jars are unusually rich with densely overlapping mountains, rocks, and trees, depicted in dynamic twisting and swirling forms.

The Art Institute jar decoration has two figures as its focal points. One—an immortal—is seated on a peculiar plateau-like structure and extends one hand toward an approaching monstrous bird, who stretches its head over the top of a cliff. It is difficult to determine whether the upper part of this figure extended to our right is meant to be the wing of a "winged man," or simply his extended left arm. The "plateau" is supported by layers of curving vertical bands and topped with cloud-like curving horizontal bands which are extended to the upper left. From behind the immortal, other curved bands, most likely some sort of trees, move upward. The second figure is located on the opposite side of the jar. He stands on swirling clouds, or a cloud-like peak, and touches with his one hand the back of a dragon which moves toward the left over the layers of peaks, turning its head and upper body back toward the figure.

Details of the decoration of this jar are by no means clear enough to make positive identifications. However, we can recognize a monstrous animal, possibly a tiger, behind the bird, and a standing bear in the lower part just to the right of the figure associated with the dragon. There is one prominent tree growing on the top of a peak which is placed to the left of the dragon. Toward the end of the first century AD the convention of Four Guardian Deities assigned to the four cardinal directions of the universe—a dragon (east), a bird (south), a tiger (west), and a tortoise-snake combination called the "Black Warrior" (north)—was established. The deities are commonly observed on the four sides of the cosmic diagrams in the decorations of the so-called TLV mirrors. Among those four deities, the dragon, bird, and tiger had an earlier origin as directional symbols in Western Han astronomy. If we take the position that the dragon on the Art Institute jar is an indication of the east, the tree could be the Fusan tree from which the sun starts the day's journey. Then, logically, we can identify the position of the large bird as the south; that of the tiger-like animal, the west; and that of the bear, the north. It should be noted that an immortal, or a deity, is often placed face-to-face against one of the Four Guardian Deities, commonly against the dragon and bird, in TLV mirror decorations. Further iconographical study is needed to determine the exact meaning of the decoration of this jar. Nonetheless, the whole composition represented here clearly refers to the structure of the cosmos, and it is filled with cosmic energy. Iconographical and stylistic characteristics of this jar indicate that its date was about the first century BC, and that it was one of the earliest hill jars made before the standard type was established.

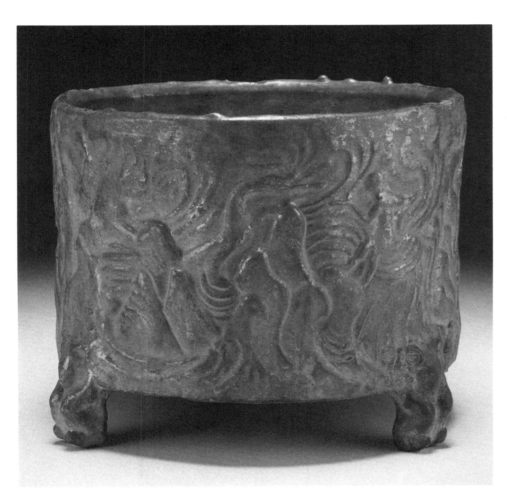

Hill Jar

Hill Jar

28

Han dynasty, 206 BC – 220 AD

Earthenware

21.6 high x 20.3 diameter

The Art Institute of Chicago
Gift of Mrs. Bertha Palmer Thorne
1972.1260

This hill jar is one of the standard types in its structure and decoration. The lid is in a loose conical shape with mountain ranges forming concentric circles around the central peak group. The central peak group consists of four peaks surrounding one larger peak; these four peaks stand vertically with a slight outward curve, forming a handle for the lid. The mountain ranges in the surrounding area are arranged so that the contours of high and low peaks flow rhythmically in a circular motion. Also, peaks are located to form groups, so that they represent mountainous areas to be contrasted to relatively flat highlands. On the side of the mountain ranges and on the flat areas, human figures, animals, and birds in various activities are shown in low relief.

On the side of the body of the jar is a large band in which scenes of mystical animals flying over the mountains are represented in low relief. One noticeable image is a human figure riding a horse and turning back to shoot an arrow toward an animal behind him— in the posture of the so-called Parthian shot. This is a remnant of the traditional "hunting" theme, which was a ritualistic, as well as symbolical, expression of exorcising the intermediary realms between heaven and this world. The traditional meaning of the mountainous areas as these intermediary realms is clearly intact in the total design program of this jar.

Hill Jar

Hill Jar

29

Han dynasty, 206 BC – 220 AD

Earthenware

15.5 high x 21 diameter

Field Museum of Natural History
119258

Cast of a Hill Jar

30

71 high x 11 wide x 2 deep

Field Museum of Natural History
Model of 119258

The motifs found on the decorative band running around the vertical side of a hill jar constitute one of its important features. In order to show the details of these compositions, which are not easy to observe and are often overlooked by casual viewers, the Field Museum of Natural History, Chicago, has made casts from the hill jars in its collection. These casts are stretched flat so that the original designs from the cylindrical shape are seen on a two-dimensional surface. An original hill jar and its cast are shown here.

The composition of the band of this jar is characterized by a very prominent mountain form which is repeated four times. The mountain is represented by overlapping peaks of triangular shapes, and each peak is shown with a humped right-side slope and a steeper left-side slope. Hatches are applied on the space between the overlapping slopes. On both sides of the major group of peaks, additional peaks—on the left a low peak and on the right a very high peak—are added to form an asymmetrical "three-peak" motif. The whole structure of this mountain group is actually a prototype of one of the very basic formulas for representing mountains in China in the periods following the Han. It was used not only in the representations of symbolic mountains on mirrors and other objects from the Six Dynasties period and the Tang dynasty, but also as a conventional way of representing mountains in later landscape paintings.

The whole composition of the band decoration represents auspicious sacred mountains. Clouds rise from the four major mountains, and dragons and tigers fly in the sky. Auspicious clouds, in a symbolic cloud-scroll (*yunqi*) form, float further above. Some of the iconographical details of this decoration will be discussed in comparison with the other two hill jars from the Field Museum of Natural History in the following entry.

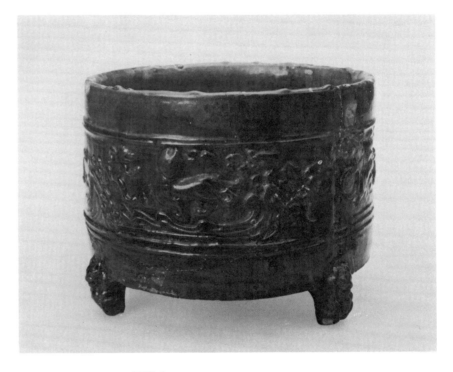

Hill Jar

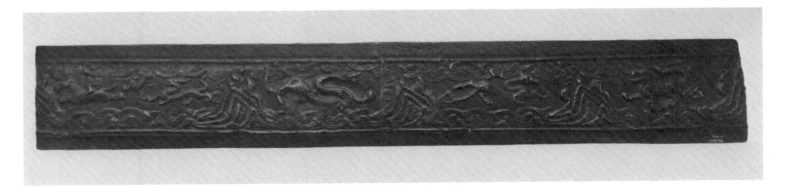

Cast of a Hill Jar

Hill Jar

🪶 **31**

Han dynasty, 206 BC – 220 AD

Earthenware

18 high x 22.5 diameter

Field Museum of Natural History
118475

Hill Jar

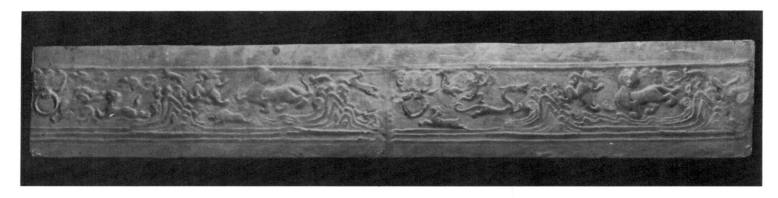

Cast of a Hill Jar

Hill Jar

32

Han dynasty, 206 BC – 220 AD

Earthenware

25.5 high x 20 diameter

Field Museum of Natural History
118488

The images depicted within the horizontal band on the side of all three of the hill jars from the Field Museum in the exhibition, including the one introduced in the previous entry, follow the same basic design. There are four peaks, represented in essentially the same way, with triangular outlines that lean to the left and are topped by trees. The forms of the mountains in cat. no. 31 are simplified versions of those in cat. no. 29, and those in this hill jar are even simpler.

At the top of the band on jar 119258 are the *yunqi* motifs that curve and move, accentuating the movement of the dragons, tiger, and bear that are shown between each pair of mountains below. A bear on his hind legs holds his front paws in fists poised to fight and confronts a tiger whose chest is puffed out in noble arrogance. More animals in lively activities are shown on jar 118475. The image of confronting bear and tiger appears twice. In between these two images, a deer leaps to the top of and perhaps over one of the mountains. To the right of the deer, and above a flying dragon, is an image of an immortal running in the sky.

These scenes of confrontation between two animals are reminders that the areas depicted are the realm of wilderness. The sky, the upper part of this realm, is closer to heaven and should therefore be calmer and auspicious. The decorations of the three hill jars of the Field Museum belong to a group that emphasizes the wilderness of the realm, in contrast to another group that eliminates the animal confrontation scenes and thus emphasizes the felicity of the realm.

Hill Jar

Hill Jar

33

Han dynasty, 206 BC – 220 AD

Earthenware

22.5 high x 19 diameter

The Nelson-Atkins Museum of Art
Nelson Fund
34-148/2

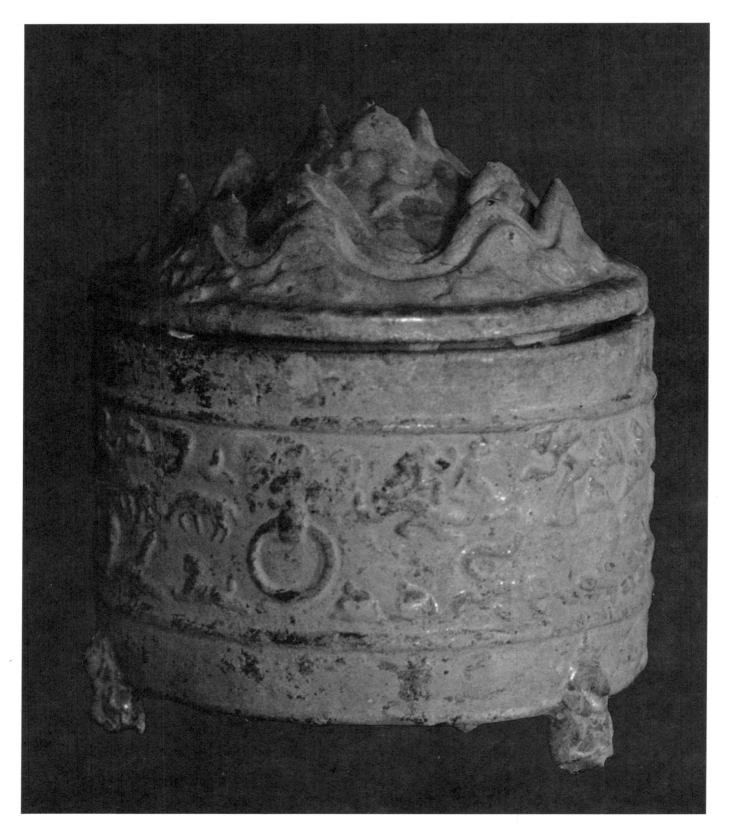

Hill Jar

Han dynasty, 206 BC – 220 AD

Earthenware

24.7 high x 20 diameter

The Minneapolis Institute of Arts
Anonymous gift
89.43.1a, b

Han dynasty, 206 BC – 220 AD

Earthenware

21.6 high x 19.3 diameter

Seattle Art Museum
51.199

The three hill jars grouped here have band decorations that eliminate forms of mountains and emphasize activities of animals and other creatures. Those images are placed in a horizontal row without reference to a ground plane. It must be understood that the band designs, even though they do not include the images of mountains, are still depictions of the intermediary realm of the sacred mountains. This point is supported by the three-dimensional mountains on the jar lids and by the activities of the spiritual beings shown in the bands, which are comparable to those of more clearly defined mountain scenes in other hill jar representations.

The representations in the bands of these hill jars lack the scenes of the confrontation of animals; instead they introduce figures, such as those riding on dragons who are greeted by winged men. These features indicate that the areas represented are, within the intermediary realm, closer to heaven than to earth. It is possible to interpret the men on the dragons as symbols of the souls of the deceased, who, after ascending to heaven on the backs of dragons, are greeted by officials of heaven.

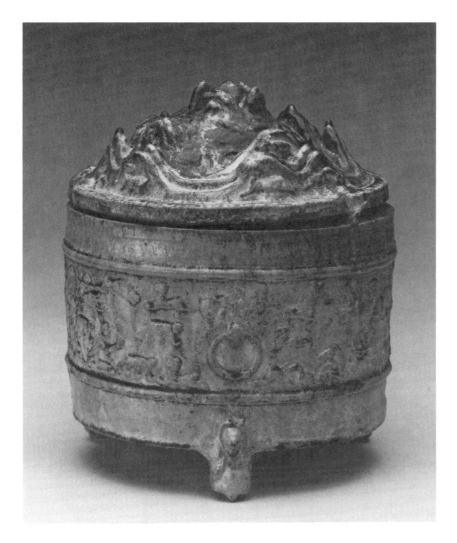

Hill Jar

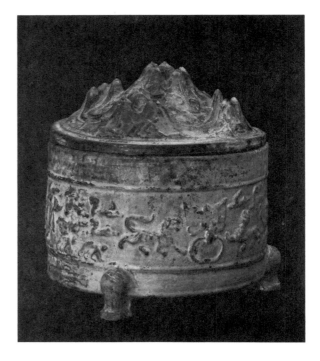

Hill Jar

Hu Vessel

✧ **36**

Han dynasty, 206 BC – 220 AD

Earthenware

33 high x 25.4 diameter

The Portland Museum of Art
Ella M. Hirsch Fund
38.41

This large and beautifully made *hu* jar has a band on its shoulder where mountain scenes are represented in low relief. Mountains are shown with a wavy double line over which many animals are shown running. Each image is relatively deeply carved, so that the figures are clearly seen. The use of incised lines and dots in depicting the surface patterns of the animals is effective.

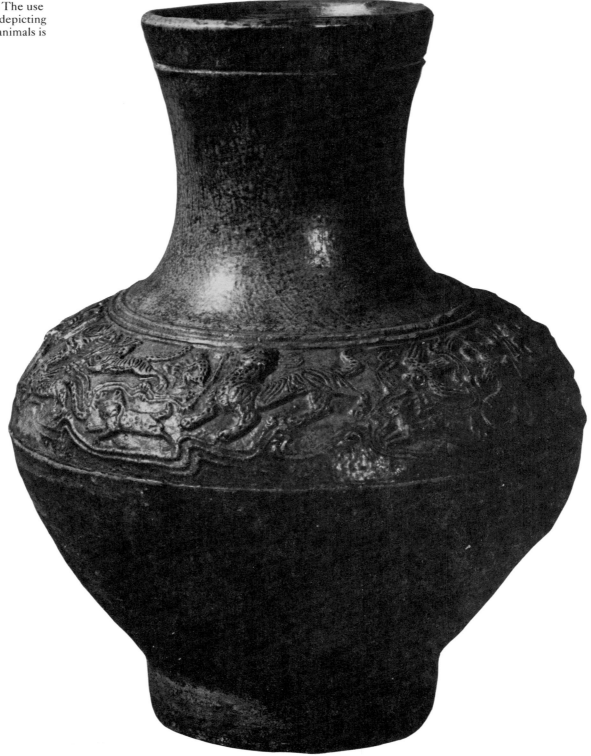

Hu Vessel

Finely decorated bronze mirrors from the Han dynasty through the Tang dynasty have long been admired for their beautiful and intricate designs. Decorations on mirror backs are images cast in relief and represent delicately detailed motifs. The main themes of these mirror decorations are essentially "cosmic images." Some symbolically represent the structure of the cosmos as a whole, and some symbolize the deities, immortals, monsters, animals, and birds residing in heaven, earth, and the intermediary realm between the two; others represent the sacred mountains in a diagrammatical way or show the immortals' activities in those mountains in narrative form.

Mirrors in early China had significance beyond their ordinary use as reflecting surfaces. Their mystical power to reveal "truth" was utilized in magic and rituals. The First Emperor of the Qin (reigned 221–210 BC) used a special mirror to test his harem ladies. It was said that it revealed the viewer's intestines as well as her thoughts, performing the combined functions of a present-day x-ray machine and a lie-detector. The Daoists, when they stayed in solitary mountains, carried with them mirrors in which they were able to see the true identity of disguised monsters. The mirrors decorated with cosmic themes must have been considered tools for reflecting the powers of the cosmos. Inscriptions cast on mirrors as part of the decorative designs are usually prayers for the happiness and prosperity of the owners and their descendants, seeking protection for them by the power of the harmonious cosmos.

In many Han mirror decorations the mountain theme is not quite obvious due to the abstract, symbolic nature of the depiction. However, since the Han people treated the sacred mountains as cosmic pillars or intermediary realms between heaven and this world where many deities, strange creatures, and immortals resided, the spaces filled with peculiar creatures in mirror designs can be safely interpreted as the realms of the spirit mountains. Some late Han mirrors represent the Queen Mother of the West, who was believed to live on Mt. Kunlun, or immortals having an ordinary human appearance and engaging in a variety of activities in the mountains. These later, more narrative depictions do not really indicate a change in the underlying theme. They were still meant to represent the blissful intermediate realm within the cosmic entity, a realm through which heaven's will would be sent down to earth.

The decoration of mirrors after the Han and continuing through the Tang dynasty (618–907) followed the trend of late Han development and tended to be more narrative, showing the activities of deities and immortals in human form. Images of mountains also became more clearly identifiable. Some of the Tang mirrors representing the immortals' islands attained a poetical flavor. The mirrors of this period, loosely called the medieval era, reflect China's cultural development from the ancient to the modern era.

TLV Mirror

37

Han Dynasty, 206 BC – 220 AD

Bronze

15.2 diameter

The Minneapolis Institute of Arts
John R. Van Derlip Fund
52.11.4

TLV mirrors are so named because the designs on the backs of these mirrors include symbols that appear like the letters *T*, *L*, and *V*. Commonly there is a square at the center which is enclosed by a circle, with *T*s placed perpendicular to the four sides of the square, *L*s on the inner rim of the circle just opposite the *T*s, and *V*s on the circle opposite the four corners of the square. Scholars generally agree that the central square stands for earth, which was imagined to be in a square form, and the circle for heaven, which was thought to be a dome covering the earth; they also agree that the total design is a diagrammatical representation of the cosmos.

The symbolic meanings of the *T*, *L*, and *V* are uncertain, and many possible interpretations have been proposed. One way to approach this puzzling problem is by starting from the most obvious. If the circle means heaven and the square, earth, the space between them should be the intermediary realm. This space on a TLV mirror is filled with many creatures, and it corresponds to those intermediary realms associated with mystical mountains that are represented on various types of objects from the Han dynasty, such as hill censers and hill jars. One important consideration here is that although the central square must mean

Figure 37

earth, its inside motif of a boss surrounded by four petals is a lotus flower which symbolizes the center of heaven in the Han iconography (Hayashi 1989: 219–79). In other words, the central square is earth in the middle of the cosmos, to which the central part of heaven is projected.

A backgammon-like game called *liubo*, which was popular during the pre-Han and Han periods but has been long forgotten, used a playing board which had a structure very similar to that of the mirror design—a central square and *T*, *L*, and *V* motifs surrounded by a larger square, as seen on objects discovered by archæologists (fig. 37). The way it was played has been reconstructed to some degree (Yang 1952: 124-39). The player moved his "horse" according to the result of throwing dice, starting from the *V*, and was allowed to jump to *T* with a particular throw, then further to *L*, and finally to the inside of the central square. The symbolic meaning of these moves seems to have been that the player started with a corner of the world (*V*), then moved to the top of a cosmic mountain (*T*), on to a gate into the dome of heaven (*L*), and finally to the center of heaven (the space inside of the central square). This was a cosmic game, and was believed, understandably, to be a game which immortals liked to play. In some late Han decorations, on mirrors as well as on the walls of tombs, there are motifs of immortals playing this game. There is no reason to doubt that the *T*, *L*, and *V* in the TLV mirror decorations had the same symbolic meanings.

The creatures filling the intermediate space in the Minneapolis mirror include the four directional deities—dragon (east, and also symbolizing spring), bird (south-summer), tiger (west-autumn), and intertwining snake and tortoise (north-winter). Among the four deities, the positions of the dragon and tiger are reversed in relation to the north-south axis. This discrepancy, which is relatively common in the Han designs, can be explained; this arrangement places the four directions of the mirror in the proper order when the mirror is turned so that the front (reflecting) side is up.

The inscription placed in the circular band reads, clockwise:

The light of this mirror causes a joyous thought. On it are the dragon and the tiger which keep the order of the four seasons. May our parents be protected long years, and our joys not be disrupted. May our descendants live peacefully, and preserve wealth and prosperity. May heaven's favor have no end, providing kind aids to the emperor and averting all that is evil.

(translated Munakata)

TLV Mirror

TLV Mirror

38

Han dynasty, 206 BC – 220 AD

Bronze

18.3 diameter

The Nelson-Atkins Museum of Art
Nelson Fund
46-31

This TLV mirror is rich in iconographical details. There is a square surrounding the central boss, and twelve small bosses are distributed around it; these in turn are enclosed by a larger square, on the periphery of which *T*s are placed. In the spaces between the small bosses the characters of the "twelve terrestrial branches"—Chinese zodiac signs—are distributed in consecutive order, counterclockwise, defining twelve directions of earth (in mirror image). *T*s, *L*s, and *V*s divide the area between the outer circle and the square, and mystical creatures fill the remaining space, completing the image of the "intermediate" area between heaven and earth. An inscription, to be read clockwise, is engraved in the circular band adjacent to this space. The outermost circular band is also filled with mystical creatures.

The inscription reads:

The Han empire possesses fine copper produced in Tanyang. It was refined and mixed with silver and tin and became bright like the sun and moon. The dragon on the left and the tiger on the right provide [four seasons] with four forces, and the Red Bird and the Black Warrior harmonize the [forces of] yin and yang.

(translated Munakata)

Here, left and right are determined in relation to the emperor, who faces south, thus meaning east and west, respectively.

The creatures in the space between the circle and the square are represented in dramatic postures that clearly convey their counterclockwise movement. There are three of the Four Guardian Deities: Red Bird (south, upper-left corner in the illustration), Blue Dragon (east, lower-left corner), and White Tiger (west, upper-right corner). In the place of the Black Warrior of the north, which is usually shown with the image of a combined tortoise and snake, there appears a goat-like animal with a long curving horn. This creature may be identified as either one of the heavenly animals called *bixie*, or *tianlu* (Hayashi 1989: 78-79, and 139-40). This irregularity is possibly due to the fact that this mirror was made before the tortoise-snake combination was devised as the image of the Black Warrior sometime during the first century AD. Other creatures which appear in the same space are,

counterclockwise, a monkey, a creature with a bird's head and a dragon's body, a monster holding a snake with his teeth and one hand, and a monkey-like figure riding backward on the back of a large winged hare-like animal. These additional creatures seem to represent those deities which are described in the *Shan hai jing* (Classic of the Mountains and Seas) as residents of the great mountains. If that is the case, the space, which is identified as an intermediary realm between heaven and earth, is represented here as the area where the heavenly deities and the earthly deities interact.

The decoration on the outermost ring is a unique feature of this mirror. Four scenes are placed between *yunqi*

motifs: combinations of a bird and a tiger, a monkey and a dragon, a winged animal and a monkey-like creature on an animal, and a huge shell from which emerges the upper body of a strange figure. Among them, the figure with the shell could be identified as a deity of winter, north, and the *yin* force, since all creatures with a shell, including tortoises and shellfish, belong to the "winter" category in the Han cosmology. We may take the large bird in the inner circle as the Red Bird, and the shell-figure as the Black Warrior; then we can interpret the inner circle as representing the world of the *yang* force controlled by the Red Bird, and the outermost ring the world of the *yin* force controlled by the Black Warrior. This interpretation at least fits well with the inscription. This mirror offers many problems in the Han iconography, which have to be left for future study.

Reference:
Bulling 1960: pl. 42.

TLV Mirror

TLV Mirror

39

Han dynasty, 206 BC – 220 AD

Bronze

17 diameter

The Metropolitan Museum of Art
Purchase, Rogers Fund, 1917
17.118.42

The decoration of this mirror is similar to the Minneapolis mirror in depicting all four directional deities. However, it shares with the Nelson Gallery mirror the feature of the twelve earthly branches engraved between the bosses in the inner square band. Unlike either of those mirrors, it lacks the prayer-inscription.

The twelve earthly branches are placed in clockwise order, not in mirror image as in the Minneapolis mirror, thus making the directional order correct as we look at them. The locations of the four deities are also in the correct order, except that the directions of the four deities and the directions defined by the twelve branches do not coincide—there is 180 degree gap between the two systems. It is difficult to explain this discrepancy.

One new feature in the Metropolitan mirror is the appearance of a winged immortal. Unlike the designs of the two previous mirrors in which an animal deity confronts another animal deity, the Metropolitan mirror design introduces one winged man facing the Black Warrior across a *V* of the north corner. This feature foresees the trend of the association of the immortal cult with mirror designs, which became fashionable probably from the late first century AD onward.

Reference:
Bulling 1960: pl. 36.

TLV Mirror

94

 40

Mirror with Images of Deities

Han dynasty, 206 BC – 220 AD

Bronze

17.8 diameter

The Metropolitan Museum of Art
Purchase, Rogers Fund, 1917
17.52

Toward the end of the Western Han, the cult of the Queen Mother of the West as the residing goddess of Mt. Kunlun reached its zenith. By this time she became a goddess who assured longevity and other worldly pleasures to the believers. The official history of this cult, which involved huge numbers of peasants, records that an explosion in its activities took place around 3 BC. The decorations on mirrors, as well as those on the walls of tombs of aristocrats and other influential people, attest that from the first century AD onward the cult of the Queen Mother of the West enjoyed great popularity also among the people of the ruling class, particularly during the Eastern Han and the periods immediately following. The King Father of the East, who had no mythological origin, was invented as a consort of the Queen Mother about this time and was worshipped as a member of the pantheon.

On the Metropolitan mirror, in a circular band surrounding the central circle, the Queen Mother is shown as a beautiful queen with two wings growing from her shoulders. She is seated and is attended by two standing ladies. The King Father is also seated and attended by one standing man. Between the king and his attendant there is a strange object that looks like a pile of combs. Since these comb-like objects are seen here and there on the base line of the composition, they seem to represent peaks of mountains. In the space to the left of the king, an immortal hurries on the back of a galloping horse, followed by a "fat bird." Whatever the bird's mythological identity may be, it is a common member of the transcendental world, including that shown on the TLV mirrors. A dragon and a tiger occupy the remaining two spaces.

The inscription placed in the outer circular band reads:

The Blue Dragon made this mirror which is of an unsurpassed quality. / May you reach the rank of the "three dukes" like the King Father of the East, / And may you attain longevity comparable to the Queen Mother of the West.

(translated Munakata)

There are some instances among Han mirrors when the inscription claims the Blue Dragon as the maker of the mirror. Probably this indicates that the power of the Blue Dragon was invoked during the process of making the mirror.

The decoration of this mirror differs from other standard mirrors of the type, since it places the queen and the king in asymmetrical positions, and includes the rushing immortal on horseback and the mountain motifs in the composition. It retains a suggestion that the realm represented is an upper part of the intermediary realm between heaven and earth.

Reference:
Bulling 1960: pl. 68.

Mirror with Images of Deities

Mirror with Images of Deities

☙ **41**

Han dynasty, 206 BC – 220 AD

Bronze

20.5 diameter

The Art Institute of Chicago
Lucy Maud Buckingham Collection
1929.644

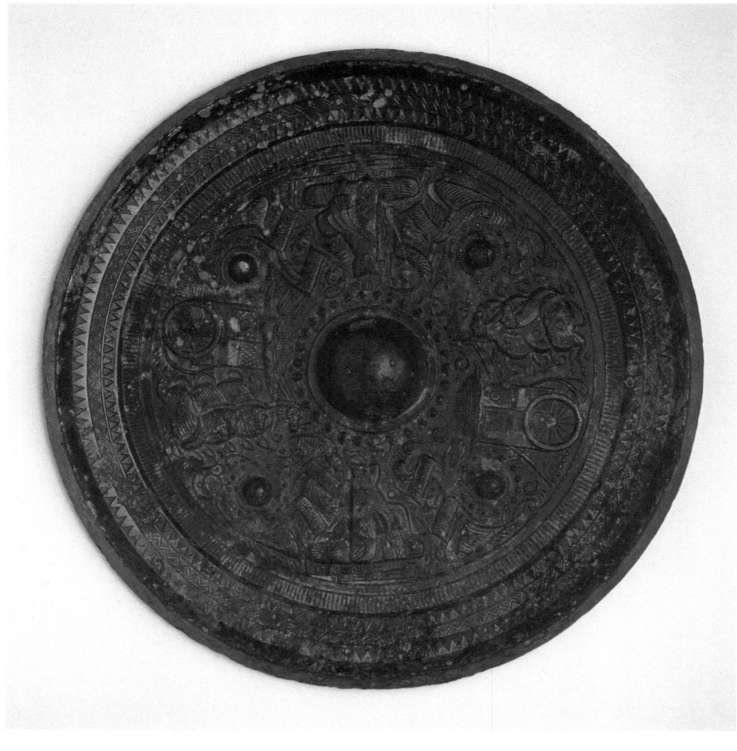

Mirror with Images of Deities

The Queen Mother of the West in this mirror does not have her usual hairpiece, called a *sheng,* which is a horizontal bar with a ball-shaped object attached on each end. Instead she wears a hat with a flat top and two semicircular patterns at the front (at bottom in the illustration). She is attended by two immortals on each side—one stands behind another who is seated. On the opposite side the King Father of the East, identified by an inscription, appears almost in the same way as the queen, except that he wears a simpler hat. A chariot drawn rapidly by three horses is placed in each of the spaces between the queen and king.

One interpretation of the chariots in this decoration is that they show the cosmic movement of sun and moon, since the Queen Mother is associated with the moon and the King Father with the sun. Another interpretation is that they simply represent the queen and king on their cosmic tours. Either way, the queen and king appear more like heavenly deities than those residing on the cosmic mountains connecting heaven and this world. A clue to their identity as deities related to this world lies in the presence of the immortals. Each of them carries in his hand a long object that looks like a stalk of straw. According to one study, the peasants involved in the cult of the Queen Mother "carried wands made of stalks of straw or hemp which they passed from one to the other saying: 'I am transporting the wand of the goddess's edict'" (Bulling 1960: 87). The immortals in this mirror design were possibly regarded by the people at the time as the messengers of the queen and king to this world. This mirror design is not as elegant as some other Han mirror designs, but has a raw energy that captures the viewer.

Reference:
Chinese Bronzes from the Buckingham Collection: pl. lxxxiv.

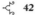 **42**

Mirror with Images of Deities

Six Dynasties period, 220–581 AD

Gilt bronze

15.2 diameter

The Minneapolis Institute of the Arts
John R. Van Derlip Fund
52.11.7

This beautiful gilded mirror is ascribed to a post-Han period. Its composition, however, follows basically the one created during the late Han. In the widest circular band, the Queen Mother, wearing the *sheng* hairpiece, is seated on a dragon, and is flanked by two lion-like animals. The King Father, placed opposite her, appears almost identical to the queen, except without the hairpiece. Neither figure has wings as in earlier representations, but instead, both have two cloud-like scrolls growing from their shoulders. In one space a deity shows a cloth-like object to a confronting bird, and in another space a deity faces a winged immortal who gestures dramatically.

A second, narrow, circular band, counting from the outside, shows many creatures flying at great speed; they include two phoenix-like birds, six crane-like birds, a dragon-like monster, a tiger, an elephant, a winged immortal on a boat-shaped *yunqi* cloud, and another immortal sharing another cloud-boat with a monstrous bird. Apparently this space represents the intermediary realm between heaven and this world.

An inscription is placed in a narrow band just outside the major band representing the deities; one word appears in each of several small squares arranged in clockwise order. The resulting inscription reads:

The "nine sons" made this treasure. / May the person who carries this be with the three blessings [i.e., happiness, longevity and wealth].

(translated Munakata)

The "nine sons" refers to the nine stars in the constellation of Tail (the Scorpion in Western astronomy), which is supposed to be the tail of the Blue Dragon. The "nine sons" as a maker of the mirror is, thus, a variation of the Han inscription which claims the Blue Dragon as the maker (see cat. no. 40).

Mirror with Images of Deities

Spirit Mountain Mirror

43

Sui dynasty, 589–618

Bronze with green patina

18.4 diameter

Indianapolis Museum of Art
Gift of Mr. and Mrs. Eli Lilly
60.15

This mirror ascribed to the Sui dynasty follows the tradition of the TLV mirrors of the Han dynasty. It has a central square (earth) and *V*s which are attached to an encircling band (the bottom of the dome of heaven, with four corners defined by the *V*s); four mythical animals fill the "intermediary" space. Within each *V* "is an ogre face biting the enclosing ring—one opposing pair is in profile and the other pair is presented frontally" (*Beauty and Tranquility*: 142).

The inscription placed in one of the outer circular bands reads as follows:

The spirit mountain is the mother of this treasure; / A divine messenger the supervisor of the furnace [operation]. / Its shape is round like the moon of the dawn, / Its light pure like the pearl of the evening. / [The lady on] the jade terrace, a rare beauty in the world, / [Shall reflect in this mirror] her face for applying powders and rouge. / May one thousand joys be gathered on that image; / May one hundred happiness come to it.

(An original translation of this poem is in *Beauty and Tranquility* [142]; here it is retranslated.)

The term "spirit mountain" (*lingshan*), while still carrying a zoomorphic image, now resonates with a romantic tone that is remarkable.

Reference:
Beauty and Tranquility: pl. 46.

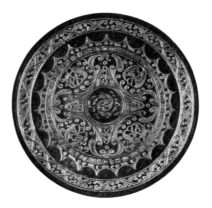

Figure 38

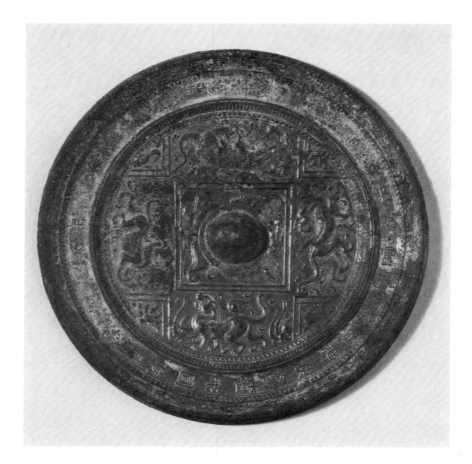

Spirit Mountain Mirror

Marriage Mirror

44

Tang dynasty, 618–906

Bronze

20.2 diameter

Seattle Art Museum
Eugene Fuller Memorial Collection
45.32

This mirror is called a marriage mirror because of its function as a protective charm to be given to a bride or groom. The inscription placed in the outermost circular band reads counterclockwise:

Birds, animals, fish, bamboo, grasses, trees, marrying sun and moon, and the golden hairpiece; all of them show the auspicious omens.

The next circular band includes the images of those auspicious omens, including lotus, bamboo, trees, rice, and wheat, which grow as pairs, often crossing stems with their partners; a pair of birds each of which has only one wing, and a pair of fish each of which has only one eye—they can only fly or swim when they are together with their mates (they are shown as a single flying bird and single fish in a pond); the sun and the moon rising together (a circle with a bird inside it, symbolizing the sun, with a crescent attached at the bottom to represent the moon); and a golden hairpiece called *sheng* (shown in the form of a bar with a wheel attached to each end), which is the familiar hairpiece of the Queen Mother of the West. The auspicious omens are supposed to be unusual but actual happenings (miracles) in this world to be witnessed by the people, and are interpreted as revelations of heaven's will. The omens included here focus on the theme of two people being together, growing and working together, thus assuring a happy marriage that will last forever.

The main motif in the center of the mirror is a diagrammatical representation of the Five Sacred Mountains, with the knob appearing as the central mountain. The waters represented between the mountains are the Four Sacred Rivers (they can be interpreted as the Four Seas surrounding the earth). The design of the central motif of this mirror decoration closely resembles the so-called "animal-head mirrors" of the Han dynasty, popular during the second and third centuries AD (fig. 38). Whether the "animal-head mirror" design was conceived by the Han people as symbolizing the Five Sacred Mountains is difficult to prove. However, it is very clear that this design became a prototype for later artists, during the Six Dynasties period, who modified some details of it and created a clearly identifiable diagrammatical formula of the Five Sacred Mountains.

In the marriage mirror design, auspicious clouds rise over each of the peaks of the four mountains, and in the sky four additional auspicious omens appear. The Sacred Mountains and Rivers apparently give their blessings to the newlyweds, joining all the auspicious omens that heaven sends to them.

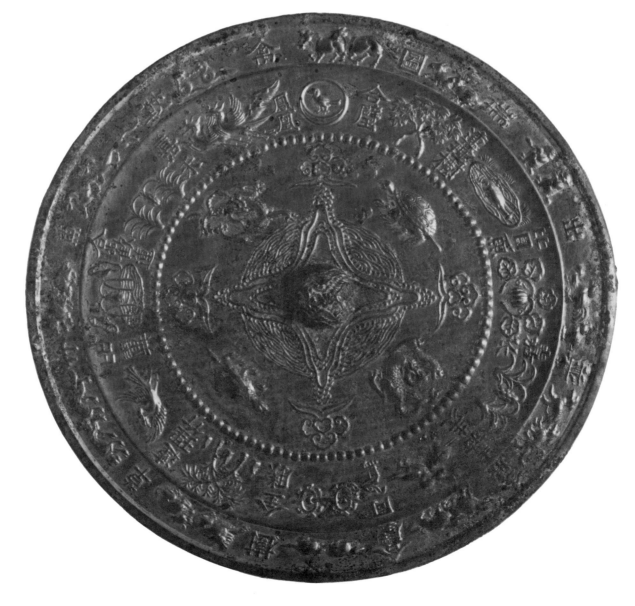

Marriage Mirror

*Cosmic Mirror with Mountains Showing
the Four Directions*

45

Tang dynasty, 618–906

Bronze

23.7 diameter

Seattle Art Museum
Eugene Fuller Memorial Collection
51.32

The design of this mirror is a naturalistic representation of the theme of mountains. The central knob is made in the form of a mountain. Surrounding it is a circular area of water with a lively wave pattern. At the periphery of this water area, a towering mountain of three peaks is placed at each of the four directions. Each mountain has a smaller hill at the bottom of it, facing the water, and grass can be seen on the side of this hill. The land expands from there: many animals roam around on the plains, and beyond (above) them roll distant mountains with growing trees. In the sky are auspicious clouds and flying birds. It should be noted that the design is a variation of the diagrammatical Five Sacred Mountains seen in the *Marriage Mirror* (cat. no. 44).

Four Chinese characters are placed in the water area: *jiang* (river, which refers specifically to the Yangzi River), *zhong* (on, inside, middle, etc.), *wu* (five), and *ri* (day or sun). The best possible way to read the four characters as a phrase in the present situation is "on the fifth day in the (Yangzi) River." The "fifth day" in this case refers to the fifth day of the fifth month, the day of the Duanwu festival. According to Wu Zhun (469–520), this day was traditionally associated with the suicide of the administrator-poet Zhu Yuan (active around 300 BC), the cultural hero who chose death instead of accepting the foulness of this world. Wu says that on this day the people in the middle Yangzi River region mourned and threw bamboo tubes filled with rice into the water as a sacrifice to the soul of their tragic hero (Dun Chong 1906: 27a-27b). It is most logical to assume that this mirror was made in commemoration of this festival in the middle Yangzi region.

Some major points in interpreting the Seattle mirror composition may be drawn from the discussion above. The water in the design was regarded as the Yangzi River and the mountains as those most prominent in the Yangzi River region. Among the four mountains, two placed on the opposite sides of an axis are more prominently represented than the others—a deity stands in front of each of these two mountains. Since all the animals represented, as well as the inscription, move in a clockwise direction, the flow of the water is assumed to be in this direction. When we take the mountain shown at the top in the illustration as the starting point, the two distant mountains, seen between the prominent mountains on the right side, are three-layered, and the two on the left have just one layer. Thus, the landscape would move from the more mountainous upper Yangzi to the flatter lower Yangzi. It is also inferred that the Yangzi River runs clockwise and spirals into the sea, at the center of which is a mountain-island which is supposed to be the immortals' island in the Eastern Sea.

The decoration of the Seattle mirror as a whole is an iconic representation of the landscape of southern China. The great mountains are still represented as the sacred realms of wilderness in which deities and wild animals reside. The great river is also shown in its mystical aspect, implied by the existence of monstrous fish among other fish and waterfowl, by the presence of Qu Yuan, who is now deified and resides among other water deities, and by its long spiralling flow into the mysterious Eastern Sea.

Reference:
Umehara 1945: no. 68.

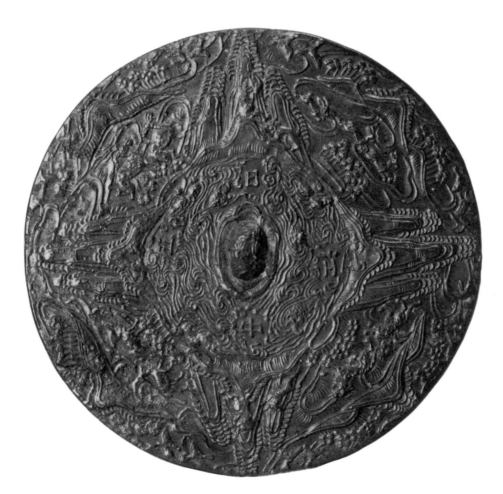

Cosmic Mirror with Mountains Showing the Four Directions

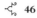

Mirror

Tang dynasty, 618–906

Bronze

17.3 diameter

The Art Institute of Chicago
1932.45

The figure playing the *qin* zither is Boya, a deified master of the musical instrument. He appears among other deities in some of the Han mirror decorations. In many Tang mirrors he is shown alone playing the *qin* on the immortals' island of Penglai in the Eastern Sea. The story is that when Boya was studying the *qin* under his teacher, Cheng Lian, the teacher took him to Penglai Island and left him there alone, asking him to keep practicing the instrument. According to the legend, Boya kept playing the *qin*, expressing his intense feelings toward his teacher and toward his new environment, which included the sound of the breaking waves, the darkness of the woods, and the sad voices of the birds. When the teacher returned to the island after a long time, he found that Boya had reached the divine level both as a person and as a *qin* player.

The mirror design represents Boya playing the *qin* in a paradisiacal place with lotus growing from a pond and auspicious clouds floating above. The mountains seen in the distance symbolically define the place as the Penglai Island, far away from the mainland.

Reference:
Umehara 1945: pl. 63 bottom

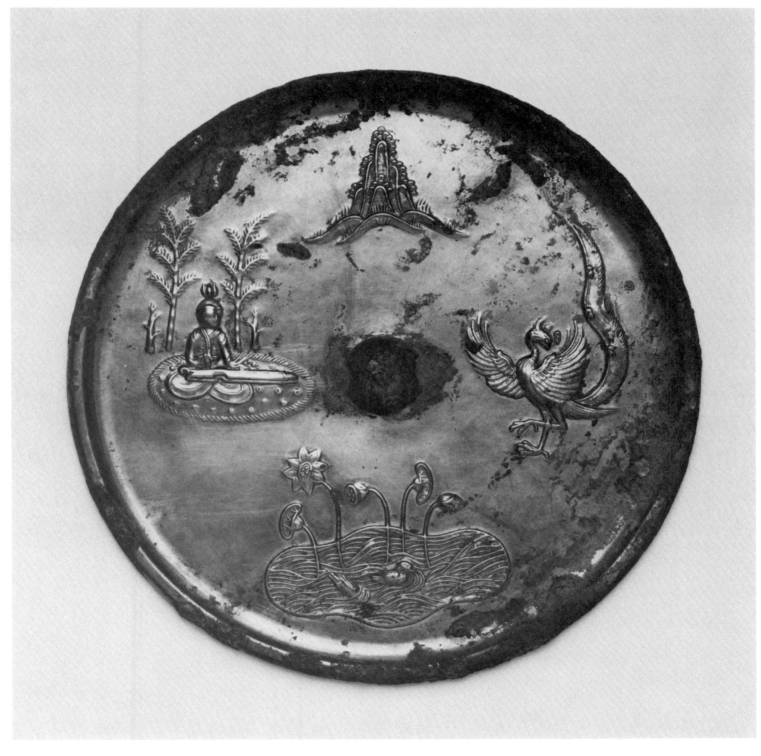

Mirror

Rubbings from Reliefs on the Walls of Han Tombs

Decorations on the walls of tombs became common beginning in the late Han period, from about the first century AD onward, when the tombs of upper-class people started to take the form of elaborate architectural units, somewhat like underground houses with many chambers. Those decorations are either paintings on plastered surfaces, or reliefs on stone slabs or baked tiles, and are found not only on walls, but sometimes also on pillars and beams.

The main purpose of the tomb decorations was to provide an appropriate spiritual environment for the deceased. According to common Chinese belief, a human being has two kinds of souls, one, a spiritual soul called HUN, and another, a physical soul called PO. After a person's death, HUN ascends toward heaven, while PO remains with the corpse. Elaborate tombs were apparently for the benefit of PO souls. However, the decorations of the tombs were often for both HUN and PO. For example, the decorations in

certain tombs include a scene of a cosmic mountain that reaches the top of Mt. Kunlun where the Queen Mother of the West resides. This scene was an expression of prayer for the successful ascent of the HUN of the interred person. On the other hand, scenes of annual rituals and other activities from daily life included in the decorations were prayers for the PO in the netherworld, and possibly wishes for the continued prosperity of the deceased person's descendants in this world.

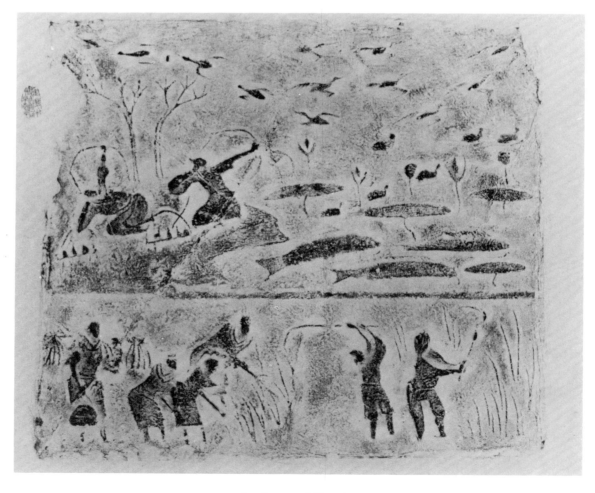

A. Scenes of Hunting and Plowing-Planting

Modern Rubbings from the
Wall Reliefs of Tombs in Sichuan

Han dynasty,
second and third century A.D.

Sizes vary

Private Collection

Scenes of Hunting and Plowing-Planting

These scenes are often taken as events from daily life. However, more serious religious meaning seems to have been attached to them. The shooting of birds with arrows is a subject commonly included in the decorations of the ritual bronze vessels of the Warring States period (see cat. no. 13). It was a part of the annual ritual performed in the royal Zhou court or in the feudal vassal's court during the Zhou dynasty. The Sichuan scene of shooting birds has an almost complete iconographical precedent in the decorations of the so-called Jannings *hu* in Beijing from the Warring States period; both include the major elements of the "hunting" ritual—archers, flying birds, waterfowl, and fish in the water (fig. 39). The only difference is that the Han representation, though still essentially conceptual, is more rational, showing all of the elements in a unified scene. The scene usually identified as "harvesting" is more likely a scene of plowing and of planting rice seedlings. "Imperial Plowing" was one of the major festivals of the Han which can be traced back to the Zhou dynasty (Bodde 1975:223-41). "Planting Seedlings" is not listed among the Han festivals, but its iconographical precedent is found in the decorations on a bronze vessel excavated in Huaiyin ("Huaiyin Report," pl. 13). It is not that the local people represented imperial festivals, but that they depicted local annual festivals which continued from the Warring States period as the custom of the ruling class, with some of the iconographical traditions kept intact.

Reference:
Stories from China's Past: pl. 9.

A Scene of the Salt Industry

The scene of salt making, an important local industry, is represented here in a mountainous region. Saltwater is taken from a deep well, and is piped to the place where it is boiled down in large kettles to produce salt lumps. This image has also been treated as a scene of daily life. However, its religious significance is clear in its structure of overlapping triangular peaks; with the exception of those mountains where salt is actually being made, the peaks are shown as areas where animals, birds, or hunters roam, as in the compositions of the mountain censers. This scene, therefore, must be meant also to depict a sacred mountain, with the additional local element of the mountain as the benevolent provider of salt.

This scene, as well as the previous "hunting" scene, does not show the sacred mountain as an intermediary realm in the communication between heaven and earth; rather, the mountain is a benefactor that provides society with crucial earthly products necessary for prosperity.

Reference:
Stories from China's Past: pl. 14.

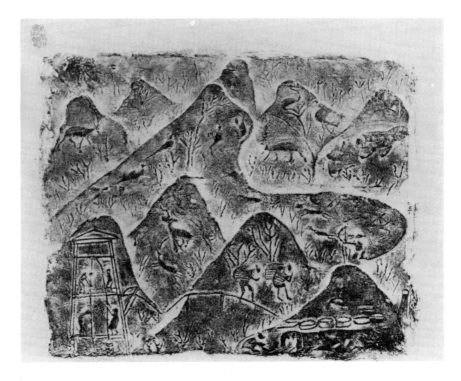

B. A Scene of the Salt Industry

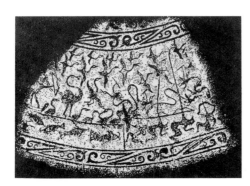

Figure 39

Images of the Queen Mother of the West

The Queen Mother of the West, the resident goddess of the cosmic mountain Mt. Kunlun, is seated on a canopied throne with the head of a tiger on her left and the tail of a dragon on her right. The Queen Mother, who by this time had been elevated to become the central deity in the immortals' cult, commands the ceremony of bestowing elixir on the deceased. In the central position in front of the queen a toad is dancing, holding a stalk of straw or hemp, a symbol of the goddess's edict (see cat. no. 41). To the right, a hare holds an elixir plant. To the left of the toad is a bird with three legs, which is usually a symbol of the sun, but is sometimes referred to as a servant and messenger of the queen. The toad and hare are residents of the moon; thus together with the bird, they show that sun and moon are under the queen's command (S. Cahill 1985: 22-24). To the far right of the queen there is a winged fox with nine tails. This mystical animal sometimes appears in Han representations of heavenly scenes, but its exact relationship with the queen is not clear. On the lowest level, in the foreground, a figure bows in front of the table, and a pair of figures, a male and a female, is seated to the right of the table. Probably the bowing man was the one who performed the funeral ritual, and the pair represents his parents who were buried in the tomb. It was for their souls that a prayer for attaining immortality—a request to reside in the paradise of the queen forever—was offered. A peculiar figure standing to the left of the bowing man looks like an exorcist, but here probably stands as a guardian of the gate for the queen.

This scene of the Queen Mother of the West is tightly organized in a hierarchical way, and appears almost like a religious icon.

Immortals Playing the *Liubo* Game

This is a common scene of two immortals engaged in playing the *liubo* (also called simply *bo*) game. Although this activity is represented without showing its environment, it is an event that takes place on top of a sacred mountain, as attested by many other similar scenes from the same period which clearly indicate the location. The game is played in a rectangular playing space; on the far side is a square gameboard, and on the near side is a place to throw dice shaped like short square rods. The design of the playing board is not clearly shown here, but it is supposed to appear close to the design of the TLV mirrors in its basic elements (see cat. no. 37).

In the scene, two immortals are playing the game with animated gestures, and the third immortal, an observer, appears to be involved in the excitement of the game as much as the players are. Since the game of *liubo* is a cosmic game of moving the "horse" in and out of heaven, earth, and the intermediary realms, it symbolizes the status and life of the immortals. At the same time, the scene of the flamboyant and free life of the immortals represents the ideal which the Han people yearned to attain after death.

C. Images of the Queen Mother of the West

D. Immortals Playing the LIUBO Game

Later Paintings

The concept that great mountains contain hidden realms where deities, ghosts, and monsters roam and sometime harm people in nearby communities never really died. Instead, it has been quite alive in folk culture throughout the history of China. Folk tales and ghost stories related to mysterious mountains are abundant. More seriously, the cultural heroes who were known to have successfully pacified the malevolent powers of nature were worshipped at shrines that were specifically built for them. One of the most popular heroes in this regard was the god Erlang. Relatively large numbers of paintings depicting legends of Erlang are extant. At least three narrative handscrolls on this subject are in collections in this country. The extant works on this theme are painted in different styles and indicate that paintings of this subject were popular in different periods, possibly from the Song dynasty onward, and were enjoyed by diverse circles of people.

Searching for Demons on Mt. Guankou ○ *Detail*

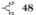
The theme of this scroll is the capturing and destroying of demons on Mt. Guankou in Sichuan province by ghost soldiers under the command of God Erlang. This painting carries a signature of Ding Yefu, a Yuan painter who followed the tradition of the Southern Song Academy artists Ma Yuan and Xia Gui, and is dated 1327. However, it has been reattributed to an anonymous painter of the Ming dynasty, around 1500 AD, because of its representational style.

God Erlang was probably originally a local nature deity. However, over time, various historical figures who helped the people by controlling floods were ascribed one by one to the person who became God Erlang after death. The earliest historical figure identified as Erlang was Li Bing, a governor of Shu (Sichuan) in the state of Qin during the Warring States period, in the early third century BC. Later, Zhao Yu, a governor of Jiazhou of Sichuan during the Sui dynasty (581–618), and Yang Jin, a eunuch of the Northern Song court in the eleventh century, became historical identities of Erlang. Among those, Li Bing, or sometimes his second son (*erlang*, in Chinese), is the most likely identity of Erlang; most important for us, Li Bing's divine deeds, which were recounted in folk legends, became some of the elements in the present scroll painting (Rong 1929).

The Princeton scroll, like most of the extant scrolls dealing with this theme, does not depict God Erlang in combat with monstrous animals, one-on-one, as recounted in the legends. Instead it shows him as a commanding general, seated and surrounded by attending ghost soldiers. The scroll begins with a few soldiers holding snakes and a tiger which have already been captured and contained— one snake is still resisting by emitting fire from its mouth. The God Erlang, wearing a white robe without armor, is receiving a report from a bowing soldier. As the story unfolds there are many scenes in which ghost soldiers fight against animals and monsters in the mountains and in the river. There is a huge dragon chained and carried by the soldiers, a gigantic shark-like fish (a mythical fish called *jiao*) and an octopus just captured in the river, and a huge bull chained and being pulled. The dragon, bull, and *jiao* fish are those which folk legends said Li Bing was to have subdued. Other animals shown killed or captured in the scroll, such as the wolf, bear, tiger, snake, frog, and

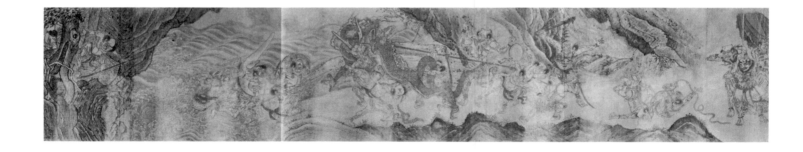

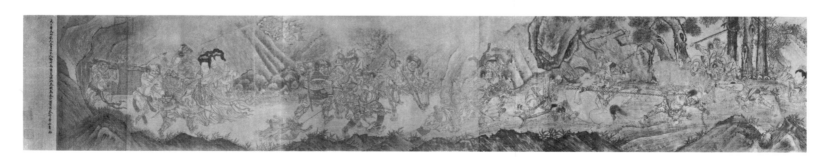

Searching for Demons on Mt. Guankou

deer, are all those which are often seen in the mountain scenes represented as the "realms of wilderness" on various objects from the Han dynasty.

Beautiful ladies appearing in the scroll are demon-ladies. Their true identities are revealed by their feet; some look like monkey's feet, and some like human hands with long fingernails. One of the women is shot by a soldier, another attacked by a hawk. Some are still trying to seduce soldiers with their coquettish postures, an effort which seems to be working, at least temporarily. Ghost soldiers who work for Erlang and the demon-ladies do not appear in the Erlang or Li Bing legends, but appear in a Yuan drama based upon the Erlang legends, called *Drunken Erlang Shot Through the Demon-locked Mirror.* This drama does not agree in details with the contents of the scroll painting, and cannot be considered a textual basis of the painting. However, certain similarities of the contents of the painting and the drama suggest that both were derived from a comprehensive story of God Erlang written before the Yuan dynasty (Wang 1989).

As far as literary records are concerned, Gao Yi, a well-known figure painter of the beginning of the Northern Song, painted a *Searching in the Mountains* around 960 AD, which was presumably a painting of a story of God Erlang (Guo Ruoxu: 3/10a). The earliest extant representation of this subject is a group of line drawings in the format of album leaves from the Southern Song period; they were apparently copied fragmentally from a scroll of the Erlang story, and include scenes that coincide with those in the Princeton scroll (Ch'en 1984). It is possible that a popular literature based upon the Erlang legends was written as early as the late Tang period, in the ninth or tenth century, from which a narrative scroll painting was first made. We have to await further investigation of these problems. Nevertheless, the stories and paintings of Erlang vividly illustrate that the early belief of the mountains as mysterious and dangerous realms of wilderness was strongly retained in folk tradition for a long time in China.

Reference:
Images of the Mind: no. 19

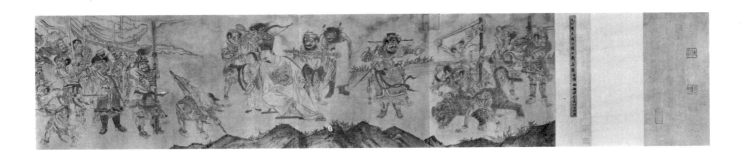

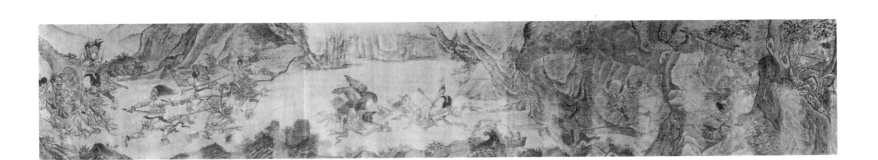

Clearing Out the Mountains: Demons Fighting with Animals in the Forest

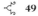 **49**

Ming dynasty, c. 1500

Handscroll, ink and color on paper

37.3 x 927

University Art Museum, University of California at Berkeley
1977.22

This scroll, although vaguely titled, is apparently a painting of the story of God Erlang. It is traditionally ascribed to Jia Shigu, a court painter of the Southern Song, but it is stylistically close to the Wu school of the Ming dynasty, around 1500 AD. Its content is further removed from the original Erlang legends than that of the Princeton scroll; here there is greater emphasis on the ghost soldiers' attack of the demon-ladies, who seem to have controlled the mountain area with their mysterious power. Except for the scenes of fighting against a snake and a dragon, the animals and monsters of the mountain are not the direct objects of the ghost soldiers' attack. Instead, those animals are shown as pets of the demon-ladies, and thus serve to make the women appear strangely eerie and evil.

The Berkeley scroll starts with a group of demon-ladies happily gathering while petting their favorite monsters and animals. The next scene shows the coming of the disastrous end to these happy, evil ladies; here ghost soldiers are already attacking a second group of women who are running toward the first group, asking their help. As the scroll unfolds, the demon-ladies are attacked group by group all over the mountain, and even in the water; some are attacked by divine birds, some are cruelly restrained by the ferocious soldiers, and some desperately ask for mercy. At the very end of the scroll God Erlang appears seated in the same posture as in the Princeton scroll, but here he pays attention to a strange creature to his right.

Although the two scrolls may be attributed to about the same period, the Princeton scroll retains all the elements of an earlier version, and is probably a faithful copy of the Yuan or an even earlier original; the Berkeley scroll, although based upon a similar original, is completely restructured. Many iconographical details, such as Erlang's appearance and posture, his attendants' poses, the ladies attacked by birds, and the lady shot by an arrow, are almost exactly the same between the two versions. The artist of the Berkeley scroll simply rearranged the positions of some scenes, eliminated others, and added some new scenes, in accordance with a new thematic interest. He placed the happy scene of the demon-ladies in the beginning and the group of God Erlang and his attendants at the end, thus putting the main emphasis of the narrative painting on the tragic fate of the evil but beautiful demon-ladies, instead of on Erlang's divine power in crushing the evil elements of the mountains.

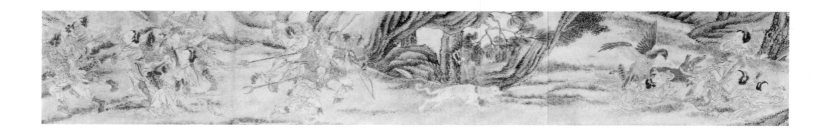

Clearing Out the Mountains: Demons Fighting with Animals in the Forest

The faces of the demon-ladies are quite beautiful, following the plump beauty-type fashionable among Tang dynasty court ladies. Colors are also subtle and beautiful, with a hint of the archaistic blue-and-green style, but showing a softer, more natural application of colors reminiscent of the work of Shen Zhou (1427–1509), founder of the Wu school. The hovering clouds toward the end of the scroll give a heavenly aura to God Erlang. The total effect of the scroll is exotic, erotic, and mysterious.

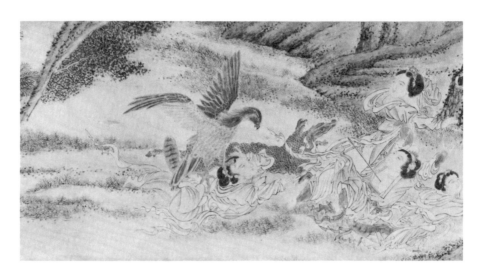

Detail

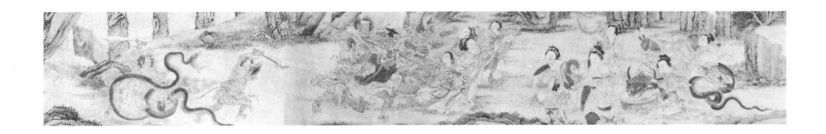

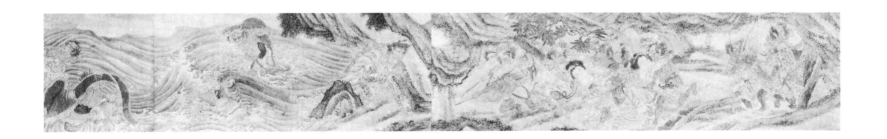

Clearing Out the Mountains: Demons Fighting with Animals in the Forest ◦ *Detail*

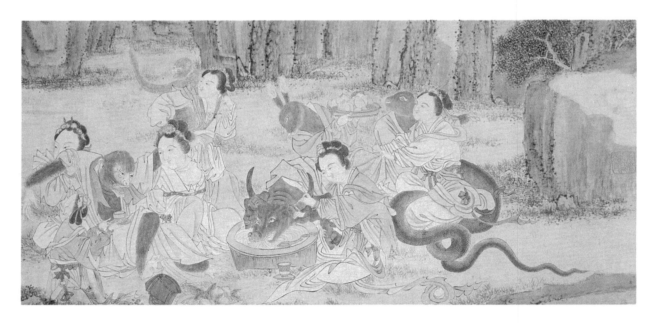

Detail

III.

Religious Daoism developed beginning around the second century AD, combining philosophical Daoism—that is, the thoughts of Laozi (supposedly active in the sixth century BC) and Zhuangzi (active around 300 BC)—mountain worship, the cult of immortals, certain aspects of shamanism, and the elements of various local popular cults. Before the Tang dynasty, Daoism established its status as one of the major religions in China, with its systematized theologies and canons (partially borrowed from Buddhism) and its organization of monastic orders of ordained monks. Its aim was to attain physical as well as spiritual freedom from earthly ties—to attain immortality. The image of an immortal moving freely between heaven and earth was an aspiration for many Chinese, even for those who had little affinity with religious Daoism. It stood as a counterimage to the learned, ethically upright and socially committed ideal man of Confucian thought. Many Chinese intellectuals who were committed to Confucian ideals in their daily work became Daoist dreamers in their free time.

The lands of immortals were, according to early Daoistic thought, hidden in the great mountains and could be reached by human beings only through some designated caves, called DONGTIAN (literally, "cave-heaven"). Later, this concept of DONGTIAN was redefined to suit a more metaphysical cosmic image; according to this thinking, many DONGTIAN existed in the vast stretch of the Great Void between heaven and earth, and the immortals moved freely around heaven and earth and among the DONGTIAN. The imaginary mountains of earlier belief, such as Mt. Kunlun and the island-mountains in the Eastern Sea, are included among those "designated lands."

MOUNTAINS AND DAOISTIC IMAGES OF THE IMMORTALS' REALM

During the formative period of religious Daoism those who aspired to immortality went to the mountains and pursued their spiritual and physical training with the aid of the mystical power of the mountains. Making elixir was a major aim in this pursuit. One of the earliest Daoistic writings, BAOPUZI by Ge Hong (284–363), lists as many as twenty-eight mountains, including the Five Sacred Mountains, as "fine mountains" governed by proper deities, and thus suitable places for making elixir.

When Daoists established their monastic orders, they often located their study centers in some of the mountains renowned for their mystical powers. Mt. Mao of the Shangqing (or Maoshan) sect and Mt. Longhu of the Tianshidao (later, Zhengyi) sect are well known. In addition, the Daoists identified particularly potent mountains, or sections of mountains, in the country and classified them according to their religious importance: there were ten great DONGTIAN, thirty-six small DONGTIAN, and seventy-two FUDI (blessed lands). Here the term DONGTIAN was meant to denote an earthly landmark that would be connected mysteriously with a real DONGTIAN, i.e., a land of immortals. The FUDI were less important sites: the list of seventy-two FUDI is a mixed bag of less well known mountains, a particular terraced cliff or a cave in an area already included in the DONGTIAN category, and, inexplicably, the mountains on the imaginary islands in the Eastern Sea.

Following the lead of first the Daoists and then the Buddhists and other laymen, people started to visit mountains more frequently and became familiar with individual mountains during the Three Kingdoms and Six Dynasties periods (220–588). Consequently, *representations of individual mountains emerged during these periods, although they are not extant today and are known only through literary records. As far as we can reconstruct them from those records, however, the representations were essentially conceptual, with strong emphasis on the symbolic aspects of those mountains; they remained more or less as icons of the mountains. From the Tang dynasty (618–907) onward, the depictions of specific topographic features of the individual mountains became more common. However, it should be noted here that the strongly conceptual character of Chinese culture has kept those paintings of specific mountains in the minority among the vast number of landscape paintings produced through a long history. Even a painting said to depict a particular mountain, or part of a mountain, is, generally speaking, not realistic in the Western sense of the word. The quality of those paintings rather rests in the way the artists meaningfully synthesized the specific aspects of the particular mountains with the general concept of "mountain."*

Wu yue zhen xing tu

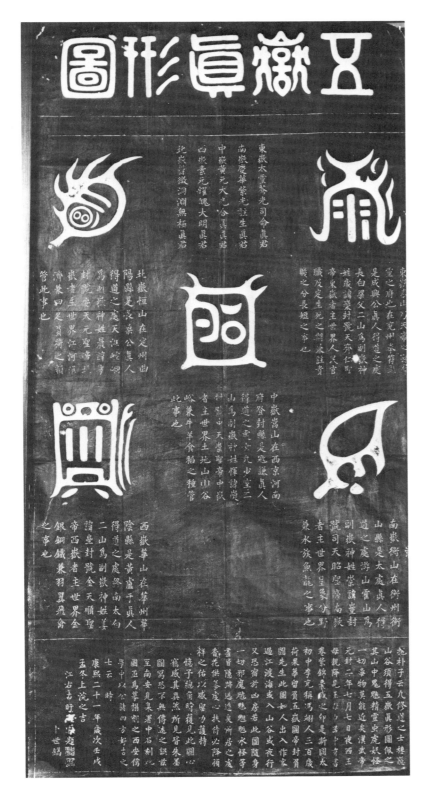

⌁ 50

Diagram of True Forms of the
Five Sacred Mountains

Qing dynasty, dated 1682

Rubbing from a stone stele in Xian,
Shaanxi

124 x 62

Field Museum of Natural History
244121

Five symbolic forms of the Five Sacred Mountains are placed at the four corners and the center of the diagram: clockwise from the right top they are Mt. Tai of the east, Mt. Heng of the south, Mt. Hua of the west, and Mt. Heng of the north, and in the center, Mt. Song of the center. The inscription at the top center identifies each mountain as a deity with its Daoistic name. The inscription placed under each mountain-symbol gives the mountain's location, the name of the most renowned Daoist who attained enlightenment on that mountain, and the particular role of that mountain as an earthly deity. For example, Mt. Tai governs people's destiny during their lives and after death; Mt. Song governs mountains and valleys, as well as agriculture; and Mt. Hua governs gold, silver, and other metals, as well as birds.

The diagram, originally drawn on paper in red ink, or a combination of black, red, and yellow ink, functioned as an amulet, used not only by the Daoists as protection from dangerous animals and evil spirits in their secluded life in mountains, but by the common people to safeguard their households from evil spirits. Its origin is uncertain, but it is likely from the late Han dynasty when more people started to go into the mountains in their quest for immortality. The earliest reference to this type of diagram is in *Baopuzi* by Ge Hong in the early fourth century AD.

The symbolic forms of the mountains are intriguing. The forms that are claimed to be from earlier times are more map-like, and represent conceptually a sort of bird's-eye view of the major part of the mountain complex, identifying its ranges, waterways, and important caves (see fig. 40). The five symbolic forms in the present rubbing are very different from the map-like versions, and it is difficult to relate them to the topographical realities of the mountains. It is possible, however, that they are structured from the point of view of geomancy (*fengshui*, the traditional art of divining topographical forces), emphasizing the flow of the major topographical forces.

Reference:
Chinese Rubbings from the Field Museum: no. 1467.

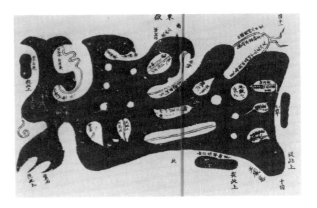

Figure 40

Wu yue zhen xing tu

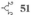

Song Xu, 1523–1605

Twelve Scenes of Famous Mountains

51

Ming dynasty, 1368–1644

Album, three of twelve leaves, ink and
light colors on silk

24.7 x 24.6 per leaf

Sarah Cahill Collection, on extended loan
to University Art Museum,
University of California at Berkeley
CM 65/1-12

Song Xu is generally regarded as one
of the early masters of the Songjiang
painters who flourished in the area of
the city of Songjiang, located southwest
of the Great Lake, not far from Suzhou,
the best-known city and the main
cultural center of the area. Songjiang
gained its status as one of the important
cultural centers in the latter part of the
sixteenth century, and produced many
prominent scholars-officials, poets, and
artists. When the Wu school of Suzhou
declined after the deaths of its leading
master, Wen Zhengming (1470–1559),
and his close followers, the artists of
Songjiang took a leading role in the
sphere of painting. Dong Qichang
(1555–1636) was the most prominent
artist among the Songjiang painters.

Song Xu, a native of Jiaxing, was a
sojourner in Songjiang and settled
there from around 1573. It is said that
he "lived alone at a shrine attached to a
Daoist temple," and a literary source

says that "meditating by a lamp or in
his lonely bed, he was looked upon as
an untonsured monk and held in high
esteem" (Cahill 1982a: 64).

Twelve Scenes of Famous Mountains is
undated and has no attached document
explaining the circumstance in which
Song painted this album. Each of the
twelve leaves in this album has his
inscription giving the name of the
place, his signature, and seal(s). The
"famous places" selected here are
scattered all over China, including
Shandong, Jiangxi, and Henan, as well
as the Nanjing and Hangzhou areas.
The selection is rather arbitrary and

Twelve Scenes of Famous Mountains ◦ *Leaf F*

only one painting is allotted to each place. The paintings are not "sketches" in the Western sense of the word, but are impressions, or the "essence," of the places selected. Song must have visited many of those spots, if not all of them, and painted them with inspiration from his own experiences.

"Mt. Tai" (leaf C) can be compared with the illustrated map of this mountain (cat. no. 4) and Wang Hui's painting of it in the scroll commemorating the Kangxi Emperor's visit (cat. no. 12). Song's painting captures the basic topographic characteristics of this mountain, although it is not quite em-phasis on the scene of the sun rising on this mountain. He placed the central peak on the left side and focused on the eastern peak, which is the spot where visitors gather to experience this mysterious cosmic drama. The peak with a vertical cliff on its eastern side floats over the clouds, and the sun is just above the clouds. The eastern peak itself is adorned with a fine building on its highest spot and, cano-pied by branches of tall pine trees, carries the air of serenity and felicity.

"Shaoshi" (leaf E) is a scene of the Small-chamber Mountain in Mt. Song, the Central Mountain of the Five Sacred Mountains. The artist depicted this mountain with a focus on the cave in which a monk is seated against the wall, meditating. When Boddhidharma, the founder of the Chan (or Zen) Buddhism in China, left India and arrived in China in 520 AD, he went to Mt. Song and resided in the Shaolin Temple, meditating in a cave behind this temple for nine years. There actually is a cave behind the temple and it is called Damo (Boddhidharma) Cave presently. The main peak of the Shaoshi Mountain is said to look like a square mass of rock with vertical walls and a flat top. Song Xu painted his spiritual image of this mountain glorified by Boddhidharma's meditation in the cave. The cave is represented with its entrance surrounded by trees, its interior highlighted. On the lower right of the mountain, the Shaolin Temple is depicted in the distance.

"Tianti" (leaf F) refers to "Heavenly Stairs," but there is no major mountain with this name in China, except one in Gansu province which does not fit in this case. Since there are so many "heavenly stairs" built in many moun-tains in China, it is difficult to deter-mine which specific spot Song Xu depicted. Nevertheless, this painting represents the experience of climbing endless "heavenly stairs." At one of the corners in the ascending stairs the visitor is suddenly exposed to an expanding space where numerous peaks soar. An extremely small figure of the traveler and a large pine symboli-cally standing beside him are placed against an empty sky. This painting expresses the cosmic ecstasy of the visitor in his climbing of the great mountain.

Reference:
Restless Landscape: no. 22.

Leaf C

Leaf E

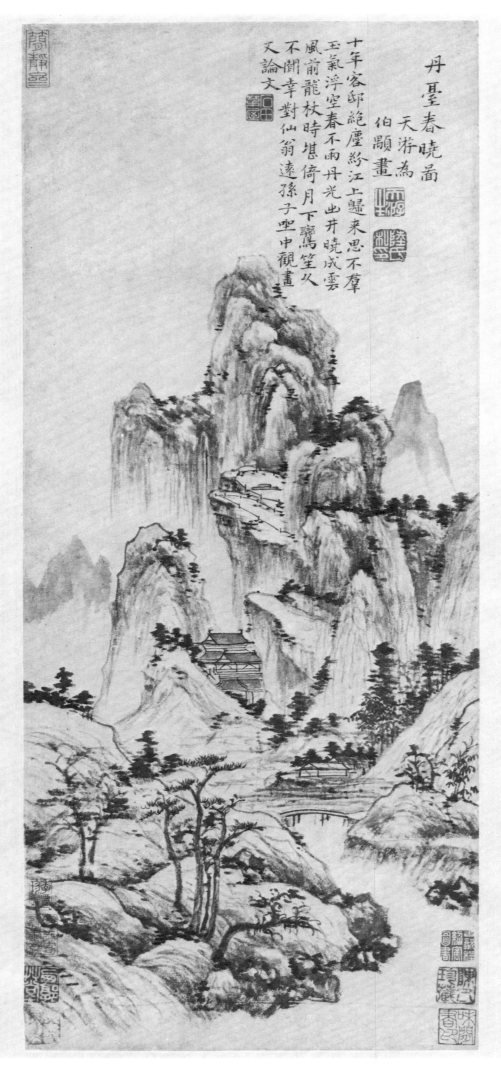

元陸天游丹臺春曉圖真蹟

丹臺春曉圖
天游為
伯顒畫

十年客邸絕塵綜江上�甦來思不羣
玉氣浮空春不雨丹光出井曉成雲
風前龍杖時堪倚月下鸞笙从
不聞幸對仙翁遠孫子坐中觀畫
又論文

Spring Dawn over the Elixir Terrace

116

Lu Guang
(active second half of the fourteenth century)

Spring Dawn over the Elixir Terrace

 52

Yuan dynasty, 1279–1368

Hanging scroll, ink on paper

61.6 x 26.1

The Metropolitan Museum of Art
Edward Elliot Family Collection
Purchase, Dillon Fund Gift, 1982
1982.2.2

Lu Guang was a little-known intellectual artist of the Yuan dynasty who was "discovered" by seventeenth-century connoisseurs. He was a man from Suzhou, but spent most of his life wandering all over China. He had very limited personal contact with the intellectuals of his time, and was, consequently, virtually unknown to most of the Yuan intellectuals (Li 1976: 994-95).

Spring Dawn over the Elixir Terrace is most likely a scene of Mt. Mao in Zhejiang, according to a recent study (Lin 1989). Mt. Mao (Maoshan), sometimes called Mt. Gouqu, was the center of study and practice of the Shangqing (Highest Clarity) school, also called the Maoshan school, of Daoism. It is designated as the eighth of the Ten Great Dongtian among the Daoist's holy sites. Mt. Mao, or more properly the Mao Mountains, is located to the west of Nanjing, and covers an area of about fifteen-and-a-half miles north and south. Its three major peaks, called the Greater Mao, the Middle Mao, and the Lesser Mao, are associated in legend with the genesis of this holy site; the three immortal brothers of the Mao family came, "each mounted on a white swan—or a white crane, according to some texts—to Hua-yan [i.e., the Mt. Mao region]," and "each of the brothers alighted on one of the three peaks" (Schafer 1989: 3). This place became particularly famous when Tao Hongqing (456–536), the virtual founder of the Shangqing school, resided there. Numerous legendary and historical accounts, as well as later poets' writings, are associated with this holy site (ibid.). It was still an important center of Daoistic activities during the Yuan dynasty.

Lu Guang's own poem, placed after the title and signature in the inscription on the Metropolitan painting, reads:

*For ten years in transient sojourns I have
 shut myself out from the dusty world;*

*I returned from the river with the thought
 of a life of seclusion*

*The emanation of jade floats in the air of
 spring devoid of rain;*

*The light of elixir is rising from the well
 and in the [sky of] dawn forms the
 clouds.*

*In the breeze the dragon-headed staff is
 sometimes needed for leaning;*

*Under the moonlight the celestial music of
 the phoenix-pipes [sheng] has not been
 heard for quite a while.*

*How fortunate am I to be in the company
 of a distant descendant of the old
 immortal;*

*Sitting together we look at paintings, and
 discuss literature.*

(translated, with some modifications, from *Chinese Art under the Mongols*: no. 263)

The painting's focal point, as the title suggests, is an alchemist's terrace at the top of a high cliff above the central valley. The small structure placed on the fenced terrace is supposed to be the well from which "the light of elixir is rising" and forming clouds in the morning. The composition is vaguely reminiscent of the actual topography of Mt. Mao. Assuming that the approach is from the northwest, a common route to this area, the bridge is Xiangzhenqiao (Bridge of the Descent of the Immortal), and a building right behind it is Xiabogong (Palace of Lower Mooring), built on the spot where the first of the Mao brothers, Mao Ying, was believed to have descended in 67 BC. The large building in the lower part of the deep valley in the middle distance must be the monastery that was built on the site of Tao Hongqing's original house of retirement, where he studied and experimented in making elixir. According to Tao's own writing, he found an ideal spot for compounding an elixir "on [the west side of] the ridge leading northward from Great to Middle Mao Mountain," which was close to his Huayang House (Strickmann 1979: 141-42). The terrace and building depicted in the painting seem to fit this description, although their existence is difficult to verify in the later topographical writings and illustrated maps. It is possible that the artists symbolically elevated a historical spot to a prominent position in the painting.

Lu Guang's painting is handled with loose brushwork and subtle shading in ink, and has a luminous quality that fits the artist's vision of the mountain illuminated by a mysterious aura of elixir light from the well. The painting, together with the accompanying poem, present the intellectual artist's inner vision of a sacred site of Daoism.

Reference:
Chinese Art under the Mongols: no. 263.

Dong Bangda, 1699–1769

Handscroll of Mt. Lu

53

Qing dynasty, 1644–1911

Handscroll, ink and light color on paper

38.9 x 310.2

Museum of Fine Arts, Boston
Frederick L. Jack Fund
1973.90

Dong Bangda, a high official and a trusted caretaker of the great collection of ancient paintings and calligraphies in the court of the Qianlong Emperor (reigned 1736–95), was himself a competent painter. The Boston handscroll is signed by Dong, saying, "Picture of Mt. Lu, respectfully painted by your servant, Dong Bangda" (translated *Elegant Brush*: no. 27). This manner of writing indicates that he painted this work to present to the Qianlong Emperor, most likely at the request of the ruler himself.

Mt. Lu is an important mountain for Daoists, Buddhists, and any laymen interested in Chinese cultural history. It is an area of mountains in a roughly oval shape, measuring about twenty kilometers east-west by fifty kilometers north-south, rising to the south of the Yangzi River and to the west of Poyang Lake, in Jiangxi province. In this relatively limited area, more than ninety peaks rise in seven layers, forming one of the most outstanding scenic spots in China. Its name, Lu (cottage), came from "a cottage of a divine-immortal," which is based upon a legend of Kuang Su (or Kuang Yu), a legendry hermit of the early Zhou dynasty who was said to have lived on this mountain. Thus, it is sometimes called Mt. Kuanglu (Kuang's Cottage). A Buddhist monk, Huiyuan (334–416), built a temple at the foot of this mountain and explored the mountain together with his disciples and lay followers. His Buddhism, which sought cosmic revelation in the mountains, is sometimes called "landscape Buddhism." From this time on, Mt. Lu gained steadily in popularity among Buddhists, Daoists, and men of letters. Daoists designated this mountain as the eighth of the Thirty-six Small Dongtian. Among the numerous poets who visited and left poems in admiration of this mountain, Li Bo (701–62) and Bo Zuyi (772–846) are particularly famous for their passionate love of the locale.

Dong Bangda painted this renowned mountain in a panoramic view from its northern approach from Poyang Lake to its southern end, showing the entire profile of its eastern side, and depicting every major topographical and architectural feature on that side (the sites in the central and western part of the mountain had to be sacrificed), each identified by a small inserted inscription. Dong must have depended upon some illustrated maps of this mountain in geography books as his model, but using his artistic skill, he successfully recreated the image of the powerful and beautiful mountain. The viewer must follow a path meandering at the bottom of the mountains, and admire the views of the great peaks soaring high. Occasionally he can make side trips to visit the peaks or other famous sites which are rich with legendary and historical anecdotes and were often glorified by the literary works of the great poets of the past.

The Qianlong Emperor, who was not able to visit Mt. Lu, was apparently fully satisfied with Dong Bangda's great endeavor. Numerous seals of the emperor, including the "Shiqu baoji" seal which was impressed on first-class works among the emperor's collection, were placed all over the painting, attesting to the Emperor's high appreciation of the work. He considered it worthy to share honor with works painted by the great ancient artists.

Reference:
Elegant Brush: no. 27.

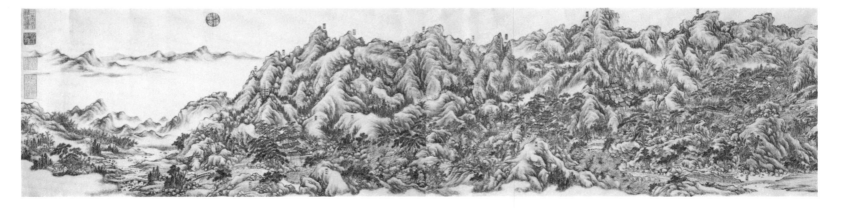

Handscroll of Mt. Lu

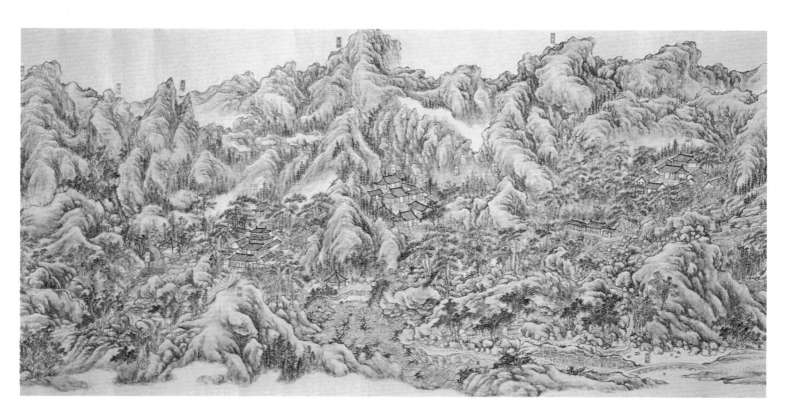

Detail

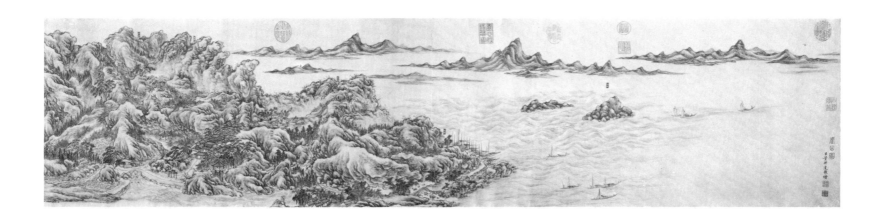

Sheng Maoye, active 1594–1640

Waterfall of Mt. Lu

 54

Ming dynasty, 1368–1644

Hanging scroll, ink and colors on silk

207 x 99.7

University Art Museum, University of
California at Berkeley
1971.15

Waterfall of Mt. Lu was immortalized by
the poems by Li Bo (701–62), one of
the greatest poets of the Tang dynasty.
The waterfall is located on the east
slope of the mountain complex and in
front of the equally famous Xianglu
(Incense-burner) peak. It is shown
about two-thirds of the way to the left
(south) in Dong Bangda's panoramic
view (see cat. no. 53). The last half of
Li Bo's poem "Viewing the Waterfall of
Mt. Lu – I" reads as follows:

Looking up I see the great power of the
 tumbling water,
How grand is the achievement of the
 Creator!
The wind from the [Eastern] Sea keeps
 blowing;
The moon over the [Yangzi] River shines
 in the empty sky,
Reflecting randomly on the splashing jet
 stream in the air,
Washing the dark-blue walls to the left
 and right [of the waterfall].
The flying pearls turn into light mist.
The rushing bubbles sweep the massive
 rocks.
I truly relish this noble mountain.
Facing it my mind becomes tranquil.
There is no need to talk about drinking
 jade-liquid [elixir];
I just wash my dusty face,
Just stay with what I savor through my
 life.
I wish to be excused from the world of
 people for a long time.

(Li Bo, *Li Taibo shi*: 21/9b-10a, translated
Munakata)

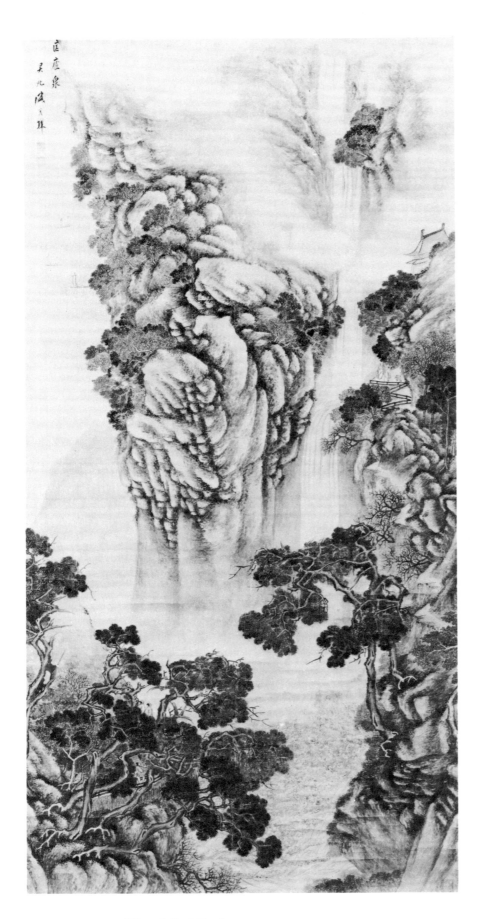

Waterfall of Mt. Lu

Sheng Maoye's *Waterfall of Mt. Lu* has a simple inscription giving the title, "Waterfall of Kuanglu (Mt. Lu)," and his signature. This large painting has very little to do with the topographical reality of the waterfall. Instead, Sheng seems to have attempted, as many other painters have, to capture at least some aspects of Li Bo's poems. He cut off from the composition the upper part of the waterfall and focused on the scene of the powerful, final descent of water into the bottom of the valley. The water falling from the very top of the composition goes behind the mist in the upper middle section and through the gap between the two massive cliffs, and finally hits the bottom. The actual bottom of the fall is not visible because of the rising vapor, but the powerful impact of the falling water is well suggested by the bubbling water in the foreground. A man stands between two large trees on the lower left landmass, and looks up at the top of the waterfall. The tall cliff on the right side has a zigzag climbing path along its edge, leading to the top where a building can be seen. Two gentlemen accompanied by servants stand on the lookout near the top of the path and gaze down into the abyss. On the very left of the composition a distant rounded peak is seen through misty air. High above, over the distant mountain, three tiny sailboats are drawn as if hanging in air, suggesting the presence, at a great distance, of the Poyang Lake, or the Yangzi River mentioned in Li Bo's poem quoted above. The scene is set in daytime and lacks the mysterious atmosphere of Li Bo's vision in the eerie light of the moon. However, the painting is successful in capturing the power of splashing water and rising vapors hovering over highlighted massive rocks. It conveys the presence of the mysterious mist which spreads into a vast expanse of space, connecting the waterfall with the water of the Yangzi River and further, if we follow Li Bo's vision, with the water of the mystical Eastern Sea.

Sheng Maoye was a professional painter active in the city of Suzhou toward the end of the Ming dynasty. Almost nothing about the details of his life has so far been found. His extant paintings indicate that his popularity stemmed from a superb technical dexterity combined with a certain literary flavor in his works. Many of his paintings have his own inscriptions which include a couplet taken from ancient poems.

Reference:
Restless Landscape: no. 12.

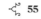

Shao Mi, c.1595–c.1642

Waterfall of Mt. Lu

55

Ming dynasty, 1368–1644

Album leaf, ink and color on silk

35.9 x 35.2

University of Michigan Museum of Art, Ann Arbor
Margaret Watson Parker Art Collection
1966/1.92

Shao Mi's *Waterfall of Mt. Lu* is a counterpart to Sheng Maoye's painting of the same title (cat. no. 54). It represents the waterfall in a distant view, in three stages. The waterfall emanates from the surrounding clouds at the top of the composition and reappears finally at the bottom as a rushing torrent. At the lower left is a land with trees growing where a path goes up toward a higher elevation. A man stands at the lowest point of the land, transfixed by the exciting sight of the torrents, while his wife (?) waits for him on a higher part of the path; their servant, carrying a *qin* lute, stays between the two. The waterfall appears powerful, yet looks as if it is in a dream, surrounded by the clouds and depicted in a softly washed color scheme.

Shao Mi was an intellectual artist in Suzhou toward the end of the Ming, a contemporary of Sheng Maoye; unlike the latter, he was well acquainted with the gentry class of people in his time. He was apparently wealthy, but not very healthy—"he was as thin as a yellow crane" and died of a lung disease at less than fifty years of age (Cahill 1982a: 59). During his lifetime he lived a life of leisure. His *Waterfall of Mt. Lu*, judging from the unusual family-type anecdotal scene inserted into it, seems to have been painted from a fond memory of his own family trip to Mt. Lu. The overall setup of the waterfall and the climbing path, although by no means photo-realistic, generally fits the actual topographic features of the area.

Reference:
Restless Landscape: no. 20.

Waterfall of Mt. Lu

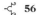
Mt. Tiantai is presently best known as a sacred site of Buddhism. The Guoqing Temple built at the foot of this mountain in 598, during the Sui dynasty, is the place where the Tiantai sect of Buddhism was founded, and it has remained the center of this sect. There are many more Buddhist temples built in this mountain range, including the Huading Temple near the top of the highest peak. Historically this mountain was an important sacred place for Daoists as well. According to a legend, Ge Xuan (active, early third century), an early Daoist, practiced alchemy in the Tanxia Cave of this mountain. Emperor Xuanzong (reigned 712–56) of the Tang dynasty built the Tongbo Temple in Mt. Tiantai for the most prominent Daoist priest at the time, Sima Zhengzhen (647–735). This temple continued to be one of the major centers of Daoistic studies through the Tang dynasty. Daoists designated Mt. Chicheng, a peak that stands in the southwest corner of the Tiantai range and is often referred to as the gatepost for it, as the sixth Great Dongtian, and Mt. Simahui, another peak in this range, as the sixtieth of the Fudi (blessed land).

One of the earliest literary works on this mountain is "Rhapsody (*fu*) of Visiting Mt. Tiantai" by Sun Chuo (314–71) (*Wen xuan*: 11a-13a). This rhapsody was copied in beautiful calligraphy by Huang Haoao (unidentified) and attached to the end of the scroll. Sun Chuo's rhapsody depicted this mountain as a mysterious realm. He started his visit with a difficult climb where no path existed, and finally reached the immortals' land where he found beautiful soaring palace buildings and the immortals flying in and out of the void; there he attained an enlightenment that encompassed both Daoism and Buddhism. Sun Chuo was one of the so-called "apologists" in the early phase of Chinese Buddhism, who tried to synthesize the newly introduced Buddhism with their own traditional values. In this rhapsody, however, Sun Chuo's visual images are completely traditional.

Sun Chuo brought several actual landmarks of the mountain into his basically imaginary description of the trip. One of his couplets reads: "Scarlet Wall, rising like rosy clouds, stands as a guidepost: / The Cascade, spraying and flowing, delimits the way" (translated Knechtges 1987: 247). "Scarlet Wall" (*chizheng*) is Mt. Chicheng, mentioned above, and the "Cascade" is identified as a large waterfall on a southwestern peak called the Cascade Peak. One of the best-known landmarks of this mountain is the stone bridge. Sun Chuo reached this bridge after a difficult climb. This section of the rhapsody reads:

Straddling the vaulted Hanging Ledge, I look down into absolute darkness, a myriad fathoms below. / I tread slippery stones covered with moss, . . .
(Ibid).

The natural stone bridge is seven meters long and hangs over a huge cascade. Sun Chuo took this bridge to be a landmark for the entrance to the mysterious realm hidden in the mountains. After crossing this dangerous bridge he got a sense of spiritual assurance and without difficulty walked into the world of the immortals. Later Daoist and Buddhist legends tell similar stories about this bridge which stands symbolically between the mundane world and the mysterious world of the enlightened.

Handscroll of Mt. Tiantai

Wu Bin, a man of Fujian, went to the southern (sub-) capital, Nanjing, probably while still in his teens, and was soon appointed to a position of painter in the Nanjing court. He was undoubtedly one of the most imaginative painters in China. He painted Mt. Tiantai in a horizontal format, emphasizing the three key landmarks mentioned in Sun Chuo's "Rhapsody." Mt. Chicheng appears in the opening section as a gate to the mountain. This section depicts a somewhat mundane scene showing the houses of people at the foot of the mountain. The scene of the stone bridge occupies the central position. It is separated from the earlier scene by a huge rock wall and lower peaks. The long natural bridge spans the space between two cliffs and is highlighted against an empty background. A waterfall can be seen above it, and a large empty pocket of space opens below. The lower part of this scene is kept empty so that the whole scene appears to float above a mysterious mist. This scene progresses to the left as a continuation of the mysterious high mountain—its top is cut at the upper frame, and the lower part is kept empty—and ends with a waterfall. The location of this waterfall is incongruous with the topographical reality, but functions, as Sun Chuo says, as a marker to "delimit the way," i.e., to separate the sacred realm from the mundane world which reappears at the end of the scroll. Eliminating from his composition the immortals' palaces in Sun Chuo's poem, and for that matter, the Buddhist temples that actually existed, Wu Bin created an image of this renowned mountain as purely a spirit mountain.

Wu Bin, 1568–after 1621

57

Album Leaf of Mt. Tiantai

Ming dynasty, 1607

Album leaf, ink and light colors on silk

29.1 x 40.5

Honolulu Academy of Arts
Gift of Miss Renee Halbedl in memory of
Mrs. Theodore A. Cooke, 1970
3678.1 (2)

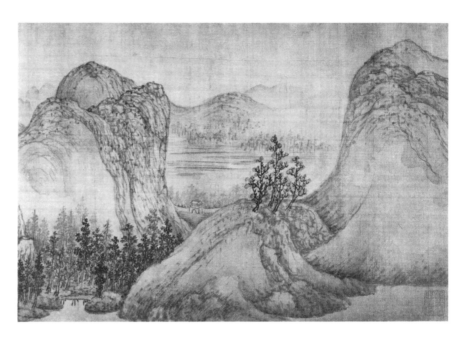

Album Leaf of Mt. Tiantai

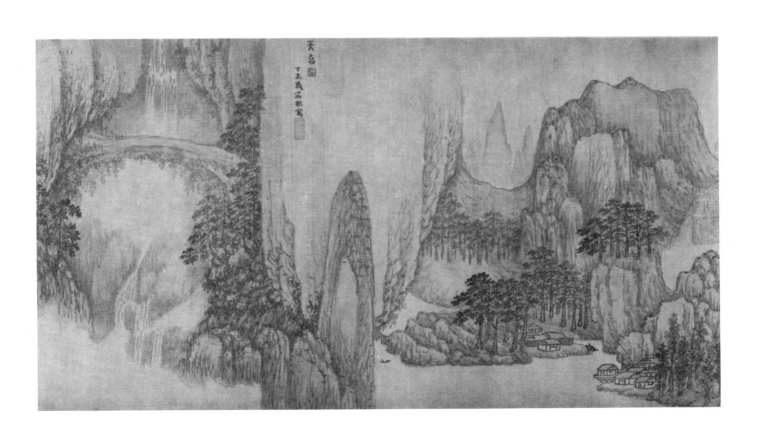

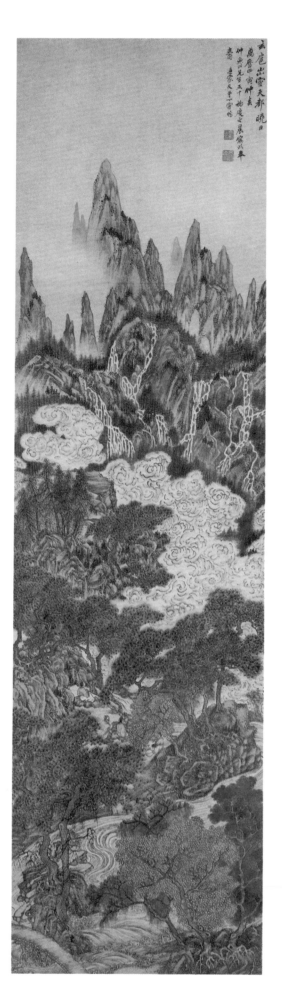

Ding Yunpeng, active 1578–1628

Morning Sun over the Heavenly Citadel

⌇ **58**

Ming dynasty, 1614

Hanging scroll, ink and light color on paper

225.4 x 55.3

The Cleveland Museum of Art
Andrew R. and
Martha Holden Jennings Fund
65.28

The Peak of the Heavenly Citadel (Tiandu peak) is the most prominent peak in the Yellow Mountains (Huangshan, or Mt. Huang) in Anhui. Mt. Huang covers a large area (154 square kilometers) where numerous peaks (72 major peaks), lakes, waterfalls, valleys, and deep ponds form a natural wonder. Those competing peaks—pointed, thin, conical shapes with sheer cliffs—appear particularly fantastic. Consequently it is currently one of the most popular tourist attractions in China for both the Chinese and foreigners. The fantastic and mysterious topographical features of this mountain site apparently convinced the people of the legend that the Yellow Emperor made elixir on this mountain. Because of this legend the name of the mountain was changed from the earlier Beiyishan (North Black Mountains) to Huangshan (Yellow Mountains) in 747 AD.

Ding Yunpeng, a native of Anhui, was one of the earliest artists who painted the marvel of this mountain complex. In this painting he captured a mysterious drama of nature. His intention is clearly stated in his inscription, which reads: "The mysterious (dark) low hills produce clouds, while the heavenly citadel is dawned by the sun" (translated Munakata). In the distance the morning sun just hits the Tiandu peak which, surrounded by equally thin and sharply pointed subordinates, soars to reach heaven. Forming a screen against this scene of heavenly dawn, the lower hills send many waterfalls cascading into the dark valley, from which clouds rise and a raging torrent rushes down. A lone witness of this drama, the artist himself or the Daoist monk for whom this painting was made, sits quietly on a bank. His two companions and one servant are depicted insignificantly in a lower position than the main figure and are not involved in the natural drama.

Laozi once said: "The valley spirit never dies; she is the mysterious (dark) goddess. The gate of the mysterious goddess is the root of heaven and earth" (*Laozi*, chapter 6, translated Munakata). The dark valley, which keeps sending clouds to heaven and streams to earth, is a symbolic image of the eternal source of cosmic creative energy. The painter climbed Mt. Huang and found this gate of cosmic unity. Ding Yunpeng's painting is his version of the Yellow Emperor's elixir, identifying and blending together the earthly power revealed by the cascades of falling water and the heavenly power made manifest by the sunlit spire of the Heavenly Citadel.

Reference:
Eight Dynasties of Chinese Painting:
no. 203.

Morning Sun over the Heavenly Citadel

Daoji, 1642–1707

Album of Mt. Luofu

59

Qing dynasty, 1644–1911

Album of eight leaves, ink and colors
on paper

Average leaf 28.2 x 19.8

The Art Museum, Princeton University
Gift of the Arthur M. Sackler Foundation
y1967-17

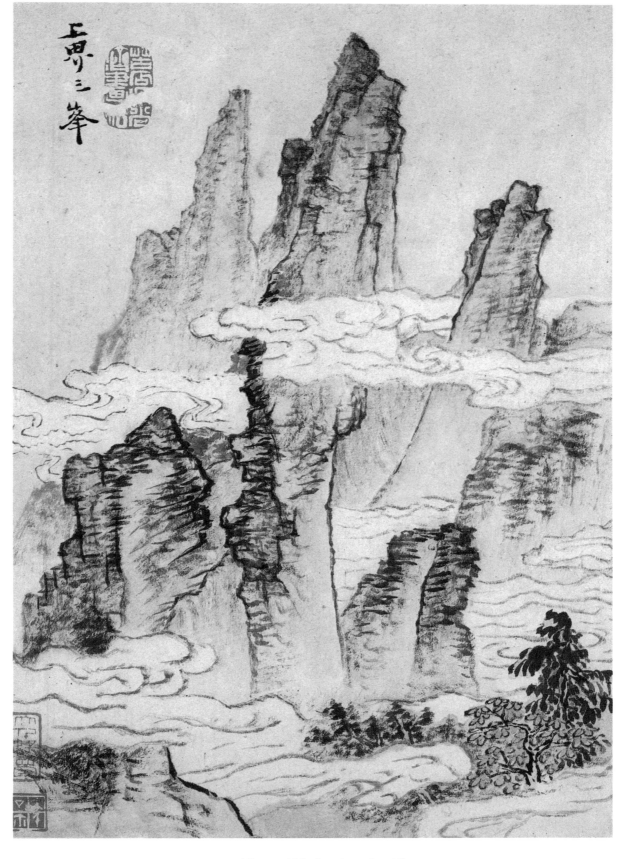

Album of Mt. Luofu ∘ *Leaf B*

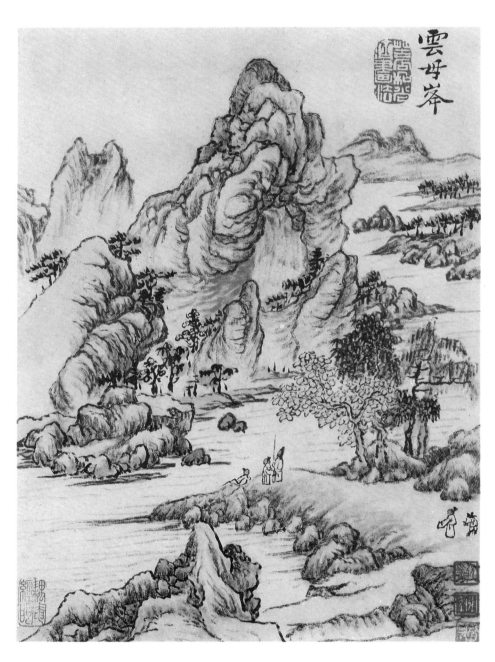

雲母峯

Album of Mt. Luofu ∘ Leaf A

Daoji was one of the "individualist" painters of the early Qing dynasty. They lived, for one reason or another, outside the ordinary fabric of society, which was ruled by the newly established Manchu government, and developed their own styles of painting reflecting their rugged life styles. Daoji was born as a prince of a branch of the royal Ming line, in the city of Guilin, Guangxi. He started his wandering life in 1645, at the age of four, when his father's resistance against the invading Manchus was put down. He became a Buddhist monk and remained so most of his life, until he severed his monastic vow sometime between 1696 and 1697 and entered the lay world (*Studies in Connoisseurship*: 36-38).

Mt. Luofu has been one of the most highly regarded holy sites of Daoism. It is said that Mt. Fu, meaning Mt. Float, drifted from the mystical Eastern Sea and joined Mt. Luo on the land east of Guangdong, which is where Mt. Luofu is actually located. Ge Hong (284–363), the author of an early Daoistic writing, *Baopuzi*, wanted to go to Vietnam to find suitable chemicals for elixir making in his later years, but on his way he stopped in Guangdong. He spent the rest of his life in the mountains of Luofu experimenting in alchemy. Later Daoists designated this mountain as the seventh Great Dongtian. In addition, Quanyuan, a spot within these mountains, was designated as the thirty-fourth (or thirty-first, according to one version) Fudi (blessed land). It is believed that this mountain is connected with Mt. Mao and other holy sites of Daoism through a mystical underground network.

According to his own inscription on the last leaf of the *Album of Mt. Luofu*—the leaf has been lost, but its inscription is known through a copy—Daoji never had an opportunity to visit this mountain, in spite of his long interest in it, and painted this album based upon a locally published book which he happened to have found. Originally he painted twelve scenes selected from this vast mountainous area (about 500 kilometers square, including 432 peaks, and 18 grottos, which are locally called Eighteen Dongtian). The present album has only four scenes, each of which is represented by one leaf of painting and one leaf of calligraphy that gives a descriptive account of the spot. This album, undated, is ascribed to Daoji's later years, about 1701–5 (*Studies in Connoisseurship*: no. xxx).

The four scenes in the album are as follows:

Leaf A, "Mica Peak": This is an area where a divine-immortal called Lady He once made elixir from mica stones found in the stream. The large grotto seen on the side of the peak is called Butterfly Cave, where many large colorful butterflies live. A recent report says that each is as large as a round fan. They live in pairs, and seem to dance around the tree branches and vines growing in the cave. Light reflects off their colorful wings, giving the visitor the impression of seeing a hallucination (Xie Hua 1984: 75).

Leaf B, "Three Peaks of the Upper Realm": The highest three peaks of Luofu appear separated by clouds from the smaller peaks, but even those lower peaks are also above the clouds. In contrast to those vertically soaring peaks, which are colored in blue-green, another peak runs diagonally between them. This other peak is recognizable only as a vermilion-colored screen partially visible through the gaps between peaks. This is the Iron Bridge Peak which is supposed to connect the two groups of mountains, Mt. Luo on the land side, and Mt. Fu (Float). Daoji eliminated human figures from this scene and structured interlocking peaks above the clouds to represent a scene of natural drama high in the sky.

Leaf C, "Solitary Azure Peak": This is an area known for the "Terrace (or Terraced Palace) of the Flowery-Haireds." There is a cave, probably the one seen on the side of a small hill behind the building complex in the painting, where five hundred "flowery-haired" (a euphemism for gray-haired) immortals were known to have come often for meetings. The palace (Daoist temple) was built in 738, during the Tang, to glorify this cave; it survived till recent years, although it was changed into a Buddhist temple sometime in its history (Xie Hua 1984: 45). The Solitary Azure Peak forms a backdrop of the temple. The description of this area excerpted by Daoji from the "local book" is a bit confusing and does not accurately describe the area. Yet, Daoji's painting quite accurately and beautifully represents the sacred space encircled by pine trees which was reached by a meandering mountain path. In painting this scene Daoji must have depended much upon the illustration of this place in the book, rather than upon the written description.

Leaf D, "Penglai Peak": The Penglai Peak got its name from the belief that this peak was originally a part of the Penglai Island of the Eastern Sea. The building seen below the peak in the painting is the Penglai Pavilion, said to be a place where the immortals gathered for a big party. This painting is compactly and beautifully structured, probably quite imaginatively, combining Daoji's artistic vocabularies with the described topographical features of the place.

Reference:
Studies in Connoisseurship: no. xxx.

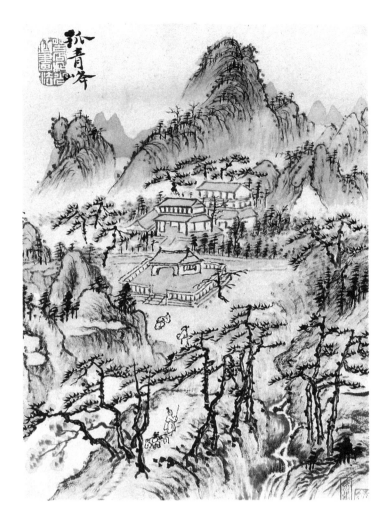

Leaf C

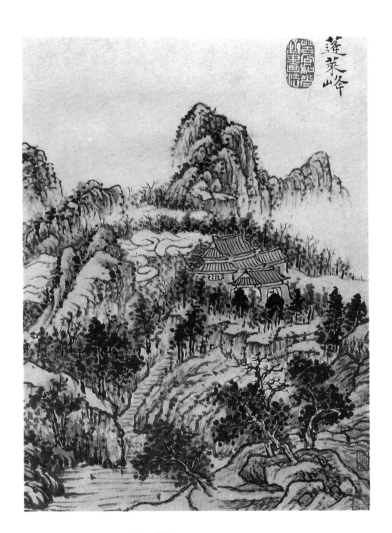

Leaf D

Daoji, 1642–1710

Outing to Zhanggong Cave

60

Qing dynasty, 1644–1911

Handscroll, ink and color on paper

45.7 x 286 mounted

The Metropolitan Museum of Art
Purchase, Dillon Fund Gift, 1982
1982.126

Zhanggong Cave is located near the city of Yixing, Jiangsu, west of the Great Lake. Its entrance is at the base of a small mountain in the shape of an inverted bowl, called Mt. Yufeng. Surprisingly, the inside of the cave is huge: its interior space covers about three thousand square meters and the inside passageway is over a thousand meters long. There are large and small chambers, "double-mantle" chambers (a grotto enclosed by a larger chamber), and so forth, numbering seventy-two all together. The rear chamber, the largest of all, is claimed to be capable of holding as many as five thousand people. The front chamber has a skylight opening in its ceiling (*Zhongguo ming sheng cu dian*: 343–44). The name Zhanggong (Mr. Zhang's) Cave is said to have come from the legend that Zhang Daoling (active in the middle of the second century), the founder of the earliest Daoist order called the Way of Heavenly Masters, stayed there during his study period, and also that another Daoist named Zhang, Zhang Guolao of the Tang dynasty, spent his life of retirement in this cave. Daoists designated this cave as the fifty-ninth Fudi (blessed land).

No inscription explains the circumstance in which Daoji painted this scroll. There is a handscroll of the same subject painted by Shen Zhou (1427–1509) (present location unknown, but preserved through a reproduction in black and white). Daoji's painting is surprisingly close to Shen Zhou's version, down to the minute details of the composition. However, the handling of brush and ink and the system of coloring are unmistakably Daoji's own. Daoji's poem, inscribed on a separate sheet attached to the end of the scroll, conveys his excitement in visiting the great cave, as well as in painting its image. This painting is undated, but his signatures, "Qingxiang" for the painting and "Qingxiang, Dadizi" for the calligraphy, both of which he used in his later years, suggest that it was painted in the 1690s or later. There is a possibility that the calligraphy on the attached sheet is a close (traced) copy of the original. It is also possible that Daoji copied Shen Zhou's painting in recalling his own earlier visit to the cave. This was quite unusual for Daoji, who was one of the most creative artists and was known for his disdain for copying earlier artists' works. It may be that Daoji despised assuming the mannerisms of another artist's style of execution, but considered, at least in his later years, copying somebody's composition a different matter.

Daoji's *Zhanggong Cave* is a symphony of color. Although his palette was limited basically to blue and pink-red, in addition to black ink, Daoji varied those colors by contrasting and fusing them, creating a scene of dancing colors in flickering light. The first section of the scroll represents the entrance to the cave. It is a huge opening surrounded by rocky configurations. Numerous stalactites hang down from the ceiling, making the opening look like the gaping mouth of a great monster. Daoji made the surrounding area darker and the inside of the cave lighter in color—light pink in the entrance way, and light blue in its depth—so that the inside of the cave appears to be a bright place, illuminated by mysterious light. A man, the artist himself, stands at the entrance, looking up at the overwhelming view of the cave. The second section of the scroll shows the idyllic landscape surrounding this sacred place.

Reference:
Peach Blossom Spring: no. 39.

Outing to Zhanggong Cave

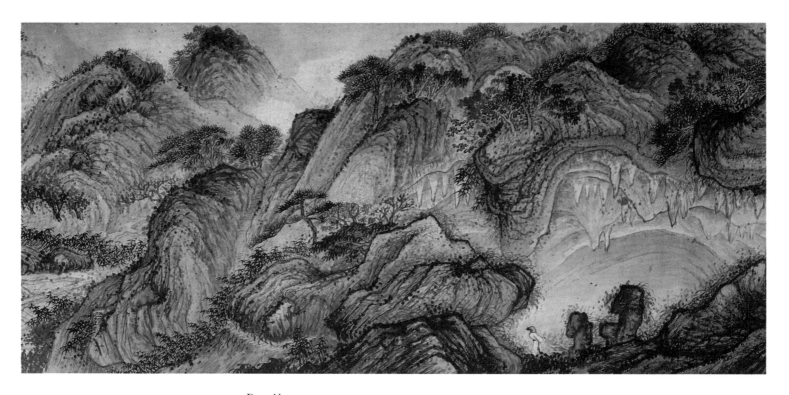

Detail

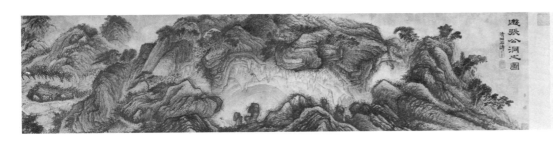

Along with the establishment of the concept of DONGTIAN
as the realm of immortals, the image of such a realm
developed into that of a fantastic world of mountains
and valleys dotted with beautiful palaces where the
immortals and jade-maidens (female attendants
in DONGTIAN) happily lived. In this joyous world the
immortals are well dressed like high governmental
officials, and the jade-maidens look like ladies of the
court; they live in pavilions and halls like those in the
imperial palace.

It is ironic that Daoism, which championed the
freedom of individuals against the strict social order,
derived its image of the ideal world from the life style
of the imperial court, or at least from the society of
high officials. In fact, it is most likely that this type of
image developed in such a high society. After all, many
Daoists were quite eager to obtain imperial favor,
and, in turn, many emperors patronized them and
built their court gardens after the image of a luxurious
paradise. Nonetheless, the courtly vision of the immor-
tals' realm constituted the Daoistic paradisiacal
image throughout its history. Many extant private
gardens from the dynastic periods are essentially
miniature versions of this standard image. The paint-
ings of this theme are usually done in the style of the
so-called "blue-and-green landscape," which is color-
ful and decorative and features bright opaque shades
of blue, green, and red.

Anonymous

Festival of the Peaches of Longevity
(*Pantao tu*)

 61

Ming dynasty, late fourteenth-early
fifteenth century

Handscroll, color and gold on silk

52 x 479.6

The Nelson-Atkins Museum of Art
Gift of the Herman R. and
Helen Sutherland Foundation Fund
F72-39

This painting is one of the most com-
plete and beautifully painted images of
a fantastic land of immortals. It includes
soaring peaks, rolling hills, and many
palace buildings, elegantly structured
and colored in red and blue, with
attached gardens. Immortals and jade-
maidens engage in various activities,
including picking peaches of longevity.

There is no artist's signature on this
painting. However, a later copy of the
same scroll, now in the Freer Gallery of
Art, Washington, DC, bears the name
of a Southern Song artist, Fang Chunian
(active in the mid-thirteenth century).
It is generally agreed, on the basis of
stylistic characteristics, that the Nelson
scroll is a copy of around 1400 made
after the original painting by Fang
(*Eight Dynasties*: no. 142).

The original title of this painting,
Pantao tu (Painting of Pan-peach),
refers to a huge peach tree growing on a
fairy mountain-island called Mt. Duso
in the Eastern Sea. The pan-peach tree
bore fruits of longevity once every
three thousand years. The Freer
Gallery copy shows that the very
beginning of the original scroll, missing
in the Nelson version, depicts a
shoreline emerging from a sea with
rolling waves. Over this sea come many
male and female immortals mounted
on fantastic animals, in chariots, or
even on foot, miraculously, as if they
are crossing over land (fig. 41). This
indicates that the major theme of this
painting was the harvest of the peaches
of longevity, and the land depicted is,
in fact, the island of Mt. Duso, where

Figure 41

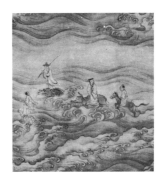

Detail of Figure 41

Festival of the Peaches of Longevity ○ *Pantao tu*

the immortals and jade-maidens are gathering to celebrate the harvest. The Queen Mother of the West must preside over this occasion. She controls the mystical peaches, and her birthday, called the Pan-peach Festival, is an event for which many immortals gather. Her figure cannot be identified in the painting, suggesting that she has not appeared yet. If so, the people standing on the high terrace toward the end of the scroll must be those who await her arrival from heaven.

There is a report that during the Hongwu era (1368–98), soon after the Ming government was established, a peach pit was found among the treasures of the destroyed Yuan imperial household. This pit bore an engraved inscription stating that it was given to Emperor Wu of the Han dynasty by the Queen Mother of the West (*Wan wei yu bian*). This amusing discovery, whether taken seriously or not, must have captured people's imaginations. There is a possibility that the Nelson painting, which is datable to about that time stylistically, was made in response to this event in the circle of the imperial court.

Reference:
Eight Dynasties of Chinese Painting: no. 142.

Detail

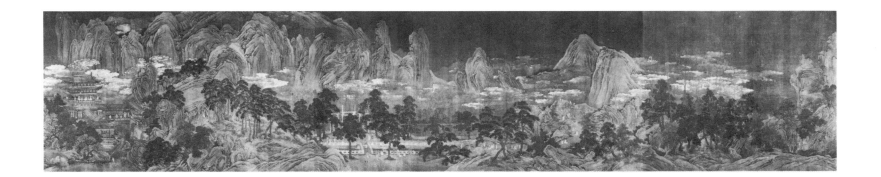

 62

Shi Rui, active 1425–69

Greeting the New Year

Ming dynasty

Handscroll, ink and color on silk

25.5 x 170.2

Cleveland Museum of Art
John L. Severance Fund
73.72

This painting represents "Pavilions in the Mountains of the Immortals," as the title on the frontispiece of this scroll reads. The water separating the main landmass in the foreground from the distant shore suggests that the land with many pavilions is an island, referring to one of the immortals' mountain-islands in the Eastern Sea. However, in contrast to typical representations of the immortals' land, which show many immortals and jade-maidens enjoying their lives, this painting depicts people taking part in ceremonial activities in an austere atmosphere. Some people are shown coming from the distant shore in boats, probably for New Year's greetings.

Shi Rui, a court painter whose official career started in the court of the Xuande Emperor (reigned 1426–35), was probably commissioned to paint this handscroll for one of the emperors whom he served or for a high official in celebration of the New Year, possibly to be used as a gift. Shi was known as an artist who particularly excelled in painting landscapes of the blue-and-green style. He masterfully employed this "archaic" style in painting a scene of the celestial world that looked auspicious and orderly, and not overly fantastic. This painting is precious as a variation on representations of the immortals' land; here the theme is treated as a celestial equivalent to the ceremonious days of this world.

Reference:
Eight Dynasties of Chinese Painting:
no. 136.

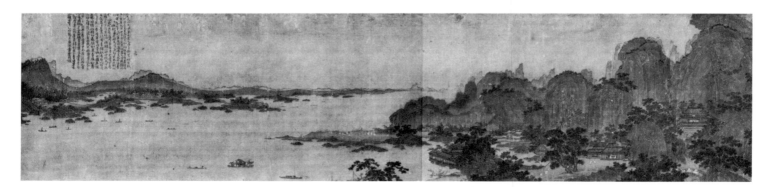

Greeting the New Year

Anonymous, attributed to Zhao Bozhu, died 1162

Blue-and-Green-Style Landscape

63

Southern Song, or Yuan dynasty, the thirteenth to fourteenth centuries

Fan painting, ink and color on silk

26.8 x 27.5

The University of Michigan Museum of Art, Ann Arbor
1970/2.157

Zhao Bozhu is known as a great master of blue-and-green-style landscape painting and of architectural painting in the Southern Song dynasty. Zhao's reputation has been so high that many of the anonymous paintings in the blue-and-green style which include architecture have been attributed to him, regardless of their stylistic characteristics. This fan painting is not an exception, and the possibility of Zhao Bozhu's hand in this painting is rather remote. Nonetheless, it conveys a quiet and elegant mood of the Southern Song court paintings very well.

The artist placed a tower, presumably one of the immortals' palace buildings in the mountains, in the center of the composition as a focal point. The pine trees growing on the foreground rock formations symbolically extend their branches to either side of the building. Pine trees, being evergreen, traditionally symbolize immortality as well as high virtues and nobility. The blue-green on the foreground mountains, the white of the soft auspicious clouds rising from the middle-ground valley, and the vermilion of the distant mountains make an exquisite harmony of colors.

The well-built path along the cliffside may be for the residents of the palace. In contrast, a visitor clad in a white robe has to cross a precarious wooden bridge over the rushing torrent, probably as a test of his will to reach the paradise.

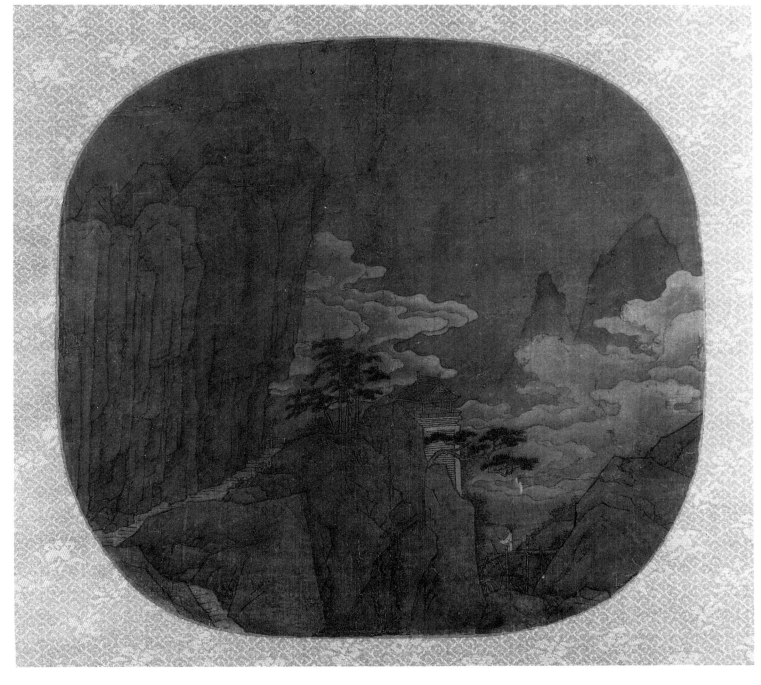

Blue-and-Green-Style Landscape

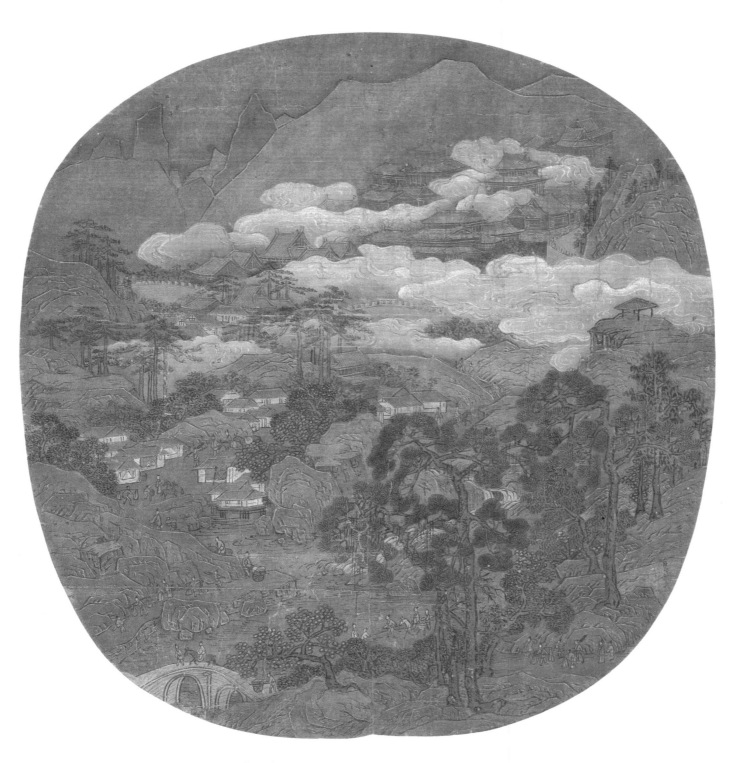

Landscape with Buildings

**Anonymous, after Goulong Shuang
(1060–1120)**

Landscape with Buildings

 64

Ming dynasty, 1368–1644

Hanging scroll, ink and color on silk

23.5 x 23.5

The University of Michigan
Museum of Art, Ann Arbor
1965/2.59

This painting is a close copy of a blue-and-green-style landscape painting from the Southern Song period, in the twelfth or thirteenth century. Although it is now mounted as a hanging scroll, the painting is in the form of a fan-shaped album leaf, a format favored during the Southern Song period for paintings intended to be appreciated intimately and privately. It is generally assumed that the small fan-shaped paintings from this period were painted mostly by the artists of the imperial court academy. The blue-and-green landscape style, which became a special means of expression for depicting scenes of the imaginary world or those from ancient stories, was standardized during the Southern Song to include gold as well as strong opaque colors. It was, thus, sometimes called the gold-and-blue landscape style, of which the present painting is typical.

A beautiful palace located in the middle of the mountains is the major theme of this painting. At the front of the palace there is a wall and a gate, and to the rear the palace space extends deep into the mountains. The palace and a few buildings in front of the gate are surrounded by auspicious clouds. A scene of a valley with a meandering river occupies the foreground, separated from the palace by the clouds. There is a village built on the riverbank where people engage in their daily activities. A road begins at the lower right corner of the composition; it moves through a wooded area, a stone bridge, a cliffside path, a main thoroughfare of the village, and a curving riverside path, and ends at the main gate of the palace. Several gentlemen on horseback, some followed on foot by their servants, are on their way to the palace via this road.

There is some question whether this painting represents a palace of immortals, or a mountain palace from the historical past, such as the Lishan Palace built on Mt. Li by Emperor Xuanzong (reigned 712–56) of the Tang dynasty. The Lishan Palace theme was one of the popular subjects during the Song dynasty, but it usually focuses on the palace itself, often identifiable by the presence of the emperor and his consort, Lady Yang, and does not include the scenes of people's activities outside the palace, as in the Michigan painting.

Goulong Shuang, to whom this painting was previously attributed, was a court painter of the Northern Song known for his figure paintings, which include scenes from Buddhist and Daoist stories. A lone painting by him listed in the collection of Emperor Huizong (reigned 1101–25) is entitled *The Purple Court on the Immortals' Mountain*. The "Purple Court" is the palace of the ruler of the immortals' realm. It is possible that the Michigan painting represents this palace, which only qualified people can visit through the mysterious mist. The valley below the palace may not be an ordinary space either; the gold lines defining the structure of the mountains and rocks may indicate the special quality of the place as the vicinity of the holy palace, rather than simply giving the painting a more decorative effect. It is possible that Goulong Shuang's *Purple Court* in Huizong's collection, or a similar painting, was actually the source for the Southern Song court painter of the fan painting, which, in turn, became the model for the present copy. This problem is still unsettled and must be left for future study. Nevertheless, the Michigan painting, rendered in beautiful colors and gold, provides the viewer with a glimpse of the courtly image of an imaginary palace on a spirit mountain in the Southern Song period.

Wang Jianzhang, active 1628–44

The Isles of the Immortals on a Spring Morning

65

Ming dynasty, 1638

Handscroll, ink and color on gold-flecked paper

19.5 x 97.2

Seattle Art Museum
Gift of Mrs. John C. Atwood, Jr.
51.134

This handscroll in the blue-and-green style is an ingeniously structured image of the immortals' land. It is one of the variations of the "courtly image" in its popularization of this subject, which was often painted for elite patrons in celebration of their longevity at the New Year, the time when they become one year older. The title of this painting is given by Wang's own inscription, which reads: "Spring Dawn on Peng-Ying [Penglai and Yingzhou, the two immortals' islands in the Eastern Sea]." Spring dawn connotes a new year. The use of luxurious gold-flecked paper for this painting indicates that this was painted for a very important person.

Wang Jianzhang was a local professional painter in Quanzhou, a commercial port city in Fujian. He gained sophistication in his art through his intimate relationship with a fellow townsman, Zhang Ruitu (1570–1641), an administrator-painter who in 1627 reached the highest governmental position in the Ming court in Beijing, just before his demotion and consequent return to his native town in 1629 (Cahill 1982a: 170-73).

"Peng-Ying" in the title of this painting, a combination of the two island mountains of Penglai and Yingzhou, is a general way to refer to the immortals' islands in the Eastern Sea, and should not be taken to mean the two specific islands. The painting starts with a scene at the bottom of the rocky mountains, where a small arbor sits on the shore of what appears to be an inland lake; two figures are seen crossing a bridge, and a house is half hidden under the trees. The theme of a man crossing a bridge often refers to stepping into a new realm, as in approaching a Daoistic paradise. The two figures are probably meant to represent the patron whose longevity is celebrated, and his companion, here

approaching the realm of the immortals. The main portion of the scroll is occupied by a range of rocky mountains. The powerful mass of rocky forms is briefly interrupted by white clouds and a foreground grove of pine trees; it concludes on the left with a steep cliff facing a vast sea covered by morning mist. Toward the end of the scroll the roofs of the immortals' palace buildings appear through the mist, as if they are a mirage.

Wang Jianzhang departed from the usual image of the immortals' land, which was of the mountainous areas with immortals' buildings scattered in the hills and valleys, and presented instead a progressive composition moving horizontally from an ideal but still earthly scene, through a powerful and vigorous spirit mountain, to a peaceful paradise wrapped in the spring mist.

Reference:
Restless Landscape: no. 49.

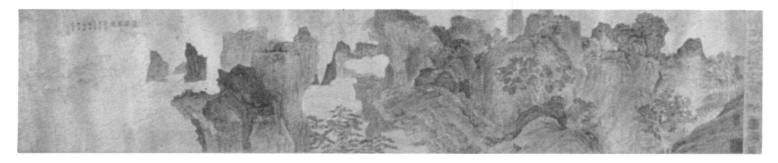

The Isles of the Immortals on a Spring Morning

Wang Yun, 1652–1735 or later

The Fanghu Isle of the Immortals

 66

Qing dynasty, 1699

Hanging scroll, ink and light color on silk

142 x 60.3

The Nelson-Atkins Museum of Art
Fortieth Anniversary Memorial
Acquisition Fund
F75-43

Wang Yun was a professional painter from Yangzhou, one of the commercial centers in south China at the time. The Fanghu is one of the islands believed to exist in the mysterious Eastern Sea. Fanghu literally means "square *hu* jar." *Hu* jars, traditional wine jars, were important ritual vessels from the prehistoric period through the Han dynasty (see cat. nos. 31 and 36). In later Daoist legends there is an immortal called Mr. Hu (Hugong) who keeps a world of immortals in a *hu* jar which he carries around (*Tai ping guang ji*: 12/1a-3a). The term "*hu* jar" thus has a connotation of magic.

The Fanghu Isle in this painting is represented in the shape of a *hu* jar, with a flat top and an extended shoulder from which the contour of the body moves down in a slow curve to a narrow bottom. There are three elaborate palaces of the immortals colored in bright red and green on the island; one is high up on a central cliff, another is at the edge of a cloud-filled valley which makes a pocket of space in the middle of the mountain, and the third is on the side of the cliff at the left. In addition, a roofed corridor is seen traversing the curved edge of the cliff at the right. A spring of water starts in a small cave far above the first palace, comes down as a waterfall behind the palace, and reappears as a torrent under the second palace. The sea at the bottom of the isle swells and bubbles with great energy, while mysterious clouds hover among the waves. The clouds move up higher along the contour of the island and lend an auspicious air to the whole painting. Three white birds perched on a small rock in the sea add a strange, mysterious effect.

According to Wang Yun in his inscription, the artist painted this work by imitating a model from the Song dynasty. If Wang was correct in identifying the date of his model, this particular type of painting of Fanghu was already established during the Song dynasty.

Reference:
Eight Dynasties of Chinese Painting:
no. 257.

The Fanghu Isle of the Immortals

Although most Chinese intellectuals were not committed Daoists, they were attracted to the idea of the immortals' realms as a counterimage to worldly reality. There are numerous poems composed throughout the long history of China that directly or indirectly refer to the immortals' land. These writings reflect the individual poets' personalities and beliefs: some treat transcendental realms as physical reality, some as an imaginary world to be dreamed of, and others, more subtly, as spiritual reality. The literati artists treated the immortals' land in their paintings in the same way. However, they stayed away from outright depiction of a courtly image of the immortals' land. Even when they painted the immortals' residence, they treated it as a structure hidden in the mountain and not as a palace complex in a paradisiacal land. Many of the paintings are so subtle in their reference to the concept of transcendental realms that their expressive contents are often not readily apparent unless one examines the relationships between the paintings and the artists' own inscriptions on them. Nonetheless, those paintings reveal that Daoistic thought, combined with veneration for the great mountains, played an important role in enriching the intellectuals' lives by offering a source of dreams, an ideal of life style, or religious salvation.

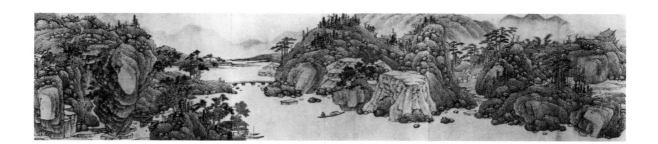

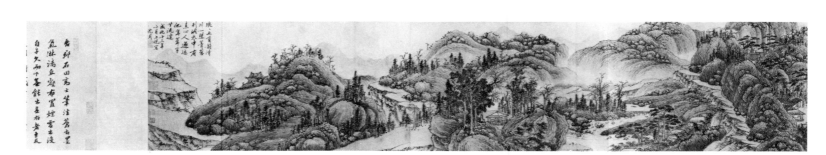

Panorama of Landscape

Shen Zhou, 1427–1509

Panorama of Landscape

 67

Ming dynasty, 1477

Handscroll, ink and color on paper

33 x 628.7

The Portland Art Museum
Helen Thurston Ayer Fund
57.13

Shen Zhou, who spent his whole life as a private individual in the area of Suzhou, was a great poet-painter of the middle Ming period, and was often regarded as the founder of the Wu school of painting. His interest in Daoism seems to have been heightened during his fifties, around 1480, by his intimate relationship with a Daoist named Fang. On one occasion, Shen Zhou reported that although he received some instructions in Daoistic practice from Fang, he failed in his attempt and was very ashamed.
Panorama of Landscape was painted during the period of Shen's increased interest in Daoism. Shen's own inscription placed at the end of the long handscroll reads:

The sound of ringing jade echoes over the
* pure water.*
In the expansion of the bluish green world
* there is a separate dongtian,*
Where only the purest hearts live hiding
* the trace of their escape.*
One day I shall build a hut there and
* move into it.*

This painting is structured as a narrative of passage from "here" to "there." It starts in the spiritual world of "here." Each bridge connecting the separate landmasses is a passage, bringing one further into "there." The final crossing is actually a thin land bridge on which a mysterious tall tree is growing. A seeker, wearing a red robe and standing before the bridge, and an achiever, dressed in a white robe and standing beyond the bridge, look at the tree from opposite directions. The final section, which is supposed to be the *dongtian*, does not have many features distinguishable from those of the previous sections—only the empty houses, a very limited number of figures wearing white robes, and the mountain stream. For Shen Zhou, *dongtian* was a place of spiritual purity and remoteness and was reachable through spiritual effort; it was not in any sense connected with the supernatural.

Reference:
Iriya et al., eds., *Shin Shū, Bun Chōmei*: no. 2.

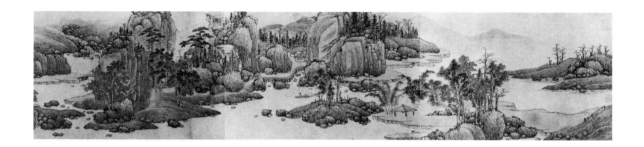

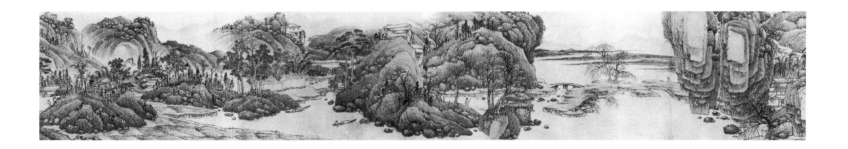

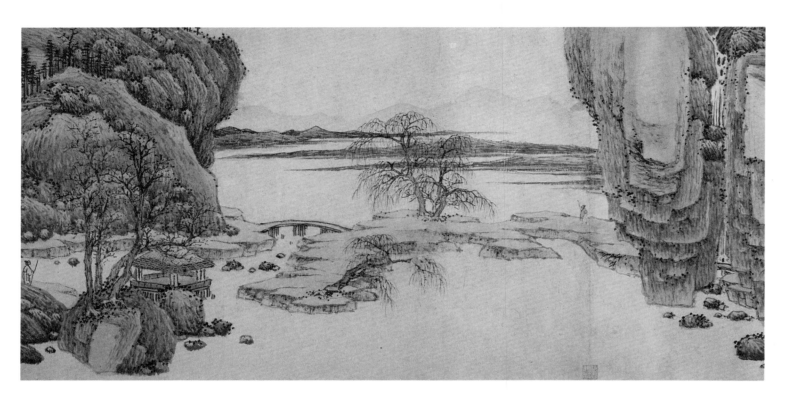

Panorama of Landscape ∘ Detail

Wen Jia, 1501–83

Immortals' Mountain with Pavilions

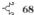 **68**

Ming dynasty, 1555

Hanging scroll, ink and light colors on
paper

102 x 28.2

Sarah Cahill Collection, on extended loan
to University Art Museum,
University of California at Berkeley
CM 77

Wen Jia was the second son of Wen
Zhengming (see cat. no. 96), and
following in his father's footsteps he
developed his own style. The title of
this painting, *Immortals' Mountain with
Pavilions,* was given by the artist
himself in his inscription placed in the
upper left corner. It is most likely
that this painting was based upon an
impression he got from a specific
mountain in the Suzhou area. However,
he developed his vision into an image
of a fantasy-land of immortals.

At the bottom of the composition
the mouth of a large cave opens, from
which a torrent rushes out. As in Lu
Zhi's *Jade Field*, two gentlemen look
into the cave, which appears fantastic,
with stalactites hanging from the
ceiling. Two large intertwining trees
growing horizontally form a gate to
this fantastic land. In contrast to this
somewhat shadowy place at the bot-
tom, the upper part of the mountain is
sunny. These two parts are separated
by a path traversing the side of the cliff,
along which some buildings are built.
At the right end of this path there is a
bridge across a gorge into which water
cascades from a cave above. Two figures
are crossing this bridge. High above,
near the summit, several buildings are
seen on a small plateau, protected by
groves of trees.

This painting shows Wen Jia's typical
style; he creates balance between the
fine drawing in ink and the beautiful
yet restrained use of color. He also
exhibits his good sense of balance in
representing the scene with the solidity
of form of the real world, and the airy
and subtle colors of the world of fantasy.

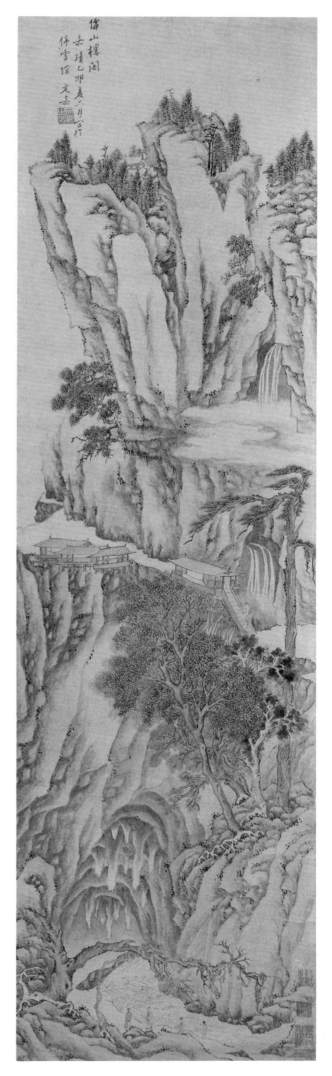

Immortals' Mountain with Pavilions

Lu Zhi, 1496–1576

The Jade Field

69

Ming dynasty, 1549

Handscroll, ink and color on paper

24.1 x 133.6

The Nelson-Atkins Museum of Art
Nelson Fund
50-68

Lu Zhi is one of the major masters of the Wu school, the school of literati painters which flourished during the middle Ming period in the area around the city of Suzhou. He spent most of his life as a recluse—in a truer sense of the word than most of the "retired" gentlemen of his time—living at the foot of Mt. Jixing, about twenty-five miles west of Suzhou. He left many poems which reveal his Daoistic inclination. He visited many caves, and in one poem described his experience inside a cave. When he stepped into the depth of the cave, he came to "a crack in the ground open to the root of the earth, from which the winter blows its breath," and found "a hole connected to the 'sea-house' [the house of the immortals thought to be in the sea], from under which the sound of spring water was heard." Afterward he ecstatically claimed that he was predestined to attain such ultimate mystical experience (Lu Zhi: 155). For Lu Zhi, mystical perceptions, which included visions and auditory and other perceptions, were important as spiritual reality.

The Jade Field is one of Lu Zhi's finest works. It was painted for Wang Laibin (1509–after 1550), a physician of Suzhou. A poem written by Lu Zhi attached to this painting as a colophon is known to be a copy of the original—somebody removed the original calligraphy and replaced it with the copy. Its content is authentic and provides insight into Lu's thinking as expressed in this painting. It reads:

In planting jade no seasonal choice
between spring and winter is required.
The great water source is abundant for
[the jade-field of] Lantian.
Although one [medicinal] leaf may take a
thousand years to grow,
The "elixir of nine cycles" is finalized
within a fraction of time.

When the divine liquid hits the cinnabar
medicinal compound,
Jade flowers blossom in purple vapor.
In the middle of darkness a pure glow of
light is concentrated;
How many years will it cast its clear light.

(translated Munakata)

The metaphor of making elixir is appropriate for a gift to a man of medicine.

The major theme of this painting is a mystical cave presented in the beginning of the scroll. Two figures, presumably Lu himself and the doctor, look into the darkness of the cave where "a pure glow of light is concentrated." The next section shows a small cultivated field hidden among the rocky formations, to which a stream flows down from above—an image of the field of jade, which is an ingredient of elixir. After another rock formation which rises like a wall at the front of the composition, there appears a small opening where colorful pavilions can be seen. This area is identifiable as a hidden realm of the immortals, because the blossoming peach trees not only symbolize it, but visually set it off by creating a bright, calm, and ceremonious mood. The place is only reachable through a mystical passage connected to the cave; at the end of the dark passage the bright world will suddenly "blossom." The scroll soon returns to the wall of rocky cliff and ends with the waterfall descending through a vertical cleft in the rock, from the base of which the life-giving water flows out.

Lu Zhi, using colors beautifully and effectively, succeeded in representing his mystical perception of the transcendental world.

Reference:
Eight Dynasties of Chinese Painting:
no. 181.

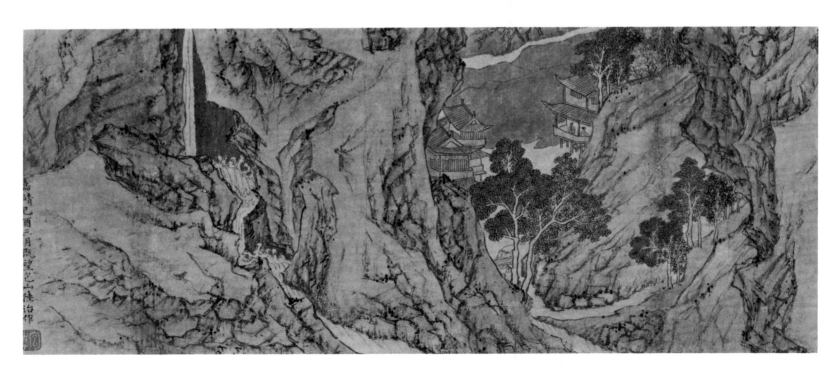

The Jade Field

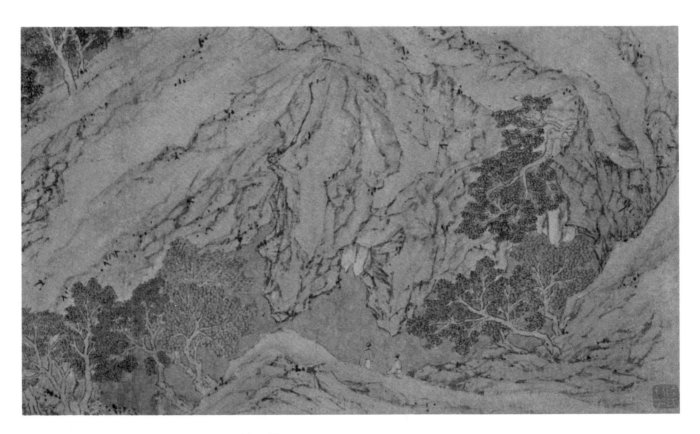

Detail

Lu Zhi, 1496–1576

Streams and Rocks

70

Ming dynasty, 1368–1644

Handscroll, ink and color on silk

31.4 x 85.7

The Nelson-Atkins Museum of Art
Fortieth Anniversary Memorial
Acquisition Fund
F75-44

This is a complete handscroll, with a frontispiece that is a title sheet, written by Lu Shen (1477–1544); a painting by Lu Zhi; and Wen Zhengming's calligraphy in clerical script (*lishu*), a lengthy essay about Wu Yunshu, to whom this scroll is dedicated. Wu Yunshu is known only by this essay. The title of this scroll is taken from Wu's studio name, *Xishi*, which means "streams and rocks." Wu, a man from Anhui province, had been staying in Suzhou for a while, but became acquainted with Wen Zhengming only in the fall of the year the essay was written. Wen praises Wu as a man of pure heart and lofty spirit, a person who loves traveling far into nature and whose mind roams among streams and rocks and sings cosmic songs together with the creator of the world.

Lu Zhi's painting is a very personal vision of nature. The scroll starts with a narrow body of water between a high cliff with a waterfall in the background and a rocky shore in the foreground.

The space expands quickly; while the foreground shore continues along the base line, the cliff diagonally recedes and abruptly ends where a stream rushes down between the cliff and small rocks. A small figure is seen clad in a bright red robe, seated on a rock-terrace under a large tree with thick green leaves in the foreground. Two rocks in the water close to the shore, one large and one small, taper to the right, leaning in the direction of the figure. The figure, although very small in size, is in a highlighted center in this corner of the composition. In the middle distance of the next section, two large rocks and several smaller rocks are shown leaning toward the left, and the stream rushes through the gaps between the rocks. The rocks and rushing water give strong leftward movement to the composition. In the foreground, three tall pine trees and one leafy tree stand on the rocky shore. In the last section the distance is completely empty, and in the foreground only pine trees symbolically stand on a rocky terrace, separated from the shore of the previous section.

The colors are applied in the blue-and-green style, which, together with the archaistic rendering of pine trees, make a strong statement that this is a world of Lu's transcendental vision.

Streams and Rocks

The composition moves from the dense, somewhat real scene in the beginning section, to the concluding section of a vast void and a terrace of pine trees, a hint of the immortals' land. The viewer senses that the whole scene is an imaginary vision coming from the seated man in the red robe. This figure is presumably Wu Yunshu, "Mr. Streams and Rocks," but is, in actuality, none other than Lu Zhi himself.

Reference:
Eight Dynasties of Chinese Painting: no. 182.

Detail

Shao Mi, c.1595–c.1642

An Album of Landscapes Illustrating the Road to Lingjing

71

Ming dynasty, 1638

Five leaves from an album of ten leaves, ink and color on paper

28.9 x 43.2

Seattle Art Museum
Eugene Fuller Memorial Collection
70.18 (a,d,f,i,j)

Shao Mi, an intellectual artist in Suzhou who suffered from ill health (cat. no. 55), painted this album about two years before he died from a lung disease. The last album leaf (leaf E) has his inscription saying: "The Spiritual Realm, and the place of the immortals; I have come to this place often in my mystical dreams" (translated Munakata). (Please note that we selected five album leaves out of the total of ten, and we identify them in alphabetical order from A to E just for the present exhibition.) Shao Mi used a very unusual two-word term, *bimeng* (*bi* dream), in describing his dreams, which is translated here as "mystical dreams." The word *bi* means "hidden, covered, in a deep place, mysterious," and is used as in *bigong* (*bi* shrine), which means a special shrine placed in the very depths of an architectural complex. Shao Mi seems to be implying in his selection of the word that these dreams were transcendental experiences which took place in a deep place in his consciousness.

The whole album is structured as a sequence of mountain scenes in a dream, progressing to the final scene of the highest place in leaf E. Leaf A shows a small-scale Buddhist temple in the middle of the mountain—a beautiful scene in color. A miniature stone stupa stands in a wooded area on the lower left, and a man holding a cane is walking toward it. A stupa is a symbol of Buddha Shakyamuni, the founder of Buddhism, and its presence here indicates that Shao Mi's dream-pilgrimage is Buddhistic as well as Daoistic. It should be noted that in the late Ming, Buddhism and Daoism were eclectic; in the thoughts and spiritual visions of

the intellectuals of this time, like Shao Mi, Buddhism, Daoism, and Confucianism coexisted harmoniously. A climbing path between hills and rocks is shown on the right side, curving and ascending to the upper right corner of the scene.

Leaf B shows another stopping place, this time possibly a Daoist temple, located on a higher plateau over the rocky cliffs. A stone wall and a gate with an upper structure like a city gate are located at the foot of the cliff, indicating that this is an entrance to the main part of the sacred mountain. The climbing path continues from the gate, bypassing the temple and rising sharply on the side of a cliff; it moves toward the upper left where it meets a running stream, then turns to the right and goes behind a large mountain mass. The water cascades downward as a great waterfall on the left side of the scene. The right third of the composition is blurred, with a few landscape elements such as trees sporadically and vaguely visible. In spite of giving an extremely clear view of the areas around the climbing route on the left, the whole scene is apparently shown in a dream.

Leaf C shows a precarious path over the narrow ridge of a cliff. A temple is seen on a small ledge at the left. The climbing route from the lower part of the mountain is vaguely shown on the

An Album of Landscapes Illustrating the Road to Lingjing ○ *Leaf D*

lower right within the faded area. It should be connected with the path on the ridge, but the connection is not clearly shown. Nonetheless, the ridge route goes up almost vertically at the right.

Leaf D is probably a scene viewed from a path in leaf C. A higher portion of a rocky mountain seems to float above swirling clouds. There is an independent high vertical rock, on top of which is a flat terrace with an octagonal building on its corner. If there is any supernatural element in this whole album, this building is it. The terrace appears to be an elixir terrace and the building is where an elixir-making stove should be located. The inaccessibility to the terrace, which is guarded by sheer vertical cliffs all around, indicates that it was not for use by an ordinary Daoist-alchemist, but by a divine-immortal such as the Yellow Sovereign, whose name is often attached in legend to a natural clifftop terrace identified locally as an "elixir terrace." Both leaves C and D are colored in a thin blue and orange-brown wash, applied over the basic forms of the rocky masses. These forms are modeled by limited but effectively used texture strokes and wash in black ink. These techniques, particularly in leaf C, which uses also a "fade-out" effect in blurring the peripheries of the mountain, make Shao Mi's paintings appear solid yet impressionistic. It is proposed that his fade-out technique was developed under the influence of Western etchings of the late sixteenth and early seventeenth centuries (Cahill 1982b: 82).

The last album leaf (leaf E) shows a very high place on a rocky mountain. There is a huge overhang in the upper right of the composition, and a climbing path, indicated by railings, goes up steeply from the bottom center to the upper-right corner. The extreme height of this place is suggested by the thinly washed distant peaks in the background on the left side, and by the vertical cliff which drops into an unfathomable valley on the right side of the main rock formation. But, this is not the summit of a mountain. The climbing path continues into the upper realm, beyond the upper-right corner of the scene. Probably following the traditional concept of the sacred mountains as a cosmic pillar, Shao Mi saw this place as an intermediary mystical realm between heaven and earth.

Shao Mi, who probably was often confined to his bed at that time and was in no condition to visit mountains, combined in this masterpiece a certain realism and a free twist of forms and space. He used a continuing climbing path persistently through the series of visions of mountain scenes, a path which did not end even in the last painting of the series. It is important to understand that for Shao Mi, this mountain climbing in a dream was a religious experience.

Reference:
Restless Landscape: no. 19.

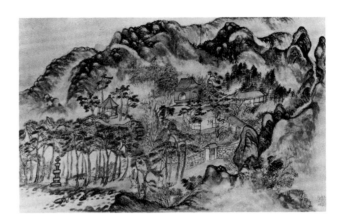

Leaf A

Leaf B

Leaf C

Leaf E

Wu Bin, 1568–after 1621

Landscape of Immortals' Island

⌇ 72

Ming dynasty, 1368–1644

Hanging scroll, ink and light colors on silk

213.9 x 87.3

Ching Yuan Chai Collection, on extended loan to University Art Museum, University of California at Berkeley
CM 83

Wu Bin is sometimes called one of the "fantastics and eccentrics of the late Ming." He painted fantastic images of mountains on a monumental scale. Recent studies reveal that Wu Bin took for his inspiration some of the Western etchings brought into China by the Jesuits who were staying in the Nanjing area at the time; he combined them with the monumentality of the Northern Song landscape paintings to create his own unique style (Cahill 1982a: 176-81; Cahill 1982b: 95-98).

Wu Bin's own inscription on the present painting reads: "The view from [the mountain] of the Fanghu isle is to appreciate all the Three Thousand World, / The spring on the Yuanqiao is the time to visit the Twelve Pavilions" (translated Munakata). The "Three Thousand World" is a Buddhist term meaning the entire universe. The "Twelve Pavilions" comes from an early

Han mythological story and refers to the palace of the Yellow Sovereign, one of the highest-ranking traditional deities of China. Combining these terms with the two immortals' islands of the Eastern Sea, the Fanghu and Yuanqiao, Wu Bin is deliberately eclectic, possibly to express the idea that his monumental mountain scene is universal, transcending Daoist or Buddhist designations.

This painting has a composition of the traditional three-peaked mountain formula, but unlike ordinary paintings, the three peaks continue down vertically and loosely divide the whole composition into three elongated vertical sections. This vertical composition is also divided into three horizontal sections somewhat vaguely by the mists. The lowest section has a hill with trees growing on its top, on the right, and a large boulder, also with leafy trees, on the left. In the lower left corner a figure stands on a path. There is another figure standing inside the cave located to the right of the boulder. This scene refers to the common Daoistic belief that a cave is an entrance to the transcendental world. A large palace-like building complex on a hill immediately above the boulder must be an immortals' palace which the person in the cave is going to visit. Immediately above this large palace is a building with a roofed corridor in front, built on a cliffside, a type of building commonly depicted as the immortals' mountain house. The left vertical section has another building, high above at the top of the central horizontal division. This building complex with a tower in its center must be the Yellow Sovereign's palace of "twelve pavilions" (*lou*, which implies a tower-like structure). The central vertical section has no building at all. The right vertical section has one building complex on a peak in the middle division. We may interpret this building as Buddhist, considering the eclectic concept expressed in the inscription, in contrast to the Daoistic buildings on the left vertical section. However those lower two-thirds of the vertical sections may be designated, the three peaks in the topmost division of this painting have no buildings, and soar together majestically above the hovering mist. They represent the universal mountain, as in many of the monumental mountains in Northern Song paintings, symbolizing the cosmos as a whole.

Reference:
Restless Landscape: no. 43.

Landscape of Immortals' Island

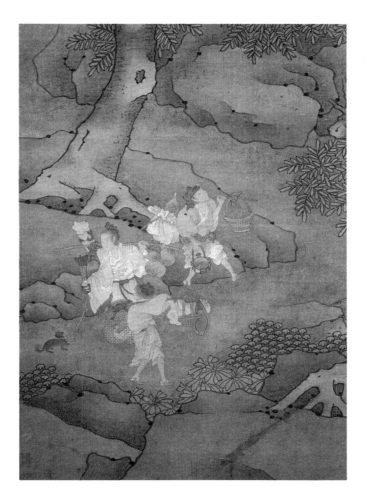

Detail

Cui Zizhong, died 1644

Xu Zhengyang Moving His Family

73

Ming dynasty, seventeenth century
Hanging scroll, ink and color on silk
165.6 x 64.1

The Cleveland Museum of Art
Mr. and Mrs. William H. Marlatt Fund
61.90

Xu Zhengyang Moving His Family ◦ *Detail*

Xu Zhengyang Moving His Family

Cui Zizhong has been considered one of the most prominent and innovative figure painters of the late Ming period. Well educated, but unsuccessful in the national examinations, Cui never held an official position in the Ming government. Yet, unlike most other literati painters, Cui, after moving from his native Shandong province in his youth, spent most of his life in the capital, Beijing. He died there of starvation when the city was under siege by the rebel army of Li Zicheng in 1644.

The story depicted is a legendary ascension of the Daoist master Xu Zhengyang, or Xu Sun, who took with him his whole family—as many as forty-two family and household members—including chickens and dogs, to heaven. Xu Sun (239–374?) was the founder of the Xu Sun school of Daoism, which insisted upon loyalty, filial piety, helping people and society, and other Confucian virtues as the basic requirements for attaining the mystical power of Dao and, ultimately, immortality. This school became popular during the Song dynasty (960–1279) because of its compatibility with Confucianism and its claimed magical powers which were supposedly particularly strong in solving the problems of the state and society. It became an organized religious order, called Zhongxiao-jingming-dao (Daoist School of Loyalty, Filial Piety, and Pure and Bright), in 1297 during the Yuan dynasty, and developed into one of the most popular Daoist sects during the following Ming and Qing dynasties, when a syncretism of Confucianism, Buddhism, and Daoism was the general mode of thought.

The idea of a whole family together attaining immortality, instead of an individual attaining it, is certainly a unique religious concept. It involves moving one social unit with the social status and functions of its members, chickens and dogs included, intact, from this world to another, i.e., to the world of immortals. Dogs and chickens symbolize an ideal bucolic life. In Cui's painting, the master Xu and his family appear to be enjoying the excursion into the ideal land through the spirit mountain, a traditional passage connecting this world to heaven. Xu and one middle-aged woman, presumably his first wife, who holds a young boy, are riding on a bull. A young girl holding a baby is on foot. A young girl with an elaborate hair dressing sits on a cart—is she Xu's daughter, or his youngest wife? Behind the family group, at the lower left in the composition, three servants follow, carrying various objects, including a chicken in a cage; one servant looks back to care for a dog on a leash.

The spirit mountain, depicted in the archaic blue-and-green style, looks eerie and surreal. The spring of life falls from the middle of the high cliff, flows behind the plateau over which the Xu family is now moving, and reemerges as a torrent below the plateau. Trees of several different species, some with violently twisting trunks, appear very expressive, probably indicating that the traveling group is now entering the mystical realm.

Reference:
Eight Dynasties of Chinese Painting: no. 209.

Gong Xian, 1619–89

Landscape

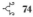 74

Qing dynasty, late 1680s

Hanging scroll, ink on paper

112.4 x 44.5

Ching Yuan Chai Collection, on extended
loan to University Art Museum, University
of California at Berkeley
CC118

Landscape

Gong Xian was an individualistic
landscape painter who lived during the
troubled times of the deterioration and
collapse of the long-established Ming
dynasty. He was a *yimin*, which trans-
lates as "left-over subject," and refused
to accept the rule of the Qing dynasty
which had been established by Manchu
invaders in 1644. Gong Xian went into
self-imposed political exile in 1645 and
did not return to his home near Nanjing
until ten years later. During the turmoil
of the Manchu invasion to the south,
he lost his wife. He lived secluded in a
small mountain in the suburb of
Nanjing and is said to have refused to
see anybody except his trusted friends. As
he aged, however, Gong Xian seems
to have become resigned to the political
situation in China and to have become
dedicated to Daoist philosophy. All of
the paintings by Gong Xian included in
this exhibition date to his later years
and show elements of Daoism.

This landscape has two separate
spaces. An imaginary realm is depicted
at the top of the work and the real
world is represented in the foreground.
In the background, the sheer cliffs
cannot be traversed and the buildings
are inaccessible, half hidden behind a
large boulder. A mysterious roofed
corridor winds around the center of the
mountain. Although it seems to lead to
the residence in the upper part of the
mountain, we are uncertain about how
to reach the corridor's entrance. As
attested by many other paintings of a
fantastic sort from the Ming dynasty,
these buildings and roofed corridor
placed high in a mist-enshrouded
mountain are meant to be the immor-
tals' residence. There are two water-
falls, one just above the pavilion and
another far to the left in the composi-
tion. We sense the power of the water-
falls, particularly the one above the
buildings. It is imbued with the force
of the mystic mountain and drops
sharply into space from an unidentified
source. It reappears in the foreground.
Here the water's activity is more true to
life, and the river flows naturally into
the area beyond the boundaries of the
painting.

Gong Xian's own inscription placed
in the upper left-hand corner reads:
"Do you know how many guests visited
this grand mansion before?" The
message is an invitation, or a challenge;
how could one qualify to reach the
mansion and be associated with the
immortals? We may take this message
as Gong's declaration to strive to attain
a status worthy of a true resident of the
spirit mountain. This painting, un-
dated, is attributable to the late 1680s
in Gong's stylistic chronology, and is
one of his earliest paintings containing
his own inscriptions referring to Daoism.

An Immortal's Abode above the Clouds

Gong Xian, 1619–89

An Immortal's Abode above the Clouds

 75

Qing dynasty, mid-1680s

Hanging scroll, ink on silk

176.2 x 53.5

The Art Museum, Princeton University
Lent by the
Edward Elliott Family Collection
L.1970.196

The composition of this painting depicting an expanse of quiet, relatively flat land is rather rare among Gong Xian's works. It is composed of four landmasses, each of which extends beyond the right and left sides of the scroll. These landmasses alternate with areas of water, which are represented by voids of white. The two together create a balanced rhythm of solid areas and empty spaces. A cluster of buildings, including a two-story mansion, is placed on the second landmass from the bottom; surrounded by trees (peach trees?), it looks quiet and peaceful. In contrast, the trees in the foreground, which are characteristic of Gong Xian's landscapes, are old, weathered, knotted, sparse, and, like the *yimin*, past their prime.

Gong Xian's inscription on the painting reads:

Outside the immortal's abode clouds rise beside mountain peaks / He erects a spacious pavilion to live above the clouds / The Queen Mother of the West often sends him the bluebird messenger; / He opens and carefully reads her letters written in purple ink.

(translated Fong 1984: 197)

We may take Gong's words "live above the clouds" as a metaphorical expression referring to the immortals' land. Then, the meaning of the composition is clear. The immortals live across the water, beginning with the buildings on the second landmass. This immortals' land, which encompasses the upper part of the scroll, is figuratively "above the clouds." The rugged, earthly trees symbolize our world, and the body of water between the two landmasses in the foreground deters humans from entering the immortal realm. The Queen Mother of the West sent a letter written in purple, the usual color of the writings of Daoist scriptures, from her abode on Mt. Kunlun, the imaginary cosmic mountain. The expanse of parallel landmasses of this painting represents the path of the bluebird's flight from Mt. Kunlun, which should be located beyond the mountain at the top of the composition, down to the Daoist retreat.

Reference:
Images of the Mind: no. 19.

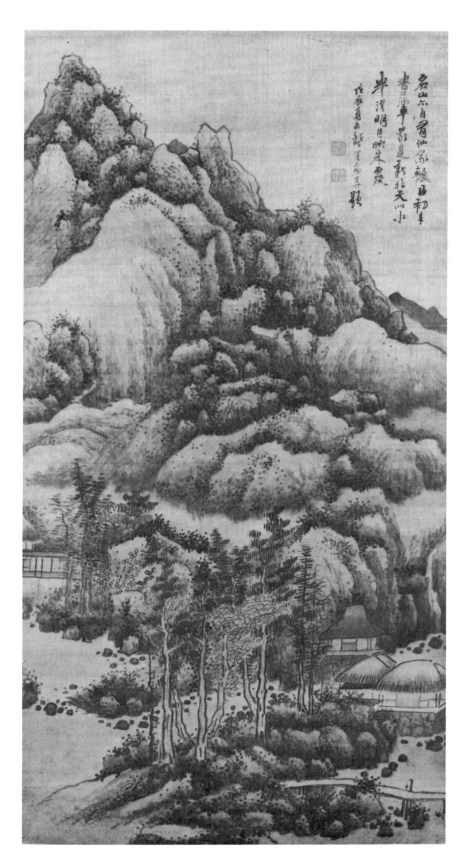

Immortals' Residences in the Mountains

Gong Xian, 1619–89

Immortals' Residences in the Mountains

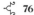 76

Qing dynasty, 1688

Hanging scroll, ink on satin

93.35 x 46.9

Nicholas Cahill Collection,
on extended loan to University Art
Museum,
University of California at Berkeley
CC114

This depiction of a peaceful, inhabitable abode in the mountains was painted just one year before Gong Xian's death. The mountains depicted here are powerful and imposing, but not as forbidding as those in his earlier paintings. The mist which separates the mystical realm of the mountain from the world below is placed almost at the very bottom of the mountain, relating the upper realm closely with the bottom area where the buildings can be seen. The bottom area seems to be a dreamland of Gong Xian. On the right side a spring of water cascades into a small lake where two arbors and a rest house, all with thatched roofs, have been built on a platform stretching into the water. There is a main building half-shown on the left end of an inlet of a larger lake. There are many trees above and running water below. A small bridge on the lower right corner is the only approach to this lofty and peaceful land from the world outside.

Gong Xian's own poem inscribed on the upper-right corner reads as follows:

*Great mountains naturally have the
 immortals's residence.
With sound of squeaking wheels I came
 here for the first time on a cart full of
 books.
This is the early autumn, and the sky is
 [as clear and cool] as the water;
The bright half moon is shining,
reflecting on the rosy clouds.*

(translated Munakata)

The affirmative tone of this poem is notable. Toward the end of his life Gong Xian finally arrived, in his inner vision, at this dreamland, blessed by the moonlit rosy clouds, a Daoist aura. He was a bibliophile, and his friend Zong Yuanding wrote, "Truly, his books pile up to the roof; pressing against his windows . . ." (Silbergeld 1980: 7). In the autumn of his life, Gong Xian has brought his cart full of books to the foot of the mountain. These books represent all that he has thought about and read and discovered during his lifetime. He has come to terms with the past and is at peace living in the mountains.

Gong Xian, 1619–89

Album of Landscapes

77

Qing dynasty, 1688

Album, four of ten leaves, ink on paper

Painting and Calligraphy: 35.4 x 52.2

The Metropolitan Museum of Art
Gift of Douglas Dillon, 1981
1981.4.1 (C, E, H, M)

Gong Xian in his later years created works which were to be called poem-paintings, closely relating paintings and poems. The Metropolitan album is the epitome of this endeavor. Painting at the age of seventy, one year before his death, Gong Xian expressed himself as a man of freedom. Daoistic thought, here more philosophical than religious, is a strong undercurrent in all of the imagery of these poem-paintings.

Leaf C: His poem reads:

The two peaks were separated when
* heaven was opened;*
The traces of the axe are still there,
* regardless of the growing green lichen.*
I ask the old pine atop the rock:
Did you see the ancient sovereign when he
* came?*

(translated Munakata)

The painting quite literally depicts the two vertical cliffs separated by a narrow gap, with pine trees growing on the left cliff, perhaps answering the question. The underlying theme is time, the long life of the spirit mountains enduring from the time of the divine creation.

Leaf E: Gong Xian's poem reads:

Moonlight falling on bare rocks, thinner
* than frost.*
Awaking from a drunken sleep at night, I
* feel cold penetrating my bed.*
I call out to Wang Zijin on the other side
* of the mountain,*
Please play the reed pipe and stroll with
* me around the long walkway.*

(translated W. Fong, *Images of the Mind*: 199).

The painting represents a rocky bare mountain, which is modeled with a minimum of brush and ink, so that it appears illuminated by the cold midnight moon. A roofed corridor around the edge of a cliff, a common element of the immortals' mountain house, is above the running stream on the left side. The bottom of the scene fades out, making the whole scene dreamlike, floating over the mysterious mist. The artist seems to be foreseeing his own image in an afterlife, walking in a moonlit empty corridor of an immortals' building, joined by Wang Zijin, an immortal-musician, playing a reed pipe.

Leaf H: The poem reads:

The cave-house of the immortals opens its
* gate at dawn;*
The vermilion clouds disgorge the sun,
* then swallow it again.*
I have walked up to the bridge with my
* hair untied for drying,*
Glimpsed my age-wasted image stolen
* away by the flowing water.*

(translated W. Fong, ibid., with modification).

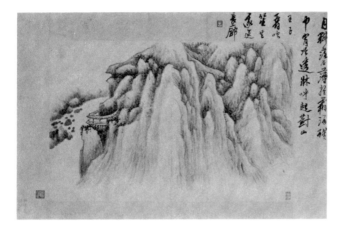

Leaf C

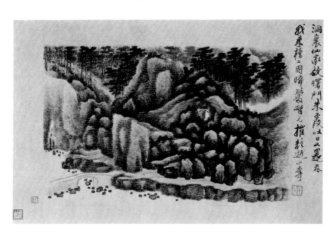

Leaf E

Leaf H

There is an open cave in the middle of a rocky hill in the painting. The rocks are richly modeled by short horizontal strokes, with their tops highlighted, making strong contrast to the darkly shadowed areas. This is a rocky realm of immortals wrapped in the vermilion light of the morning sun. To the lower left corner is a bridge crossing over a flowing stream into the mystical realm. This poem-painting is another vision of Gong Xian's joining the immortals' world. This time the scene is set in the morning, enveloped in vermilion light; the artist, his hair casually loose, crosses the bridge, giving away his aged shape to the flowing water. He walks into the opened gate of the immortals' cave-house.

Leaf M: The poem reads:
When I reached middle age, I selected a fine site, and built a secluded studio.
Many peaks facing this place overshadow the densely formed land [with rocks and trees] below.
I have naturally grown to attain a consciousness-free mind, [which enables me] to mingle with the gulls [without threatening them].
Looking around and looking back over my long life, I have no more any repressed thought.
(translated Munakata)

This is an amazing revelation for a man who was once tortured by a sense of guilt about his inability to rescue his country when the Manchus invaded, and who had a strong grudge against the new rulers and the society that accepted them. The landscape represented has a central focus on a small calm island where a "secluded studio" stands. Only the rocky bottom part of the land across the water is shown. This is the land Gong selected in which to live the life of a recluse when he reached middle age, but largely in a metaphorical sense. Gong actually lived in seclusion in a "mountain" called Qingliang Mountain, but it was, in reality, a hill without soaring peaks in the suburb of Nanjing. Nonetheless, his inner image of a "fine land" grew with him, nurtured him, and caused, as well as witnessed, his metamorphosis into a man of consciousness-free mind.

Reference:
Silent Poetry: pls. 54-56.

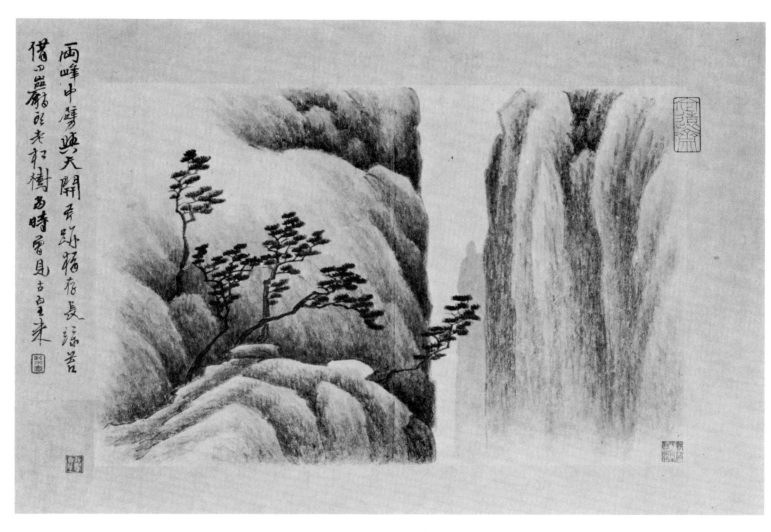

Album of Landscapes ◦ *Leaf M*

PEACH BLOSSOM SPRING

The story of Peach Blossom Spring, originally narrated by Tao Qian (372–427), is about a fisherman's visit to a utopian community (not of the immortals in the Daoistic sense, but of people pursuing an ideal farming life) reached through a secret grotto. This story is not Daoistic in the narrow sense of religious Daoism. However, it bears a close resemblance to the Daoists' idea of the hidden world in the mountains which can be reached through the secret entrance of a grotto or cave. The idea of a utopian farming community, self-sustaining and free from politics, was an ideal of the Confucians as well as of the Daoists (especially the philosophical Daoists). Because of this universal appeal, the story has enjoyed enormous popularity throughout history. Numerous paintings on this subject have been created in successive periods and in various manners.

Anonymous, formerly attributed to Qiu Ying, c.1500–c.1552

Peach Blossom Spring

 78

Ming dynasty, seventeenth century
Handscroll, ink and colors on silk
32.3 x 385

The Art Institute of Chicago
Kate S. Buckingham Fund
1951.196

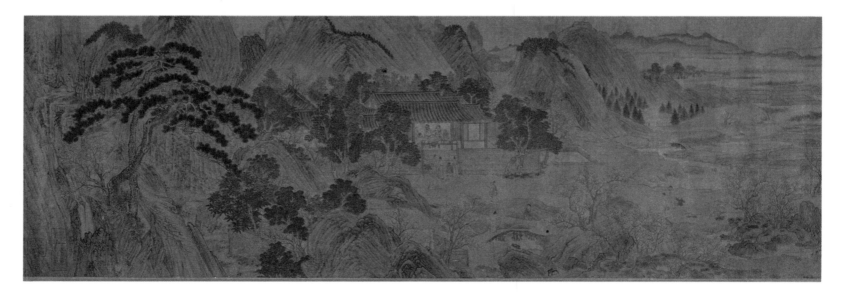

Peach Blossom Spring

This colorful handscroll is a pictorial representation of a story written by Tao Qian (365–427) called *A Story of Peach Blossom Spring*. The story is about a fisherman who accidentally wanders through a grove of peach trees in bloom and discovers a peaceful community that has been secluded from the rest of society for many years. The peach trees appear at the opening of the scroll and to their left is the fisherman's boat, moored at a grotto in the rugged mountains. These mountains separate the idyllic land to the left of the cliffs from the rest of society. The fisherman crosses these mountains through the cave opening and is pictured in two places within the Peach Blossom community: in the middle of the scroll he is met by a group of residents and at the end of the scroll he is seated at the table within one of their comfortable homes, looking over the expanse of fields. At the end of the scroll there is a transcription of Tao's poem and a colophon by Wen Zhenming (1470–1559).

Although Tao does not make specific mention of a land of immortals, several references in the poem can be associated with a Daoist world beyond. Peach trees symbolize immortality. In the beginning of the story, the fisherman is said to have searched the upper end of the stream and found on a hillside a cave opening in which he saw mysterious light. All of those points are common elements of the stories of a man who wanders into the immortals' land. The mysterious land hidden in the mountains is a remnant of the early religious belief of mountain worship which held that a mystical realm of wilderness was hidden in the depths of the mountains.

The scroll is executed in the detailed and colorful blue-and-green style, the traditional way to depict historical narratives and paradisaical scenes. A handscroll in the Museum of Fine Arts in Boston is almost identical with the Chicago scroll. Qiu Ying was famous for his excellent skill using the styles of old masters, including the blue-and-green style. He seems to have maintained a studio with assistants helping him. The paintings carrying his name vary in quality, and it is often difficult to determine whether they are his studio works or later copies, unless they were painted by him with his superb skill from the beginning to the end. Presently the Chicago scroll is considered as a seventeenth-century copy.

Liu Du, active seventeenth century

Peach Blossom Spring

 79

Qing dynasty, 1650

Hanging scroll, ink and color on silk

135.8 x 52

The Cleveland Museum of Art
John L. Severance Fund
71.227

Among the paintings of the theme of Peach Blossom Spring, Liu Du's work shows a unique approach. A utopia is hidden high up in the mountain, and only its palace-like buildings can be seen through a narrow gap between two high cliffs. A cave is placed at the bottom of the steep cliff as an entrance to a mysterious passage leading to the paradise. It looks more like the immortals' realm than an ideal farm community. One of the unusual aspects of this painting is that the fisherman is leaving the place by boat; two figures who look like immortals, standing inside the cave opening on the front cliff, seem to be seeing the fisherman off. The fisherman looks back, saying farewell to the utopia with peach blossoms which is fading into the distance. If we note that the date of this painting, 1650, was six years after the official end of the Ming dynasty and only two years after the crushing of the last resistance of a remnant of the Ming in the Canton area, we realize that this painting was made as the expression of a sad farewell to the lost dynasty.

The paradise is here treated as a mystical never-again dreamland. The painting is a fascinating revelation to the viewer about the way mysticism of the mountains was used for an expressive purpose, with an individualistic twist of the traditional theme.

Reference:
Eight Dynasties of Chinese Painting:
no. 198.

Peach Blossom Spring

Detail

Fan Qi, 1616–after 1694

Peach Blossom Spring

Qing dynasty, 1646

Album, one of eight leaves, ink and color on paper

16.8 x 20.3 mounted

The Metropolitan Museum of Art
Sackler Fund, 1969
69.242.10g

Fan Qi, one of the Eight Masters of Nanjing in the seventeenth century, painted the album of eight leaves, including the leaf of the Peach Blossom Spring, in 1646, during the period of turmoil after the Manchu invasion of the south. He was staying—we presume, taking refuge—at the Qingliang Monastery in the suburb of Nanjing at that time, according to his inscription placed on the last leaf of this album.

Fan Qi painted only a cave as the entrance to the Peach Blossom Spring, and omitted completely the depiction of the utopian land itself. Yet, there are many blossoming peach trees around the cave entrance, even inside the cave, clearly suggesting the main theme. There are several unusual features in this depiction of the popular story. A stream flows through the cave and comes out the front. A figure who is supposed to visit the utopian land is placed on the far right end of the path leading toward the cave, and he is not depicted as a fisherman— he holds a staff, not an oar, and his boat is nowhere to be found. The path on which the man is walking is also unusual for the story, which usually takes place in the unexplored land of the upper reaches of a river. Here, the path is actually a well-paved wide road running along the foot of the mountain; it crosses a well-structured stone bridge over the stream in front of the cave and continues to the far left of the composition.

Fan Qi apparently did not intend to narrate the usual story of the fisherman visiting the Peach Blossom Spring in this painting. Instead he depicted a man who, after hearing the story, ventures to visit the utopian land. This man is not the one in the original story who made a futile attempt to visit there after the fisherman had left. Fan Qi brought the cave close to civilization; in fact, he located it right on the side of a highway. People would simply pass by the cave, admiring the sight of its entrance. Fan Qi left the viewer a puzzle, to find a parable presented in this painting. The whole painting is thinly washed in rose-pink, so that the entire scene, including the "white" clouds hovering above, the "blue-green" rocks, and the water, appear rosy, as if reflecting the color of the peach blossoms in full bloom.

References:
Studies in Connoisseurship: no. xv.
Peach Blossom Spring: no. 1.

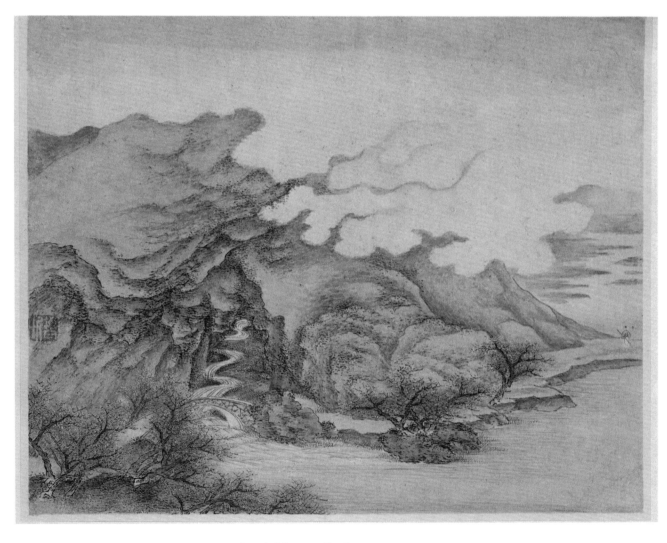

Peach Blossom Spring

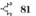

Xiao Yuncong, 1596–1673

Seeking the Ford

81

Qing dynasty, 1672

Fan painting, ink and color on paper

19 high

Seattle Art Museum
Eugene Fuller Memorial Collection
52.137

Xiao Yuncong, a man from Anhui, became a government-appointed student, a privileged status for those preparing for the national examination which was required to become a high-ranking official in the late Ming. However, when the Manchus destroyed the Ming government and established the Qing dynasty, Xiao decided not to pursue an official career. He remained as a private intellectual throughout his life, supporting himself with painting, including making drawings for woodcut illustrations for books.

Painting on a folding fan has been popular in China for a long time, particularly since such a fan is suitable for a personal gift. Its format, a horizontally extended curved band, demands that the artist pursue a certain compositional contrivance. In *Seeking the Ford*, another title given to a painting of the Peach Blossom Spring, Xiao Yuncong used the format of a small-scale horizontal scroll, starting on the right and unfolding the story to the left. There is a large rock formation on the right side of the composition, where a large cave—rather a cave-tunnel—opens. Peach blossoms bloom around the cave entrance, and a fisherman carrying an oar walks on a path inside the cave. To the left of the rock formation a large span of water separates this landmass from the main utopian land, which expands into the far distance where layers of mountains are seen. The two lands are connected by bridges via a small island in the center. On the flat area of the main utopian land are some farmhouses and fields, and the roofs of a temple can be seen on the lower part of a distant mountain.

Xiao Yunzong represented his poetic vision of the utopian world in delicate color-washes, instead of using the opaque blue-and-green coloring system which was the common way of depicting imaginary worlds at the time. His ideal land is no more than a peaceful idyllic world surrounded by beautiful mountains and water.

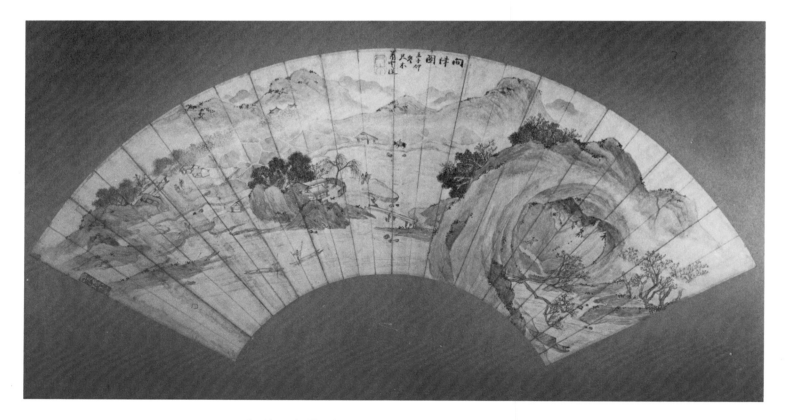

Seeking the Ford

The Chinese love of natural rocks with fantastic shapes can be traced back almost two thousand years. Rocks of various sizes, shapes, and textures were collected and admired by emperors, officials, poets, and artists. Among them, the TAIHU rocks, taken from the Great Lake (Taihu), were especially admired for their remarkable configurations of holes and concavities. They inspired poets' imaginations with their similarity to the caves in the mountains, the mystical entrance-ways to DONGTIAN. Su Shi (1037–1101), the great poet of the Song dynasty, said in his poem on the subject of a rock in a friend's collection: "When water from the Heavenly Pond falls over it, / Each layer of the mountain is clearly revealed. / The windows of jade-maidens are lighted; / They are connected to many places [of the mystical world]" (translated Munakata).

Many Chinese gardens are filled with those rocks, which provide an atmosphere of fantasy-land. In particular, private gardens preserved from the earlier period, such as those in Suzhou, were designed to create a complex of miniature DONGTIAN. In this type of garden, the master of the house was able to spend his leisure time, either meditating or studying in solitude, having private gatherings with his close friends, or enjoying other playful activities, freed from worldly concerns.

Small jade carvings from the Ming and Qing dynasties bring the fantasy of the immortals' mountains into the space of daily life. These exquisite carvings of the miniature mountains, with their caves, pine trees, waterfalls, and strolling immortals, give the viewer an intimate understanding of the imaginary world of the immortals which has enriched Chinese life throughout its long history.

Detail

Yuan Jiang, active c.1690–1746

The Gazing Garden

 82

Qing dynasty, 1644–1911

Handscroll, ink and color on silk

66 x 294.6 mounted

The Metropolitan Museum of Art
Gift of Constance Tang Fong in honor of
her mother, Mrs. P. Y. Tang, 1982
1982.461

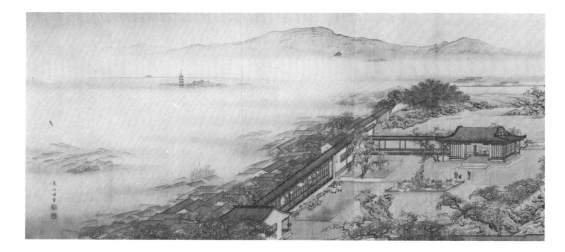

The Gazing Garden

The Gazing Garden, or Zhanyuan, was a private garden in the estate of a Manchu official in Nanjing. Yuan Jiang, one of the most renowned professional painters of the Qing dynasty, painted this grand-scale garden in a large handscroll format. It is expected that Yuan represented the garden fairly accurately, with some unavoidable exaggerations and omissions. The painting shows that this garden is similar, in its basic design principles, to the extant large-scale private gardens from the same period, from the seventeenth to nineteenth centuries, such as those in Suzhou.

Some of the basic principles of the designs of the large private gardens are as follows: The garden itself is completely separated from the living quarters. The buildings located in the gardens are garden houses for leisurely purposes, such as informal gatherings of friends or family, or for solitary pastimes pursued by the master of the house—reading, writing, or meditating—and not for daily life. The entire garden space is divided into many sections, and often each section is divided further into subsections. Each section is a complete entity surrounded by walls, open-roofed corridors, or, in rather rare instances, by some rock formations, as seen in *The Gazing Garden*. In many cases, each of the sections is designed to create an illusion of *dongtian*, the Daoist paradise, and often named as "such and such *dongtian*." Also characteristic is the extensive use of the eroded and fantastically shaped *taihu* rocks; they are appreciated for their own visual values, as seen in the left front section of *The Gazing Garden*, or for the effect of groups of them as fantastic mountains. A small section of a garden with a composition of only a few rocks and plants is sometimes designed for quiet private meditation (Munakata 1988).

Yuan Jiang's painting is quite magnificent in showing the grand-scale garden in its panoramic view. However, in order to appreciate the true meaning of the garden, the viewer is advised to walk into the garden mentally, to stand on the terrace to view the distant mountain across the lake, to walk in and out of sections and subsections following a path or an open corridor, and to experience the illusory moment of being in the immortals' paradise.

Reference:
Peach Blossom Spring: no. 42.

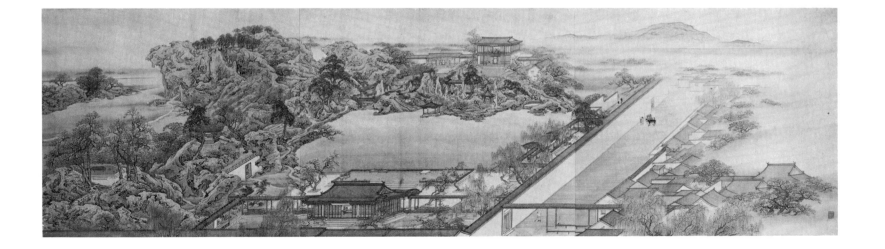

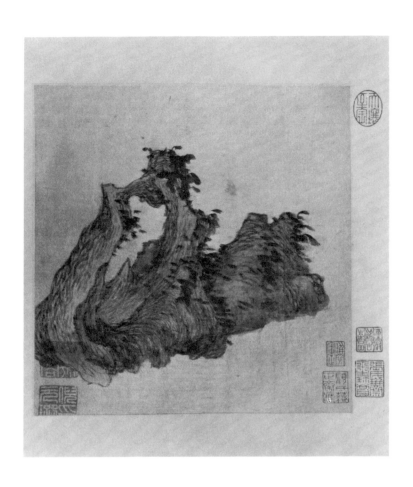

Ni Yuanlu, 1594–1644

Rock Bound

83

Ming dynasty, 1640

Album of ten paintings, ink and colors on silk

20.8–21.6 x 19.8–20 per leaf

The Art Museum, Princeton University
Lent by John B. Elliott
L.1970.229

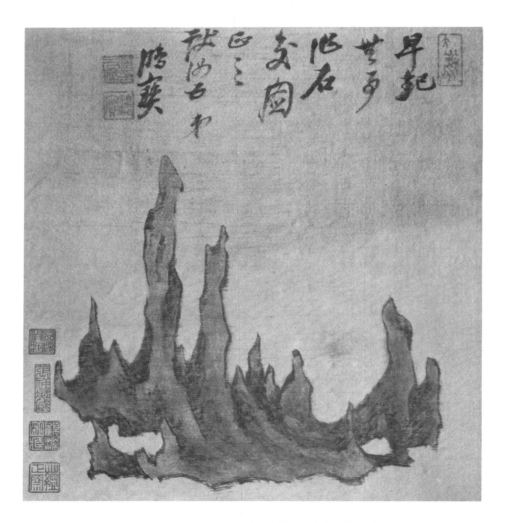

Rock Bound: 6 Album Leaves

Ni Yuanlu, a man from Zhejiang, was one of a few high officials during the last period of the Ming who kept his upright principles by fighting against eunuchs and corrupt officials and who tried to manage the declining empire. In 1644, when the rebel army of Li Zicheng took the capital, Ni, who was in the presidency of the Board of Revenue at the time, committed suicide rather than fall into enemy hands (Hummel 1943/44: 587).

Ni painted this album in 1640, during a period of forced retirement in his hometown of Shangyu, Zhejiang, and two years before he was called to Beijing to serve the government. The inscription placed on the last leaf reads:

Getting up early, with no event to attend, I made the pictures of the variety of rocks, sincerely, for the fifth brother Xiangnu, Hongbao [Ni Yuanlu].

(translated Munakata, adopting partially the reading in *Kernels of Energy*: 141)

The title given by Ni for this album, *Shizhi*, has been translated as "rock bound," but its actual meaning is "varieties of rocks." Ni Yuanlu was a rock-lover as were many other literati in the long history of Chinese culture, including Su Shi, whose poem on a rock is quoted above. Ni was undoubtedly fascinated with the fantastic forms of the rocks and with the Daoistic fantasy which they incited, but another traditional symbolic meaning of them—immutability, or unchanging principle—might have been as important.

Reference:
Kernels of Energy: no. 37

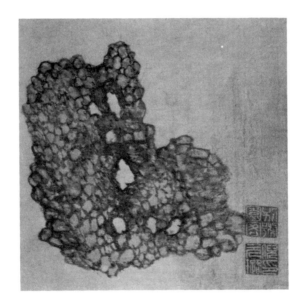

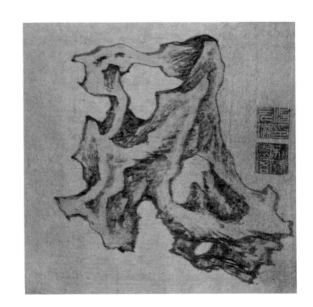

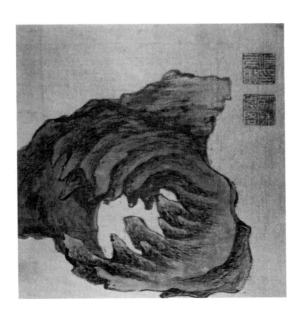

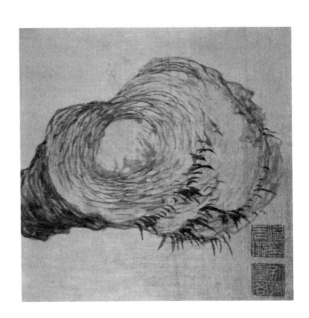

Robert Poor, contemporary

Tray Garden: View of Wu

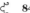 84

Recent

Carved featherstone, Chinese snow
rose, moss, grasses

30.4 high x 30.4 wide x 65.9 long

Robert Poor Collection

Tray Garden: View of Wu

Robert Poor, contemporary

Tray Garden: Long Shan

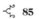 **85**

Recent

Limestone slab encrusted with mineral
deposits, dwarf Sawara cypress, dwarf
Japanese juniper, moss, grasses

40.6 wide x 60.8 long

Robert Poor Collection

Tray Garden: Long Shan

85

Robert Poor, with Dean Windham, contemporary

Tray Garden: Han Shan

86

Recent

Carved featherstone, black spruce, vines, moss, grasses

55.8 high

Robert Poor Collection

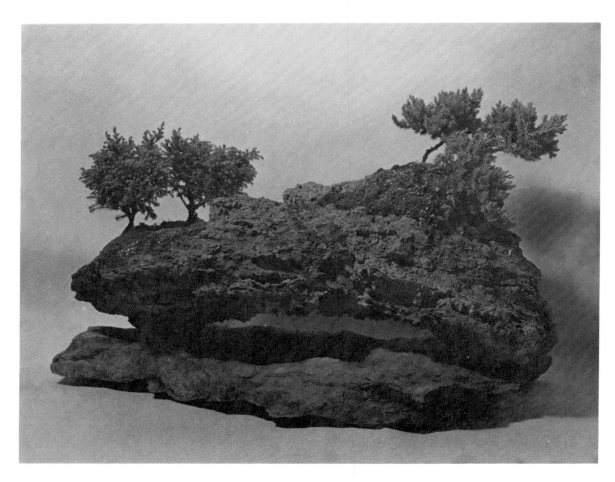

Tray Garden: Han Shan

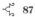

Miniature Mountain

87

Qing dynasty, eighteenth century

Jade carving

23.5 high x 12.6 wide

Asian Art Museum of San Francisco
Avery Brundage Collection
B60 J265

This piece is very similar in its main iconographical elements to the following piece from San Francisco—a gentleman followed by a servant stands facing a waterfall and a pine tree on a rock. This composition is more vertical, emphasizing a high steep cliff behind the figures.

An inscription is carved on the flat wall above the cliff. It reads:

Imperial Inscription: [A poem] composed using the rhyme of Wen Zhengming's poem [on his painting of] Flying Waterfall and Sound of Pine Tree:

Between the cliffs an echo of pine answers the voice of the spring water.

A noble person carrying a staff completes visually the total picture.

A visual equivalent of [such literary expressions as] "one thousand feet of snow over the Cold Mountain,"

Or "hitting the center of the endless circle," is the essence expressed in this painting.

(translated Munakata)

The inscription was supposedly composed by the Qianlong Emperor (reigned 1736–95). The jade carving is possibly a work from the imperial workshop.

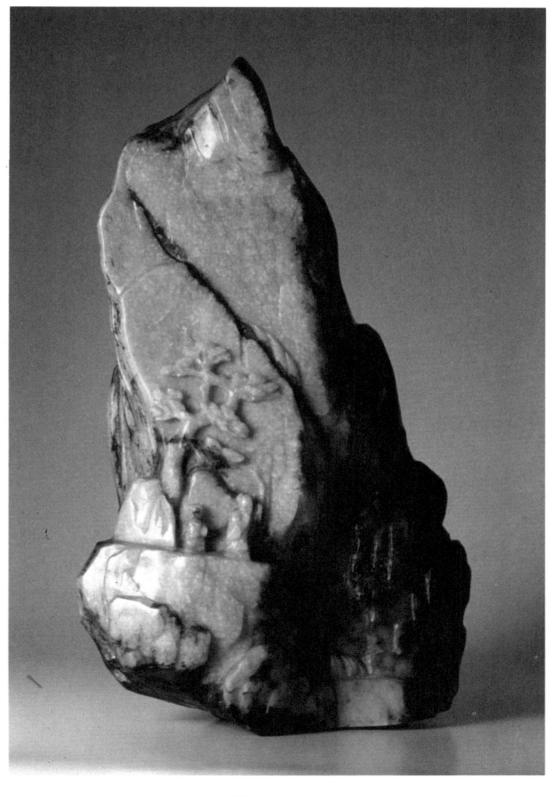

Miniature Mountain

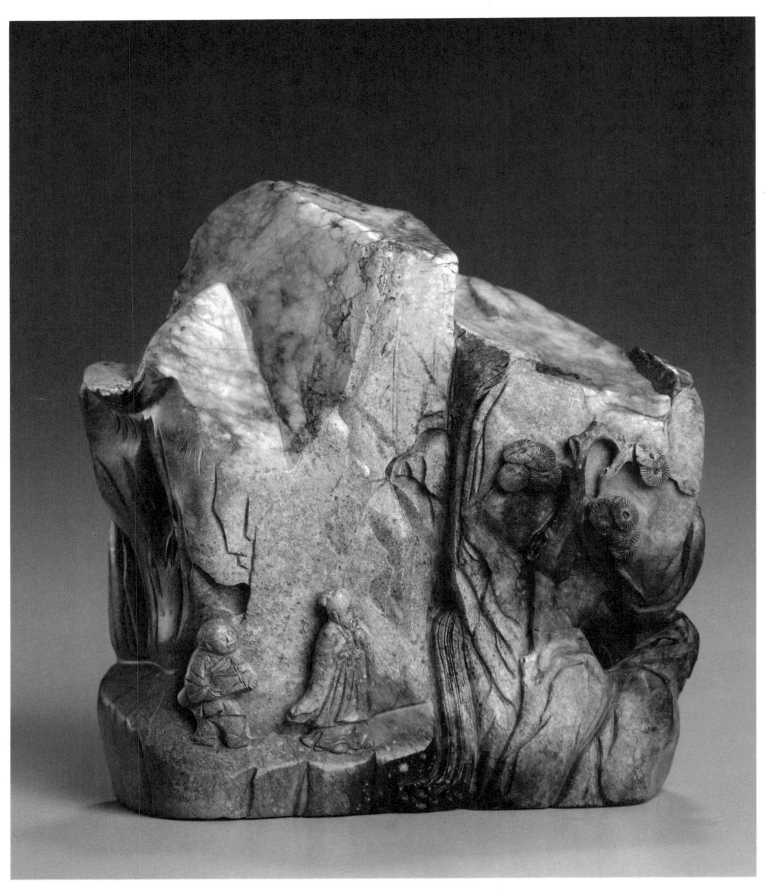

Miniature Mountain

Miniature Mountain

⚘ **88**

Qing dynasty, seventeenth to eighteenth century

Saussuritized gabbro, light grey with black and purple markings

11 high x 9.9 wide

Asian Art Museum of San Francisco
Avery Brundage Collection
B60 J474

A figure stands in front of a waterfall which cascades through a vertical gap in a cliff. His servant behind him holds a *qin* lute. Across the waterfall on a rock stands a tall pine tree represented with its clusters of needles in round shapes, as if they were blooming flowers. The mouth of a cave opens beside the pine.

The figure may be interpreted as an immortal, a hermit, or a noble person (*gaoshi*) visiting the mountain. Nonetheless, all the basic iconographical elements—the waterfall, which is, more correctly, a life-giving mysterious spring, the pine tree, and the cave—symbolize immortality. The theme of immortality, or longevity, continues on the back of the piece.

References:
Chinese Jades in the Brundage Collection:
no. lxvi; *Kernels of Energy*: no. 11.

Mountain of Immortals

⚘ **89**

Qing dynasty, eighteenth century

Yellow and brown steatite

19 x 20.3

The Metropolitan Museum of Art
Bequest of Jacob Ruppert, 1939
39.65.33

On the upper part of the mountain there is a large cave, the opening of which is adorned by two large pine trees. On a terrace at the entrance of the cave an immortal plays a game of *weigi* (better known in the West by the Japanese term *go*) by himself, while another, seated beside the table, watches the progress of the game. The cave, an entrance to the mysterious passage leading to the immortals' paradise (*dongtian*), is here represented as a place of relaxation for the immortals. Immortals playing the *weigi*

game—as a rule it should be played by two—under a pine tree, or around the entrance of a cave on a mountain, has been popular as a theme of painting from the Tang dynasty onward. This theme is, in fact, a later variation of the Han dynasty theme of the immortals playing the *liubo* game (see cat. no. 47). As in the case of *liubo*, playing the *weigi* game has a symbolic meaning of contemplating cosmic movement.

From under the cave, spring water flows down as a rushing stream. On the lower part of the mountain three immortals and a pack-carrying servant are on their way to the transcendental realm; one has already passed the dangerous crossing of the stream and anxiously looks back at the rest of the group who are approaching the stream. A certain sense of tenseness in this scene provides a noticeable contrast to the relaxed mood of the immortals on the upper terrace.

The whole piece appears as a unified mass because it is carved in relief on the undulating surface of the rock (an appropriate way to handle the extreme softness of steatite) rather than as a sculpture in the round.

Reference:
Kernels of Energy: no. 10.

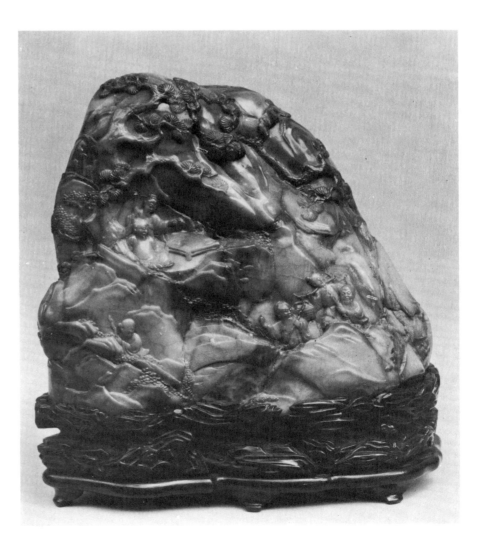

Mountain of Immortals

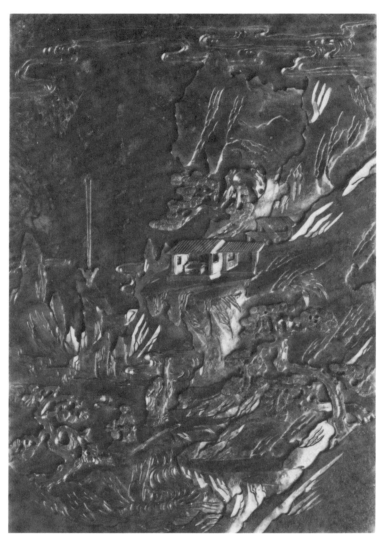

Screen

Screen

 90

Qing dynasty, Qianlong period,
1736–95

Nephrite carving

29.3 x 20.2 x 1.37

The Metropolitan Museum of Art
Gift of Heber R. Bishop, 1902
02.18.682

This table screen depicts the home of
an immortal, high in the mountains.
Auspicious clouds swirl around the
fantastic rocks surrounding the house
and a supernatural light seems to
stream from the mouth of a ritual
vessel. The immortal and his servant
stand on a bridge in the middle ground.
In this scene the concepts of private
garden (see cat. no. 82) and dwelling
place of an immortal are combined.

The mountains not only have been worshipped or regarded as the source of inspiration, but also have been taken as suitable places for recluses to reside. There have been two basic types of eremitism identified in China. One is Confucian eremitism, wherein one takes refuge in the mountains to escape from the society that, ruled by foreign invaders or corrupt governments, one cannot accept from a Confucian point of view. Another is Daoistic eremitism, whose adherents seek spiritual freedom in the mountains away from the restraining social order.

A mountain as the place of residence for a hermit has been one of the popular themes of Chinese painting. During the Tang dynasty, a retiring life in the mountains became fashionable. The emperors, particularly the emperor Xuanzong, thought so highly of those noble recluses that they were often called to the capital, where they were sometimes offered governmental positions or given particular honors and rewards. There were many recluses; some were genuine noble persons and some were "pretending recluses" waiting to be recognized by the emperor. Among the "genuine" recluses was Lu Hongyi (often mistakenly called Lu Hong; active, early eighth century), whose group of ten poems on his retired life at Mt. Song (the Center Sacred Mountain), called "Ten Notes on Mt. Song," is well known; an album of paintings depicting these poems, supposedly painted by Lu himself, is known through a later copy.

IV.

Wang Wei (701–61), whose life was mainly tied up with governmental jobs, built a villa in Wangchuan Valley and spent his free time there. His poems and paintings of WANGCHUAN VILLA became cultural monuments (cat. nos. 91-93). The poems and paintings depicting lives in mountains have been generally called those of "mountain dwellings" (SHANJU).

The Song dynasty (960–1279) is generally characterized as the period of naturalistic idealism in Chinese art. Mountains were considered as revelations of Cosmic Truth, and the artists had a strong tendency to try to depict mountains in their "true" forms, i.e., in their ideal forms, which were monumental, powerful, orderly, harmonious, and so forth. A particular person's dwelling on a particular mountain was not a popular subject of poems and paintings at the time, at least not as much as during the Tang dynasty. This situation was drastically changed in the following Yuan dynasty, when China was ruled by the Mongols and when many Chinese intellectuals chose or were forced to become recluses, often in the mountains. The rise of individualism during this period also caused a tendency to "personalize" the depictions of mountains; i.e., an individual artist depicted his personal perception of a particular mountain, which was identified by the artist's own inscription. The subject matter of "mountain dwellings" regained popularity. Huang Gongwang's (1296–1354) DWELLING IN THE FUCHUN MOUNTAINS was an example of this tendency, as was Wang Meng's DWELLING IN THE QINGBIAN MOUNTAINS (cat. no. 95).

The intellectual artists in the Ming and Qing dynasties followed the lead of the Yuan artists and developed landscape paintings that expressed their personal perceptions or reactions in their relationship with nature. There are several types of landscape paintings depicting mountains as their spiritual homes from these later periods. One is a continuation of the general category of "Dwelling in the Mountains." These paintings didn't depict reality so much as they expressed the artists' imaginations, as in the case of Lu Zhi (cat. no. 94) of the Ming, or their spiritual environment, as in the case of Gong Xian (cat. nos. 74-77) or Hongren (1610–64) in the early Qing. Another type is what may be called "Calling on a Hermit," a category of poems very popular during the Six Dynasties period, in which a poet wanders into mountains seeking a "hermit," or more correctly a mystical environment suitable for a hermit. We may include in this category any painting in which a great mountain is represented as an ideal or mystical place for a wanderer who seeks a transcendental experience. The third type shows the activity of one person or a few people on a vast mountain; they often listen to the sound of a waterfall, play the lute, or just rest and view the scenery. Those figures could be resident hermits, or visitors to the mountains. The last two types were, in the Ming and Qing context, essentially poetical expressions of the urbanized artists' romantic dreams of life in nature, even though some of their actual experiences might have been behind those paintings.

The artists, according to their social and cultural environment as well as their personalities and convictions, took different approaches in depicting man's relationship with mountains. Yet, it is clear that mountains have remained powerful and benevolent, and accommodating to those who sought their actual or spiritual homes.

A Copy after Wang Wei (701–61)

Wangchuan Villa

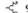 **91**

Stone engraved by Guo Shiyuan
during Ming dynasty, 1617

Handscroll, rubbing from a stone stele

31 x 924

Far Eastern Art Seminar
Department of Art and Archæology,
Princeton University

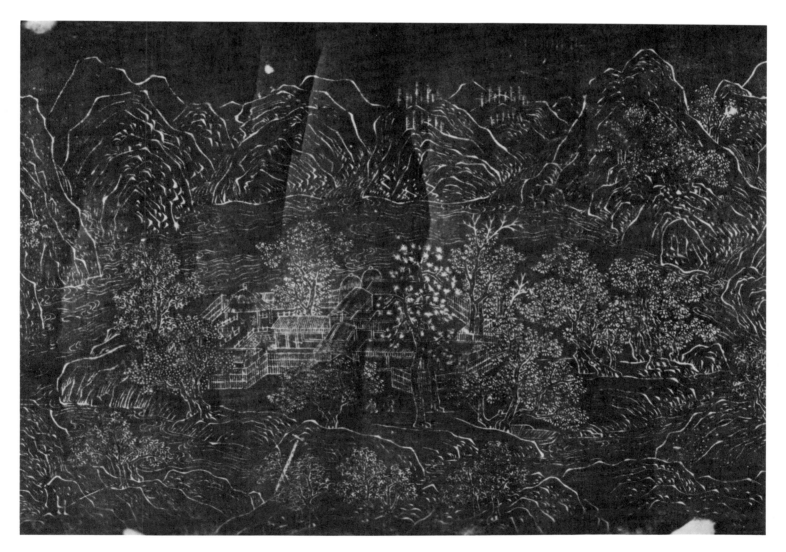

Wangchuan Villa ∘ *Detail*

Wangchuan Villa was a country home of Wang Wei, one of the greatest poet-painters of the Tang dynasty. Wang Wei composed twenty poems on notable sites of the Wangchuan Valley, where his villa was situated, and put them together along with corresponding poems by his younger friend Pei Di, under the title of *Wangchuan ji* (Collection of Wangchuan Poems). The present rubbing shows in horizontal handscroll format a landscape of the Wangchuan Valley introducing each theme-site of the poems in pictorial terms, one by one. Major buildings were represented in superb architectural drawings.

During the Song dynasty there were at least two copies of the *Wangchuan* handscroll, claimed to be Wang Wei's own work. Guo Zhongshu (910–77), himself a well-educated and flamboyant person and a great master of landscape and architectural painting, copied one of them. The present rubbing is from an engraving on a stone stele of the seventeenth century which copied Guo's copy of *Wangchuan*. Although its imagery has come through so many copyists' hands, the present rubbing has been considered to be one of the most reliable copies in retaining the features of Wang Wei's original.

The scroll starts from the right with a house surrounded by water, a narrow running stream in front of it and a large lake behind, into which, at four separate points, waters from the surrounding mountains pour. There is every reason to believe that this house is Wang Wei's own villa, and the large lake is Lake Yi, around which most of the sites in Wang's poems are situated. The buildings of this villa are modest

in structure and scale and are surrounded by many trees. This opening scene sets the basic theme: the life of a man of noble spirit surrounded by mountains and isolated by water from the dusty world.

The scene of Wang Wei's villa is followed by that of a ruined site of an old castle which is said to be located on a hill just above Wang's villa. Its empty lot with only a few trees growing is a reference to time, which pushes the individual fates of men into obsolescence. Immediately following this is a magnificent building that looks like a palace with a front hall, a two-story pavilion, attached wings, and roofed open-sided terraces. This building is unique in that the whole complex is placed over a lake which is artificially created by a surrounding bank. Scholars have been puzzled about the indentity of this building, which is vaguely called "Wangkou Villa, or a Villa at the Mouth of the Wang Valley." According to one of Wang Wei's own poems (not included in *Wangchuan ji*), however, it must be identified as a villa of Cui Jizhong (active, middle of the eighth century), a grand-governor of Puyang province (Iritani 1976: 598-99). Nonetheless, it appears more like a palace in a paradise, either Buddhist or Daoist. The inclusion of this building, which is not

among the sites in the *Wangchuan ji*, in such a glorified form should be interpreted as an attempt to introduce this valley symbolically as a spiritual paradise. Similar idealization of a building can be seen later in the scroll in another fantastic "water palace" represented as Linhuting (Lakeshore House). Wang Wei's poem on this place reads:

I welcomed an important guest on a light skiff.
It came unhurriedly over the lake.
When we sat under the eaves and started to drink from a keg, lotus flowers blossomed all around us.

This is an image of a paradise dramatically unfolded. Who was the "important guest"? The building, probably a humble drinking place on a lakeshore, was suddenly changed into a palace of paradise in the poem, and so in the painting.

After the opening three scenes, the major sites on which the poems were composed are arranged one by one as the scroll unfolded, generally following the order of the arrangement of the poems in the *Wangchuan ji*. In other words, this scroll is composed as an illustration of the poems, rather than as a depiction of the actual topography of the valley. Those sites supposedly located around Lake Yi are rearranged in a linear sequence as if they were lined up along the running water. The general approach of the artist in depicting each site is to visualize hermits'

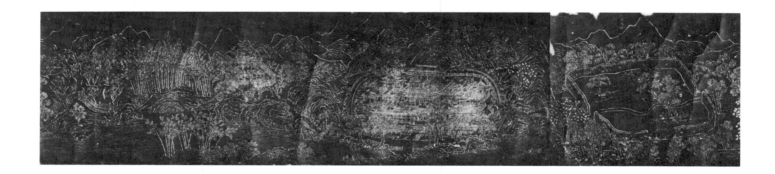

Wangchuan Villa

activities in nature, taking hints from Wang Wei's, and sometimes Pei Di's, poem on the site. For example, Wang Wei's "Gold-dust Spring" reads:

A daily drink of water from the Gold-dust Spring results in a life of at least one thousand years.

Then, I fly on a phoenix-chariot drawn by the ornate dragon, and holding a feather-made flag [a symbol of imperial recognition] attend the court of the Jade Emperor.

The corresponding scene in the scroll shows a person in a house, seated on a chair and about to drink water from a pitcher. The meaning of this scene is made clear by two cranes, symbolizing immortality, in the front court of the building.

The Wangchuan Valley represented here is a spiritual paradise for the poet-recluse whose poetical imaginings were nurtured by the surrounding mountains and water.

The monument is illustrated here by photographs of rubbing 116203 in the collection of the Field Museum of Natural History.

Reference:
Iriya et al., eds., *Ōi*: pl. 5.

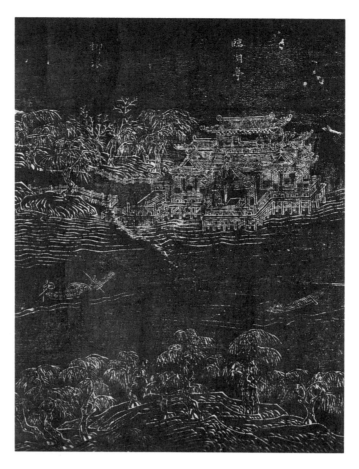

Detail

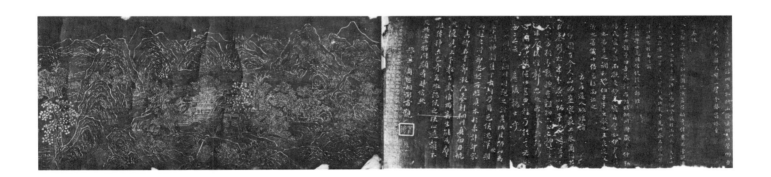

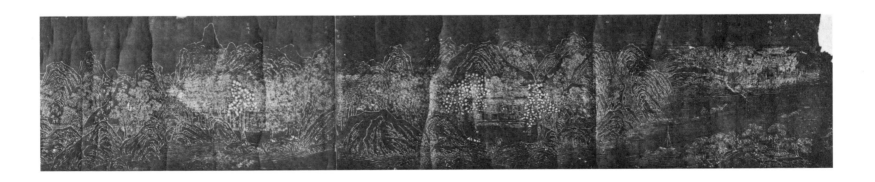

Anonymous, after Wang Wei (701–61)

Wangchuan Villa

92

Ming dynasty, 1368–1644

Handscroll, ink and color on silk

30 x 480

Seattle Art Museum
Eugene Fuller Memorial Collection
47.142

The popularity of the painting of Wangchuan Villa, or more correctly, Wangchuan Valley, can be attested by numerous copies made by both well-known and anonymous artists from the Song dynasty onward. A recent study lists as many as nineteen extant copies in various collections worldwide, some carrying the names of famous Yuan and Ming artists as the ones who copied them; some are painted in color and some are rendered in ink monochrome drawing.

The Seattle scroll is painted in color, and has been traditionally claimed to be the original Guo Zhongshu copy of Wang Wei's painting. Recent scholarship places this painting as a copy made during the Ming dynasty, possibly during the sixteenth century. However, it retains fairly well the original features of Guo's version, attested by the rubbing of the seventeenth-century copy. Among the colophons attached at the end of the scroll, the one by Li Gui (1219–1307), dated 1298, is beautifully written in cursive style and is possibly original. It seems that it was removed from Guo's original painting and added to this Ming dynasty scroll at the time when the copy was made. It attests that Guo's *Wangchuan* painting, which Li Gui saw, was in color, and fine and rich in every detail.

The coloring method used in this scroll is very different from those of most other *Wangchuan* copies, and, for that matter, from that of any other painting in the blue-and-green coloring style. An opaque white-emerald green is used as a main color throughout the painting. This color is the only one applied on the mountains and rocks, and only on the upper parts of them, resulting in the effect of a mysterious glow emanating from them. This color is also applied on selected parts of buildings. For example, in the case of the palace-like building called Wangkou Villa, the special color was applied on the brackets under the eaves, and on the peripheries of the wall panels and the screens placed on the lower parts of railings. This color, together with a soft pink applied mainly on the interior of the rooms, gives the building the effect that it is illuminated from within.

Since the unique coloring system seen in the Seattle scroll is so suitable to the original intention—if not that of Wang Wei, at least that of Guo Zhongshu—of the original *Wangchuan* painting, it is hard to consider it as an invention of the Ming copyist. We may ascribe the invention of this coloring system to a Song artist, if not to Guo Zhongshu himself.

Reference:
Iriya et al., eds., *Ōi*: pl. 13-15.

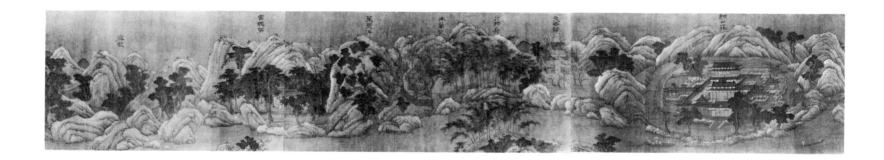

Wangchuan Villa

Detail

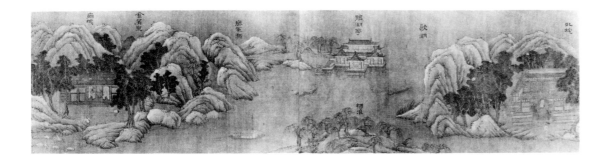

Anonymous, attributed to Li Gonglin, 1040–1106

Wangchuan Villa

93

After Wang Wei, 701–61

Yuan dynasty, late thirteenth-early fourteenth century

Handscroll, ink on silk

26.3 x 554

The Art Institute of Chicago
1950.1369

The *Wangchuan Villa* scroll in Chicago has a signature of Li Longmian placed, or "hidden," within a part of the painting around the central section of the scroll. The condition of this scroll is rather poor; the silk is darkened and deteriorated, and the painting was heavily retouched by the repairer(s), who replaced or thinned out original brushwork. The scroll has lost some of its original beginning and ending portions, and it was trimmed at the top and bottom by as much as an inch, in the process of repeated remounting. In spite of all these preservation problems, this scroll remains an important and interesting work among the copies of Wang Wei's *Wangchuan Villa*, because it provides a version which is different from the one copied by Guo Zhongshu during the tenth century. All the other extant copies of *Wangchuan Villa* known to us are copies after or derived from the Guo Zhongshu version.

The Chicago scroll shares basic iconographical elements of the *Wangchuan Villa* with the Guo version, indicating that it took as its model a very similar, but slightly different version from the one on which Guo based his work. One obvious difference in this scroll is the scene of the "Locust-tree Path" (*gonghuai mo*), which is shown in all Guo-version copies as a small hut behind some trees, including a large locust, located in front of a running stream. The Chicago version

represents the scene as a complex of houses on the shore of a lake (Lake Yi), where a running stream flows into the lake. There is an arched bridge over the stream, and a man who looks like a Buddhist monk, followed by a servant, walks over it toward the house. The poems by Wang Wei and Pei Di on this place in *Wangchuan ji* suggest that this path was in front of the gate of Wang's main residence and led to Lake Yi. The path under the trees was covered by fallen leaves in autumn. Wang says that he just sweeps around the gate, and prepares humbly for a possible visit by a monk from the mountain. The Chicago version literally depicts this portion of the poem, while ignoring the dark path under the locust tree.

This scroll represents the whole scene as a single continuous landscape with its topographic features rendered as naturally as possible. The scenes mentioned in the *Wangchuan ji* are, without changing their order much, placed as natural parts of this overall composition. This is characteristic of the Song style, rather than the Tang style, and suggests that the artist who originated this version during the Song dynasty exercised his originality freely in "copying" his model.

Li Gonglin (better known by the name Longmian) was an intellectual artist of the late Northern Song. He retired around 1100 from a respectable position in the Song court, and lived in his villa at the Longmian Mountain near his hometown of Shucheng,

Wangchuan Villa

Anhui. Imitating Wang Wei's *Wang-chuan Villa* scroll, he painted his *Long-mian Villa*. The extant copies of the *Longmian Villa* are an interesting mixture of archaism and Song naturalism, and rather remotely resemble the Chicago *Wangchuan* scroll in style. The Chicago scroll seems to be a relatively free copy of Li Gonglin's version of the *Wangchuan Villa*, which, judging from its stylistic characteristics, was copied by a professional painter of the Yuan dynasty who was well versed in the tradition of the Li Cheng-Guo Xi landscape style of the Northern Song period.

Reference:
Iriya et al., eds., *Ōi*: pl. 47-50.

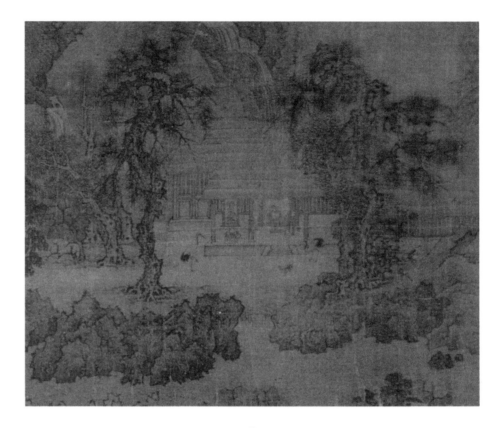

Detail

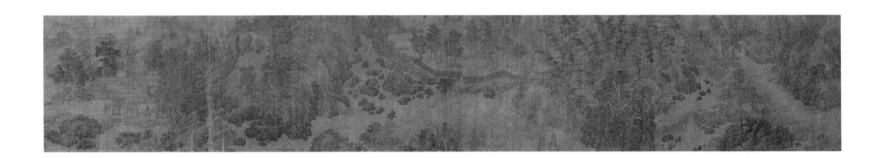

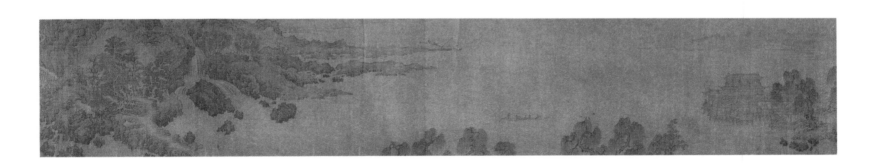

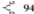

Lu Zhi, 1496–1576

Planting Chrysanthemums

94

Ming dynasty, c. 1550

Hanging scroll, ink and color on paper

106.7 x 27.3

The Metropolitan Museum of Art
Gift of Douglas Dillon, 1986
1986.266.3

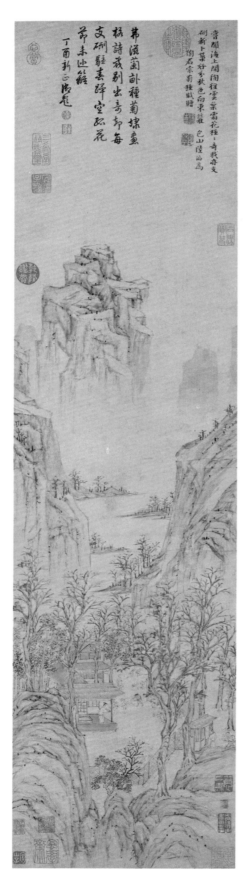

Planting Chrysanthemums

Lu Zhi (see cat. no. 69) built a house at the foot of Mt. Zhixing, about twenty-five miles west of the city of Suzhou, around 1550, and spent the rest of his life there as a recluse. A contemporary record describes his life in this place as follows:

The place was surrounded by clouds and mists on all sides, with a running stream winding around it. There he planted hundreds of kinds of beautiful flowers, and when a guest whom he liked arrived, at any time of the year, he would go to greet him among the flowers and would cut off a piece of honeycomb or a bamboo shoot to give him.

(Cahill 1978: 240).

Lu Zhi's own poem inscribed on this painting reads:

I once heard, on the [mysterious Eastern] Sea a pleasant path (garden) was open,
Where the leaves of clouds, the flowers of frost, and all sort of marvels were seen.
I also have built one newly at Zhixing Mountain;
How nice it is, when I look at its eastern hedge in autumn colors!

(translated Munakata)

Lu says, in addition, that he painted this for his friend Mr. Tao, who asked him to spare some chrysanthemum seedlings. Mr. Tao shares the same surname with one of the greatest poets in early China, Tao Qian (365–427), whose couplet, *Picking chrysanthemums under the eastern hedge, and looking at the South Mountain in indolence,* is one of the best-known phrases in China. Lu Zhi used the words "eastern hedge" in his poem as an echo of Tao Qian's phrase. In selecting that particular poet he makes a playful reference to his friend's name. He also used the rather uncommon words "pleasant path" (*taojing*) in the poem as a play on the name "Tao."

Lu Zhi depicted his estate in the lower part of the painting. He appears on the veranda directing his servant to take care the garden, while the visitor, presumably on his way out, stands at the gate with his servant, who holds the chrysanthemum seedlings given by Lu Zhi. It seems that Lu Zhi intended to depict his garden as a "path" that extends further, passing through the gap between the two cliffs and far into the distance. The towering rocky peak in the distance and other barely visible distant peaks depicted in thin wash are meant to be those on the mysterious islands in the Eastern Sea. It should be noted that the vista of water represented here has almost nothing to do with the actual topography of the area of the Zhixing Mountains. Lu Zhi represented here his inner vision, which, as with his many other visions shown through his poems and paintings, was a unique blend of reality and his fantasy. Lu Zhi is showing to his friend Tao, and the viewer, through the opening of the gate, that he is living on the land which is, to his mind, a "pleasant path" on earth that is directly connected to the mystical realms of immortals.

Reference:
Peach Blossom Spring: no. 27.

Anonymous, after Wang Meng (died 1385)

Dwelling in the Qingbian Mountains

 95

Modern copy of the original

Hanging scroll, ink on paper

97.4 x 27.9

The Art Museum, Princeton University
Lent by John B. Elliott
L.1970.215

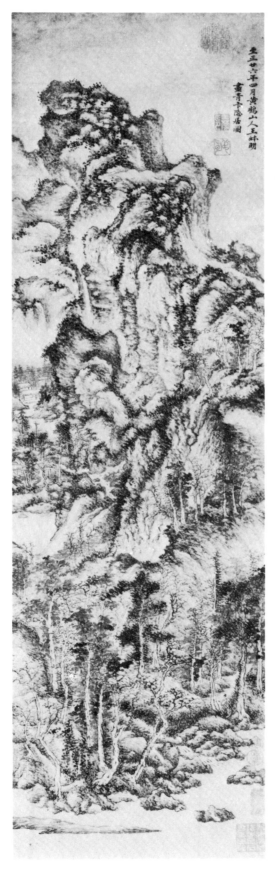

Dwelling in the Qingbian Mountains

Wang Meng was highly admired as one of the Four Great Masters of the Yuan dynasty. His influence on later generations of artists is truly immeasurable. He was primarily a recluse-painter during the Yuan dynasty, and became an official when the new Ming government was established in 1368. He ended his life tragically in prison in 1385, when the first emperor of the Ming became irrationally suspicious about the loyalty of intellectuals and executed as many as three thousand officials.

Among the extant works of Wang Meng, one of the most highly regarded is the *Dwelling in the Qingbian Mountains*, dated 1366, presently in the Shanghai Museum of Art. Since this painting has so far never been allowed to travel outside China, we present here an amazingly close copy of it from the Art Museum at Princeton University. A very small-scale dwelling of the recluse is placed in the upper part of a valley to the left of the major mountain mass. There is a steep cliff behind it and a lake in front. At the front edge of the lake is a symbolic pine forest through which water runs as a mountain torrent, flowing into a larger lake on a lower level. Wang Meng ingeniously placed this small pocket of space containing the recluse's dwelling in an overwhelmingly large and powerful mountain. There is a traveler at the foot of the mountain, beside a running stream, but no path to the retreat is shown. Wang Meng, synthesizing the Northern Song type of monumental landscape with the idea of a "mountain dwelling," represented the mountain as the provider of great spiritual as well as physical sanctuary to the recluse.

Mt. Qingbian (literally, "Blue Bian"), or officially, Mt. Bian, is a mountain of high peaks—the tallest is said to be as high as six thousand feet—standing on the otherwise flat land with some rolling hills to the west of the Great Lake. It had great significance as the spiritual landmark for the residents of the region centering on the city of Wuxing. This was the hometown of Wang Meng and his relatives, including his grandfather Zhao Mengfu (1254–1322), a towering figure of the early Yuan known as a statesman, poet, and painter (Vinograd 1979: 211-39). Wang Meng's inscription on the painting simply gives the date (the fourth month of 1366), his signature, and the title *Recluse Residence in the Qingbian*. The year 1366 was two years before the end of the Yuan dynasty, a time of rebellions and great civil disturbances in the region. Zhao Lin (active 1350–70), a relative of Wang Meng who is thought to have been the recipient of this painting, possibly held a nominal position of governorship of this ungovernable, disturbed region at the time (ibid.: 252-64). Zhao might have taken refuge temporarily in the Bian Mountain, but apparently was not a "recluse" there. Wang Meng probably painted his masterpiece not for a specific person, but rather for all the people, including himself and Zhao Lin, who shared the cultural heritage of the region, symbolically representing the Blue Bian as their spiritual home away from a world of turmoil and confusion.

Wen Zhengming, 1470–1559

Landscape

96

Ming dynasty, 1368–1644

Hanging scroll, ink on paper

93.2 x 20.8

The University of Michigan Museum of
Art, Ann Arbor
1959/1.109

Wen Zhengming, a great master of the Wu school of painting in the middle Ming period, spent most of his life in the city of Suzhou as a scholar, poet, and painter, except for a brief period of 1523–26 when he was appointed Hanlin academy scholar in the imperial court in Beijing.

Among other achievements, Wen Zhengming originated a unique format of landscape painting called the "Wang Meng style." He took Wang Meng's composition, which fills the whole space of a painting with a powerful structure of compressed landscape elements, and changed it into an elegant and intricate tapestry-like composition in an extremely elongated vertical format. This "Wang Meng style" was imitated and manipulated by many of his followers. The Michigan landscape painting has no signature of the artist, only his two seals. However, his son Wen Jia appended an inscription to it certifying that this was his father's early work. The painting is now considered one of Wen Zhengming's earliest extant paintings in the "Wang Meng style" and is given a date between 1500 and 1523 (*The Art of Wen Cheng-ming*: no. xv.).

The Michigan landscape is painted with delicate brushwork that basically repeats short, almost dot-like strokes in thin ink, building up an intricate composition of rocky cliffs on the lower half and the powerful peaks high above. Two figures are seated on a small plateau at the foot of the mountain. Directly above them, an empty arbor is seen on a terrace of the cliff. There is a zigzag path on the side of the cliff on the right, and a stream which runs between the two cliffs. The upper reaches of the two cliffs appear like upper edges of screens, and hidden behind these screens is a deep valley from which a solid peak of medium height rises. There is another valley behind this peak, and a waterfall cascades into it from a group of higher peaks behind. This group of peaks looks unapproachable, part of a complex configuration extending to the highest mountains.

There is a similar painting by the same artist in the Palace Museum, Taibei, entitled *The Listening Pine*. It is undated, but bears Wen's own poem, inscribed by him, which reads:

In the sixth month the flying waterfall
pours over the jade rainbow.
The immortals' 'pavilion of the void' is
in the middle of the mountains.
Its four eaves are of a fine color in the
rain falling over the thousand peaks.
One sleeping-bench is surrounded by the
sound of pines, responding to the wind
which has come through the myriad
ravines.

(translated Munakata)

Wen Zhengming, who did not show much of his interest in Daoism in his writings and poems, probably used the beautiful Daoistic image to express metaphorically his pious feeling toward the mysterious great mountain. The unapproachable high peaks in the Michigan painting almost appear to be sacred images in an icon on an altar, which the two figures seated at the bottom worship, like priests, while listening to the voice from the myriad ravines.

Reference:
The Art of Wen Cheng-ming: no. xv.

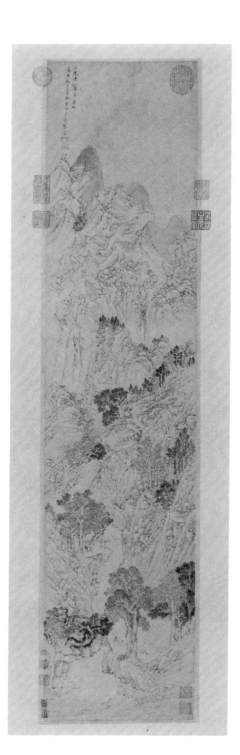

Landscape

Hou Mougong, 1550–1600

Landscape

97

Ming dynasty, 1576

Hanging scroll, ink and color on paper

127 x 32.4

Krannert Art Museum
74-5-2

Hou Mougong was an artist of the Wu school in Suzhou and a follower of Wen Zhengming. Details of his life are not known, but the extant paintings of Hou Mougong reveal that he was an artist of considerable creative talent. He brought power and expressive elements to the Wu school in the late sixteenth century, a period when it had started to decline by merely manipulating the elegant aspects of Wen Zhengming's works.

The Krannert painting is in the vertically elongated "Wang Meng style" of Wen Zhengming. The inscription says that Hou painted this work "on the twelfth [lunar calendar] month of 1576, snow covering the ground, at the Songling guest house." The location of the Songling guest house is not known, but possibly it was in an area east of the Great Lake along the Song River, which is sometimes called the Songling River. Hou, using the white of the paper effectively, painted snow-covered powerful mountains. Unlike Wen Zhengming, Hou Mougong likes to take the viewer along the paths through the rugged terrain. A lone visitor in winter clothing is seen in the wooded area at the bottom of the composition, as if to lead the viewer on the adventurous trip. At the end of the stream there is the residence of a recluse, which is composed of a few buildings, including a multistoried house. The dwelling is enclosed by a fence and gate in front, steep cliffs on both sides, and a waterfall to the rear. The rock formations surrounding this residence are powerful and fantastic, forming a cave-like space into the depths of which continue a stream with several falls and a zigzag cliffside path.

The excitement of this painting arises when the viewer begins to discover and "visit" many groups of buildings drawn on a minute scale and placed in various parts of the high mountains above and behind the large central mass of rock formations. There are two groups of temple-like buildings just behind the central mass: one, on the right side, is in a small pocket of space behind a sheer cliff, and another, on the left side, is in a wooded area just behind the top of the central rock.

Above the temple on the right, on a high cliff, there is a dangerously tapered terrace on which there is a cluster of small houses (a small community?). Further, in a space located behind this clifftop terrace and half hidden by the left cliff of the high massive peak, is another temple-like building surrounded by pine trees. The high, massive peak is a highlight of the climb; it stands silhouetted against the range of the highest peaks. There is a zigzag path along the lower part of this peak, a climbing route to the top. Finally, at the top of one of the knolls on this peak, there stands a small arbor, a lookout, facing the majestic highest peak across an unfathomable valley.

This is a painting of pilgrimage to a sacred mountain which is majestic and pure, covered with snow. Some of the topographic features and the buildings tucked among them in this painting have a vague similarity to, or rather faintly echo, those in the illustrated maps of the sacred mountains, particularly those of Mt. Hua (cat. nos. 5 and 6). It is very possible that in this painting of imaginary pilgrimage to a spirit mountain, Hou Mougong projected his past experiences in visiting some of the renowned sacred mountains.

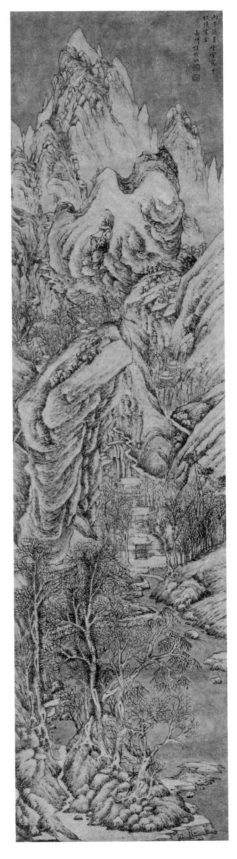

Landscape

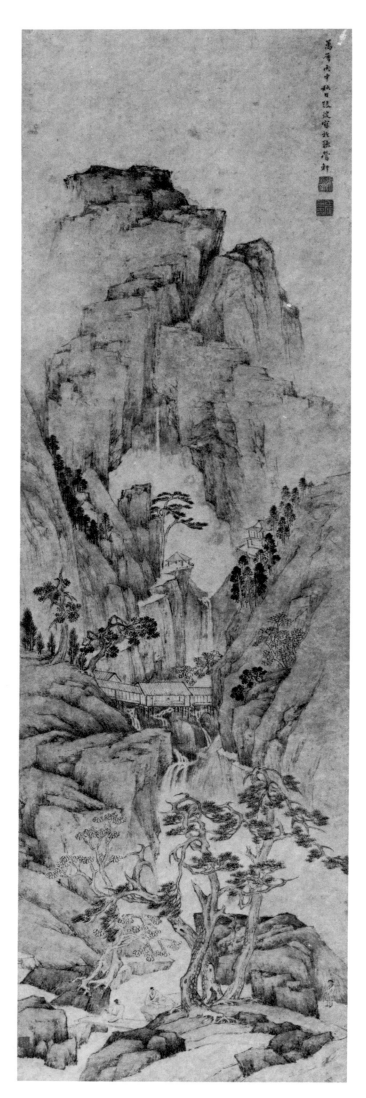

Landscape with Waterfall

Zhang Fu, 1546 – after 1631

Landscape with Waterfall

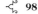 98

Ming dynasty, 1596

Hanging scroll, ink and light colors on paper

103.2 x 31.4

Nicholas Cahill Collection, on extended loan to University Art Museum, University of California at Berkeley
CM 14

Zhang Fu was a younger contemporary of Hou Mougong, active in the same city of Suzhou; in fact, he studied painting with the same teacher, Qian Gu (1508–after 1574), who was a pupil and younger friend of Wen Zhengming.

The *Landscape with Waterfall* follows Wen Zhengming's vertically elongated "Wang Meng style" format, but shows neither the intensity of Wang Meng's and Hou Mougong's works, nor the complexity of Wen Zhengming's composition. It is calm and airy. A mountain spring begins at a cave-like gap in the cliffs at the top of the rock formation, and in a sequence of waterfalls flows down to the bottom of the composition. Large pine trees and rocks, symbolizing man's virtue and longevity, occupy the foreground, and two figures in relaxed postures engage in conversation under the pines. A complex of houses spans a waterfall like a bridge in the middle of the composition. There is a larger waterfall cascading from the vertical cliff behind the bridge of houses. On the cliff at the left, an arbor is placed at the end of the cliffside path, and across the valley, slightly higher on the hill to the right, a portion of a house can be seen. The topmost rock formations are drawn with a minimum of shading and with the fade-out effect, emphasizing the calm, misty atmosphere rather than the ruggedness of the structure.

The architecture drawn here, particularly the houses built over a waterfall, is of a type that commonly appears in paintings of the immortals' mountain. However, the buildings also became common architectural features in the actual mountain scenes, probably imitating the fanciful images of the immortals' land. Zhang Fu's house by the waterfall is of the more ordinary type rather than a fanciful immortal's house, and does not look unapproachable. Yet, there is a "romantic" distance between the house and the two figures conversing under the pines. It seems that Zhang Fu here is depicting a dream of living as a recluse in an ideal mountain setting.

Reference:
Restless Landscape: no. 1.

Gao Yang,
first half of the seventeenth century

Rocky Landscape

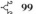 **99**

Ming dynasty, 1609

Hanging scroll, ink and light colors on
silk

178 x 68

Nicholas Cahill Collection, on extended
loan to University Art Museum, University
of California at Berkeley
CM 44

Gao Yang, a man from Ningbo, Zhe-
jiang, was active as a professional
painter in Nanjing, and had a close
relationship with another Nanjing
artist, Wu Bin (see cat. nos. 56, 57, and
73) (Cahill 1982:180-81).
 Gao Yang's *Rocky Landscape* has a
simple inscription giving just his
signature and the date. The painting is
divided into a lower, realistic section,
and an upper section which is fantastic.
The upper section is composed of a
series of free-floating mountain units
which are connected sequentially from
the topmost peak down to the lowest
waterfall, following a zigzag composi-
tional line. A large natural stone bridge
crosses diagonally over a waterfall at
the lowest part of the upper area. This
stone bridge is a reference to the
famous stone bridge at Mt. Tiantai (cat.
no. 56). As in the case of Mt. Tiantai,
this stone bridge appears to mark the
division between a mystical realm of
the mountain and the mundane world
below. Two men are talking on a path in
the lower section. One wears the robe
of a Buddhist monk and seems to have
come down from the mountain; the
other, wearing the clothing of an
ordinary gentleman and holding a cane,
is apparently on his way to wander in
the mountains, "calling on a hermit," so
to speak. The Buddhist monk is
another reference to Mt. Tiantai, which
by this time was better known as a
Buddhist sacred mountain, although
the mystical realm in the mountain was
probably regarded as an area beyond
any particular designation, as in the
case of Sun Chuo's "Rhapsody on
Wandering in the Tiantai Mountains"
(see discussion for cat. no. 56).

Reference:
Restless Landscape: no. 45.

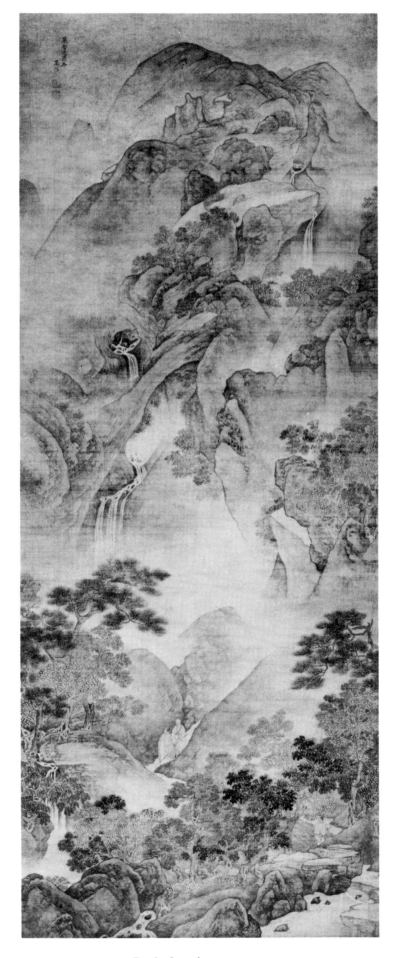

Rocky Landscape

Zhang Feng, died 1662

Listening to the Waterfall

100

Qing dynasty, 1658–60

Hanging scroll, ink on paper

94.3 x 40.9

The Art Museum, Princeton University
Gift of Mrs. Edward L. Elliott
1984-53

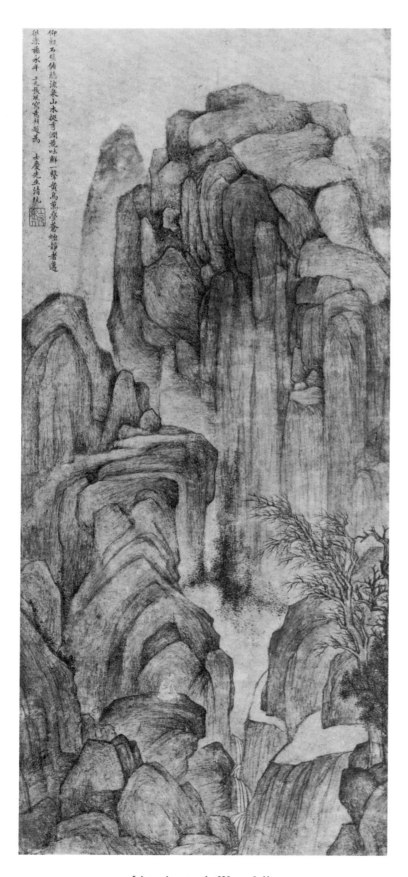

Listening to the Waterfall

Zhang Feng was an intellectual artist in Nanjing in the early Qing dynasty. When he was preparing for the national examination to be a governmental official, the Ming dynasty collapsed. As in the case of Gong Xian (cat. no. 74), he refused to serve under the Manchus and spent the rest of his life as a scholar, poet, and painter.

The Princeton painting is not dated, but is attributed, from the stylistic characteristics of the work, to Zhang's later years, around 1658–60. It has his inscription, including his own poem which reads:

Looking up he contemplates the stone
 wall;
Bending he listens to the running spring.
Mountain trees tall and graceful;
Valley flowers disgorging bright colors,
One [piercing] voice of a yellow bird;
Ten thousands layers of blue mist,
A quiet man unhesitatingly walked into
 [this realm].
May his joy last for long years.

(translated Munakata)

Zhang Feng composed this poem using crisp four-character phrases, as in the inscriptions on the ancient mirrors; like those inscriptions, this poem can be interpreted as a prayer. He painted and composed the poem for a Mr. Shiqing (unidentified).

In the painting, the "quiet man" sits on a rock in the lower part of the composition and listens to the sound of the running stream. A "quiet man" probably refers to a virtuous man, who enjoys mountains and is quiet, in the sayings of Confucius (*Lun yu*: 3/16a-b). Zhang Feng painted this scene of a rocky mountain in a deliberately archaistic way, in concert with the form of the poem. The mass of rocks on the left side is simply structured by overlapping and piling basically triangular forms one over the other, and other rock formations too are represented using a conceptual formula. This formula can be observed also in the decorations of mirrors from the Han to the early Tang periods, or in the painting of a mountain ascribed to Gu Kaizhi (c. 343–c. 406). (See essay, above.)

In successfully representing this dream-like subject matter, Zhang Feng avoided any sweetness, romantic flavor, or fantastic appearance in his painting. He even disregarded the colorful elements in his poem, such as the flowers in bright colors, the yellow bird, and the blue mist. The painting is, in short, intentionally drab. It is in drabness, that is, in the world of real substance (*zhi*), Zhang Feng is saying, that the quiet man of virtue hears true messages of nature which Confucius heard over two thousand years before.

Reference:
Images of the Mind: no. 36.

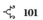

Wang Dongling, born 1945

Spirit Mountain

101

1989

Ink on paper

68.5 x 134.6

Krannert Art Museum

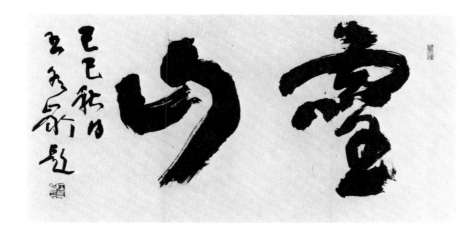

Spirit Mountain

List of Figures

Bai Di	白帝
bei	背
Beiyi (Mt.)	北黟
bigong	閟宮
bimeng	閟夢
Bo (game)	博
Bo (Mt.)	博
Bo Juyi	白居易
boshanlu	博山爐
Boya	伯牙
Cangwu (Mt.)	蒼梧
Cheng Lian	成連
Chicheng (Mt.)	赤城
Chiyou	蚩尤
Chu ci	楚辭
Ci	祠
Ci Fei	佽飛
Da (bird)	鴃
Dahe	大鼈
Damo (cave)	達摩
Da Yue	大嶽
da zongbo	大宗伯
Di	帝
ding	鼎
Ding Huan	丁緩
Dong Qichang	董其昌
dongtian	洞天
Dongting (lake)	洞庭
Dou Wan	竇綰
Duan (bird)	鶑
Duanwu	端午
Emei (Mt.)	峨眉
Erlang	二郎
Fang (Daoist)	方
Fang Chunnian	方椿年
Fanghu	方壺
fangshi	方士
fengchan	封禪
fengshui	風水
Fengyi	馮夷
fu	賦
Fu (family)	甫
Fu (Mt.)	浮
Fuchun (Mt.)	富春
fudi	福地
Fufu (Mt.)	夫夫
fusang	扶桑
ganlei	感類
gaoshi	高士
Gao Yi	高益
Gao Zhuang	高庄
Gaozong	高宗
Ge Hong	葛洪
Ge Xuan	葛玄
Gonghuai mo	宮槐陌
Gouqu (Mt.)	句曲
Gu (deity)	鼓
Gui (Mt.)	騩
Guilin	桂林
Gu Kaizhi	顧愷之
Gun	鯀
Guo Pu	郭璞
Guo Xi	郭熙
Guo Zhongshu	郭忠恕
Hai fu	海賦
haiji jing	海磯鏡
Hai nei qi guan	海內奇觀
Haitong	海童
Hanfeizi	韓非子
He (Lady)	何
Hebo	河伯
Heng (Mt., North)	恒
Heng (Mt., South)	衡
Hongren	弘仁
Houtu	后土
hu	壺
Huai (river)	淮
Huai nan zi	淮南子
Huaiyin	淮陰
Huang (Mt.)	黄
Huang Di	黄帝
Huang Di	皇帝
Huang Gongwang	黄公望
Huang Haoao	黄鶴翱
Huayang (house)	華陽
Hua yi tu	華夷圖
Hua yue zhi	華嶽志
Hugong	壺公
Huiji (Mt.)	會稽
Huixian	輝縣
Huiyuan	慧遠
Huizong	徽宗
hun	魂
Huo (Mt.)	霍
Ji (river)	濟
Jia Dan	賈耽
Jiang (clan)	姜
Jiangfu	江賦
jiang zhong wu ri	江中五日
jiao	蛟
Jia Shigu	賈師古
Jiaxing	嘉興
Jiazhou	嘉州
Jing (prince)	靖
Jiuyi (Mt.)	九疑

Kang (prince)	穅		Mancheng	滿城	Sanpanshan	三盤山
Kangxi	康熙		Mao (Mt.)	茅	Shang Di	上帝
Kuang Su (Yu)	匡俗（裕）		Maoshan (school)	茅山	Shangqing (school)	上清
kun	鯤		Mao Ying	茅盈	Shan hai jing	山海經
Kunlun (Mt.)	崑崙		Mawangdui	馬王堆	shanju	山居
			Ma Yuan	馬遠	Shaolin (temple)	少林室
Lantian	藍田		mian	面	Shaoshi (Mt.)	少室
Laozi	老子		Miao Xiyong	繆希雍	Shen (family)	申
lei	纇		mingqi	明器	sheng	笙
li (fish)	鯉		Mu (king)	穆	shengri	勝日
li (measure)	里		Mu Hua	木華	Shi jing	詩經
lian	奩				Shiqing	士慶
liangfeng	涼風		Nanshan	南山	Shun	舜
Li Bing	李冰		pantao	蟠桃	si (animal)	兕
Li Bo (Taibo)	李白（太白）		Pei Di	裴迪	si (resemblance)	似
Li Cheng	李成		Penglai	蓬萊	sidu	四瀆
Li Gui	李珪		pipa (lute)	琵琶	Sima Chengzhen	司馬承禎
lingli	鯪鯉		pixie	辟邪	Sizhen	四鎮
lingshan	靈山		po	魄	Song (Mt.)	嵩
Lingyun	靈均				Song Gao	嵩高
Linhuting	臨湖亭		Qian Gu	錢穀	Songjiang (school)	松江
lishu	隸書		Qianlong	乾隆	Song shu	宋書
Liubo	六博		qin (lute)	琴	Song Yu	宋玉
Liulige	琉璃閣		Qin Gao	琴高	suanxingqi	算形器
Liu Sheng	劉勝		Qingbian (Mt.)	青弁	Sun Chuo	孫綽
Liu Xiang	劉向		Qingxiang	清湘	Su Shi	蘇軾
Liu Yin	劉歆		Qinpei	欽碼		
Li Zicheng	李自成		Qinyuan	欽原	Tai (Mt.)	泰
Longhu (Mt.)	龍虎		qiong shu	瓊樹	Taibai (Mt.)	太白
lou	樓		Quanyuan	泉源	Tai bai quan tu	太白全圖
Lu (Mt.)	廬		que	闕	Tai Di	太帝
Lu Hongyi (Hong)	盧鴻一（鴻）		quliu	軀劉	Taie	太阿
Lunyu	論語		Qu Yuan	屈原	Taihu	太湖
Luofu (Mt.)	羅浮				Tai hua quan tu	太華全圖
Lu Shen	陸深				Tai hua shan tu	太華山圖
Lu Wu	陸吾				tailao	太牢
					Taipingdao	太平道
					Tai ping guang ji	太平廣記

Tai shan guan tu	泰山全圖	
Taizong	太宗	
Tao Hongjing	陶弘景	
taojing	陶徑	
Tao Qian	陶潛	
Tian	天	
Tian Di	天帝	
Tiandu (peak)	天都	
tianlu	天祿	
Tianshidao	天師道	
Tiantai (Mt.)	天台	
Tian ti	天梯	
Tian wen	天問	
Tulou	土塿	
Wang (ritual)	望	
Wang Chang	王長	
Wangchuan	輞川	
Wangkou (villa)	輞口	
Wang Mang	王莽	
Wang Yi	王逸	
Wang ziqiao	王子喬	
Wang Zijin	王子晉	
Wencheng	文成	
wu	巫	
Wu (emperor)	武	
Wu (state)	吳	
Wudoumidao	五斗米道	
Wu Jun	吳均	
wuxing	五行	
Wu yi shan zhi	武夷山志	
Wuyue	五嶽	
Wu yue zhen xing tu	五嶽真形圖	
Wu Yunshu	吳允叔	

Xiabogong	下泊宮	
Xia Gui	夏珪	
Xiang (river)	湘	
Xianglu	香爐	
Xianglufeng	香爐峯	
Xiangrui	祥瑞	
Xiangzhenqiao	降真橋	
xianren	仙人	
Xi jing za ji	西京雜記	
Xishi	谿石	
Xuande	宣德	
Xuanmu (Mt.)	玄墓	
Xuanpu	懸圃	
Xuanzong	玄宗	
Xu Jingyang (Xun)	許旌陽（遜）	
Xunlu	薰爐	
Xuyi	盱眙	
Yang (Lady)	楊	
Yangshao	仰韶	
Yang Xi	楊羲	
Yangzi (river)	揚子	
yi (box)	匜	
Yi (lake)	歙	
Yi (Mt.)	沂	
yimin	遺民	
Yingzhou	瀛州	
Yiwulü (Mt.)	醫無閭	
youdu	幽都	
youming	幽冥	
Yu	禹	
Yuanqiao	員嶠	
Yue	嶽	
Yuer	于兒	
Yu fu	漁父	
Yu ji tu	禹蹟圖	
yunqi	雲氣	
yunqiche	雲氣車	
Yuntai (Mt.)	雲臺	

Zang Jingyi	葬經翼	
ze	澤	
Zhanggong (cave)	張公	
Zhang Guolao	張果老	
Zhang Jue	張角	
Zhang Ling (Daoling)	張陵（道陵）	
Zhang Ruitu	張瑞圖	
Zhanmeng	占夢	
Zhanren	占人	
Zhanyuan	瞻園	
Zhao (empress)	趙	
Zhao (king)	昭	
zhaodan	照膽	
Zhaogong	昭公	
Zhaohun	招魂	
Zhao Lin	趙麟	
Zhao Mengfu	趙孟頫	
Zhao Sheng	趙昇	
zhaoxin	照心	
Zhao Yu	趙昱	
Zhayu	窫窳	
Zhengyi (sect)	正一	
zhenren	貞人	
zhenren	真人	
zhi	質	
Zhixing (Mt.)	支硎	
Zhongnan (Mt.)	終南	
Zhongshan (State)	中山	
Zhongxiaojingmingdao	忠孝淨明道	
Zhou li	周禮	
zhu	祝	
Zhuangzi	莊子	
Zhuhuai	諸懷	
Zhu Yidong	朱亦棟	
Zhu Yuanzhang	朱元璋	
Zong Bing	宗炳	
Zong Yuanding	宗元鼎	
Zuo zhuan	左傳	

Index of Artists in the Exhibition

73	Cui Zizhong	崔子忠
59, 60	Daoji	道濟
48	Ding Yefu	丁野夫
58	Ding Yunpeng	丁雲鵬
53	Dong Bangda	董邦達
80	Fan Qi	樊圻
99	Gao Yang	高陽
74, 75, 76, 77	Gong Xian	龔賢
64	Goulong Shuang	勾龍爽
97	Hou Mougong	侯懋功
93	Li Gonglin	李公麟
79	Liu Du	劉度
52	Lu Guang	陸廣
69, 70, 94	Lu Zhi	陸治
83	Ni Yuanlu	倪元璐
78	Qiu Ying	仇英
55, 71	Shao Mi	邵彌
54	Sheng Maoye	盛茂燁
11, 67	Shen Zhou	沈周
62	Shi Rui	石銳
51	Song Xu	宋旭
12	Wang Hui	王翬
65	Wang Jianzhang	王建章
95	Wang Meng	王蒙
91, 92	Wang Wei	王維
66	Wang Yun	王雲
68	Wen Jia	文嘉
96	Wen Zhengming	文徵明
56, 57, 72	Wu Bin	吳彬
81	Xiao Yuncong	蕭雲從
82	Yuan Jiang	袁江
100	Zhang Feng	張風
98	Zhang Fu	張復
63	Zhao Bozhu	趙伯駒

REFERENCES

CATALOGUES

Barnhart, Richard M. 1983. *Peach Blossom Spring: Gardens and Flowers in Chinese Paintings.* Exhibition catalogue, Metropolitan Museum of Art. New York.

Cahill, James, ed. 1971. *The Restless Landscape: Chinese Painting of the Late Ming Period.* Exhibition catalogue, University Art Museum. Berkeley.

Chou, Ju-hsi, and Claudia Brown. 1985. *Elegant Brush: Chinese Painting under the Qianlong Emperor 1735-1795.* Exhibition catalogue, Phoenix Art Museum. Phoenix.

Cleveland Museum of Art. 1980. *Eight Dynasties of Chinese Painting: The Collections of the Nelson Gallery-Atkins Museum, Kansas City, and the Cleveland Museum of Art.* Cleveland.

Edwards, Richard. 1976. *The Art of Wen Cheng-ming (1470–1559).* Exhibition catalogue, University of Michigan Museum of Art. Ann Arbor.

Fong, Wen, and Maxwell K. Hearn. 1981/82. *Silent Poetry: Chinese Paintings in the Douglas Dillon Galleries.* Metropolitan Museum of Art. New York.

Fu, Marilyn, and Shen Fu. 1973. *Studies in Connoisseurship: Chinese Paintings from the Arthur M. Sackler Collection in New York and Princeton.* Exhibition catalogue, The Art Museum, Princeton University. Princeton.

Hay, John. 1985. *Kernels of Energy, Bones of Earth: The Rock in Chinese Art.* Exhibition catalogue, China House Gallery. New York.

Karlgren, Bernhard. 1952. *A Catalogue of the Chinese Bronzes in the Alfred F. Pillsbury Collection.* Minneapolis Institute of Art. Minneapolis.

Kelley, Charles Fabens, and Ch'en Meng-chia. 1946. *Chinese Bronzes from the Buckingham Collection.* Art Institute of Chicago.

Lawton, Thomas. 1982. *Chinese Art of the Warring States Period: Change and Continuity, 480–222 BC.* Freer Gallery of Art. Washington, DC.

Lee, Sherman E., and Ho Wai-kam. 1968. *Chinese Art under the Mongols: The Yüan Dynasty (1279–1368).* Exhibition catalogue, Cleveland Museum of Art. Cleveland.

Lefebvre d'Argencé, René-Yvon. 1977. *Chinese Jades in the Avery Brundage Collection.* Asian Art Museum of San Francisco. San Francisco.

Mino, Yutaka, and James Robinson. 1983. *Beauty and Tranquility: The Eli Lilly Collection of Chinese Art.* Exhibition catalogue, Indianapolis Museum of Art. Indianapolis.

Shōsō-in Office. 1968. *Shōsō-in no kaiga* (Paintings in the Shōsō-in). Tokyo.

——————. 1976. *Shōsō-in no kinkō* (Metal Works in the Shōsō-in). Tokyo.

Tokyo Institute of Art. 1962. *Zōhin zuroku* (Catalogue of the Collection; Ancient Art–2). Tokyo.

Umehara, Sueji. 1945. *Tōkyō taikan* (Grand Compilation of Chinese Mirrors from the Tang Dynasty). Tokyo.

Walravens, Hartmut. 1981. *Catalogue of Chinese Rubbings from the Field Museum.* Field Museum of Natural History. Chicago.

SOURCES IN ENGLISH

Acker, William R. B. 1973. *Some T'ang and Pre-T'ang Texts on Chinese Painting.* Vol. 2. Leiden.

Bauer, Wolfgang. 1976. *China and the Search for Happiness.* Michael Shaw, trans. New York.

Berger, Patricia. 1983. "Purity and Pollution in Han Art." *Archives of Asian Art* 36: 40-58.

——————. 1987. "In a Far-off Country: Han Dynasty Art from South China in the Asian Art Museum of San Francisco." *Orientations* 18, no. 1: 20-31.

Bishop, Carl Whiting. 1927. "The Ritual Bullfight." In *Annual Report of the Smithsonian Institution for 1926,* 447-56. Washington, DC.

——————. 1933. "Rhinoceros and Wild Ox in Ancient China." *China Journal* 18: 322-30.

Bodde, Derk. 1961. "Myths of Ancient China." In *Mythologies of the Ancient World,* ed. Samuel N. Kramer, 367-408. Chicago.

——————. 1975. *Festivals in Classical China.* Princeton and Hong Kong.

——————. 1978. "Marshes in *Mencius* and Elsewhere: A Lexicographical Note." In *Ancient China: Studies in Early Civilization,* ed. David Roy and Tsuen-hsuin Tsien, 157-66. Hong Kong.

Bulling, Anneliese Gutkind. 1960. *The Decoration of Mirrors of the Han Period: A Chronology.* Artibus Asiæ Supplementum XX. Ascona, Switzerland.

Bush, Susan. 1983. "Tsung Ping's Essay on Painting Landscape and the 'Landscape Buddhism' of Mount Lu." In *Theories of the Arts in China,* ed. Susan Bush and Christian Murck, 132-64. Princeton.

Cahill, James. 1978. *Parting at the Shore.* New York and Tokyo.

_____.1982a. *Distant Mountain.* New York and Tokyo.

_____.1982b. *The Compelling Image.* Cambridge, Mass., and London.

Cahill, Suzanne E. 1982. "The Image of the Goddess Hsi Wang Mu in Medieval Chinese Literature." Ph.D. dissertation, University of California, Berkeley.

Chang, K. C. 1983. *Art, Myth, and Ritual: The Path to Political Authority in Ancient China.* Cambridge, Mass.

Ch'en, Pao-chen. 1984. "Searching for Demons on Mount Kuan-k'ou." In *Images of the Mind,* ed. Wen Fong, 323-24. Princeton.

DeWoskin, Kenneth. 1983a. *Doctors, Diviners, and Magicians of Ancient China: Biographies of Fang-shih.* New York.

_____.1983b. "Early Chinese Music and the Origins of Aesthetic Terminology." In *Theories of the Arts in China,* ed. Susan Bush and Christian Murck, 187-214. Princeton.

Eliade, Mircea. 1964. *Shamanism.* Princeton.

Erickson, Susan Nell. 1989. "*Boshanlu* Mountain Censers: Mountains and Immortality in the Western Han Period." Ph.D. dissertation, University of Minnesota.

Gray, Basil. 1966. *Admonitions of the Instructress of the Ladies in the Palace.* London.

Hawkes, David. 1959. *Ch'u Tz'u, The Songs of the South.* Oxford.

Hummel, Arthur W., ed. 1943/44. *Eminent Chinese of the Ch'ing Period (1644-1912).* Washington.

Hung, Wu. 1984. "A Sanpan Shan Chariot Ornament and the Xiangrui Design in Western Han Art." *Archives of Asian Art* 37: 38-59.

Keightley, David N. 1978. "The Religious Commitment: Shang Theology and the Genesis of Chinese Political Culture." *History of Religions* 17: 211-25.

Knechtges, David R. 1982. *Wen xuan, or Selections of Refined Literature.* Vol. 1. Princeton.

_____.1987. *Wen xuan, or Selections of Refined Literature.* Vol. 2. Princeton.

Lau, D. C. 1963. *Lao-tzu; Tao-te ching.* London.

Laufer, Berthold. 1909. *Chinese Pottery of the Han Dynasty.* Leiden.

Legge, James. 1935a. *The Ch'un Ts'ew with the Tso Chuen.* Shanghai. Reprint. Vol. 5 of The Chinese Classics, Hong Kong, 1960.

_____.1935b. *The She King, or the Book of Poetry.* Shanghai. Reprint. Vol. 4 of The Chinese Classics, Hong Kong, 1960.

Li, Chu-tsing. 1976. "Lu Kuang." In *Dictionary of Ming Biography 1368–1644,* ed. L. Carrington Goodrich, 994-95. New York and London.

Lin, Li-juan. 1989. "The Myth of Elixir Light in Mao-shan: A Study of Three Paintings of the Late Yüan." Unpublished paper, University of Illinois.

Loewe, Michael. 1979. *Ways to Paradise.* Boston and Sydney.

Major, John Stephen. 1973. "Topography and Cosmology in Early Han Thought: Chapter Four of the Huai-nan-tzu." Ph.D. dissertation, Harvard University.

_____.1978. "Research Priorities in the Study of Ch'u Religion." *History of Religions* 17, nos. 3-4: 226-43.

Mather, Richard. 1961. "The Mystical Ascent of the T'ien-t'ai Mountains." *Monumenta Serica* 20: 226-45.

Munakata, Kiyohiko. 1983. "Concepts of *Lei* and *Kan-lei* in Early Chinese Art Theory." In *Theories of the Arts in China,* ed. Susan Bush and Christian Murck, 105-31. Princeton.

_____.1988. "Mysterious Heavens and Chinese Classical Gardens." *Res* 15 (Spring): 61-88.

Needham, Joseph. 1956. *Science and Civilisation in China.* Cambridge.

Schafer, Edward H. 1951. "Ritual Exposure in Ancient China." *Harvard Journal of Asiatic Studies* 14: 130-84.

_____.1967. *The Vermilion Bird: T'ang Images of the South.* Berkeley and Los Angeles.

_____.1968. "Hunting Parks and Animal Enclosures in Ancient China." *Journal of the Economic and Social History of the Orient* 11: 318-43.

_____.1989. *Mao Shan in T'ang Times.* 2d. ed., rev. Society for the Study of Chinese Religions Monograph No. 1. Boulder, Colo.

Schwartz, Benjamin I. 1985. *The World of Thought in Ancient China.* London.

Seidel, Anna K. 1969-70. "The Image of the Perfect Ruler in Early Taoist Messianism: Lao-tzu and Li Hung." *History of Religions* 9, nos. 2-3: 216-47.

Silbergeld, Jerome. 1980. "Kung Hsien's Self-Portrait in Willow, with Notes in the Willows in Chinese Painting and Literature." *Artibus Asiæ* 42, no. 1: 5-38.

Sivin, Nathan. 1978. "On the Word 'Daoist' as a Source of Perplexity, with Special Reference to the Relations of Science and Religion in Traditional China." *History of Religions* 17, nos. 3-4: 303-30.

Strickmann, Michel. 1979. "On the Alchemy of T'ao Hung-ching." In *Facets of Taoism*, ed. Holmes Welch and Anna Seidel, 125-30. New Haven and London.

Sullivan, Michael. 1962. *The Birth of Landscape Painting in China.* Berkeley and Los Angeles.

Sun-Bailey, Suning. 1988. "What Is the 'Hill Jar'?" *Oriental Art* 34, no. 1: 88-90.

Vinograd, Richard Ellis. 1979. "Wang Meng's 'Pien Mountains': The Landscape of Eremitism in Later Fourteenth Century Chinese Painting." Ph.D. dissertation, University of California, Berkeley.

Wang, Ching-fei. 1989. "The Mythological Story of Erh-lang: Three Versions of 'Searching for Demons on Mt. Hei-feng in Kuan-k'ou.'" Unpublished paper, University of Illinois.

Ware, James R. 1966. *Alchemy, Medicine, Religion in the China of AD 320: The Nei p'ien of Ko Hung (Pao-p'u tzu).* Cambridge, Mass., and London.

Weber, Charles D. 1966. "Chinese Pictorial Bronze Vessels of the Late Chou Period—Parts II and III." *Artibus Asiæ* 28, no. 4: 271-311, and 29, no. 2/3: 115-92.

Yang, Lien-sheng. 1945. "A Note on the So-called TLV Mirrors and the Game Liu-po." *Harvard Journal of Asiatic Studies* 9: 202-7.

_____. 1952. "An Additional Note on the Ancient Game Liu-po." *Harvard Journal of Asiatic Studies* 15: 124-39.

SOURCES IN CHINESE AND JAPANESE

In the following entries, the *Si bu cong kan* edition is abbreviated as SBCK ed.

Akizuki Kanei. 1978. *Chūgoku kinsei dōkyō no keisei.* Tokyo.

Ban Gu. "Xi du fu." In *Wen xuan* 1/4b-25a.

Chen Mengjia. 1936a. "Gu wen zi zhong zhi Shang Zhou ji su." *Yan jing xue bao* 19: 91-155.

_____. 1936b. "Shang dai de shen hua yu wu shu." *Yan jing xue bao* 20: 485-576.

Chu ci. SBCK ed.

Dongfang Shuo. "Dong xuan ling bao Wuyue gu ben zhen xing tu." *Daozang* 197, *guo* 11, 1a-27a.

Dun Chong. 1906. *Yanjing sui shi ji.* Beijing. Reprint. 1969. Kuanwu shuju, Taibei.

Fu Baoshi. 1941. *Jin Gu Kaizhi "Hua Yuntai shan ji" zhi yan jiu.* Zhongqing.

Fukui Kōjun. 1962. *Dōkyō no kiso teki kenkyū.* Tokyo.

Ge Hong. *Baopuzi.* SBCK ed.

Guo Baojun. 1959. *Shanbiaozhen yu Liulige.* Beijing.

Guojia Wenwushiye guangliju. 1981. *Zhongguo ming sheng ci dian.* Shanghai.

Guo Pu. "Jiang fu." In *Wen xuan* 12/11a-19a.

Guo Ruoxu. *Tu hua jian wen zhi. Jiguge* ed.

Han shu. SBCK ed.

Hayashi Minao. 1962. "Sengoku jidai no gashōmon." *Kōkogaku Zasshi* 48, no. 1: 3-14.

_____. 1967. "Chūgoku kodai no shinfu." Kyoto *Tōhōgakuhō* 38: 199-224.

_____. 1968. "Inshū jidai no zushō kigō." Kyoto *Tōhōgakuhō* 39: 1-117.

_____. 1971. "Chōsa shutsudo So hakusho no jūnishin no yurai." Kyoto *Tōhōgakuhō* 42: 1-63.

_____. 1984. "Iwayuru tōtetsumon wa nanio arawashita mono ka?" Kyoto *Tōhōgakuhō* 56: 1-97.

_____. 1989. *Kandai no kamigami.* Kyoto.

Hou Han shu. SBCK ed.

Huai nan zi. SBCK ed.

Huaiyinshi Bowuguan. 1988. "Huaiyin Gaozhuan Zhanguo mu." *Kao gu xue bao*, no. 2: 189-232.

Hunansheng Bowuguan and Zhongguo Kexueyuan Kaogu Yanjiusuo, eds. 1973. *Changsha Mawangdui yihao Han mu*. Beijing.

Ikeda, Suetoshi. 1981. *Chūgoku kodai shūkyōshi kenkyū*. Tokyo.

Iriya Sensuke. 1976. *Ōi kenkyū*. Tokyo.

Iritani Yoshitaka et al., eds. 1975. *Ōi*. Bunjinga suihen series, Vol. 1. Tokyo.

——————.1978. *Shin Shū, Bun Chōmei*. Bunjinga suihen series, Vol. 4. Tokyo.

Kimata Tokuo. 1962. "Eon to Sō Hei o megutte." In *Eon kenkyū*, 2 vols., ed. Eiichi Kimura, vol. 2, 278-364. Kyoto.

Kobayashi Taichirō. 1947. *fhūgoku kaigashi rōnkō*. Tokyo.

Laozi. *Laozi dao de jing*. SBCK ed.

Liang shu. SBCK ed.

Li Bo. *Fen lei bu zhu Li Taibo shi*. SBCK ed.

Lie xian zhuan. Daozang 138.

Li Lincan. 1971. *Zhongguo minghua yanjiu*. Taibei.

Lun yu. SBCK ed.

Lüshi chun qiu. SBCK ed.

Lu Zhi. *Lu Baoshan yi gao*. Lidai huajia shiwenji series. Reprint. 1960. Xuesheng Shuju, Taibei.

Maeda Taiji. 1948. "Gyobutsu kaiki-kyō zu kō." *Bijutsu kenkyū* 148: 104-19.

Mitarai Masaru. 1984. *Kodai chūgoku no kamigami*. Tokyo.

Miyagawa Hisayuki. 1964. *Rikuchōshi kenkyū—Shūkyōhen*. Kyoto.

Morohashi Tetsuji. 1955-60. *Dai kanwa jiten*. 13 vols. Tokyo.

Mu Hua. "Hai fu." In *Wen xuan* 12/7a-b.

Mutianzi zhuan. SBCK ed.

Nanjing Bowuguan. 1979. "Jiangsu Xuyi Dongyang Han mu." *Kao gu* 164: 412-26.

Nishida Morio. 1968. "Shinjūkyō no zuzō: Hakuga kyogaku no meibun o chūshin to shite." *Museum* 207: 12-24.

Obi Koichi. 1962. *Chūgoku bungaku ni arawareta shizen to shizenkan*. Tokyo.

Ogawa Takuji. 1928. *Shina rekishi chiri kenkyū*. Tokyo.

Ono Katsutoshi. 1938. *Rekidai meiga ki*. Tokyo.

——————.1967. *Enkyō saiji ki*. Tokyo.

Quan Tang wen. Reprint. 1972. Wenyou shudian, Taibei.

Rong Zhaozu. 1929. "Erlang shen kao." *Min zu zhou kan* 61-62. Reprinted 1982 in *Erlang shen yan jiu*, ed. Zhu Chuanyu. Taibei.

Shan hai jing. SBCK ed.

Shenxian zhuan. Shuo ku ed.

Shi ji. SBCK ed.

Shi jing. SBCK ed.

"Shui xian cao." In *Gu shi yuan Si bu bei yao* edition, 1/7a-b.

Shu jing. SBCK ed.

Sima Chengzhen. "Dongtian fudi, Tiandi gongfu tu." In *Yun ji qi qian*. SBCK ed., *juan* 27.

Sima Xiangru. "Shanglin fu." In *Wen xuan*, 8/1a-20a.

Sofukawa Hiroshi. 1981. *Konronzan eno shōsen*. Tokyo.

Song shu. SBCK ed.

Song Yu. "Zhao hun." In *Chu ci*, 9/1a-19b.

Sun Chuo. "Yu Tiantai shan fu." In *Wen xuan*, 11/1a-13a.

Suzuki Kei. 1981. *Chugoku kaiga shi*. Tokyo.

Tai ping guang ji. Reprint. 1969. Xinxing shuju, Taibei.

Tang shu. SBCK ed.

Wang Wenru, ed. 1915. *Shuo ku*. Shanghai. Reprint. 1986. Zhejiang gushu chubanshe.

Wang Wei. *Wang Youcheng ji*. SBCK ed.

Wen xuan (Liu chen zhu wen xuan). SBCK ed.

Xiao Gang (Liang Jianwen Di). "Dahe fu." In *Yi wen lei ju*, 9/1a-b.

Xie Hua. 1984. *Luofu shan fengwu zhi*. Guangdong.

Xi jing za ji. SBCK ed.

Yi wen lei ju. Reprint. 1969. Xinxing shuju, Taibei.

Yonezawa Yoshiho. 1962. *Chūgoku kaigashi kenkyū*. Tokyo.

Yuan Ke. 1980. *Shan hai jing jiao zhu*. Shanghai.

Yu Jianhua et al., eds. 1962. *Gu Kaizhi yanjiu ziliao*. Beijing.

Zang Lihe et al., eds. 1931. *Zhongguo gujin diming dacidian*. Hong Kong.

Zhang Yanyuan. *Li dai ming hua ji*. Ono Katsutoshi collated edition in Ono 1938, 272-392.

Zhongguo shehui kexueyuan kaogu yanjiusuo. 1980. *Mancheng Hanmu fajue baogao*. Beijing.

Zhonghua Shuju. 1982. *Wu yue shi hua*. Zhongguo lishi xiaocongshu hedingben. Beijing.

Zhou li. SBCK ed.

Zhuang Bohe. 1976. *Zhongguo yishu zhaji*. Taibei.

Zuo zhuan (Chun qiu jing zhuan ji jie). SBCK ed.

Photo Credits

The Art Institute of Chicago, cat. nos. 27, 28, 41, 46, 78, 93; The Art Museum, Princeton University, cat. nos. 48, 59, 75, 83, 95, 100; Asian Art Museum of San Francisco, fig. 36, cat. nos. 14, 15, 16, 20, 22, 87, 88; The British Museum, London, fig. 27; Ching Yuan Chai Collection, Berkeley, California, Ben Blackwell, photographer, cat. nos. 72, 74; The Cleveland Museum of Art, fig. 28, cat. nos. 58, 73, 79; Field Museum of Natural History, Chicago, John Weinstein, head photographer, fig. 22, cat. nos. 2 (neg. 109828), 3 (neg. 109823), 4 (neg. 109827), 5 (neg. 109831), 6 (neg. 109830), 7 (neg. 109826), 18 (negs. 111432, 111433, 111434), 19 (neg. 109824), 29 (neg. 111435), 30 (neg. 111438), 31 (neg. 111437), 32 (neg. 111436), 50 (neg. 109829), 91 (negs. 90537, 90538, 90539, 90540, 90541, 90542); Freer Gallery of Art, figs. 21, 25, 38, 42; Honolulu Academy of Arts, cat. nos. 56, 57; Indianapolis Museum of Art, cat. no. 43; Krannert Art Museum, Champaign, Illinois, Wilmer Zehr and George Rehrey, photographers, cat. nos. 97, 101; The Metropolitan Museum of Art, New York, cat. nos. 12, 25, 26, 39, 40, 52, 60, 77, 80, 89, 90, 94; Minneapolis Institute of Arts, cat. nos. 13, 21, 24, 34, 37, 42; The Museum of Fine Arts, Boston, cat. no. 53; Nelson-Atkins Museum of Art, Kansas City, fig. 7, cat. nos. 11, 17, 33, 38, 61, 66, 69, 70; Nicholas Cahill Collection, Berkeley, California, Ben Blackwell, photographer, cat. nos. 76, 98, 99; Portland Art Museum, Portland, Oregon, cat. nos. 36, 67; Private Collection, Urbana, Illinois, Harry Zanotti, photographer, cat. no. 47 a, b, c, d; Robert Poor Collection, Minneapolis, cat. nos. 84, 85, 86; Sarah Cahill Collection, Berkeley, California, Ben Blackwell, photographer, cat. nos. 51, 68; Seattle Art Museum, cat. nos. 35, 44, 45, 65, 71, 81; University Art Museum, Berkeley, California, Ben Blackwell, photographer, cat. nos. 49, 54; The University of Michigan Museum of Art, Ann Arbor, cat. nos. 55, 63, 64, 96; Yale University Art Gallery, fig. 26.

Figure 10 reproduced courtesy of Tokyo Institute of Art; figs. 30-34 reproduced courtesy of Treasure of Shōsō-in, Japan; fig. 37 reproduced courtesy of Professor Minao Hayashi; fig. 8 reproduced courtesy of Eiseibunko Collection, Tokyo.

Ann Tyler Communication Design
IntelliText Corporation
Andromeda Printing and Graphics Company

DATE DUE